State the facts. Explain all evidence with
the greatest economy. C... ...original
function of the pain... ... what
space was it intended.
does our contemporary frame of mind differ
from the audience for which the painting was
intended?
Surface appearance and deeper meaning

PRINCIPLES
OF
ART HISTORY WRITING

Metonymy
describes the whole
as the sum of its parts.
Where is the picture?

Synecdoche
places the work in a
historical framework

Deictic images evoke the presence of the viewer.
Socratic images are completed in the past
and self-contained

A humanistic approach to art writing
falsely supposes that one can reconstruct
the intentions of the artist.

PRINCIPLES
OF
ART HISTORY WRITING

· · ·

DAVID CARRIER

THE PENNSYLVANIA STATE UNIVERSITY PRESS

UNIVERSITY PARK, PENNSYLVANIA

Quotation from "Self-Portrait in a Convex Mirror" by John Ashbery.
Copyright © 1974 by John Ashbery. Reprinted by permission of the
publisher, Viking Penguin, a division of Penguin Books USA Inc.

Library of Congress Cataloging-in-Publication Data

Carrier, David, 1944–
 Principles of art history writing / David Carrier.

 p. cm.
 Includes bibliographical references.
 ISBN 0-271-00711-7 (alk. paper)
 1. Art—Historiography. I. Title.
 N380.C37 1991
 707′.2–dc20 90–34962

ISBN 0-271-00711-7 (alk. paper)
ISBN 0-271-00945-4 (pbk.)

Second printing, 1993

It is the policy of The Pennsylvania State University Press to use acid-free
paper for the first printing of all clothbound books. Publications on uncoated
stock satisfy the minimum requirements of American National Standard for
Information Sciences—Permanence of Paper for Printed Library Materials,

for M.R.

Mark Roskill

In what is called philosophy of art, there is usually lacking one of the two: either philosophy or art.

—Friedrich von Schlegel

. . . those apparatuses—the baffling mirror, the black velvet backdrop, the implied associations and traditions—which the native illusionist, frac-tails flying, can magically use to transcend the heritage in his own way . . .

—Vladimir Nabokov

Contents

Illustrations

Acknowledgments

· · ·

I thank those patient journal editors who encouraged me to rework earlier versions of the chapters that follow: the late John Fisher, *The Journal of Aesthetics and Art Criticism*; Terry Diffey, *The British Journal of Aesthetics*; Michael Leslie and John Dixon Hunt, *Word & Image*; John Onians, *Art History*; Richard T. Vann, *History and Theory*; Ralph Cohen, *New Literary History*; Stephen Bann, *History of the Human Sciences*; and Anita Silvers, *The Monist*. The original essays have been completely revised for this volume. I am indebted also to various audiences of lectures on themes related to those of this book: the art history departments of Brown University, Cornell University, and the University of Texas at Austin; the philosophy departments of Central Michigan University and the University of Houston; and the Intermuseum Laboratory, Oberlin.

A draft of this book was completed in the summer of 1987, and so it makes only occasional reference to the more recent art-historical literature, which does not, I think, call for changes in my philosophical arguments. Unless otherwise indicated, the translations are my own.

The philosophers Arthur Danto and Alexander Nehamas and the art historians Paul Barolsky and Richard Shiff have very generously supported my work. As this book radically opposes Danto's view of art history, it is a measure of his intellectual charity that he has helped teach its author how to argue with him. Nehamas may find echoes of his ideas here, and perhaps will remember the very hot summer day when he persuaded me that I could finish my essay on Caravaggio and the cold winter day when we attended the great Manet exhibition at the Metropolitan. In very different ways, Barolsky and Shiff challenge the traditional views of art history, and so the stimulus of their work and their support for mine has been important.

Many discussions with Marianne Novy have forced me to clarify my arguments. My daughter Elizabeth, not born when this book was conceived, has taught me many things about narratology. Philip Winsor, my patient editor, persuaded me to make stylistic changes. Frank Hunt did sensitive editing. The painter Frances Lansing and Ann Stokes Angus and Ian Angus have helped me to see art in Italy and in England. I thank the many people, some known to me only as correspondents or commentators on my publications, who have made suggestions or corrected errors of fact: Svetlana Alpers, Michael Baxandall, Norman Bryson, the late Sir William Coldstream, Robert Grigg, Craig Harbison, Ann Sutherland Harris, Marilyn Aronberg Lavin, Lisa Leizman, Alex Potts, Richard E. Spear, and Leo Steinberg. At Carnegie-Mellon University Francie Mrkich arranged essential interlibrary loans, and Maria Wilkinson was helpful in making slide reproductions. I am grateful to the National Endowment for the Humanities for a summer research grant.

I dedicate my essays, and earlier versions of the chapters that follow were dedicated to friends: the artists Howard Buchward, Catherine Lee and Sean Scully, Vered Lieb and Thornton Willis, Jean Feinberg, Michael Kessler, Tom Nozkowski and Joyce Robins, Harvey Quaytman, and David Reed; and Alexander Nehamas. Mark Roskill and I originally planned to collaborate on this volume, and in an odd way we have, as our discussions have permitted me to write this book and helped him complete his

own very different account, which appears in *The Interpretation of Pictures* (Amherst, 1989). Over the past decade, Mark has read many drafts of my essays, given me many references, and visited museums with me. Without his very generous encouragement, this book would never have been written.

PRINCIPLES
OF
ART HISTORY WRITING

Introduction

. . .

I began by asking two simple questions: Why does the argumentation of present-day art historians differ so dramatically from that of earlier artwriters? And since those modern historians often disagree, how is objectivity in art history possible? I answer them by means of a parallel between the history of art and the history of artwriting. According to Vasari and E. H. Gombrich, painting progressed by making ever more perfect naturalistic representations of the world. Perhaps the same is true also of artwriting. The modern texts are superior to the older accounts because they give better descriptions of the artworks.

I use the word "artwriting" to refer to texts by either critics or art historians. I speak of "art history" when referring to texts by present-day

professional historians of art.[1] This verbal distinction underlines an important conceptual point. Vasari and Leo Steinberg both write about Michelangelo; Crowe and Cavalcaselle and Erwin Panofsky discuss van Eyck; Zola and Theodore Reff both analyze Manet. But are the earlier writers and the modern historians really doing the same thing? If they are not, then we need two different words to indicate that their texts belong to different literary genres.

If premodern artwriting is a different genre of writing from art history, then perhaps there is no progress in the study of art. Once we recognize that the interests of the modern art historians are very different from those of the older figures the claim that the more recent texts are better becomes questionable. Today many writers question the belief in progress in art. Analogously, maybe there is no progress in artwriting. Giotto and Constable have very different goals, and so it is hard for Gombrich to show convincingly that Constable's works progress beyond Giotto's. Since present-day artwriters also have different goals from their predecessors, comparing their texts with the older accounts may be impossible.

The goal of all artwriting is to describe artworks truthfully. Yet this in itself does not tell us how to compare the older accounts with the modern texts. A truthful account is true to the facts. But often the facts about an artwork are themselves in dispute. And since it is debatable what facts about other artworks, texts, or the culture of the time are relevant to an artwork, no simple appeal to the facts will tell us how to choose between conflicting interpretations. And yet until we can explain how truth is achieved in artwriting, the very notion that there can be rational debate among art historians is problematic.

The recognition that artwriting too has a history raises a difficult problem: How can we distinguish genuinely conflicting interpretations of the selfsame artwork from representations that merely draw attention to different features of that work? Arguing that objectivity of interpretation is possible, I defend a form of relativism. I argue that no single methodology provides a privileged way of interpreting artworks and shows how real argumentation among opposed methodologies is possible. My relativism is consistent both with the claim that some interpretations are better than others and with the belief that artwriting gives truthful representations of the artifacts it describes.

1. For discussion of these words, see my *Artwriting* (Amherst, 1987).

There is no neutral naturalism in visual art, no way of depicting the world except by depicting it in a certain style. Analogously, there is no neutral way of representing artworks. In retrospect, my claim that artwriting is a form of writing seems obvious. But I only slowly came to understand its significance. When I did, I recognized that it had important consequences. Just as there are differing styles of naturalistic art, so there are various styles of artwriting. And we can learn about artwriting by comparing it with another genre of writing, the novel.

One aim of the literary critic is to analyze the style of novels, describing their complex relation of form and content. My related task is to describe the literary structure of artwriting. A historian of literature discusses the changing style of novels. As a historian of artwriting I seek to explain the history of the ways in which art historians have emplotted their narratives. Style is important in artwriting, for we cannot entirely extract an artwriter's argument from the text in which it is presented. Although this point seems obvious when baldly stated, much critical discussion of art history, which focuses exclusively on the "ideas" of artwriters, is weakened by the failure to take it into account. Unless we understand the style of writing in which an artwriter presents her claims, we cannot be prepared to genuinely argue with them. (In lectures, my use of the feminine pronoun to refer to the artwriter has caused some controversy, which is one reason I use it here too.) In art history the "content" of the argument thus cannot be understood apart from the "form" of its presentation. Art history writing is a verbal representation whose argumentation can be understood only by analyzing its narrative structure.

A historian may describe the development of the novel from Jane Austen to Thomas Pynchon. Certainly these novelists have very different styles, but that does not imply that Pynchon's books are more truthful. Artwriting, however, differs in two essential ways from fiction. Novels do not claim to be truthful, although the truths some tell about society may interest social historians. And since Austen and Pynchon describe different fictional worlds, her novels cannot conflict with his. But various artwriters who discuss a painting are describing the same artwork. And so if there is to be rational debate, we must find some way of comparing and contrasting their accounts of those works.

A successful account of artwriting must both do justice to its rhetorical dimension and explain how it differs from fiction. My study of the rhetoric

of artwriting has two dimensions. The *diachronic* analysis explains the changing styles of writing about art from Vasari to the present. The *synchronic* analysis compares and contrasts the alternative interpretations presented at a given time. Only the combination of synchronic and diachronic analysis permits us to understand both how styles of artwriting change and why truthful accounts of artworks are nevertheless possible.

As a historian of artwriting, I want to explain *how* the style of modern professional scholars is unlike that of the amateur, preprofessional art historians. And I want to explain *why* this change has taken place. My history will explain how the modern art-historical text was created. Any useful history that aims to provide something more than a survey of the literature must be extremely selective. A historian of the novel typically uses a small number of examples to explain the development of the novel over the centuries. In examining the enormous literature of art history, I focus on a detailed analysis of a few case studies. This analysis leads to a general theory of the history of artwriting. This book invades the territory of many specialists, a practice whose dangers I am conscious of. What justifies this practice and will, I hope, excuse some of the errors I will inevitably make is the broad philosophical perspective that emerges.

Within present-day art history, the conflict of interpretations is consistent with truth in interpretation. Behind the real conflict of interpretations, we can find a deeper agreement about the rules governing admissible interpretations. Modern art history can exist as an academic discipline only because art historians are able to agree about what disagreements are important and how to disagree. And when these implicit rules governing their discourse are spelled out, we can understand how truth in interpretation is possible.

These implicit rules are the conventions of artwriting, the strategies that permit an art historian to identify her problem and convincingly solve it. To understand these rules is to focus on artwriting as a form of writing. Once we recognize that standards of objectivity are defined by these rules, then we can understand both why objectivity is possible and how standards of objectivity can change. Objectivity is possible because (nearly) every serious scholar obeys the same rules. Standards of objectivity can change because those rules can be changed by an original scholar.

For the humanist tradition, the goal of art history is to re-present the

mental states of the artist. Humanism provides a way of achieving objectivity in interpretation. It claims to offer a nonconventional standard by which to judge objectivity in interpretation. In principle, a uniquely correct re-creation of an artist's mental states should be possible. In practice, because the evidence is incomplete, that goal may not be achieved. The multiplicity of interpretations of an artwork reflects this unfortunate fact.

My focus on the conventions or rhetoric of artwriting leads me to reject humanism. A good interpretation must be true to the facts, plausible, and original. Writing such an art-historical interpretation is a creative activity, for the facts alone do not tell the artwriter how to emplot her narrative. The humanist will think that my account leaves out one further essential point—that narrative must be a truthful representation of the artist's intention. A central argument of this book is that this appeal to the artist's intentions adds nothing.

If the organization of the artwriter's text depends upon conventions, what alternative strategies of emplotment are possible? Part One of this book discusses that question. Some art-historical narratives are organized around the study of individual works. Because there is a tradition of elaborate interpretation of several of Piero's works, any new account must build upon those interpretations. Other art-historical narratives deal with an artistic personality. Because we know much about Caravaggio, it is natural to interpret his art in relation to his life. Still other art-historical narratives develop by comparing and contrasting related works by different artists within one artistic culture. Because van Eyck's visual allegories function differently from Robert Campin's, we can understand their works by comparing and contrasting them.

As almost nothing is known about Piero himself, interpretation can depend upon the belief that Piero's art may express a complex response to contemporary political events or contain elaborate religious symbolism. Because neither Vasari's laconic life of the artist nor any other near-contemporary documentation suggests that Piero's painting contains such political commentary or symbolism, his interpreters must show that they are not simply projecting modern concerns into his work. Something is known of Caravaggio's life, and there are a number of near-contemporary responses to his work. It is therefore possible, as is not really the case with Piero, to interpret his painting as an art of self-expression. Since the evolution of Caravaggio's art is unusually complex,

it is tempting to narrate the history of his artistic evolution as a story of his personal development. But no premodern text says what some modern historians claim, that Caravaggio expressed erotic feelings in his art or that his paintings contain complex symbolism.

Van Eyck's *Arnolfini Marriage* and Campin's Mérode Altarpiece raise similar problems. All earlier commentators treat these as marvelously naturalistic images, and so the discovery of complex hidden symbolism seems surprising. Once the rules of this discourse were implicitly defined by Panofsky and Meyer Schapiro, it was open to their successors to argue with details of their interpretations while accepting their general view of allegorical images. But as Panofsky and Schapiro themselves disagree in some basic ways about the significance of allegory in Flemish art, comparing their accounts suggests different ways of interpreting these works.

Study of these narratives points to three different ways of organizing modern art-historical narratives. This is essentially a synchronic analysis, but it gains historical perspective by comparing the modern styles of argument with those of earlier artwriters. Part Two turns to a diachronic analysis. Now we are prepared to understand how the conventions of art-historical argument have changed over time. Someday it will be possible to write a full history of art history. For my purposes, a discussion of the conventions employed at three crucial historical moments suffices to demonstrate that these conventions have changed.

The key tool of Renaissance artwriting is *ekphrasis*, verbal re-creations of the visual artwork. Modern art history employs interpretations. *Ekphrases* and interpretations are different sorts of texts. The goals of the modern art historian and the Renaissance artwriter differ. An *ekphrasis*, the word-painting serving as a substitute for a photograph or engraving of an image, need only be detailed enough to identify the subject matter of a picture. An interpretation explains the significance of many details of an artwork, often demonstrating that some small, seemingly insignificant element is the key to the meaning of the whole. I illustrate this *ekphrasis*/interpretation distinction by contrasting the roles of Vasari and the modern art historian. An *ekphrasis* substitutes for a photograph, identifying the subject matter of a painting. An interpretation gives a controversial account of the meaning of a picture, which means that a good interpretation will be imitated and debated.

This is a contrast between premodern artwriting and art history. But we can also find evolution within premodern artwriting. The contrast be-

tween Winckelmann's late eighteenth-century use of metonymy and Pater's employment of another trope, synecdoche, illustrates such a change in narrative strategy. This difference in strategy means that Winckelmann and Pater will interpret the same artifacts differently.

Both my account of the *ekphrasis*/interpretation distinction and my contrast of Winckelmann's metonymy with Pater's synecdoche are studies in the rhetoric of premodern artwriters. My third example involves an artwork much discussed recently. Revisionist artwriters claim that the traditional artwriter's search for a picture's sources do not do justice to David's *Oath of the Horatii*. Their texts involve novel emplotting of narratives. Like Vasari, Winckelmann, and Pater, these writers employ a different rhetoric than the humanist art historian.

Parts One and Two of this book are methodological studies. They show how artwriters' texts are composed. Part Three turns from this theorizing about artwriting to the development of original interpretations. The historical studies prepare the way for this practice of artwriting.

Discussing the role of the spectator in artwriting, I ask two questions: *Where* is the spectator in relation to the artwork he perceives? And *when* is the spectator in relation to that artwork? One reason that Gombrich, Michael Fried, Steinberg, and Michel Foucault interpret paintings differently is that they identify the place of the spectator differently. Winckelmann's employment of metonymy and Pater's of synecdoche determine how they interpret classical sculpture. Analogously, how these four modern artwriters emplot their narratives heavily influences their interpretations. We can contrast their positions by comparing their accounts of the spatial relation of the artwork to the spectator.

Art historians have had less to say about the temporal relation of artwork to spectator. But just as the spectator may have various imagined spatial positions, so he may also have different possible temporal relations to the depicted scene. The figures represented in a painting normally imaginatively exist as if at some time in the past. But in some seventeenth-century works they are presented as if in the presence of the viewer. Panofsky's classic account of Poussin's *Arcadian Shepherds* matches the two images of that title by Poussin with two readings of the text they illustrate. I argue that identifying the implied temporal location of such images helps us better understand these paintings.

These discussions of the spatial and temporal location of the spectator use examples from old-master art. I argue that a revisionist art history

provides better interpretations of these works than the older accounts of humanists. These works have long been discussed by art historians. Early modern painting has been less extensively interpreted, and so raises different problems. My focus on the rhetoric of artwriting suggests original ways of interpreting the art of Manet and Matisse.

I begin discussion of Manet by contrasting the early, relatively straight-forward accounts of his art with the highly elaborate recent interpreta-tions. Here the historical discussion is immediately relevant to art today. Our view of Manet is influenced by our understanding of contemporary art. I introduce Matisse by analyzing his images of himself depicting his model, an important motif for him. These paintings and drawings con-struct a self-contained pictorial space in which there is no possible external place for a viewer, creating the illusion that we are viewing them as they are being created. Manet's images are representations that call into question their very capacity to represent an external reality. Ma-tisse's motif places the spectator within the artwork. These modernist artworks cannot be properly analyzed without taking into account their temporal relation to the viewer.

Modern art history was created by scholars trained in the traditions of German philosophy, to which a number of them contributed. Present-day art historians have little interest in philosophy. It is possible to study the history of art history in a purely historical way.[2] Some art historians believe that once their field emerges as a self-sufficient academic disci-pline, it abandons its philosophical concerns. My view is different. For me the philosophy of art history is inseparable from the practice of interpretation that arises from reflection on art history. If there is ulti-mately no distinction between the practice and the philosophy of artwriting, a properly philosophical history should demonstrate the valid-ity of its theorizing by exhibiting the implications of that theorizing for the practice of interpretation. This I do in Part Three. Having argued that objectivity of interpretation depends upon changeable conventions, here I show how the present conventions of art history writing might be changed. I thus bring together in my conclusion what initially seemed far apart: the practice of art historians and the philosopher's reflection on that practice.

2. See Michael Podro, *The Critical Historians of Art* (New Haven, 1982), and Michael Ann Holly, *Panofsky and the Foundations of Art History* (Ithaca, 1984).

PART ONE

. . .

Case Studies: Interpretation in Present-day Art History

1

Preservation as Interpretation

·　·　·

The first problem that an art historian must consider is the identity of the artwork as artifact. There is an important link between the concerns of the historian and the activity of the restorer. The museum's aim, the preservation of art, involves an implicit act of interpretation, a view of how the artist intended his work to appear in the future. There are two plausible but opposed ways of understanding the preservation of artworks. Before we can interpret an artwork, we must preserve what the artist made. But how do we achieve this goal? Titian painted *Bacchus and Ariadne* in 1523, and in the past 468 years that object has aged. What did he create? Two views are possible:

(1) Titian made a pigmented surface, and such objects darken with age. To preserve what Titian made, we must allow that artifact to show its age.

(2) Titian made an object with a certain appearance that changes with age. To preserve what Titian made, we must re-create the original appearance of that artifact, removing the effects of aging.[1]

Did Titian make a physical object, a thing that will darken with age? Or did he create an image with a certain appearance that ought to remain forever unchanged?[2] In 1523 Bacchus's cloak was bright red. If we think that what Titian created was a physical object, then by 1991 that cloak will have darkened. If, rather, we believe that what Titian created was an image in which Bacchus's cloak is bright red, then the only way to preserve that artwork is to remove the effects of aging, so that today it appears as it did in 1523, bright red.

In 1523 these two descriptions of what Titian created were indistinguishable. But now we can choose between these descriptions of his activity if we can appeal to some plausible account of his intention as to how his artwork was to appear in the future. Much of the discussion of restoration refers to the artist's intentions. "The patina on paintings," Otto Kurz writes, "is a sign of age, but not a sign of decay; on the contrary, artists regard it as an enhancement. . . . artists were aware that their pictures would be seen through a yellowish varnish, and they chose their colors accordingly."[3] Gombrich makes a similar point more cautiously. He is not certain that we know Titian's intentions, but can say that "what we do know is surely that he meant the appearance of his paintings to result from ever richer and subtler networks of interacting relationships."[4]

It is easy to question these claims. Why would an artist who had first

1. These two views are derived from Alois Riegl's contrast between age value and artistic value; see his essay "The Modern Cult of Monuments: Its Character and Its Origin," trans. K. W. Forster and D. Ghirardo, *Oppositions* 25 (1982): 33. This text is available in a convenient French translation, *Le culte moderne des monuments: Son essence et sa genèse*, trans. D. Wieczorek (Paris, 1984), with a useful introductory commentary by Françoise Choay.

2. For discussion of the ontological point, see Richard Wollheim, *Art and Its Objects*, 2d ed. (Cambridge, 1980).

3. Otto Kurz, "Varnishes, Tinted Varnishes, and Patina," *Burlington Magazine* 104 (1962): 58.

4. E. H. Gombrich, "Dark Varnishes: Variations on a Theme from Pliny," *Burlington Magazine* 104 (1962): 54.

to satisfy his patrons be concerned with the appearance of his work in the distant future?[5] Even if he was concerned about the appearance of his work in the future, what future audience would he have been thinking of? Yellowing of varnish is a continuous process; had Titian wanted to please late eighteenth-century observers, he could not also aim to satisfy us. If the painting is allowed to darken naturally, its appearance will change between 1791 and 1991.

In this debate, both those who favor restoration and those who wish to let the artwork darken appeal to some indirect evidence about the artist's intentions. As neither Titian nor most other painters have said how they wished their work to be treated, the best evidence available, many art historians argue, is such indirect evidence. I offer the following examples:

(1) Pliny says that Apelles used varnish. "Was it likely . . . that a practice attributed to the proverbial Great Painter was never imitated?"[6] But even if we think that Renaissance artists did imitate Pliny, that gives us no reason to believe that they wanted their varnish to be left unrestored, allowed to darken.

(2) Soft color, like that produced by varnish, was praised by a seventeenth-century commentator on Tintoretto. This writer, admittedly, "does not speak of the effect of varnish, but of the influence of distance which . . . he attributes to the action of the intervening layer of air."[7] This effect does not change with time. As Tintoretto's varnish darkens, however, the appearance of his paintings at a distance will change.

(3) Rembrandt's prints may offer evidence about the intended appearance of his paintings. Those engravings, like his paintings if unrestored, have dark tones.[8] This assumes that he intended his prints and paintings to have a similar appearance and that darkening of varnish achieves this effect. Both claims are easy to question.

(4) "To earlier generations a predilection for bright colors was a

5. Denis Mahon, "Miscellanea for the Cleaning Controversy," Burlington Magazine 104 (1962): 468.

6. Gombrich, "Dark Varnishes," 51.

7. E. H. Gombrich, "Controversial Methods and Methods of Controversy," Burlington Magazine, 105 (1963): 92.

8. E. H. Gombrich, Art and Illusion (Princeton, 1961), 57–58.

sign of an uneducated taste."[9] Artists intended their paintings to darken. This claim presupposes that painters were more concerned with future viewers than with their contemporaries.

(5) Bright trousers were worn in Titian's Venice; this shows that he wanted his paintings to appear bright.[10] But as knowledge of 1940s dress doesn't indicate whether color in abstract expressionist painting was intended to be subdued or garish, why should this claim about cinquecento Venetian dress be any more convincing?

(6) Removing varnish may also take off paint if the artist used glazes with soft resins, and Titian was too intelligent to create artworks vulnerable to the restorer's hand.[11] This argument too assumes that Titian was concerned with how distant future generations would handle his work.

The rhetorical function of appeals to the artist's intentions is to justify either cleaning the picture or letting it age. As there is no direct evidence about those intentions, opposed accounts of restoration can all appeal to the artist's intentions. Thus Denis Mahon says that his cleaning of a Guercino makes visible a distinction "that Guercino wished ... to be apparent." He adds that a picture "usually provides a considerable amount of evidence *of its own of what the artist's intentions may have been.*"[12] Conversely, Kurz argues that a Vernet "disfigured by surface dirt" is nevertheless "infinitely preferable [to] a recently cleaned Vernet and, I feel sure, *correspond[s] to the artist's intentions.*"[13] Why should we believe that artists ever considered how their works should appear in the distant future? Mahon can argue that it was right to clean a Luca Giordano because uncleaned it had green skies that in 1822 had been described as being blue; and Roger Fry can praise an uncleaned Rubens for its "unexpected" red, which, after cleaning, disappeared.[14] Neither example, however, necessarily shows that cleaning was the best policy.

Maybe these artists intended their works to show their age and even the effects of the damage suffered in aging. The restorers of the Cimabue

9. Gombrich, "Dark Varnishes," 53.
10. Moshe Barasch, *Light and Color in the Italian Renaissance Theory of Art* (New York, 1978), 103–5.
11. Helmut Ruhemann, *The Cleaning of Paintings* (London, 1968), 221.
12. Mahon, "Miscellanea," 467 (italics added).
13. Otto Kurz, "Time the Painter," *Burlington Magazine* 105 (1963): 95 (italics added).
14. Mahon, "Miscellanea," 469.

crucifix caught in the 1966 flood speak of its status "as document": "no one can erase . . . the reality of the flood . . . an indisputable occurrence in its history."[15] Because that painting was irreversibly changed by being exposed to the floodwaters, perhaps restoring its original appearance— were that possible—would falsify its history, denying that it is an artifact that has dramatically suffered the effects of time. If that argument is correct, no appeal to the artist's intentions should matter.

Faced with these inherent difficulties, Gombrich has offered two highly ingenious arguments. Suppose that we are genuinely uncertain whether or not to remove yellowing varnish. If we do nothing, then future restorers may always decide to remove the varnish. But if we remove it and future restorers conclude that doing so was mistaken, then what we have done probably cannot be undone; our restoration may also have removed paint applied by the artist. "The slow inevitable changes of time are perhaps less disruptive . . . than any violent interference can be."[16] This argument contrasts the virtues of doing nothing with the dangers of doing what future generations may regret. But the argument is misleading. Granted, if we remove the varnish and restorers in 2091 decide that we were wrong to do so, we have done something that cannot be undone. But suppose we do not remove the varnish, and restorers in 2091 decide that it should be removed. In that case, too, we have done something that cannot be undone. Everyone who views the painting between 1991 and 2091 will have had an impoverished experience of that work.[17]

Gombrich's second argument is that our propensity to overrestore old-master works stems from our experience of bright colors in modern works.[18] Because our perception of Titian's painting is influenced by our experience of Picasso's art, we tend to overclean Titians. Is this argument consistent? If we can see that some recently cleaned Titians have been overcleaned, but others look fine, then our eye has not been corrupted.

15. Umberto Baldini and Ornella Casazza, *The Crucifix by Cimabue*, trans. M. Foster and T. Macklin (New York, 1980): 50.

16. Gombrich, "Dark Varnishes," 55.

17. This point is made by Mahon, "Miscellanea," 467: to choose not to clean a painting is to take "the responsibility . . . of tampering to a certain degree—and possibly for an indefinite period—with an important testimony of the artist's legacy to posterity."

18. A version of this position appears in Edgar Wind, *Art and Anarchy* (New York, 1969), 76: "Vision has increasingly been trained on derivative prints. . . . in the [modern] artist's own vision we can observe the growth of a pictorial and sculptural imagination that is positively attuned to photography."

In that case, seeing Picasso's bright colors has had no effect on how we see old-master art. On the other hand, suppose that Picasso's bright colors have corrupted our eye. If so, then how can we see that Titian's paintings have been overcleaned? Reformulating Gombrich's argument in a more subtle way leaves the same problems. Suppose we argue that only some observers have been corrupted by Picasso's bright colors; these are the people who mistakenly want to overrestore Titians. But as almost everyone has seen recent artworks with those bright colors, the existence of Picasso's brightly colored paintings cannot explain the fact that only some observers want to overrestore Titians. Unless we have some independent way of distinguishing between corrupted and uncorrupted taste, this appeal to the use of bright color in modern art proves nothing.

Gombrich seeks some way of comparing Titian's painting as it really was with that Titian when it is overcleaned. Titian's *Assumption of the Virgin* was painted for the church of Santa Maria Gloriosa dei Frari, to which it has now been returned after remaining for some time in the nineteenth century in a museum. When it was in the museum, an observer wrote: "Seen where it is now, the cadmium and blue appear violent, the blue mantle of the Madonna has a hard edge, but we have every reason to believe that seen in the church the outlines were drowned until just the right degree of distinctness subsisted and the yellow pigment became a luminous aureole."[19]

Here we have a genuine comparison between the appearance of the work in its intended site and in the museum, a difference that could be shown today by moving the painting from one place to the other. By contrast, imagining how viewers saw Titian's work before and after the creation of modern pictures using bright colors is more difficult. Because we cannot undo our experience of the modern pictures, we cannot imagine what it was like to see Titian's paintings without knowing Picasso's. Edgar Wind says, "That our vision of art has been transformed by reproductions is obvious."[20] His claim is either a trivial falsehood or an uninteresting truth.

19. Quoted in the 1896 edition of Giorgio Vasari, *The Lives*, ed. E. H. and W. W. Blashfield and A. A. Hopkins (New York), 4: 270 n. 35. For another nineteenth-century account, see Henry James, *Italian Hours* (New York, 1979), 25; for an account of its appearance after it was returned to the church, see David Rosand, "Titian in the Frari," *Art Bulletin* 53 (1971): 196–213.

20. Wind, *Art and Anarchy*, 76.

Many Renaissance works were site-specific; when they are moved to a museum, they are perceived differently. Analogously, when the surroundings of a great building are changed, it may not remain the same building. An Elizabethan church may not be entirely preserved when today it stands, physically intact, "a few yards from a traffic circle."[21] Here we are on a slippery slope. How far are we to go? Titian's *Assumption* has been returned to the church for which it was made, but that building now contains a nineteenth-century tomb for Titian with sculptures by Canova's students. The presence of that artwork nearby may change our experience of Titian's masterpiece. If an Elizabethan church is not preserved because it is near a traffic circle, does Chartres cathedral remain the same church when cars are allowed to park nearby and a train station is not far away?

If every change in its surroundings changes how we see an artwork and so affects that work's identity, then we can never see the same artwork as earlier generations. The most obvious change is bringing paintings into museums: sacred works become objects of aesthetic contemplation; the lighting is far different from what the artist calculated or could have imagined; and individual paintings are presented in an arrangement intended to remind us of their place in the history of art. With experience, we get used to these changes. The movability of artworks "at first . . . seems very shocking," Kenneth Clark wrote, "but after they have been in possession of one place or person for long enough, the situation becomes respectable."[22] Can the identity of the individual work be preserved as such changes occur?

The philosophical problem of identity has been extensively discussed, and it is helpful to see how artworks differ from things (organic and inorganic) and persons. The raft of Theseus is a functioning artifact whose parts are gradually replaced. Suppose that those parts are set aside as they are removed, and that when all the parts of the original raft have been replaced, the parts that have been set aside are assembled into another raft. Then there will exist two different artifacts that could both claim to be the raft of Theseus: the continuously functioning raft that now has none of its original parts, and the assemblage of the parts from the original raft. Can a raft all of whose original parts have gradually

21. David Wiggins, "Reply to Richard Wollheim," *Ratio* 20 (1978): 58.
22. Kenneth Clark, "The Ideal Museum," *Artnews* 52 (1954): 30.

been replaced be identical to one that is a reconstructed combination of the original parts? We do not know how to answer the question, because we do not know whether the raft is a functional artifact or an arrangement of physical elements. Plants and animals preserve their identity through changes of parts because those changes normally are gradual; the tree grows, and the snake sheds its skin, yet they remain the same organisms.[23]

Explaining the identity over time of rafts, books, and persons is difficult. Artworks raise further problems. We are tempted to identify Theseus's raft with the boat that has had all its parts replaced because this artifact functions continuously, carrying passengers during these gradual changes in its physical identity.[24] Artworks as such do not serve such a function; it is therefore harder to determine whether a painting continues to exist. Titian's paintings continued to function as altarpieces while smoking votive candles blackened them, dust accumulated on their surfaces, and inept restorers removed some original varnish. But though the altarpiece continued to exist, the painting perhaps did not. It is because paintings are neither such functioning artifacts—which can survive gradual replacement of parts—nor organisms that we are inclined to define the survival of a painting by appeal to the artist's intentions.

In his discussion of this problem David Wiggins appeals first to "the artist's conception of his own making of the work" and then to "the effect that the artist envisages the work's presence having on an ideal spectator."[25] This condition seems both too weak and too strong. Because sacred works today are either removed to museums or, if they remain *in situ*, treated as artworks, surely we do view them differently than the artist intended. "Altar painting was a servant of religion," whereas today "a

23. David Wiggins's work, which I draw on here, itself raises this problem. He calls his *Sameness and Substance* (1980) "a new book" as well as a "revision" of his *Identity and Spatio-Temporal Continuity* (1967), which defends a similar view of identity over time "sometimes less summarily and dogmatically" than the later book. Has he written two books or one, which he has revised? My view is that we cannot distinguish, except by convention, between his "new" book and a revised version of his earlier book. (See David Wiggins, *Sameness and Substance* |Oxford, 1980|: v–vi.)

24. Consider a similar case. The Byzantine mosaics in and near Ravenna are composed of many small stones that might gradually be replaced; if all those stones were eventually replaced, would we say that the artwork had survived? I owe this example to William Coldstream.

25. Wiggins, *Sameness and Substance*, 126. Wiggins distinguishes three kinds of objects—natural things, artifacts, and artworks—each with its own conditions for identity through time.

complete separation . . . from a non-artistic purpose is seen as the prereq-
uisite of great art."[26]

Surely Titian envisaged the ideal spectator of his *Assumption* as a be-
liever who saw the Holy Virgin rising upwards. "The Resurrected Christ
stands above a sarcophagus . . . and the ascendant Christ appears at the
top of the tomb of Doge Foscari. . . . Death is vanquished and mankind
redeemed when Christ sacrifices himself for man's sake, and then tri-
umphs over death in the Resurrection and Ascension."[27] This much could
have been seen only by an unusually erudite contemporary of the artist.
Even so, that person, like his less erudite contemporaries but unlike
most art historians, who are nonbelievers, would have seen moving sa-
cred scenes, whereas most of us see a complex grouping of artworks
illustrating beliefs we cannot share. The "ideal spectator" of the work
does not simply view the *Assumption* aesthetically, but also sees it as a
sacred work. But how is that possible for a nonbeliever?

This question is hard to answer because it is hard to know what would
count as an answer to it. There is a difference between knowing Catho-
lics' beliefs about the Virgin Mary and sharing those beliefs. Part of what
is involved in grasping the significance of the *Assumption* as a sacred work
is being a believer. Vasari does not strike the modern reader as an
especially pious man, but because he lived in a Christian society, he
could take for granted some beliefs we do not share. If Wiggins is right,
then not even the perfect physical preservation of the artwork will pre-
serve the original artwork Titian created. But that cannot be correct.
Titian's *Assumption* has survived, even if today it is not exactly the same
work his contemporaries saw (unlike his *Saint Peter Martyr*, which was
destroyed by fire and today is known only from engravings). What we
need, then, is some theory of the identity of paintings that permits us to
make this intuitively obvious distinction.

The natural conclusion is that preservation of artworks cannot be under-
stood by appeal to the artist's intentions. Even if Titian was concerned
with his reputation in the distant future, he could not have imagined a
secular society, the museum, electric lighting, the bright color of impres-

26. Lotte Brand Philip, *The Ghent Altarpiece and the Art of Jan van Eyck* (Princeton, 1971), vii.
27. Rona Goffen, *Piety and Patronage in Renaissance Venice: Bellini, Titian, and the Franciscans* (New
Haven, 1986), 87. My discussion borrows from Michael Podro, *The Critical Historians of Art* (New
Haven, 1982), 3–4.

sionist painting, or modern restoration techniques. To believe, further-more, that artworks are artifacts that serve no function does not do justice to the role of the complex and expensive institutions that house these objects. Clark tells us that the "function [of museums] . . . is bound up with the historical process by which they took their present form."[28] As another director of the National Gallery (London) frankly said, because old-master paintings are expensive objects, "Politics have to come first. . . . we have to consider the context of every work of art, the purpose which it is serving, the nature of the public concerned with the result."[29]

Like more mundane artifacts, paintings serve a function; how we think of their restoration depends upon their complex role as both objects we enjoy contemplating and historical records.[30] Questions about the iden-tity of paintings are best understood in relation to their institutional function. Some aestheticians will think this analysis perverse. They might say: Reconstruct, as best as possible from the available indirect evi-dence, the artist's intentions, and then we will know how to preserve the artwork. I maintain that such appeal to intentions is irrelevant: irrelevant to practicing restorers, who can find indirect evidence to support either the conservative view that paintings should be allowed to age or the radical view that advocates extensive restorations; and irrelevant to the theoretician who wants to understand what it is for artworks to survive through time. Everyone who appeals to the artist's intentions believes that there is a unique correct answer to questions about how to preserve artworks. This I deny.

My argument involves both a point of theory and a practical concern. There is no reason to think that appeal to the artist's intentions will tell us how she intended her work to appear in the distant future. And as the indirect evidence for her intentions is capable of justifying either conser-vative or radical restoration practices, it is of little use.

28. Clark, "Ideal Museum," 29.

29. Philip Hendy, "Taste and Science in the Preservation of Damaged Pictures," in *Problems of the Nineteenth and Twentieth Centuries: Acts of the Twentieth International Congress of the History of Art*, ed. M. Meiss et al. (Princeton, 1963), 4:139.

30. Christian von Mechel made this point as early as 1788: museums are "intended for instruction more than fleeting pleasure . . . like a rich library" (quoted in Helmut Selig, "The Genesis of the Museum," *Architectural Review* 141 [1967]: 109). For a modern statement of the Kantian view, which unrealistically refuses to recognize the institutional role of museums, see Anthony Savile, *The Test of Time* (Oxford, 1982), 82: artworks survive by possessing "virtues that are intimately connected with the ability of the work to achieve art's aims."

Once we turn from this unproductive concern with the artist's intentions to a discussion of the function of artworks, then we can understand the goal of restoration. We can agree that we want to preserve the object made by the artist, while disagreeing about whether doing so involves preserving the appearance of that object or permitting it to age. Consider the changes over the past four centuries in the display of Renaissance artworks. Many sacred works have been moved to museums; in many cases separate panels of the same work are now dispersed among different museums. Although these changes make it harder to see the paintings as originally intended, moving them from dimly lit, poorly heated churches to museums with good light and temperature controls makes it easier to view and preserve them. In Venice it is difficult to see many works *in situ*, even with the aid of electric lights. Something would be gained by moving many paintings remaining in Venetian churches to a museum with white walls and good natural or artificial lighting. On the other hand, because the works were painted for these churches, something would also be lost. However we try to serve the artist's intentions, preserving the artwork involves an unavoidable compromise. Titian, we may suppose, wanted his works to be seen as best as possible, but as he painted them for settings in which they are hard to see, appeal to his conception of an ideal viewer cannot give us much guidance.

We preserve artworks differently than did our grandfathers, who made direct traces from frescoes because then "the semblance of archaism disappears, and leaves a vision of pure beauty, delicate and spiritual."[31] That practice seems to us as barbaric as another custom of restorers of that time: repainting faces in an up-to-date style. Once we recognize, however, that ideals of restoration do change with the times, then we come to understand that our practices may someday surprise our grandchildren as much as these Victorian customs do us. Consider two examples in which our intuitions about how to restore are genuinely unclear.

The older way of treating damaged frescoes was to fill in the destroyed areas, repainting the original design. Richard Offner moralistically asserts that this is an unacceptable practice: "A work of art can be organic only so long as it is the product of a single personality. Any restoration ... that introduces paint or shape within its boundaries ... must

31. John Addington Symonds, *The Renaissance in Italy* (New York, 1877), 3: 220.

prove intolerable. . . . [It is] intended to flimflam the spectator."[32] But there are good reasons to question his claim. While repainting damaged areas may add paint to the original, it does preserve the composition of the work, which becomes hard to see when large areas of the wall are blank. Piero della Francesca's Arezzo cycle has "been drastically restored on the new Italian principle by which damaged portions are filled in with neutral colour. . . . By a curious paradox this 'formalist' approach has become fashionable at a period when historians are paying more attention to subject-matter and iconography."[33]

Just as there is a genuine, irresolvable conflict between letting artworks age and preserving their original appearance, so there is here a real conflict between preserving the original materials and preserving the design of the original. Offner's claim depends upon a belief in the organic unity of the artwork, a belief that today seems problematic. What the poststructuralist theoreticians teach is shown also in the practice of art history. If the unity of many paintings is the subject of dispute, and the mutilation of well-known works remained long undetected, then the belief that the original artwork possesses an organic unity seems implausible.[34]

Debates about restoration are not important only in dealing with old-master art. David Smith left unfinished sculptures with white primer, and Clement Greenberg had that paint removed. That act certainly undid what the artist had done, taking "these sculptures one step backward . . . in the process of finishing."[35] But if the paint was unattractive, and tells us nothing about what colors Smith would have used on the finished sculpture, then it is arguable that removing it was the best way to pre-

32. Richard Offner, "Restoration and Conservation," in *Problems*, ed. Meiss et al., 157, 161.
33. Kenneth Clark, *Piero della Francesca*, 2d ed. (Oxford, 1969), 7. More recently, the work has again been restored.
34. After long study, the experts cannot agree whether Piero's *Madonna and Child with Four Saints and the Annunciation* in Perugia is a carefully conceived unit or a makeshift assemblage of panels from his workshop. The claim that a work of art is an organic unity, no part of which is either superfluous or redundant, ought then to be unconvincing. For a summary of the poststructuralist argument, see my "Art without Its Artists?" *British Journal of Aesthetics* 22 (1982): 233–44; for examples of works whose unity is in question, see Meyer Schapiro, "On Perfection, Coherence, and Unity of Form and Content," in *Art and Philosophy*, ed. S. Hook (New York, 1966).
35. My account of this debate is drawn entirely from the published exchange between Greenberg and Krauss. See Rosalind Krauss, "Changing the Work of David Smith," *Art in America* 62 (1974): 30–34; Greenberg's response, *Art in America* 66 (1978): 5; and Krauss's rejoinder, *Art in America* 66 (1978): 5.

serve these works. This is a compromise. If color was essential to Smith's work, then a bare steel work constructed by him is an unfinished sculpture. But just as we preserve unfinished altarpieces, so preserving Smith's unpainted work is surely preferable to destroying it. Rosalind Krauss and Greenberg engaged in a bitter dispute about this point, both assuming that there could be but one correct answer to this question. But the only justification for their assumption is appeal to the artist's intention. Giving up that assumption permits us to see that restoration can often involve a compromise between two alternatives, each of which has some justification.[36]

"The task of criticism," Richard Wollheim writes, "is nothing other than to retrieve the artist's intentions." Otherwise we relegate "art to the status of nature."[37] Artworks, unlike trees, are not organisms that grow naturally, but artifacts that start to decay once they are completed. The restorer can only strive to preserve as much as possible of the original object. We need not conclude, however, that the only alternative is treating artworks like natural objects. When a gardener attempts to preserve a damaged tree by pruning, no appeal to nature's intentions can tell us whether that tree has been preserved. Artworks are artifacts that perform a function; although the function of an altarpiece and that of a Renaissance painting in a museum are different, there is enough overlap between Titian's concerns and the modern viewer's to find ways to restore his paintings.

The restorer must compromise. We can allow the work to show its age, or we can re-create its original appearance; we can leave an altarpiece in a church or place it in a museum: in either case the aim is to present that artwork as best as possible. Because paintings in museums serve different functions from altarpieces in churches, it is natural to expect that we will think of preservation differently than earlier generations. When a painting functions as a devotional image, it may be blackened by candle smoke, poorly lit, and placed in bad lighting; repainting does not prevent

36. Smith's friends were unable to agree on what he would have thought about removal of the primer paint. Even if we were to find tomorrow a statement in the Smith archives stating his preference for leaving the primer, that would not necessarily show that Greenberg was wrong to have it removed. Just as we do not believe that an artist is always the best interpreter of his work, so we need not think that an artist is the best judge of how to preserve that work.

37. Richard Wollheim, *The Sheep and the Ceremony* (Cambridge, 1979), 13.

it from serving its devotional function. When that selfsame painting is treated as an artwork, it must be properly lit and cleaned, and the over-painting is best removed.

In comparing the painting as altarpiece with the work in a museum, we should not make the contrast overdramatic. Were there no overlap between our concerns and those of Titian's contemporaries, placing his sacred works in museums would be like putting artifacts from third-world cultures—which may altogether lack our concept of art—in the museum. We may appreciate aesthetically a dagger used in Mayan rituals, but to display it in a museum is to transform an artifact into an artwork. By contrast, when we read Vasari's account of the rivalry between Donatello and Brunelleschi, we can recognize that they share concerns about the aesthetic qualities of sculpture akin to those of the modern art historian.[38] Titian's contemporaries thought of art differently than do we in a post-Christian culture, but there is a large overlap between their view of paintings and ours.

To restore an artwork is to interpret it. We can recognize both that there are serious disagreements about interpretation and that these disagreements take place against a background of broader agreement. The arguments about restoration, though often bitter, always involve debate in which there is some consensus. Nobody today advocates repainting whole sections of paintings, or cutting out some surviving portions even if they are inferior to other parts. This real overlap between our concerns and those of Titian's patrons means that our disputes about how to restore his work are arguments only about questions of degree.

38. See Giorgio Vasari, *The Lives*, trans. A. B. Hinds (London, 1963), 1:301.

2

Piero della Francesca: Modern Interpretation of Renaissance Artworks

. . .

Turning from Vasari's account of Piero to the modern interpretations is a startling experience. Vasari devotes but one long paragraph in his *Lives* to the frescoes in the church of San Francesco in Arezzo (Fig. 1), within walking distance of his house. His *ekphrasis* gives what seems an almost random list of eye-catching details: "the dresses of the women of the Queen of Sheba . . . a divinely measured row of Corinthian columns, a serf leaning on his spade awaiting the commands of St. Helena while the three crosses are being dug up . . . an angel foreshortened . . . which appears suddenly by night to carry the sign of victory to Constantine."[1] Were the frescoes destroyed, it would be impossible to determine from

1. Giorgio Vasari, *The Lives*, trans. A. B. Hinds (London, 1963), 1:333–34.

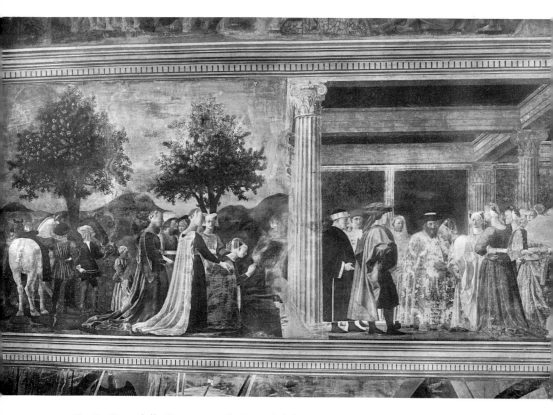

Fig. 1. Piero della Francesca, *The Legend of the True Cross*, Arezzo, S. Francesco, detail from *King Solomon's Meeting with the Queen of Sheba* (photo: Alinari/Art Resource, New York)

this account how many scenes Piero depicted and their relative positions. Without saying so, Vasari moves from the upper to the middle and to the lower level, each time looking from right to left; for him this spatial order overrides the more complex chronological order of the story Piero tells.

Modern interpreters describe this work very differently. They find significance in the spatial relations of the scenes on the three walls of the

chapel.[2] Adam and Seth prefigure Christ, and the queen of Sheba prefig-
ures the Virgin. Heraclius's defeat of Chosroes in A.D. 631, bottom left, is
anticipated by Constantine's victory over Maxentius in A.D. 320, bottom
right, which marked the final triumph of Christianity in the Roman Em-
pire; Chosroes and Maxentius were both "defeated by Roman emperors
in the name of the cross." The modern interpreters compare the fresco
with other quattrocento fresco cycles. Unlike "the majority of Florentine
frescoes," Piero's are "conceived as decoration."[3] They think it may be a
political allegory. Constantine is modeled on the next-to-last Byzantine
emperor, who visited Florence in 1439 seeking aid in the struggle against
the Turks. The fresco was "begun when the infidels' triumph at Constanti-
nople seemed inevitable, and finished after that triumph was accom-
plished."[4] And they place it chronologically in Piero's development, iden-
tifying the order in which he painted these panels and relating them to
his other works.[5]

It may be unfair to compare Vasari's account with these modern inter-
pretations. Vasari would be astonished to learn that we think Piero a
great master. For him, Piero is a good artist, but no equal of the masters
of his own day; Raphael interests him more, and so he does describe that
painter's visual quotations, references to contemporary politics, and sty-
listic evolution.[6] But why does he say so much less about Piero than
present-day commentators? Two answers to this question have been
given. Perhaps Vasari lacked the tools of the modern interpreter. "Much
today that we experience in S. Francesco was beyond Vasari's range of
analysis and expression."[7] Lacking the tools created by Panofsky, Aby
Warburg, and Heinrich Wölfflin, Vasari could not describe Piero's art as

2. Laurie Schneider, "The Iconography of Piero della Francesca's Frescoes Illustrating the
Legend of the True Cross in the Church of San Francesco in Arezzo," Art Quarterly 32 (1969): 22–
48; Michel Alpatov, "Les fresques de Piero della Francesca a Arezzo: Sémantique et stylistique,"
Commentari 14 (1963): 17–38. For a full bibliography and excellent plates, see Eva Borsook, The
Mural Painters of Tuscany: From Cimabue to Andrea del Sarto, 2d ed. (Oxford, 1980), 92–102.

3. Kenneth Clark, Piero della Francesca, 2d ed. (Oxford, 1969), 28–29, 45.

4. Aby Warburg, La rinascita del paganesimo antico, trans. E. Cantimori (Florence, 1980); Clark,
Piero, 38.

5. See Creighton Gilbert, Change in Piero della Francesca (Locust Valley, N.Y., 1968).

6. In Raphael's Repulse of Attila, for example, he identifies a figure who "is copied from Trajan's
Column" (Vasari, Lives, 2:234). I owe this example to Michael Baxandall.

7. T.S.R. Broase, Giorgio Vasari: The Man and the Book (Princeton, 1979), 165. See also Mark W.
Roskill, Dolce's "Aretino" and Venetian Art Theory of the Cinquecento (New York, 1968), 2–3.

we can. Maybe "our disappointment with the humanists' remarks about art . . . is . . . ahistorical."[8]

Alternatively, perhaps when Vasari is read properly we find that he does "all the modern art critic does, and a bit more, but differently and sometimes elliptically."[9] Vasari looked at a great deal of art and himself painted complex compositions. It is condescending to suggest that he could not properly see the elaborate structure of Piero's composition, compare it with other fresco cycles, or note that it might contain a political allegory. But we know only what he wrote about Piero, not how he saw the paintings in San Francesco.

We may explain some of the differences between Vasari's text and the modern accounts by noting how his concerns differ from ours. He praises the artist's naturalism: "Piero shows how important it is to imitate reality and to draw from the things themselves."[10] We are less likely to praise a painter for his skill as a naturalist. Vasari's use of *ekphrasis* means that he thinks about artwriting differently than a modern interpreter. He "does not indicate the arrangement of the figures" because "his interest is specifically in the subject of the pictures, which he attempts to make as real for the reader as it is for the viewer."[11]

Clark writes that in San Francesco each scene "is divided a little to the right of the center by a strongly marked vertical"; and he distinguishes between what we know of these works and what we absorb by "leaving our unconscious free."[12] The former observation could have been made by Vasari. But as he lacked our concept of the unconscious, how could he have made the latter distinction? He could understand the claim that "God Father in the Annunciation seems to share a cartoon with Chosroes being beheaded. . . . [His] crime was to pretend to be God Father." He could not, like modern historians, see Piero's kinship with Cézanne, El Greco, Caravaggio, and van Gogh.[13]

8. Michael Baxandall, *Giotto and the Orators* (Oxford, 1971), 111.

9. Michael Baxandall, personal correspondence.

10. Vasari, *Lives*, 1:334.

11. Svetlana Alpers, "*Ekphrasis* and Aesthetic Attitudes in Vasari's Lives," *Journal of the Warburg and Courtauld Institutes* 23 (1960): 191.

12. Clark, *Piero*, 43–44.

13. Gilbert, *Change*, 72; Philip Hendy, *Piero della Francesca and the Early Renaissance* (New York, 1968), 85. The comparison of Piero's figures to "the sculptured cavities of some great 'Reclining Figure' by Henry Moore" (Hendy, *Piero*, 125) would baffle him. It is hard to imagine that observation being paraphrased in terms of any sculptures he knew.

Today, some thirty years after its publication, Clark's book on Piero itself raises similar problems. Set a Piero Virgin next to a smiling Buddha, he writes, "and how strongly she asserts her Mediterranean humanity!"[14] This echo of Pater's account of *Mona Lisa*, which today few art historians would cite in such a context, will lead future historians of taste to turn to Clark's book "for an explanation of all that the mid-twentieth century valued in Piero's art."[15] Clark's claim that "[Piero's] Madonna is the great mother, his risen Christ the slain god; his altar is set up on the threshing floor, his saints have trodden in the wine-press" today seems indefensible.[16]

There are two ways of explaining such changes in styles of artwriting. The antirelativist asserts that some recent accounts are better (or truer or more accurate) than others. There is progress in art history; the recent interpretations are better than the earlier accounts. The relativist argues that change does not mean progress. Vasari wrote *ekphrases*; Clark imitates Pater while acknowledging the influence of Freud and Roberto Longhi; and more recent historians study in close detail Piero's iconography and political allusions. But there is no convincing noncircular standard by which to compare these accounts of Piero.

Styles of artwriting change because the general culture changes and because there is a felt need to say something new.[17] Today an art historian can attract attention, and so achieve recognition, only by finding a novel approach to Piero. Unless the successors of the earlier artwriters can find something new to say, interpretation will cease. Both relativism

14. Clark, *Piero*, 44.

15. E. H. Gombrich, "Piero della Francesca," *Burlington Magazine* 94 (1962): 177 (he is reviewing the first edition). Clark's introduction to Pater's *The Renaissance* shows his awareness of this issue: "We cannot improve on Pater's characterisation . . . of the *Mona Lisa* which . . . remains, if read in its context, a defensible interpretation" (Walter Pater, *The Renaissance* [London, 1961], 16). Clark accepts, almost, the ahistorical vision of Piero as humanist presented earlier by Aldous Huxley: "Piero seems to have been inspired by what I may call the religion of Plutarch's *Lives* . . . not Christianity, but a worship of what is admirable in man" (Aldous Huxley, *Along the Road* [New York, 1925], 181).

16. Clark, *Piero*, 75. Because Piero is much admired, no one suggests a link to contemporary anti-Semitism in Urbino, though nothing is known of his politics; for a social history, see Marilyn Lavin, "The Altar of Corpus Domini in Urbino: Paolo Uccello, Joos Van Ghent, Piero della Francesca," *Art Bulletin* 49 (1967): 26.

17. A reviewer of Gilbert's *Change* praises him for drawing attention to a previously neglected question, Piero's evolution, while taking issue with the details of his analysis (Giles Robertson, review of Gilbert, *Change*, *Art Quarterly* 34 [1971]: 357). This is how any such novel analysis is likely to be received.

and this need for original interpretations seem to undermine the very possibility of truth in interpretation. Once we acknowledge that standards of interpretation change with the times and that we value originality, by what standard are we to compare different interpretations?

A look at the recent debate about Piero's *Flagellation* (Fig. 2) helps answer this question. This is an unusual composition. Three large figures stand to the right of the flagellation. There are two much-discussed theories about their identity: the first holds that they are Piero's contemporaries; the second, that they are contemporaries of Christ.[18] It is possible to avoid identifying these men altogether. Longhi says that the picture shows the "mysterious union of mathematics and painting"; Bernard Berenson calls the men "mysterious" and "unconcerned."[19] Philip Guston observes that "the picture is divided almost in half, yet both parts act on each other, repel and attract, absorb and enlarge one another."[20] These remarks show the importance of identifying these figures. How can we know that they are mysterious or unconcerned if we do not know who they are? How can we say that the two halves of the picture act on each other if this trio may have nothing to do with the flagellation?

Once attention has been called to such a puzzle, it is not easy to give up the belief that it has some solution. Gombrich claims that the men cannot be Piero's contemporaries: "Is there any evidence that scenes from the Passion were painted in the fifteenth century to allude to contemporary events . . . ? Is it not more likely that Piero's painting illustrates two connected scenes from the gospels?"[21] This, however, does not settle the dispute. Renaissance pictures usually distinguish the space of the sacred drama from that other place where living people stand. Were these men kneeling in profile, they would be donors, Piero's patrons. Were they nearer Christ, they would be Christ's contemporaries.[22] What is puzzling is that Piero's figures cannot be readily placed.

18. Already in 1901 "much ingenuity" had been spent on this debate (J. A. Crowe and G. B. Cavalcaselle, *A New History of Painting in Italy*, ed. E. Hutton [London, 1909], 3:16).

19. Roberto Longhi, *Piero della Francesca*, trans. L. Penlock (London, 1947), 44; Bernard Berenson, *Piero della Francesca, or The Ineloquent in Art* (New York, 1954), 4–5; Bernard Berenson, *The Italian Painters of the Renaissance* (London 1960), 137.

20. Philip Guston, "Piero della Francesca: The Impossibility of Painting," *Artnews* 64 (1965): 38–39.

21. Gombrich, "Piero," 177.

22. See Sven Sandström, *Levels of Unreality: Studies in Structure and Construction in Italian Mural Painting during the Renaissance* (Uppsala, 1963).

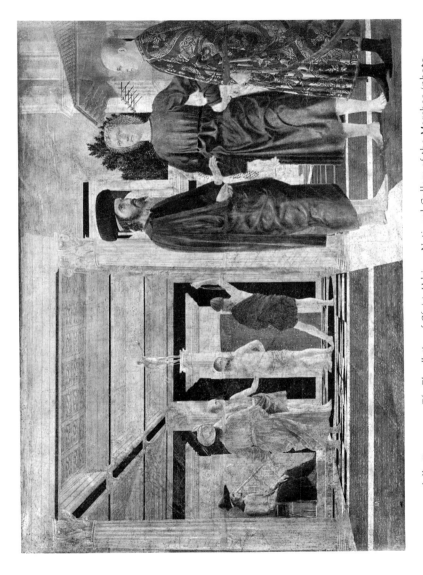

Fig. 2. Piero della Francesca, The Flagellation of Christ, Urbino, National Gallery of the Marches (photo: Alinari/Art Resource, New York)

Marilyn Lavin argues that the light shining on Christ comes from the north, and therefore is "not of our world."[23] Piero uses perspective to create a sharp division between the space on the left, a "divine world with supernatural attributes," and the world on the right. The three men stand in a different space than Christ, and so are not his contemporaries. Lavin identifies the two older figures as the lord of Mantua and his court astrologer.[24] The astrologer's son had died, and the lord's brother was crippled. The men discuss that double tragedy while the youth—a condensed image, standing for both the dead son and the crippled brother—is shown as if alive and unblemished.

Maybe none "of Piero's contemporaries . . . would have offered of his own accord his features" for such a picture.[25] But this criticism of Lavin cannot be conclusive until we identify the men, and so determine whether they are wicked or good. In the Arezzo cycle, Vasari says, the donors are depicted as the witnesses of Chosroes' execution. (Here the context tells us that these are good men.) As we lack evidence that any Renaissance artist painted a condensed picture of the sort Lavin invokes, akin to dream images as Freud describes them, perhaps her account is anachronistic. But Gombrich's counterproposal is itself open to obvious objections. He suggests that the *Flagellation* shows a rarely painted drama, Judas's repentance.[26] Piero's Judas, he allows, does not look wicked, but "neither does Piero's villainous Jew who hid the cross in the Arezzo series." But that figure, the namesake of Christ's betrayer, repented and became a bishop. "Possibly," Gombrich admits, "the real clue may still be found in the various figures introduced into the passion plays." Lavin finds portraits matching the two older men because she believes that they are Piero's contemporaries. Gombrich may find the clue in the passion plays if he believes that that is the right place to look

23. Marilyn Lavin, *Piero della Francesca: The Flagellation* (London, 1972), 45, 48. Lavin uses the analysis of the perspective presented in Rudolf Wittkower and B.A.R. Carter, "The Perspective of Piero della Francesca's 'Flagellation,'" *Journal of the Warburg and Courtauld Institutes* 16 (1953): 292–302.

24. Lavin, *Piero della Francesca: The Flagellation*, 62, 71, 74–75.

25. Ludovico Borgo, "New Questions for Piero's 'Flagellation'," *Burlington Magazine* 121 (1979): 549

26. Gombrich himself has noted these problems in "The Repentance of Judas in Piero della Francesca's Flagellation," *Journal of the Warburg and Courtauld Institutes* 22 (1959): 172. More exactly, as Marilyn Lavin has pointed out to me, Piero's Judas did not hide the True Cross, but knew where it was hidden.

for it. Many portraits and many passion play texts may be matched to the painting.

Two commentators offer variations on Lavin's analysis. Perhaps the bearded man in the trio is Bessarion, a Greek prelate who came to Italy to appeal for a crusade; he stands before Federico of Montefeltro with a young man, his pupil.[27] The work is a political allegory. The trio stand by as Christ is flagellated, a reminder that the Italians of the late fifteenth century stood by as the Christians of the Eastern Church suffered under the Muslims. On the other hand, the bearded man need not be Greek. Though Christian Italians of the time did not wear beards, Italian Jews did.[28] We have other contemporary images of debates between Jews and Christians. Perhaps in Piero's picture the boy "appears to adjudicate" the debate, while the flagellation, showing the Jews' "refusal to atone for the collective sin through conversion," is an appropriate background scene.

Both of these accounts identify the mysterious trio, explaining why they are appropriate bystanders to a flagellation. "It is a curious paradox that the art of Piero . . . the prototype of *l'arte non eloquente* should thus have given rise to a revival of eloquence in criticism."[29] It is hard to give a convincing argument against any of these proposals, and easy now to generate more such accounts.[30] Lavin studies the perspective; Gombrich, other flagellations; other commentators, the relation of Italy to Constantinople and Jewish history. They can argue with one another because they can agree, more or less, on what kind of evidence is relevant. Contempo-

27. Carlo Ginzburg, *The Enigma of Piero*, trans. M. Ryle and K. Soper (London, 1985), 130, 134–39. Ginzburg's response to critics of the Italian edition appears in his "Mostrare e dimostrare risposta a Pinelli e altri critici," *Quaderni storici* 50 (1982): 702–27.

28. "Urbino boasted of a thriving Jewish community" (Joseph Hoffman, "Piero della Francesca's 'Flagellation': A Reading from Jewish History," *Zeitschrift für Kunstgeschichte* 44 [1981]: 340–57).

29. Gombrich, "Piero," 177. Gombrich implies that at most one interpretation can be correct. This claim could be questioned. No one has yet argued that the picture shows the lord of Mantua with his astrologer *and* Bessarion before Federico *and* a Jew debating a Christian, all in one condensed image, although that would be one possible extension of Lavin's claim that the youthful figure is a condensed image of two distinct men.

30. When, for example, Borgo ("New Questions," 548) proposes that a yet to be discovered text might supply the narrative, and suggests that Vasari's account of Castagno's *Flagellation* implies that the lost painting was a similar composition (Vasari says that it was damaged by simple-minded people who scratched out the Jews, and so "as in Piero's *Flagellation* [the Jews] must have been situated to some significant extent toward the background"), his account is as speculative as Lavin's.

rary portraits can be matched to those in Piero's picture, which may be compared with other Flagellations of the time; and we understand how Piero's picture could refer to contemporary politics. By contrast, when Maurizio Calvesi sees Christ centered in the magical space later described by Giordano Bruno and relates the light on the golden statue to alchemy and early capitalism, his account is too eccentric to be worth debating.[31]

Serious art historians agree on the terms of debate. An interpreter may look for portraits matching the trio on the right of the *Flagellation*. She may not look for hidden, upside-down figures. But since each interpreter's conclusion depends heavily upon her starting point, the debate is an open-ended one in which each "solution" is vulnerable to obvious counterarguments.[32] Nothing short of major new archival evidence could end this debate. Perhaps when the difficulty of achieving agreement becomes generally recognized, the problem will be abandoned as insoluble, or interpretations like Calvesi's will become acceptable. If the past is any guide, in another fifty years the rules of interpretation will have changed. The accounts of Lavin and her critics may then seem as dated as Longhi's analysis does today.

These interpretations are like fictional narratives. They pose a dilemma—how will the heroine get married? who is the murderer?—

31. Maurizio Calvesi, "Sistema degli equivalenti ed equivalenze del sistema in Piero della Francesca," *Storia dell'arte* 23–25 (1975): 103–4.

32. The recent account by John Pope-Hennessy argues that all earlier interpretations are "inconclusive because they rest on one untested assumption, that the scene in the distance on the left represents the *Flagellation of Christ*" (John Pope-Hennessy, "Whose Flagellation?" *Apollo* [September 1986]: 162–65). The picture depicts another scene altogether, Saint Jerome's dream in which he is whipped for refusing to give up his beloved texts of Cicero; the "dazzling light and the seated figure" correspond precisely to the description of Saint Jerome's letter. Pope-Hennessy admits that, like the earlier interpretations he criticizes, his own account provides a "solution" to the puzzle only at the cost of neglecting many other features of the painting not discussed in his text. Like the artwriters he criticizes, he believes that knockdown solutions to such puzzle-pictures are possible: "The harmonious architecture, the classical column, the gilded figure and the celestial staircase . . . are . . . readily explained as extrapolations on the subject of St. Jerome's dream." Those writers in turn, I predict, will observe that Pope-Hennessy's extraordinarily ingenious narrative is also highly speculative. Robert Black, who is more optimistic about the possibility of achieving such a solution, judges that the work Pope-Hennessy discusses is "in composition and detail . . . extraordinarily similar to Piero's *Flagellation*," but lacks the two most distinctive features of Piero's work: the trio of bystanders and the separation between that trio and the scene of the flagellation (Robert Black, review of Ginzburg, *Enigma*, *Oxford Art Journal* 9 [1986]: 71).

entertain alternative solutions, and achieve narrative closure by working out a best solution. Unlike a fictional text, however, an art historian's interpretation aims not only to be plausible, but also to be true to the facts. Plausibility and truth are different criteria; what seems plausible need not be true, and vice versa. Perhaps more facts will solve this dilemma. Recent debate about the *Flagellation* has been little influenced by factual discoveries. In two other cases, however, recent interpretation of Piero's art has had to take account of such discoveries.

Piero's mother is not, as Clark and Philip Hendy believed, buried in Monterchi, the site of his *Madonna del Parto*.[33] This discovery undermines, but does not necessarily refute, their claim that Piero himself painted the picture. Piero might have had other reasons, unknown to us, for making an autograph painting for Monterchi. Maybe the reversed angels are evidence that this is a shop work.[34] But perhaps the "extreme simplicity" of this device was one way "to satisfy the natural desire of country folk for something suggestive of court ceremonial."[35] Whether we think the painting is a shop work or not depends upon our broader view of Piero's style.

Identification of the suspended shape in Piero's Brera Altarpiece (Fig. 3) requires a complex use of facts. According to Millard Meiss's original calculation, it was six inches long, too large to belong to any bird but an ostrich.[36] In Piero's time ostriches were believed to hatch eggs by peering at them, to lay eggs only after consulting the heavens, and to eat metal. They could appropriately symbolize the Virgin, and the ostrich egg was a good emblem for the donor, a warrior duke. Upon recalculation, Meiss found that he had radically underestimated the size of this object. He did not retract his interpretation, however, but claimed that the exact size of the object was unimportant. This is surprising. As Piero was a famous mathematician, it is not easy to believe that he miscalculated. Ostrich eggs were familiar objects, "imported into Europe in surprisingly large numbers," and ostriches were believed to often abandon their eggs. Is an

33. Clark, *Piero*, 54; Hendy, *Piero*, 112.

34. Gilbert, *Change*, 59.

35. Longhi, *Piero*, 87. One art historian's shop work is another's masterpiece. Gombrich puts this point in historical terms: "A Piero could still dare to paint the two flanking angels with one cartoon. . . . But . . . this rigidity was excluded by the masters of the *terza maniera*" of Vasari's time (E. H. Gombrich, *Norm and Form* [London, 1966], 95).

36. Millard Meiss, *The Painter's Choice: Problems in the Interpretation of Renaissance Art* (New York, 1976), 107, 116, 131. See also John Shearman, "The Logic and Realism of Piero della Francesca," in *Festschrift Ulrich Middeldorf*, ed. A. Kosegarten and P. Tigler (Berlin, 1968), 180–86.

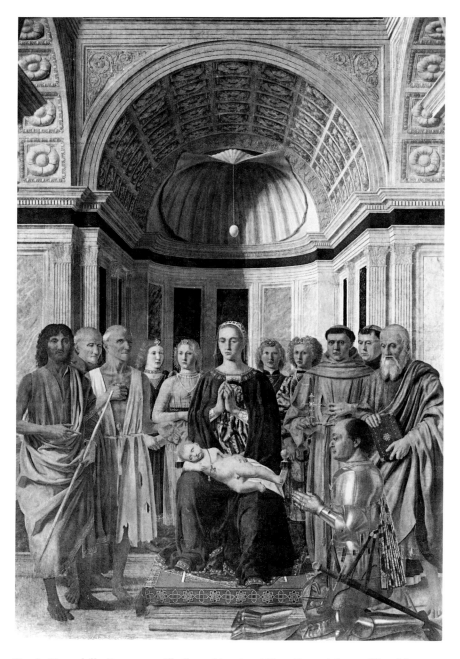

Fig. 3. Piero della Francesca, *The Brera Altarpiece*, Milan, Brera (photo: Alinari/Art Resource, New York)

ostrich egg then an appropriate symbol here?[37] There is no similar paint-
ing from the artist's time showing an ostrich egg, and no obviously
appropriate text asserting that the ostrich egg is a symbol.[38] And though
many facts about ostrich eggs have been brought into the debate, these
could, with subtle argumentation, be discounted.[39]

As with the three men in the *Flagellation*, once attention has been
called to a problem unknown to earlier interpreters, it is hard to dis-
miss it. It would be disappointing to find that Piero's object has no
symbolic significance.[40]

The alternative proposal, that the painting depicts Leda's egg, draws
on a well-established tradition. Renaissance thinkers read pagan myth as
anticipating Christian doctrines.[41] But this proposal too is speculative.

Making the implicit rules of such argumentation explicit is one way to
attempt to solve these puzzles. If nearly every art historian could agree
on how to interpret Piero's works, then we would have some way of
comparing and contrasting particular interpretations. Three historians,
Lavin, Michael Baxandall, and Carlo Ginzburg, offer methodological state-
ments. Lavin proposes two principles: "First . . . every element visible in
the painting contributes to an overall message. . . . secondly . . . all the
elements necessary for understanding the message are to be found
within the painting itself."[42] Baxandall's criteria are avoidance of anachro-
nism, coherence, and critical necessity.[43] Coherence is a variation on
Lavin's first condition—"on the whole, the explanation positing the
more complete and embracing order is preferable"—but avoidance of

37. Creighton Gilbert, " 'The Egg Reopened' Again," Art Bulletin 56 (1974): 252–58.

38. Manet also painted an ostrich egg, demonstrating that "admiration of the ostrich egg . . .
survived into the nineteenth century"; until recently, ostrich eggs hung in Abyssinian churches;
and Dali engages in "surrealist mockery" of such symbolism (Meiss, Painter's Choice, 127; Clark,
Piero, 132; Creighton Gilbert, "On Subject and Non-Subject in Italian Renaissance Pictures," Art
Bulletin 34 [1952]: 210).

39. For example, one recent analysis points out that the object in the Brera Altarpiece is
shaped not like an ostrich egg, but more like the egg of a chicken (see David W. Brisson, "Piero
della Francesca's Egg Again," Art Bulletin 62 [1980]: 284–86).

40. One plausible alternative proposal is that what Meiss identified as an egg is a pearl.
While this proposal has the advantage of avoiding problems about the size of the object, it is
unexciting. A pearl, unlike an ostrich egg, is so obvious a symbol that it requires little icono-
graphic analysis. This proposal (Constantin Marinesco, Bulletin de la société nationale des antiquaires
de France, 17 December 1958, 201) seems not to have been debated.

41. Gilbert, " 'The Egg Reopened' Again," 252–58.

42. Lavin, Piero's Flagellation, 15.

43. Michael Baxandall, Patterns of Intention: On the Historical Explanation of Pictures (New Haven,
1985), 121–22.

anachronism rules out both her "argument from late antique and medi-
eval . . . texts and artifacts" and her belief that "multiple and layered
intention was compatible with the theory" and "practice of the fifteenth
century altarpiece image." Ginzburg mentions comprehensiveness, coher-
ence, and economy. Other things being equal, the best solution fits
together as many puzzle pieces as will convincingly fit with as few hy-
potheses as possible.[44]

All three interpreters appeal to a variation on the Aristotelian ideal of
the artwork as an organic whole. As for Aristotle no part can be added to
or subtracted from a good artwork without diminishing the whole, so no
part can be added to or subtracted from the best interpretation without
creating a less convincing analysis.[45] There is much general agreement
here. An interpretation must explain every puzzling picture element as
economically as possible. But once we descend from this statement of
principles to particular cases, we find much disagreement.

According to Lavin, in Piero's *Baptism* (Fig. 4) the elders on the far bank
allude to the Epiphany, and the three angels on the left to the Wedding at
Cana.[46] The nut of the walnut tree is "a metaphor for Christ's divinity,"
and its hard shell stands for "the wood of the cross"; the plant near Saint
John's foot is "associated with the Passion . . . because of its ability to
staunch bleeding." The gesture of the man with raised garment is ambigu-

44. Ginzburg, *Enigma*, 21.

45. I note three minor confusions in these interpreters' claims. First, Lavin's suggestion that
we should look only within the painting makes an important claim in a misleading way. Every
interpreter aims to explain what is in the picture, but this unavoidably involves relating the
picture to other pictures and texts. Gombrich's economical reading of the *Flagellation* differs from
Calvesi's far-fetched account only in sticking to a narrower range of references outside the
painting. Second, Baxandall's claim that we should avoid appeal to late medieval texts is
inconsistent with the universally accepted belief that the Arezzo cycle illustrates the thirteenth-
century legend of the True Cross. What Baxandall means is that appeal to late medieval texts is
admissible only when supported by documentation from the artist's own time. (Here I oversim-
plify Baxandall's account of the artist's intentions; for further discussion, see my review of his
Patterns, Art Journal 46 [1987]: 75–79.) Third, is it true, as Baxandall asserts, that "only superior
paintings will sustain explanation of the kind we are attempting" (Baxandall, *Patterns*, 120)? In
Urbino, one can see not only Piero's *Flagellation* but also the fascinating, though artistically
insignificant, frescoes of the Salimbeni brothers, which a social historian might find much more
interesting than Piero's panel. Why should only superior paintings have interestingly complex
iconographies? What is true is that only paintings considered superior are likely to receive the
sustained attention that has been given to Piero's work.

46. Marilyn Lavin, *Piero della Francesca's Baptism of Christ* (New Haven, 1981), 13, 66–67, 85–86,
112, 114–15.

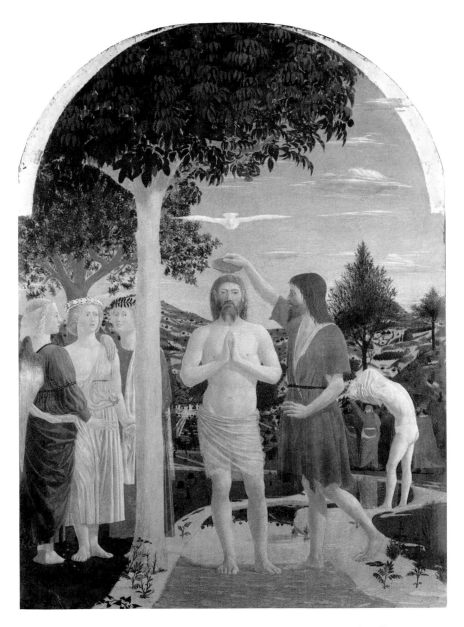

Fig. 4. Piero della Francesca, *The Baptism of Christ*, London, National Gallery
(photo: National Gallery)

ous. Undressing means "stripping off of vice," while dressing stands for marriage "to Christ at baptism."[47] As with the egg, with enough ingenuity apparent factual discrepancies may be explained away. The picture shows four elders, and there were but three Magi. But Psalm 71:10–11 speaks of four lands offering gifts, and so Piero's four elders can allude to the Epiphany.

Lavin admires Piero for depicting in a Baptism also an Epiphany and a Wedding at Cana, combining "complementary and mutually reinforcing elements in the expression of one coherent theme." Baxandall calls this account "unparsimonious," asserting that it is mistaken to search for so complex an iconography.[48] His interpretation appeals to quattrocento texts. Whereas Alberti describes painting in terms of "a metaphor from our use of language," Piero uses a mathematical term; as a painter, Piero displays his knowledge of the mathematics of gauging, inviting the public to recognize in the pavilion he depicts "a compound of cylinder and cone."[49] Renaissance writers thought that in heaven "the blessed can see the front of an object from the back"; the nearest "mortal experience" of such vision is provided by Piero's perspectival drawings.

It is easy to see that Lavin's imaginative interpretation is speculative. She cites no documentation suggesting that Piero combined a Baptism, and Epiphany, and a Wedding at Cana in one scene. But Baxandall's more parsimonious claims are also debatable. The relevance of Piero's experience with barrel gauging to his painting is not established by the text Baxandall cites, which makes only the more general point that a painter "should use the visual sense's special quality of immediacy and force." And as only Piero's drawings—which would not in his time have been publicly displayed—provide the analogy between the vision of the blessed and perspective, is it not potentially misleading to describe the artist's mastery of perspective in this way?

Piero, Baxandall asserts, is concerned less with "the accurate use of

47. See the discussion of such polysemous images in Leo Steinberg, "Guercino's Saint Petronilla," in *Studies in Italian Art and Architecture*, ed. H. Miller (Cambridge, 1980), 228 n. 40.

48. Baxandall, *Patterns*, 123.

49. Cenni said that painting involves *disegno* and *colore*; Alberti adds *compositione*, which Piero replaces with *commensuratio*. Alberti, like Piero, was a mathematician, and so we may wonder whether the change of one word is so significant. (Michael Baxandall, *Painting and Experience in Fifteenth Century Italy* [Oxford, 1972], 87, 103–4; Creighton E. Gilbert, "Antique Frameworks for Renaissance Art Theory: Alberti and Pino," *Marsyas* 3 (1943–44): 87–106.)

outline to state an object's position; less [with] . . . the way bodies and parts of bodies move than [with] . . . precise information about their shapes."[50] He "might not agree with" this account, Baxandall says, but "he would understand it." As the artist provides no account himself, however, only we can judge whether Baxandall correctly describes the way these artworks were seen in the Renaissance. Furthermore, although Baxandall's account is more parsimonious than Lavin's, it says nothing about her interesting claim that Piero related his *Baptism* to its frame, which contained portraits of Saints Peter and Paul.[51] The more parsimonious account may explain fewer features of the artwork.

Like the dispute about Piero's *Flagellation*, the debate about his *Baptism* is potentially open-ended, because there is both partial agreement about the rules of debate and deep disagreement about particular points. Baxandall and Lavin agree that a good explanation ought to explain all the visual facts, but they disagree about whether Piero made polysemous images. They agree that an interpretation must explain the shape of the water at Christ's feet, but they offer different accounts of it. According to Baxandall, it illustrates a theory of optics quoted in contemporary sermons that "if Piero went to church during his journeyman years in Florence, he could have heard."[52] They agree that the composition is original, but they disagree about how to explain its originality. Piero's work is hard to interpret partly because we have very few facts about his life, and even the simplest ones demand interpretation. We know that in his sixties Piero was led by the hand by a boy. This testimony, recorded when the boy was an old man, would seem to imply that when he was old Piero made no paintings. But "it is possible for a very near-sighted man to write clearly with his eye an inch or two from the surface of the paper. . . . the combination of large, simple areas with focal points of minute detail, which appear in all Piero's work, suggests that he was always short-sighted."[53]

50. Michael Baxandall, *Piero della Francesca* (Poulton, Nr. Bristol, 1966), 3.
51. Because the commission was "for an altar dedicated to John the Baptist," Piero chose "the one Gospel scene in the life of the Baptist that relates him to the city of Christ's tomb." It was a matter of local pride that Sansepolcro—site of the *Baptism*—was not, like most Italian towns, founded in ancient times, but, rather, was Christian "from its origin" (Lavin, *Piero's Baptism*, 138). In noting that Lavin's account may explain more features of Piero's work, I am not claiming (or denying) that her interpretation is better.
52. Baxandall, *Patterns*, 123.
53. Clark, *Piero*, 69.

Ginzburg's elaborate account develops Warburg's idea that the Arezzo cycle contains a political allegory. This interpretation, like all such accounts of Piero, involves the construction of a coherent narrative from a very few facts. Ginzburg must supplement the limited evidence—the emperor John VIII visited Florence in 1439, and Piero was in the city late that year—with speculations about other trips in order to construct a narrative in which Piero's earlier art provides a commentary on contemporary Italian politics. But even if we accept Ginzburg's claim that the figure of Constantine in the Arezzo cycle is modeled on John VIII, it does not necessarily follow that Piero intended to identify their political roles.[54] Ginzburg finds the same emperor in the *Flagellation*, there *not* presented as a heroic figure. "The Arezzo fresco was a public tribute; the *Flagellation* was a picture for private use, in which it was possible to hint at a negative judgement on the emperor's character."[55] But as only a few knowledgeable contemporaries would have recognized the emperor in either picture, is this contrast plausible? Even if it is the same man, how do we understand his role?[56] We lack both evidence commenting on contemporary events in this way and any text suggesting that Piero's pictures were intended to have such a meaning.[57]

54. Ginzburg, *Enigma*, 43. Ginzburg refers for support to Clark, *Piero*, 78, which, however, makes a different argument: as Piero's picture and Pisanello's famous medal show figures whose heads have different shapes, Piero must have seen John VIII in Florence in 1439.

55. Ginzburg, *Enigma*, 135–36.

56. The problems posed by Ginzburg's account arise in other, simpler interpretations that treat Piero's works as political commentaries. Thalia Gouma-Peterson argues that Piero's Pilate in the *Flagellation* is a portrait of John VIII, implying that a Roman ruler who ordered Christ's execution is to be identified with a Christian emperor whose indecision contributed to the fall of Constantinople (Thalia Gouma-Peterson, "Piero della Francesca's Flagellation: An Historical Interpretation," *Storia dell'arte* 28 [1976]: 219). But how far are we to take that analogy, which seems hard to understand? Pilate's action fulfilled Scripture, whereas the aim of depicting John VIII in a quattrocento work would have been to remind contemporary Italians that the fall of the Eastern Empire resulted, in part, from their failure to respond to John VIII's call for help. Cecil H. Clough, "Piero della Francesca: Some Problems of His Art and Chronology," *Apollo* 91 (1970): 286, which argues that the figure in Piero's *Augustinian Monk* is identical with the Saint Francis in the Brera Altarpiece, raises similar problems: what would it mean to depict the same man as Saint Francis and as an Augustinian monk?

57. Ginzburg also sees the same man kneeling in Piero's *Madonna della Misericordia*, on the far right in the *Flagellation*, and—"grown a little heavier with age"—to the left of Chosroes in San Francesco (Ginzburg, *Enigma*, 123–24). Though the three look similar, they are distinct figures. The right ear of the first is rounded, whereas the left ear of the second is more angular; and the crucial portion of the ear of the Arezzo figure is obliterated. These ears may be important. Connoisseurs use such features in identifying authentic works, as Ginzburg notes in "Clues:

Hayden White compares historians' texts with fictional narratives.[58] How a historian narrates her story determines, and in turn is determined by, her general conception of history. In historians' texts, form and content cannot be separated. White's work has been criticized by historians who fear that it undermines the possibility of objectivity. If the form of a historian's plot influences her conclusions, how can one historian argue with another? We expect a traditional novel to have a plausible plot, raising conflicts that are then solved in the conclusion, achieving narrative closure. But since novels describe merely fictional worlds, novels cannot contradict one another. By contrast, historians' accounts of the same events can contradict one another.

That Baxandall, Clark, Crowe and Cavalcaselle, Ginzburg, Gombrich, and Lavin adopt different starting points and employ different narrative techniques does not itself tell us how their accounts conflict. Here I return to the problem of relativism. Studying the writing on Piero, we can see both how its style has changed with the times and what kinds of disagreements are taken seriously by present-day interpreters. But if we lack some standard by which to compare the various interpretations of Piero, how can we either speak of progress in the interpretation of his work or identify the most convincing interpretations?

The elaborate recent argumentation about the *Flagellation* may seem depressing if we observe that nothing Lavin has said in response to Gombrich, or that either of them can say to Ginzburg, is likely to result in a change of views. Vasari or Crowe and Cavalcaselle would find our accounts of Piero unrecognizable, and we would like to believe that, after so much research, Piero is better understood. Is this belief justified?

Perhaps not. Suppose we become relativists, and define truth in art history by relation to the current consensus. In their day, Crowe and Cavalcaselle provided a good account; at one time Longhi and Clark presented good interpretations; nowadays Piero is described differently. In another decade, Calvesi's interpretations may seem less eccentric than they do today. Nothing is gained by asking whether these accounts interpret Piero's pictures as they really are. Truth to the facts is too weak

Morelli, Freud, and Sherlock Holmes," in *The Sign of Three: Dupin, Holmes, Peirce*, ed. U. Eco and T. A. Sebeck (Bloomington, Ind., 1983), 81–118.

58. Hayden White, *Tropics of Discourse: Essays in Cultural Criticism* (Baltimore, 1978) and *The Content of the Form: Narrative Discourse and Historical Representation* (Baltimore, 1987).

a criterion to explain how standards of artwriting change over time or to adjudicate disagreements among present-day interpreters.

Such relativism is inconsistent with truth in interpretation only if we assume that verbal representations of Piero's artworks employ their medium transparently. But White rejects this belief. What both the relativist and the antirelativist may assume is that there is a real distinction between coming to see Piero's pictures as they really are and explaining how they have been interpreted differently at different times. This, however, is a distinction without a difference.[59] A parallel between art historians' interpretations and visual artworks gives us reason to reject the metaphor of "seeing the paintings as they really are." Just as there is no way that the legend of the True Cross, the Flagellation, or the Baptism of Christ *are*, independently of *how they are represented* by various painters, so there is no way that Piero's paintings of those subjects are, independently of how they are interpreted. Since interpretation involves selective focus, different historians may compose truthful accounts of those pictures by focusing on different features or by focusing differently on the same features.

To compare the modern accounts with Vasari's, then, is to suppose that we can describe Piero's pictures *as they really are*, apart from how artwriters represent them. Of course, the same artifacts, the Arezzo frescoes, have—after various restorations—been viewed by Vasari, Clark, Ginzburg, and the other historians. But to claim either that we see more than Vasari or that he lacked the concepts needed to describe what he saw supposes that there is some test, apart from plausibility as judged by professional consensus or truth to the facts, for judging interpretations. No such test, however, has been found.

Baxandall suggests that Vasari, when properly read, provides an adequate guide to Renaissance art. We can now see why that suggestion is misleading: it implies that transparent, unambiguous interpretation of Vasari's texts is possible. This, however, is not the case. Just as different readings of George Eliot's novels are possible, so the same is true of Vasari's *Lives*. When Vasari says that the Corinthian columns depicted in

59. The visual metaphor implicit in the word "see" emphasizes the link here between knowledge and truthful vision. See Martin Jay, "In the Empire of the Gaze: Foucault and the Denigration of Vision in Twentieth-century French Thought," in *Foucault: A Critical Reader*, ed. D. C. Hoy (Oxford, 1986), 175–203.

the Arezzo frescoes are "divinely measured," we may read those words as a mere cliché. But if, as Ginzburg argues, Piero's unit of measurement was a relic believed to mark Christ's height, if in the *Flagellation* "a rectangle defined by Christ's position ... has the same area as a circle with the column at its center," and "Christ's tormentors ... have unwittingly brought Him to precisely the point where one of the great mysteries of classical mathematics, the rectangling of the circle, could testify to His divine nature," then Vasari's words express a deep idea that we have only now begun to understand.[60]

60. Ginzburg, *Enigma*, 130; Warren Welliver, "The Symbolic Architecture of Domenico Veneziano and Piero della Francesca," *Art Quarterly* 30 (1973): 18–19.

3

Caravaggio:
The Construction
of an
Artistic Personality

$\bullet \qquad \bullet \qquad \bullet$

Compare two accounts of Caravaggio's personality: Giovanni Bellori's brief 1672 text and Howard Hibbard's *Caravaggio*, published in 1983. Bellori says that Caravaggio, like the ancient sculptor Demetrius, cared more for naturalism than for beauty. Choosing models, not from antique sculpture, but from the passing crowds, he aspired "only to the glory of colour."[1] Caravaggio abandoned his early Venetian manner in favor of "bold shadows and a great deal of black" because of "his turbulent and contentious nature." The artist expressed himself in his work: "Caravaggio's way of working corresponded to his physiognomy and appearance.

1. Howard Hibbard, *Caravaggio* (New York, 1983); Bellori is quoted in Walter Friedlaender, *Caravaggio Studies* (Princeton, 1955), 245–54.

He had a dark complexion and dark eyes, black hair and eyebrows and this, of course, was reflected in his painting." The curse of his too naturalistic style was that "soon the value of the beautiful was discounted."

Some of these claims are hard to take at face value. Surely when Caravaggio composed an altarpiece he did not just look until "it happened that he came upon someone in the town who pleased him," making "no effort to exercise his brain further." While we might think that swarthy people look brooding more easily than blonds, we are unlikely to link an artist's complexion to his style. But if portions of Bellori's text are alien to us, its structure is understandable. He discusses the origin of Caravaggio's style and tells why it created a sensation in Rome, comparing Caravaggio with his rival, Annibale Carracci.

We have no real knowledge of Piero's personality or political opinions. By contrast, enough is known about Caravaggio's life to make a film about him. And so his art can be described differently. Whereas interpretations of Piero's painting focus on his iconography, Caravaggio's work is often related to his life. Hibbard's "Afterthoughts" offers a psychoanalytic account of his subject. Caravaggio's repeated conjunction of young boys and bald elders shows him both seeking "to retrieve a father whom he lost when . . . only six" and also, unconsciously, punishing that father. As he depicted the beheading of Saint John, and "decapitation is . . . symbolic castration, perhaps Caravaggio unconsciously feared punishment for sexual thoughts or deeds." His *Medusa* and *David with the Head of Goliath* (Fig. 5) "reflect . . . the psychological origins of homosexuality (i.e. exaggerated fear of the female genitals . . .)" and "comment on his own conscious experience with a younger homosexual partner." As Goliath, Caravaggio "is 'bitten' by his young lover . . . David." His chiaroscuro "expresses an unusual personality," one whose "world was made up of a few friends set against a background of nameless 'others'."[2]

Just as Lavin's account of Piero's work differs from Vasari's *ekphrasis*, so Hibbard's "Afterthoughts" is very different from Bellori's text. Bellori's nine pages, the fullest early biography, refer to no other texts; in the eleven pages of his "Afterthoughts," Hibbard takes note of Longhi's view of Caravaggio's homosexuality and Alfred Moir's account of his drawing, borrows from Herwarth Röttgen's and Laurie Schneider's psychoanalytic

2. Hibbard, *Caravaggio*, 251–61; Laurie Schneider, "Donatello and Caravaggio: The Iconography of Decapitation," *American Imago* 33 (1976): 90.

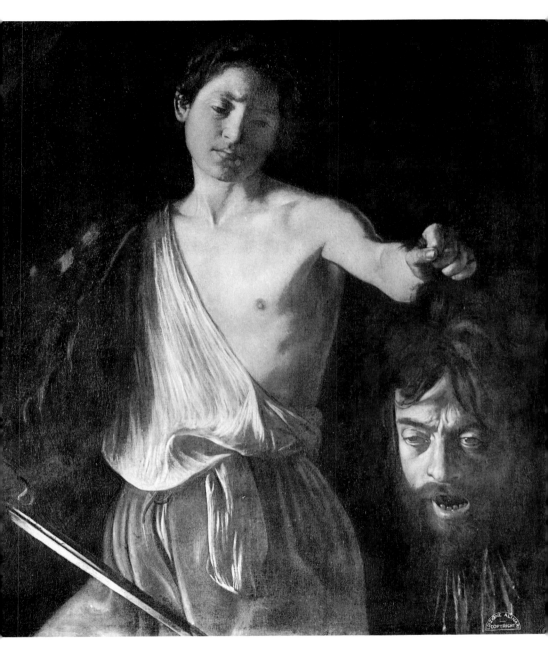

Fig. 5. Caravaggio, *David with the Head of Goliath*, Rome, Galleria Borghese (photo: Alinari/Art Resource, New York)

accounts, notes Mahon's theory of Caravaggio's visual quotations, and adapts Rudolf Wittkower's description of his *tenebroso*. It is easy to see that Bellori thinks of art differently than we do. Today, however, Hibbard's psychoanalytic account seems as dated as Clark's imitation of Pater. Like many much less knowledgeable commentators, Hibbard views Caravaggio's painting as an art of self-expression. I will not comment on the obvious limitations of his account of the link between homosexuality and castration anxiety. What interests me more is how he weaves one bit of factual evidence into this narrative.

"All my sins are mortal"—so Francesco Susinno's 1724 account claims Caravaggio said after painting *The Beheading of Saint John the Baptist* (1608). What are we to make of this anecdote? Upon entering a church and being given holy water, "Caravaggio asked . . . what was the purpose of it, and the answer was that it would erase any venial sin. 'It is not necessary,' he replied, 'since all my sins are mortal.' "[3] A familiar of Cardinal del Monte could not be ignorant of the purpose of holy water. Caravaggio's question could be ironical and his reply sincere, as Hibbard assumes in attributing guilt to the painter, but maybe he was just being provocative.

Just as Ginzburg's reconstruction of Piero's career creates a full narrative from very incomplete data, so the same is true here of Hibbard. We really do not know whether Caravaggio felt guilty for his aggressive actions, and this psychoanalytic interpretation of *Medusa* and *David with the Head of Goliath*, we will see, is not altogether plausible. Like any skilled writer, Hibbard achieves narrative closure by making his conclusion seem inevitable. Caravaggio was "moving toward a tragic, terrific end in his later art." This statement fits with Hibbard's idea that the painter felt guilty and so sought punishment. But if the late images of the beheading of Saint John and the burial of the martyred Saint Lucy support this theory, the existence of two versions of *The Adoration of the Shepherds* and a *Resurrection of Lazarus* does not. Much of Caravaggio's late art is about birth and rebirth. Hibbard makes his death seem inevitable, but Caravaggio was not a tragic hero, a man who must suffer catastrophe in the last act.

In Chapter 2, I introduced the idea that an artwriter's text is best

3. Quoted in Hibbard, *Caravaggio*, 386. Susinno's text is unreliable; Hibbard omits "some extraneous material that shows Susinno to be both garrulous and credulous."

understood as a continuous narrative constructed from a limited group of facts.[4] The present chapter discusses many texts, most of them recent. To analyze these texts, I will break them up into ten codes.[5] By a "code" I mean a distinctive way of describing an artwork. Four of these ten codes appear in both seicento and modern accounts of Caravaggio: *contemporary commentary, naturalism/realism, playacting*, and *public response*. Six occur only in recent accounts: *allegory/symbolism, attributions, cultural history, homosexuality, pictorial quotation/self-expression*, and *theories of art*. These codes overlap, and there is nothing special about the number ten. A different analysis may find more or different codes. What matters is only that some convenient system is adopted.

Allegory/Symbolism

Giovanni Baglione says that when you view *Boy Bitten by a Lizard* (Fig. 6), "you can almost hear the boy scream."[6] The work is a masterpiece of naturalism. A tradition of recent interpretation, however, finds this picture an allegory that may reflect the artist's personal concerns. Noting "the squeamishness and effeminacy . . . of [the boy's] reaction," Donald Posner thinks that this leaves "no doubt . . . about the kind of youth Caravaggio represents."[7] A psychoanalyst adds: "Part of the middle or love finger . . . appears to be bitten off, castrated, as it were, by the artistic device of having a shadow cover the lower half of the finger."[8] Perhaps the picture shows "a disillusionment with the world of the senses" that

4. This idea, extensively developed by narratologists, can be found in Freud, who contrasts what he calls analysis and synthesis: "So long as we trace the development from its final outcome backwards, the chain of events appears continuous. . . . But if we proceed the reverse way . . . then we no longer get the impression of an inevitable sequence of events" (*The Complete Psychological Works of Sigmund Freud*, ed. J. Strachey [London, 1955], 18:167).

5. Here I make use of Roland Barthes, *S/Z*, trans. R. Howard (New York, 1974). Barthes is interested in how Balzac uses clichés to create his text. I am concerned with phrases repeated by artwriters.

6. Quoted in Hibbard, *Caravaggio*, 352.

7. Donald Posner, "Caravaggio's Homoerotic Early Works," *Art Quarterly* 34 (1971): 304–5.

8. Hans J. Kleinschmidt, "Discussion of Laurie Schneider's Paper," *American Imago* 33 (1976): 96–97.

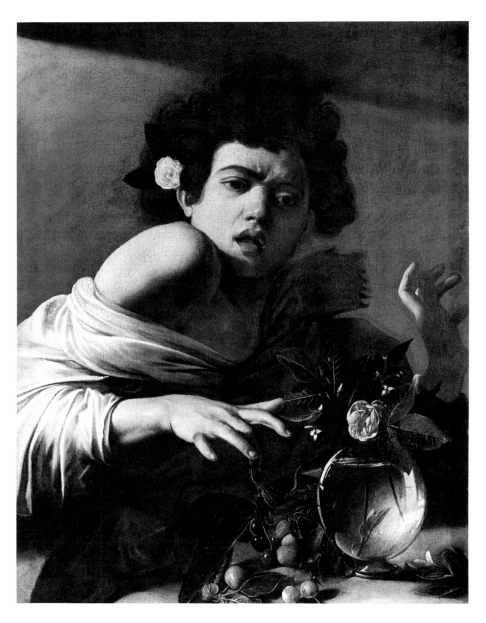

Fig. 6. Caravaggio, *Boy Bitten by a Lizard*, London, National Gallery (photo: National Gallery)

deliberately contrasts with a scene whose "overt appearance is provoca-
tively and even wittily sensuous."[9]

But it is possible to appreciate the work without seeking any symbol-
ism here, admiring how the action "is frozen in a fraction of a second, as
in a snapshot."[10] Hibbard, whose erudite account aims to be conciliatory,
notes that "whether we choose to read the picture as a private, even
campy homosexual reference or as a more general warning against the
evils of life, there is no avoiding the need to interpret."[11] This is true, but
if styles of interpretation change with the times, how may any of these
modern accounts be justified? Today Posner's account seems visually
convincing, but it is not supported by any evidence from the artist's time.
Does that mean that we are better able to see Caravaggio's pictures than
his contemporaries, or that Posner ahistorically projects modern con-
cerns into the work?

If any depicted object may be treated as a symbol, where do we stop in
our search for symbols? Calvesi finds that the violin in perspective in
Amor Vincit Omnia "alludes to the farsightedness and virginal love of
Christ"; in the Madonna di Loreto the "subject . . . is really faith, symbolized
by the two pilgrims, like Adam and Eve"; the X on the window in The
Calling of Saint Matthew is "the sign of the cross which divides the rectangle
so that the window appears lined with an X, that of the similar symbol of
love of Giordano Bruno"; and the red drapery in The Death of the Virgin
refers "to the clothing of cardinals . . . the color of triumph and resurrec-
tion." "Everything in Caravaggio is hieroglyph, emblem, symbol"; the
paintings offer "a vision of the world as rebus to be deciphered."[12] Today

9. John Gash, Caravaggio (London, 1980), 18. Posner's account is rejected by Leonard Slatkes,
who argues that since lizards "were believed to be deadly poisonous animals . . . the boy's
actions cannot be considered . . . squeamish or effeminate; he really is in danger" (Leonard J.
Slatkes, "Caravaggio's Boy Bitten by a Lizard," Print Review 5 [1976]: 149). A part-book in another
genre work is "conspicuously marked 'Bassus'," which might "clarify the sex of the androgynous
youth" (H. Colin Slim, "Musical Inscriptions in Paintings by Caravaggio and His Followers," in
Music and Context: Essays for John Ward [Cambridge, 1985], 244). In reply, Posner notes that green
Italian lizards did not bite; this lizard, then, confronts the boy with "not death but the painful
experience of rejection in love" (Donald Posner, "Lizards and Lizard Lore . . . ," in Art the Ape of
Nature, ed. M. Barasch and L. F. Sandler [New York, 1981], 389–90).

10. Giorgio Bonsanti, Caravaggio, trans. P. Blanchard (Florence, 1984), 6. Caravaggio's earliest
surviving work shows "the disillusioning surprises which life has in store for inexperienced
youth" (Benedict Nicolson, The International Caravaggesque Movement [Oxford, 1979], 34).

11. Hibbard, Caravaggio, 44.

12. Maurizio Calvesi, "Caravaggio o la ricerca della salvazione," Storia dell'arte 9/10 (1971): 110,
116, 120, 120 n. 105, 133, 139.

this seems an extravagant account, but thirty-five years ago, Posner's text would have seemed as eccentric. Once we acknowledge that standards of interpretation change with the times, it is difficult to offer a convincing noncircular standard by which to judge interpretations.

Attributions

Just as allegorical interpretations change our view of Caravaggio's early genre works, so new attributions cause us to revise our vision of his entire development. If those early paintings differ radically from his mature works, how can we define the unity of his oeuvre? "Could anyone have thought of ascribing the Uffizi *Bacchus* to the Master of the Naples *Works of Mercy*?" "If we had only his earliest and latest pictures, it would be almost absurd to maintain that they were by the same hand."[13] The recently rediscovered *Jupiter, Neptune, and Pluto*, though mentioned by Bellori, does not fit into Hibbard's story of the young painter of genre works who was out of place in the world of large-scale Roman artworks. Not surprisingly, Hibbard questions the attribution of this work, which another authority describes as "Caravaggio's most important youthful work, both for its dimensions and its invention."[14] Controversial attributions involve an unavoidably circular argument—an artwriter's general view of the artist determining what works are attributed to him and those attributions, in turn, determining the writer's image of him.[15]

It is difficult to study Caravaggio without adopting some view, however

13. Denis Mahon, "On Some Aspects of Caravaggio and His Times," *Metropolitan Museum of Art Bulletin* 12 (1953): 42; Rudolf Wittkower, *Art and Architecture in Italy 1500–1750* (Harmondsworth, 1974), 42.

14. Hibbard, *Caravaggio*, 337; Mina Gregori et al., *The Age of Caravaggio* (New York, 1985), 232. A historian who accepts the attribution makes a conciliatory suggestion: perhaps the daring effects, "not unexpected in a showpiece by a cocky young artist," show that Caravaggio got help with the perspective (Alfred Moir, *Caravaggio* [New York, 1982], 86).

15. The assumption that Caravaggio acted in character when making his works is worth questioning. In daily life, nobody is absolutely consistent, so why expect such consistency in an artist's work? For discussion, see my "Art without Its Artists?" *British Journal of Aesthetics* 22 (1982): 233–44. Bonsanti makes this point about Caravaggio: archival discoveries "should serve as a warning to those scholars who feel they know how to distinguish . . . the smallest inflection of style. . . . The path of an artist's career is not always straight" (Bonsanti, *Caravaggio*, 31).

tentative, about his career. When Hibbard rejects one widely accepted attribution, *The Conversion of the Magdalen*, claiming that "standing before the painting, I have the immediate and intense feeling that . . . it is not by Caravaggio," his connoisseur's response is conditioned by his general view of the artist's life. One of the seemingly least plausible recent attributions, *The Tooth-Extractor*, is dismissed quickly by him as "an animated genre scene that is wholly unlike any of Caravaggio's known works."[16] Still, it is akin to unquestionably genuine Caravaggios: the old woman is like the corresponding figure in *The Crucifixion of Saint Andrew*; the bald man's head "reveals the circular brushstroke that Caravaggio characteristically used to define the point of maximum illumination"; the half-shadows occur in some faces in Caravaggio's Sicilian works; and the hands are typical.[17]

What is perhaps most disconcerting about *The Tooth-Extractor* is that it would mark a return at the end of Caravaggio's life to the creation of genre works. But if Annibale Carracci could switch between monumental works and genre paintings, why could not Caravaggio do the same?[18] One commentator perversely argues that this late genre work "feels truer to Caravaggio than most of his other pictures. This time he shows the horror straight; he doesn't filter it through the screen of a Biblical or mythological story."[19] This seems a strange view of a painter best known for his sacred works. But even Walter Friedlaender's classic 1955 account of Caravaggio depends upon a list of attributions that today most connoisseurs would find far too restrictive.[20]

Just as Piero's iconography began to be intensively discussed only when he became famous, so too only when Caravaggio attributions come to be systematically studied in this way do we find highly complex theories of the artist's development. Wittkower asserts that "Caravaggio's

16. Hibbard, *Caravaggio*, 288, 342.

17. Gregori et al., *Age*, 342–44.

18. See the discussion in *The Age of Correggio and the Carracci* (Washington, D.C., 1986). Perhaps because Annibale's personality has attracted less interest than Caravaggio's, Carracci attributions are not linked in the same way to the artist's life.

19. Sanford Schwartz, "The Art World," *New Yorker*, 2 September 1985, 198.

20. In part, these problems of attribution arise because although Caravaggio's contemporaries valued his works highly, none of them provided a *catalogue raisonné*, and once Caravaggio's art fell into disfavor, many works were no longer accurately attributed. So, after Longhi's 1951 exhibition reestablished Caravaggio's fame, much research has been devoted to locating works known only from copies or from written descriptions.

activity may conveniently be divided into four different phases"; Fried-laender argues that there is a real break between the "youthful, bohe-mian canvases" and Caravaggio's "monuments of devotion"; Hibbard replies that *The Calling of Saint Matthew* "seems to have deliberately quoted from these popular early works"; and Luigi Salerno writes of his "impres-sion . . . of the extreme coherence of the artist's development."[21]

Mahon, interested "in the growth of the artistic personality," identifies *Saint Francis in Ecstasy* as "a tentative, experimental work by a young artist who is not yet sure of himself," and describes Caravaggio as searching for, finding, and then developing a style.[22] This is a very natural way of think-ing. The one undeniably authentic still life may seem out of place in Caravaggio's oeuvre, but fruit reappears on the table in *The Supper at Emmaus*, and if *Still Life* shows "Saint Philip Neri's veneration of the hum-ble," then this painting can be linked with Caravaggio's development.[23]

Suppose we imagine that Caravaggio did paint the Madrid *David with the Head of Goliath*. That "entails believing that Caravaggio managed to find . . . a peace entirely absent from the rest of his life. . . . it endows the quietude of . . . *David with the Head of Goliath* with the extraordinary power of serving as a counterweight to the violence . . . that fills the rest of Caravaggio's oeuvre."[24] If we believe that an artist's oeuvre has a unity, our view of Caravaggio's entire career will be changed by accepting this one attribution. Caravaggio's altarpieces may seem radically different from his early "homoerotic" works. But just as his boys proposition the viewer, so perhaps his *Entombment* "uses the directed glance and the offering gestures to force the spectator to assume a . . . role, . . . assistant in the grave."[25]

Given this belief in the ultimate unity of Caravaggio's work, individual works that do not fall into the pattern require explanation. Because he believes that Caravaggio was a follower of Saint Philip Neri, Moir thinks that *Ecce Homo* shows Christ "shamed not for Himself but for man's incapacity for humanity." The *Madonna and Child with Saint Anne*, painted

21. Wittkower, *Art*, 45; Friedlaender, *Caravaggio Studies*, ix; Hibbard, *Caravaggio*, 97; Luigi Salerno, "The Art-Historical Implications of the Detroit 'Magdalene'," *Art Bulletin* 116 (1974): 587.

22. Denis Mahon, "Contrasts in Art-Historical Method: Two Recent Approaches to Caravag-gio," *Burlington Magazine* 95 (1953): 214 n. 11; Denis Mahon, "Addenda to Caravaggio," *Burlington Magazine* 94 (1952): 7.

23. Moir, *Caravaggio*, 100.

24. Carter Ratcliff, "On Two Dubious Caravaggios," *Art in America* 73 (1985): 142.

25. Georgia Wright, "Caravaggio's Entombment Considered in Situ," *Art Bulletin* 55 (1978): 41.

the next year, was, by contrast, an unappealing commission, "a Counter-Reformation document . . . directed against Protestant denial of the Immaculate Conception" that Caravaggio sought, vainly, to translate "into human terms." Immediately afterward, in his *Death of the Virgin*, "Caravaggio, freed from the burden of doctrine, presented an ordinary mortal death."[26] Hibbard implicitly rejects this account, finding *Ecce Homo* "a disagreeable painting that could not be from the master's hand," and the *Madonna and Child with Saint Anne* heterodox in accentuating Christ's nudity "to the point of offense" and relegating Saint Anne to "the side as an observing old crone."[27] Each view of Caravaggio's development influences judgments about attributions.[28]

Contemporary Commentary

All modern historians are guided by the remarks of Caravaggio's contemporaries. But like Vasari's comments on Piero, those remarks require interpretation. Bellori's brief comment on the works in the Cerasi Chapel seems simple: "The story is entirely without action."[29] For Friedlaender, Bellori is quite correct from the baroque point of view, which identifies action with movement. Here it happens that "existence and not action reveals the essence of art."[30] Mahon, too, notes that "in a subject which by tradition was one of the standard vehicles for vigorous action Caravaggio eschews any but the gentlest movements." "The genre picture is the opposite of the history painting; as in Aristotle's categories, one is

26. Moir, *Caravaggio*, 122, 126, 128.

27. Hibbard, *Caravaggio*, 198, 358.

28. "All of the elements of [Caravaggio's] art come together" in *David with the Head of Goliath*, an impression "heightened by [the painting's] position in the [Age of Caravaggio] exhibition . . . on the far wall of the final gallery" (Arthur Danto, "Art," *The Nation*, 2 March 1985, 252). One can predict a book's view of Caravaggio by the work the author chooses for the dust jacket: S. J. Freedberg picks *Saint John the Baptist*, emphasizing Caravaggio's relation to Michelangelo; Longhi, a detail from *The Calling of Saint Matthew*, emphasizing Caravaggio's place in the mainstream tradition of monumental Italian painting; Röttgen, a detail from that work, a self-portrait important for his psychoanalytic study; Friedlaender, the head of Goliath, underlining his concern with Caravaggio and religion; and Hibbard, the *Entombment*, the least radical major Caravaggio, reflecting his doubts about the artist's status.

29. Quoted in Friedlaender, *Caravaggio Studies*, 249.

30. Friedlaender, *Caravaggio Studies*, 9; Lionello Venturi, *Il Caravaggio* (Novara, 1952), 23.

drama or tragedy, and the other comedy. . . . Bellori . . . knows perfectly that this picture is not a genre work and yet cannot be assimilated to tragedy."[31] Maybe Bellori's words mean the opposite of what they literally say: "In modern terms, they signify exactly the opposite: action without historical significance, that is mere happenings."[32]

But are these words worth so much analysis? Bellori was "not born until five years after Caravaggio's death . . . and did not approve of Caravaggio's style."[33] Maybe it was not within the realm of an artwriter of the seventeenth century to understand Caravaggio's realism. Because any early commentary on Caravaggio seems precious, we read with great care words that, since they do not reflect close study of his art, perhaps were not meant to be taken so seriously.

Of the Contarelli Chapel Caravaggios, Zuccaro said: "What is all the fuss about? . . . I don't see anything here but the thought of Giorgione."[34] As Giorgione was then poorly understood in Rome—Bellori, who reports the story, had "no first-hand knowledge" of Giorgione's paintings—and Zuccaro was successful but insecure, these words may be merely an ignorant expression of resentment.[35] But possibly Zuccaro did see something important. He might be thinking not of Giorgione, but of Caravaggio's use of "overly naturalistic light," or he could be saying: "See what happens when Caravaggio has to tackle a large public *storia.* . . . He simply enlarges one of those genre scenes which some of the more irresponsible *dilettanti* have found curious."[36]

Hibbard notes that Caravaggio's early works appeared "Giorgionesque in subject" and so "poetic in the eyes of . . . contemporaries."[37] Maybe

31. Denis Mahon, "Egregius in Urbe Pictor: Caravaggio Revisited," *Burlington Magazine* 106 (1964): 230; Guilio Carlo Argan, "Il 'Realismo' nella poetica del Caravaggio," in *Scritti di storia dell'arte in onore de Lionello Venturi,* 2 (1956), 30–31.

32. Other modern artwriters also offer sympathetic interpretations of Bellori's words: Caravaggio gives a "synthesis of action, as was already done by the early quattrocento Florentines"; he combines "attention to imitation . . . with a suspension of narrative action" (Marangoni, quoted in Berne Joffroy, *Le dossier Caravage* [Paris, 1969], 173; see also Svetlana Alpers, "Describe or Narrate? A Problem in Realistic Representation," *New Literary History* 8 (1976): 15).

33. Alfred Moir, "Did Caravaggio Draw?" *Art Quarterly* 32 (1969): 369 n. 6.

34. Quoted in Friedlaender, *Caravaggio Studies,* 235.

35. Hibbard, *Caravaggio,* 6 n. 9.

36. Mahon, "Egregius," 231. See also Charles Dempsey, *Annibale Carracci and the Beginnings of Baroque Style* (Gluckstadt, 1977), 23, and Valerio Mariani, "Caravaggio," in *Encyclopedia of World Art* (London, 1960), 3:75.

37. Hibbard, *Caravaggio,* 87.

Zuccaro is complaining that Caravaggio, like the Venetians, composed directly on canvas without first making a drawing. The role of drawing in Caravaggio's art has been the subject of considerable debate. Some historians believe that Caravaggio's failure to draw affects his compositions: "the mere working mechanics of pictorial representation in the High Renaissance sense never became an open book for Caravaggio"; "by masking awkward junctures and gaps with darkness, Caravaggio would disguise his limitations as painter of traditional Renaissance scenes in perspective."[38] Drawing allows an artist to work out the composition of a painting before turning to the full-scale picture, and this Caravaggio refuses to do. X-rays of *The Martyrdom of Saint Matthew* show an altogether different composition underneath.[39] But in the later *Beheading of Saint John the Baptist* there are only "insignificant changes in an ear and fabric design," so perhaps Caravaggio needed to rework the earlier picture only because it was his first large-scale composition.[40]

How we interpret these comments of Bellori and Zuccaro depends upon our view of Caravaggio's goals. Although such contemporary commentary can aid in the interpretation of his art, it cannot unambiguously support any one view of his work. As Bellori's and Zuccaro's comments are brief and hostile, a modern artwriter might dismiss them; historians who do find them valuable must interpret them.[41]

Cultural History

One way to understand Caravaggio's art is to place it within the broader context of his culture, in which new scientific and religious movements

38. Mahon, "Some Aspects," 42–43; Hibbard, *Caravaggio*, 96.
39. Mahon, "Some Aspects," 40.
40. Richard E. Spear, "Stocktaking in Caravaggio Studies," *Burlington Magazine* 126 (1984): 165.
41. Nor do these problems arise here just because Bellori and Zuccaro are historically distant figures. I have written about the work of several now well-known painters, who have discussed their work with me at length (see my "Color in the Recent Work," in *Sean Scully* [Pittsburgh, 1985], 22–27, and "Artifice and Artificiality: David Reed's Recent Paintings," *Arts Magazine* 60 [1986]: 30–33). Sometimes they have rejected my interpretations, but at other times they have given me ideas, or accepted my views and repeated them to other artwriters. What this shows is not that I have discovered their intentions, but that interpretations can be the product of such a dialogue.

were important. Because both Caravaggio and Galileo were linked to del Monte's circle, commentators have often sought to connect their work. Among artists, Caravaggio "was alone in positioning himself on the side of the new men of science, rejecting tradition and basing his work on nature alone."[42] The camera obscura perhaps gave Caravaggio ideas about how to use light.[43] But as Caravaggio's "interest in the visual world was small"—he never painted an independent landscape and probably did "without models in his later years"—these parallels seem unhelpful.[44] Such attempts to link Caravaggio, who had no known intellectual interests, and Galileo are based not upon detailed discussion of visual details but upon an easily questioned Hegelian belief in the ultimate unity of seicento culture.

Because Caravaggio painted many sacred works, it is easier to relate his art to contemporary religious movements. There is a tradition that emphasizes his heterodoxy. Among those who painted the death of the Virgin, "only Caravaggio had the courage or the cynicism, to show her not as dying to this world, but as dead in this world." "One cannot help feeling that for Caravaggio heaven did not exist: there was only the earth below. Occasionally an angel might come down to man, but man was never caught up to the angels."[45] Perhaps he had "the character of a protestant, not only in art directed against the artificial culture of his time, but in his return to a humane base, to directly observed reality."[46]

John Berger's highly personal essay develops these ideas. Caravaggio was "the first painter of life as experienced by the popolaccia. . . . He does not depict the underworld for others; his vision is one that he shares with it. . . . He was a heretical painter: his works were rejected or criticized by the Church because of their subject matter. . . . His heresy consisted of

42. Venturi, *Caravaggio*, 4. See also Roberto Longhi, *Caravaggio* (Rome, 1972), ii, and Luigi Salerno in Gregori et al., *Age*, 19.

43. See the discussion in Mahon, "Contrasts," 216, and Mario Praz, *On Neoclassicism*, trans. A. Davidson (Evanston, 1969), 28.

44. Hibbard, *Caravaggio*, 84–85. Compare Panofsky's interesting claim that the moon in Ludovico Cigoli's *Assumption of the Virgin* in the church of Santa Maria in Rome represents "the moon under the Virgin's feet exactly as it had revealed itself to Galileo's telescope" (Erwin Panofsky, *Galileo as a Critic of the Arts* [The Hague, 1954], 5). See also Luigi Salerno, "Caravaggio e la cultura nel suo tempo," in *Novità sul Caravaggio: Saggi e contributi*, ed. M. Cinotti (Milan, 1975), 22.

45. Roger Hinks, *Caravaggio's Death of the Virgin* (Oxford, 1953), 13; Roger Hinks, *Michelangelo Merisi da Caravaggio* (London, 1953), 88.

46. Mario Praz, *Il giardino dei sensi* (Turin, 1975), 272.

transporting religious themes into popular tragedies." In this art, "as you would expect, there is no property."[47] But Caravaggio was born into the gentry and, after a few years in poverty, lived as a young man in del Monte's great house. He quickly achieved financial success. If he was at home in the lower depths, he did not remain there when he could escape.

Without making Caravaggio a radical, Friedlaender emphasizes his possible connection with Saint Philip Neri, a charismatic reformer. "Caravaggio's later works cannot be fully understood without understanding Filippo's principles" and his concern for the people: "Such an extraordinary personality . . . could hardly have escaped the attention of the young Caravaggio . . . if they liked, Caravaggio and his young friends could have had easy access to the part of the Oratory in which Filippo lived. . . . One can imagine the young friends of Caravaggio . . . had participated in the singing of . . . motets and madrigals."[48] Is this the same man the seicento writers describe, the man who, "after having painted for a few hours . . . used to go out on the town with a sword at his side," who lived with "swaggering, hearty fellows" whose motto was "without hope, without fear"? Perhaps, like a Graham Greene hero, he sought salvation because he felt he was a sinner.[49]

Friedlaender admits that there is "nothing in [Neri's] preserved sermons, letters or notes which could have given Caravaggio a basic idea for the composition of any one of his paintings."[50] But we do have records of

47. John Berger, "Caravaggio, or the One Shelter," *Village Voice*, 14 December 1982, 67–69. This popular account echoes ideas presented earlier by art historians: "It is probable that . . . the poverty of his earlier years . . . caused him to rebel against convention and gave him a sharp awareness of the spiritual needs of the individual, whatever his social rank" (Friedlaender, *Caravaggio Studies*, 129); "Caravaggio appears to believe that it is only for those who have nothing in this world that Christ has come" (Émile Mâle, *L'art religieux après le concile de Trente* [Paris, 1932], 7).

48. Friedlaender, *Caravaggio Studies*, 123, 124–26. The quotations that follow appear on pp. 250 and 265.

49. We like to think that even bad-tempered geniuses hold admirable views, and so we believe that when Giordano Bruno was burnt at the stake, "Caravaggio must have recognized the inhumanity of this method of coping with dissent"; we may imagine his "identification with the suffering of the victim" (Moir, *Caravaggio*, 122; Mina Gregori in Gregori et al., *Age*, 256). But no record supports these claims.

50. This conclusion is supported by recent investigations of the iconography of the Entombment commissioned for Neri's church and rejected by the patrons (Friedlaender, *Caravaggio Studies*, 126; Hibbard, *Caravaggio*, 313; Mary Anne Graeve, "The Stone of Unction in Caravaggio's Painting for the Chiesa Nuova," *Art Bulletin* 40 (1958): 234; Wright, "Entombment," 38–39).

contemporary responses to two of Caravaggio's paintings. The *Madonna di Loreto*, Baglione wrote, shows two pilgrims, "one with muddy feet and the other wearing a soiled and torn cap"; and *The Death of the Virgin*, Hibbard says, "not only flaunted decorum but also decried the spiritual content of the scene."[51] Is this evidence that Caravaggio was a crypto-Protestant, or even religiously indifferent? When Pierre Francastel asserted in 1938 that Caravaggio was "the last representative of the grand tradition of faith," he made a point now supported by a number of accounts.[52] Removing one's shoes in a holy place, as do the pilgrims in the *Madonna di Loreto*, was an ancient custom; the painter's depiction of barefoot pilgrims "ought not to have offended an Order such as the Barefoot Carmelites and, indeed, was probably intended as a tribute to their particular way of life."[53] Caravaggio's dead Virgin may show "total authenticity, requiring that emotion wear the look and carry the behavior of the ordinary world as different as possible from the styled world of art."[54]

Homosexuality

"The nature of Caravaggio's sexual tastes can scarcely be questioned"; his early works show "erotically appealing boys painted by an artist of homosexual inclinations."[55] Only modern commentators make this claim. The first prominent suggestion of this idea, Berenson's three words of 1951— "perhaps a homosexual"—earned an indignant rebuke from Longhi, who appealed, unconvincingly, to evidence of Caravaggio's girlfriend.[56] The

51. Hibbard, *Caravaggio*, 204; Baglione is quoted in Friedlaender, *Caravaggio Studies*, 235.

52. Pierre Francastel, "Le réalisme de Caravage," *Gazette des beaux-arts*, 6th ser. 20 (1938): 62; Hibbard, *Caravaggio*, 188.

53. " 'Being-in-the-world' . . . gets the name 'homo' in relation to that of which it consists (*humus*)" (Martin Heidegger, *Being and Time*, trans. J. Macquarrie and E. Robinson [New York, 1962], 243; see also Gash, *Caravaggio*, 104).

54. S. J. Freedberg, *Circa 1600: A Revolution of Style in Italian Painting* (Cambridge, 1983), 66–68; Longhi, *Caravaggio*, 40.

55. Posner, "Homoerotic Early Works," 302; Michael Kitson, *The Complete Paintings of Caravaggio* (New York, 1967), 7.

56. Bernard Berenson, *Caravaggio* (London, 1953), 91; Roberto Longhi, "Novelletta del Caravaggio 'invertio'," *Paragone* 27 (1952): 62. What seems surprising about Longhi's response is the presumption that a man who had a girlfriend could not also have boyfriends.

seicento commentators, who say much else about Caravaggio's nastiness, omit any mention of his sexuality, either because of ignorance or because they could not discuss it. Richard E. Spear asks the right question: "If the homosexual aspects of so many of Caravaggio's pictures are dominant, why did they escape mention by any early commentator . . . ?"[57] *Amor Vincit Omnia* may look blatantly erotic, but as its owner, a "rather conventionally religious" man, "hung it in a place of honour," presumably it did not seem an offensive work.[58]

Apart from the pictures themselves, the documentary evidence about Caravaggio's sexuality is scanty.[59] Drawing on Sussino's account, a modern imaginative writer claims that Caravaggio was expelled from Syracuse "for having been caught staring too intently at a group of boys. . . . Celebrimi pittore, hell; the town fathers knew what it was all about."[60] But this too is speculation. What the unreliable Sussino actually says is that Caravaggio was annoyed by the boys' teacher and wounded the man. Lacking models, perhaps he did only want to sketch the boys.

Because the documentary evidence is so incomplete, Caravaggio's homosexuality is often deduced from his pictures. Certainly *Boy with a Basket of Fruit* "looks out at the observer with a velvety gaze, his lips parted in an inviting manner."[61] But such eye-catching effects were a commonplace Renaissance device, recommended by Alberti. The pretty boy in Caravaggio's portrait of the grand master of the Knights of Malta also catches our eye, and here again we find the motif that interested Hibbard, a young boy with an older, balding man. But this juxtaposition was presumably determined entirely by the commission, and surely the grand master would not have commissioned an erotic portrait.

S. J. Freedberg offers a sophisticated reading of Caravaggio's sexuality. Contrasting Caravaggio's *Saint John* with Bronzino's, he finds that "Caravaggio's apprehension of the model's presence *seems* unimpeded in the least degree by any intervention of the intellect or by those conventions

57. Spear, "Stocktaking," 165.
58. Hibbard, *Caravaggio*, 160.
59. One historian describes an evening at Cardinal Del Monte's house, where, "as there were no ladies present, the dancing was done by boys dressed up as girls"; another says that this report comes from a "tendentious and not very reliable source" (Hibbard, *Caravaggio*, 247 n. 7; Francis Haskell, *Patrons and Painters* [New Haven, 1980]; Gregori, in Gregori et al., *Age*, 229).
60. Stephen Koch, "Caravaggio and the Unseen," *Antaeus* 54 (1985): 99.
61. Bonsanti, *Caravaggio*, 6.

of aesthetic or of ethic that the intellect invents."[62] Even a photograph,
however, is a product of conventions. Since Freedberg also argues that
the work is "a deliberate translation into realist prose" of Michelangelo's
Ignudo, as the word "seems" hints, he is claiming not that Caravaggio
shows his model directly, but that his images seem direct when com-
pared with those of the mannerists. The art/reality distinction here identi-
fies two distinct kinds of artistic representations. Unlike Berger, Freed-
berg draws on a generally accepted fact: Caravaggio's Saint John does
quote Michelangelo. But there is disagreement about the meaning of
that quotation. For Friedlaender the painting involves "derisive irony and
in a sense a blasphemy."[63] Perhaps, however, "Caravaggio grasped the
central theme of Michelangelo's monumental works . . . but replaced the
emphasis on physical description by one of psychological penetration."[64]

In an elaborate Freudian analysis, Röttgen speculates that because
Caravaggio's mother was incapable of affection, his prolonged puberty
and social isolation left him unable to feel social reciprocity. Since the
known facts are few, Röttgen takes the "pictures [as] documents of the
actual psychic situation." The Beheading of Saint John the Baptist shows "a
grave conflict between the ego and the superego in those years which
troubled the artist's mind"; Caravaggio's Lazarus is a "symbol of a man
bound to God by death"; and "the identification of the artist with the
beheaded saint reveals the tendency to renunciation and simultaneously
illustrates the death instinct, the destructiveness turned against him-
self."[65] For Röttgen, Caravaggio's pictures are unmediated images of the
artist's mental states: a single figure reveals his self-image; two figures

62. Freedberg, Circa 1600, 53 (italics added).

63. Friedlaender, Caravaggio Studies, 59.

64. Stephen D. Pepper, "Caravaggio and Guido Reni: Contrasts in Attitudes," Art Quarterly 24
(1971): 343. Perhaps Caravaggio's ambivalence about his homosexual namesake was important;
but since another precedent for this picture was a famous Leonardoesque Saint John, he might
not have been thinking only of Michelangelo (Hibbard, Caravaggio, 154; Friedländer, Caravaggio
Studies, 91; on Caravaggio's name, see Maurizio Calvesi, "La realtà de Caravaggio Prima parte
(Vicende)," Storia dell'arte 53 (1985): 62). Hibbard supports his account of Caravaggio's homosexu-
ality by describing the artist's only female nude, the figure of Charity in Seven Works of Mercy, as
"unhappy with her chore. . . . we can only imagine . . . a groan from her coarse lips." But here he
contradicts his earlier claim that Caravaggio's Judith is "sexual and attractive" (Hibbard,
Caravaggio, 67, 106).

65. Herwarth Röttgen, Il Caravaggio: Richerche e interpretazioni (Rome, 1974), 189, 209, 219, 221.
Similar conceptual problems appear in the most elaborate attempt to provide a social history of
Caravaggio's art, Françoise Bardon's Caravage ou l'expérience de la matière (Paris, 1978).

reveal his inner conflict, as when he is said to identify with both David and Goliath in his picture of them. This complex theory thus rests on an easily contested interpretation of the pictures.

Naturalism/Realism

Although the seicento commentators have nothing to say about Caravaggio's sexuality, they obsessively describe his naturalism:

> [His] mere copying does not seem . . . to be satisfactory, since it is impossible to put in one room a multitude of people acting out the story. (Mancini)

> His beautiful style . . . consisted of painting from nature. . . . he did not have much judgement in selecting the good and avoiding the bad. (Baglione)

> He . . . paint[ed] from nature, . . . rising from imitations of flowers and fruits . . . finally . . . painting complete figures. (Scannelli)

> He claimed . . . he never made a single brushstroke that he called his own, but said rather that it was nature's. (Bellori)

> This man . . . did not know how to make anything without the actual model before his eyes. (Scaramuccia)

> He despised anything that was not done from life. (Sandrart)

> His low regard for ancient sculpture kept him from being anything more than a mere naturalist. (Sussino)[66]

As these remarks are literally untrue, perhaps these commentators, like Freedberg, mean to contrast Caravaggio with the idealizing mannerists.[67]

66. Quoted in Hibbard, *Caravaggio*, 350, 356, 357, 371, 376, 387.
67. See Heinrich Wölfflin, *Classical Art*, trans. P. and L. Murray (Oxford, 1968), 203–4, which offers a surprisingly positive early judgment of Caravaggio. "Naturalism" names what Caravaggio's contemporaries find unfamiliar, and so disturbing; we see Caravaggio's images differently, just as we find early films, which once apparently seemed so lifelike, old-fashioned looking. A

The naturalism of Caravaggio's pictures makes them inherently ambiguous. Michelangelo's *Conversion of Saint Paul* shows Christ above the saint; Caravaggio depicts only a light whose source is not present. Is he thus carrying "realism to extremes for the sake of bringing the miraculous as close to earth as possible"? Is he "translating visions into pictorial language," or is he a secular artist?[68] Does his *Stigmatization of Saint Francis* show a fainted monk supported by a pretty boy, or a vision?[69] Hibbard finds *The Rest on the Flight into Egypt* "one of the most charming works of Caravaggio's youth despite the erotic angel."[70] Arthur Danto sees "an image which connects the religious vocation and erotic preference which co-exist harmoniously." Perhaps Caravaggio's distortions "were not accidental but quite intentional, . . . intended to shock the viewer out of interpreting the paintings as simple transcriptions of visual reality."[71]

There is a tradition of hostile commentary on the naturalism of *The Conversion of Saint Paul* (Fig. 7). Burckhardt writes that "the horse nearly fills the whole of the picture," Fry says that "[Caravaggio] has made a very finished representation from nature of a horse in a stable with a man holding its head." And Berenson says: "We are to interpret this charade as the conversion of Paul. Nothing more incongruous than the importance given to horse over rider."[72] Two early commentators, however, see

long tradition of commentary links Caravaggio with Courbet: "Modern naturalism . . . begins in all its crudity" with Caravaggio (Burckhardt, quoted in Joffroy, *Le dossier*, ii); "The social character of realism was at the origin of the polemics against Courbet, a distant heir of Caravaggio" (Lionello Venturi, *Four Steps towards Modern Art* [New York, 1956], 24).

68. Walter Friedlaender, *Mannerism and Anti-Mannerism in Italian Painting*, trans. J. Costello et al. (New York, 1965), 68; Wittkower, *Art*, 55–56.

69. Gash, *Caravaggio*, 40; Moir, *Caravaggio*, 76.

70. Hibbard, *Caravaggio*, 55.

71. Danto, "Art," 251; Bruni/Cappelli, "Realism and Reality in the Art of Caravaggio," a wonderfully titled paper that exists, alas, only in a novel by Oliver Banks, *The Caravaggio Obsession* (New York, 1984), 179. How we understand Caravaggio's naturalism determines even how we identify his subjects. To Hibbard, *Sleeping Cupid* "looks like a dead baby," but according to Gash it may be a reminder of the Maltese Knight's "vow of chastity," signifying "the abandonment of worldly pleasures" (Hibbard, *Caravaggio*, 262; Gash, *Caravaggio*, 120).

72. Jacob Burckhardt, *The Cicerone*, trans. A. H. Clough (London, 1873); Roger Fry, *Transformations* (Garden City, N.Y., 1956), 158; Berenson, *Caravaggio*, 20. Burckhardt wrote his critique "in the same year in which Courbet opened the pavillion of his realism in the Universal Exposition" (Roberto Longhi, *Mostra del Caravaggio* [Florence, 1951]). For an interesting nineteenth-century account, see Anna Jameson, *Sacred and Legendary Art* (Boston, 1900).

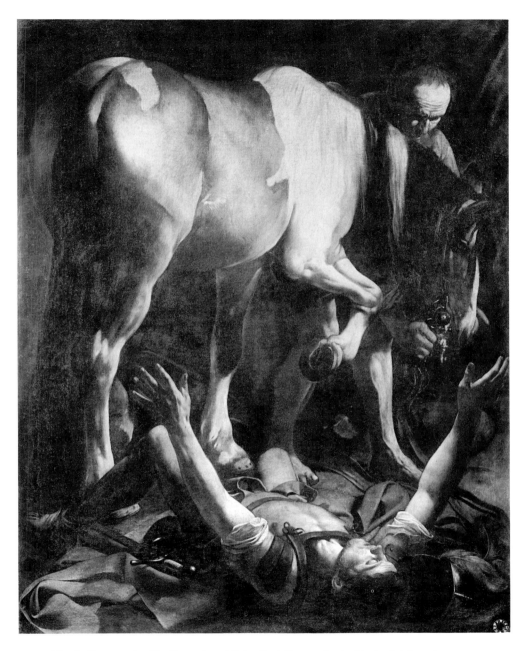

Fig. 7. Caravaggio, *The Conversion of Saint Paul*, Rome, Santa Maria del Popolo
(photo: Alinari/Art Resource, New York)

a sacred scene: "the beast, the fallen man were sharply illuminated . . . they were alone in the darkness, a universe in themselves"; "this is one of those happy cases where one sees nothing but the truth."[73]

Naturalistic images of inner visions may not always be inherently ambiguous. Visual evidence within the pictures can disambiguate such images. Perhaps *The Conversion of the Magdalen* represents that event as an "inner transformation." "When the mirror points outward to the observer . . . the figure stands as an emblem." Here, since the figure of Mary Magdalene "faces into the painting," we see a representation of her inner awareness.[74] Traditional versions of *The Supper at Emmaus* make the apostles seem a little foolish; how can they fail to recognize Christ? "By revealing an unexpected Christ—one who does not look like himself—Caravaggio was the first painter to justify the disciples' lack of recognition. . . . We look in vain for the nail prints or the side wound."[75]

Playacting

Just as the seicento writers call Caravaggio a mere naturalist, so they say that his figures playact. Bellori writes: "He painted a young girl seated on a chair with her hands in her lap in the act of drying her hair. . . . he would have us believe that she is the Magdalene."[76] But whereas nobody today accepts the idea that Caravaggio is a simple naturalist, many historians agree that his figures playact:

73. Aldous Huxley, *Crome Yellow* (New York, 1925), 111–12; Maragoni, quoted in Joffroy, *Le dossier*, 164.

74. Fredrick Cummings, "The Meaning of Caravaggio's 'Conversion of Magdalen'," *Burlington Magazine* 116 (1974): 557–58.

75. Charles Scribner III, "In Alia Effigie: Caravaggio's London *Supper at Emmaus*," *Art Bulletin* 59 (1977): 378–79. Analogously, the first *Inspiration of Saint Matthew* has been called a "popularized conception of St. Matthew as a simple scribe" (Friedlaender, *Caravaggio Studies*, 97, 127). But since Saint Matthew is writing in Hebrew "the book of the generations," this image may be an anti-Protestant polemic, documenting "the authenticity of the Hebrew Gospel as a source of the Vulgate" (Irving Lavin, "Divine Inspiration in Caravaggio's two St Matthews," *Art Bulletin* 56 [1974]: 59–81; supplementary note in *Art Bulletin* 61 [1980]: 113–14; see also Troy Thomas, "Expressive Aspects of Caravaggio's First *Inspiration of Saint Matthew*," *Art Bulletin* 67 [1985]: 637–52).

76. Quoted in Friedlaender, *Caravaggio Studies*, 246.

Does Judith really saw through the gaping neck of Holofernes? Certainly she does not. She merely holds the sword with such resolution as the model can muster. (Gowing)

The good-looking young woman named Catherine perhaps looks as if posing for her portrait. (Berenson)

His figures are merely going through the motions of movement. (Mahon)

He is theatrical, but his drama does not convince. . . . the action seems to evaporate into a sort of charade. (Hinks)[77]

In Caravaggio's time, however, playacting was not inconsistent with seriousness. A "growing sense of the reality of the stage seems to have converged with a growing sense of the illusoriness of reality, to produce a paradoxical equation of the two . . . in its most encompassing form . . . theater of the world, whose 'producer' is God."[78] Playacting emphasizes an ambiguity inherent in baroque painting, in which sacred scenes summoned up "visions of the heroic defenders of the early Church while reminding Christians that dying for the faith was a contemporary reality."[79] Caravaggio's self-portraits present him in the historically distant scene. But what is the meaning of those self-portraits? The early pictures show him reflected in a mirror because he was too poor to afford models.[80] But when Caravaggio depicts himself looking back in flight in *The*

77. Lawrence Gowing, "Incongruities of the Actual," *Times Literary Supplement*, 23 March 1984, 313; Berenson, *Caravaggio*, 14; Mahon, "Egregius," 229; Hinks, *Caravaggio*, 58.

78. Richard Bernheimer, "Theatrum Mundi," *Art Bulletin* 38 (1956): 231, 234. See also Irving Lavin, *Bernini and the Unity of the Visual Arts* (New York, 1980), and *Gianlorenzo Bernini: New Aspects of His Art and Thought*, ed. I. Lavin (University Park, Pa., 1985); Leo Steinberg, "Observations in the Cerasi Chapel," *Art Bulletin* 49 (1957): 189–90; Danto, "Art," 252.

79. Hibbard, *Caravaggio*, 104. "Caravaggio . . . seems to want to impress the scene well in his mind, in order to paint it later" (Bonsanti, *Caravaggio*, 36). Surely this is too literal-minded. But even Hibbard assumes that the portrait carries psychological significance: "We sense here a beginning of . . . his identification with violence and evil" (Hibbard, *Caravaggio*, 108).

80. Quoted in Friedlaender, *Caravaggio Studies*, 234; see also Erwin Panofsky, *The Life and Art of Albrecht Dürer* (Princeton, 1971), 16. When Pontormo shows himself helping Christ in *The Road to Calvary* (1523–24), that unprecedented self-portrait calls for no special interpretation; when Lomazzo paints himself as a pagan deity, he presents the neo-Platonic idea that artists are gifted melancholics (S. J. Freedberg, *Painting in Italy 1500–1600* [Harmondsworth, 1970], 121; Gash, *Caravaggio*, 14; James B. Lynch, "Lomazzo's Self-Portrait in the Brera," *Gazette des beaux-arts*, 6th ser. 199 [1964]: 196).

Martyrdom of Saint Matthew or "repeatedly introduce[s] self-portraits in paintings with tragic themes," is he expressing guilt or just "underscor-[ing] the realism of the scene"?[81]

Public Response

It is not easy to know how Caravaggio's art was understood in his time. Nowadays nobody would be satisfied with Arnold Hauser's idea that Caravaggio's "bold, unvarnished naturalism was unable to satisfy the taste of his high ecclesiastical patrons," or with Lionello Venturi's fantas- tic suggestion that "the difficulties he encountered . . . embittered him and eventually unbalanced his mind."[82] "Da popolani ne fu fatto estreme schiamazzo" when they saw the *Madonna di Loreto*, which may mean that "the simple people who were portrayed . . . saw it and approved."[83] *The Death of the Virgin* was highly praised by painters, and Rubens arranged for its sale to the duke of Mantua, whose agent "writes that he bows to the taste of the majority; but he confesses that the ignorant like himself might sigh for a few of those graces of style that charm the eye, and admits frankly that for his part the attractions of Caravaggio's work re- main somewhat dubious."[84]

Wittkower offers a plausible generalization: "Caravaggio's oppo- nents . . . were mainly recruited from the lower clergy and the mass of people. . . . Only the cognoscenti were able to see these pictures as works of art."[85] But as documentation is lacking, we cannot really know whether the figures in the *Madonna di Loreto* were "presented as a naive worshiper might imagine them" or whether critics objected not to the pilgrims' muddy feet "but instead to the absolute iconographic novelty of the painting."[86]

81. Mina Gregori in *Painting in Naples* 1606–1705, ed. C. Whitfield and J. Martineau (New York, 1983); Gregori in Gregori et al., *Age*, 352.

82. Arnold Hauser, *The Social History of Art*, trans. A. Hauser and S. Godman (New York, 1960), 2:184; Venturi, *Four Steps*, 29–30.

83. Baglione, quoted in Hibbard, *Caravaggio*, 190.

84. Hinks, *Death of the Virgin*, 6.

85. Wittkower, *Art*, 56.

86. Gash, *Caravaggio*, 90; Moir, *Caravaggio*, 120; Bonsanti, *Caravaggio*, 55.

Medusa is most puzzling, for a picture of a woman who petrifies men is a strange wedding present.[87] Should we see here an image from Caravaggio's "private world of fears and fantasies" or a figure who renders male viewers impotent?[88] A contemporary asserted that the recipient's true Medusa "is his own valour," and the work could be a re-creation of a famous lost Leonardo described by Vasari. We know that it was not thought offensive. As it was placed in a *Wunderkammer*, perhaps it was not regarded as an artwork at all: "The shield of the Medusa was considered more as a curiosity than as an artwork."[89]

Pictorial Quotation/Self-Expression

Studies of Caravaggio's pictorial quotations are mostly the product of modern scholars. Friedlaender, for example, claims that the horse in *The Conversion of Saint Paul* "is taken directly from Dürer's engraving," and Mina Gregori says that the body of Christ in *Christ Crowned with Thorns* is derived "from the *Belvedere Torso*."[90] As there are only a certain number of ways of depicting a horse seen from the back or a standing man, and we are unsure that Caravaggio saw the works that historians claim as influences on him, debates about quotations are typically open-ended. Perhaps *The Resurrection of Lazarus* quotes from D'Arpino, but the mere fact that Caravaggio spoke of D'Arpino with admiration at a trial gives relatively weak support to that claim. Similarly, even if a Giulio Romano engraving shows a visually similar figure, why would Caravaggio choose to quote it?[91] Charles Scribner argues that *The Supper at Emmaus* quotes an early Christian sarcophagus, Marco d'Oggione's *Salvatore Mundi*, and the Christ in Michelangelo's *Last Judgment* but not, as another scholar claims, Michelangelo's *Bacchus*.[92] As the seicento accounts support neither view,

87. Friedlaender, *Caravaggio Studies*, 88.

88. Hibbard, *Caravaggio*, 90; Schneider, "Donatello," 85.

89. Detlef Heikmap, "La Medusa del Caravaggio e l'armatura delo Scià 'Abbâs di Persia'," *Paragone* 199 (1966): 68.

90. Friedlaender, *Caravaggio Studies*, 19; Gregori in Gregori et al., *Age*, 288.

91. Richard E. Spear, "The 'Raising of Lazarus': Caravaggio and the Sixteenth-Century Tradition," *Gazette des beaux-arts*, 6th ser. 200 (1965): 65–66; Moir, *Caravaggio*, 156.

92. Scribner, "*In Alia Effigie*," 380–81.

however, only debate among modern scholars can determine whether Scribner's interpretation is reasonable.

If there is any seemingly certain fact about Caravaggio, it is that he was a violent man, the records of whose court appearances have survived. "As in his art, so in his private life he was singular and unapproachable, violently tempered and of gloomy mood, suffering, proud and from conflict deeply embittered."[93] How could a man "so very rebellious and uncontrolled in his private life . . . [have] produced thoughtful and innovative paintings"?[94] But was he exceptionally rebellious? Perhaps "there is little reason to proclaim Caravaggio an exceptionally violent and uninhibited artist." Even the facts are unclear. Friedlaender's claim that his acts of violence all occurred when he was nearly thirty or older is contradicted by Bellori, whose as yet unsubstantiated report says that the young Caravaggio "got into trouble and had to leave Milan."[95]

Connections between the violence in Caravaggio's life and that depicted in his art are even more difficult to establish. Perhaps the resurrection of Lazarus had personal meaning for him, but that subject was a natural commission from his patrons, the Lazzari family.[96] The Beheading of Saint John the Baptist (Fig. 8) has written in blood "f/Michelan . . . ," which could mean either "Fra Michel Angelo," signifying that Caravaggio "was already a Knight of Malta," or "done by Caravaggio," suggesting that he thought of himself as "in some way responsible for the murder."[97]

Theories of Art

One reason for the thinness of the seicento accounts is that Caravaggio arrived in Rome at a time when artists had lost interest in theorizing.

93. John Gash, "American Baroque," Art History 8 (1985): 253; Alois Riegl, Die Entstehung der Barockkunst in Rom (Vienna, 1923), 192. See also Wittkower, Art, 53–54; Hibbard, Caravaggio, 85.

94. Hibbard, Caravaggio, 194.

95. Rudolf and Margot Wittkower, Born under Saturn (New York, 1969), 195; Friedlaender, Caravaggio Studies, 119; Moir, Caravaggio, ii.

96. Gregori, in Gregori et al., Age, 338.

97. Hibbard, Caravaggio, 171; Gash, Caravaggio, 97. On 18 November 1604, Caravaggio got into trouble because he said to a policeman, "Ti ho in culo"; are these words revealing about his sexuality? See Banks's discussion in The Caravaggio Obsession.

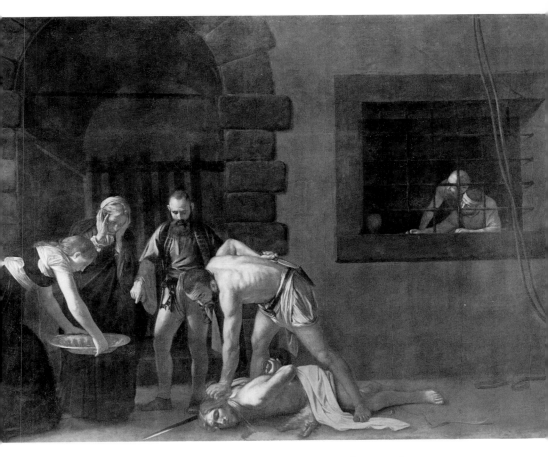

Fig. 8. Caravaggio, *The Beheading of Saint John the Baptist*, La Valletta (Malta), Cathedral of St. John (photo: Alinari/Art Resource, New York)

Vasari's notion "that art progressed by means of the solution of one quasi-technical problem after another [eventually produced] the feeling . . . that painting had got into a blind alley."[98] The story of art after Michelangelo had to be told "either in terms of decline and corruption or in terms of some new miraculous rescue"; thus "Caravaggio was naturally cast in the role of the seducer and the Carracci as the restorer of the

98. Mahon, "Some Aspects," 41.

arts."[99] If nobody described his *tenebroso* in Wittkower's terms—"light isolates; it creates neither spaces nor atmosphere"—that is because such a description does not readily fit into this historical model.[100]

Caravaggio's site-specific effects analyzed by Steinberg raise similar problems. The "brutal foreshortenings" in the Cerasi Chapel, Steinberg argues, are due "wholly to our standpoint and distance. . . . The irreverence implied in the forced distortion of sainted figures vanishes as soon as we consent to keep the altar at a decorous distance."[101] Bellori indicates one simple reason he did not respond to such effects in the Contarelli Chapel: "The darkness . . . makes it difficult to see the pictures."[102] But perhaps Steinberg's sensitivity to site-specific effects depends upon his experience of late modernism. Do we now see Caravaggio's paintings better than his contemporaries saw them, or do we only see them differently? Perhaps these are not genuine alternatives.

These modern interpretations reveal the art historians' reliance upon humanism as described in a justly renowned essay by Panofsky: "The humanist . . . has to engage in a mental process of a synthetic and subjective character . . . mentally to re-enact the actions and to recreate the creations . . . reproducing and thereby quite literally realizing."[103] Thus, "those who wish to look below the surface of |a painter's| art and discover its secret sources, must do their best to penetrate his intentions and read his thoughts while pondering on his acts."[104] Humanists invoke

99. E. H. Gombrich, *Norm and Form* (London, 1966), 101.

100. Wittkower, *Art*, 54.

101. Steinberg, "Observations," 186–88. Perhaps there is some vague anticipation of this analysis in Bellori's remark that Caravaggio called the color blue "poison"; "what he needed were colours and colour-relations which would pull his figures and objects forward toward the spectator" (quoted in Friedlaender, *Caravaggio Studies*, 16). Marangoni noted in 1922 that the oblique composition in the Cerasi Chapel was obtained by "a kind of circular bond of the horse and rider, reversed by the light which gives the illusion of the depth by the placement of the two figures on two diagonals" (quoted in Joffroy, *Le dossier*, 164). See also T. H. Fokker, *Roman Baroque Art: The History of a Style* (Oxford, 1938), 103: "The natural world draws its emphatic limits so closely around the looming horse and the awe-struck man that it brings the supernatural world uncomfortably near." Fokker does not identify what interests Steinberg, "the projected illusion . . . of a painted figure invading our own ambience, painted space overflowing into, offering to envelop, the area of our motor experience."

102. Quoted in Friedlaender, *Caravaggio Studies*, 249.

103. Erwin Panofsky, *Meaning in the Visual Arts* (Garden City, N.Y., 1955), 14. Thus Fry praises an artwriter who "does not merely see what there is in a work of art, but . . . knows what mental conditions in the artist's mind are implied by that configuration" (Fry, *Transformations*, 121).

104. Hinks, *Caravaggio*, 86.

a Cartesian argument. Mental states are private, known directly only by the person who experiences them. There is only a difference of degree between inferring from his facial expression that my friend feels pain and re-creating Caravaggio's inner states by studying his art. The re-creation of Caravaggio's mental states aims to be unambiguous. He was either homosexual or not, either a believer or not, although in practice the incompleteness of the evidence means that we can never be sure which.

Humanism is rejected by various recent philosophers. If "interpretation is nothing more . . . than the activity by which we attempt to construe something as an action," then Caravaggio as artwriters describe him is "not an historical person whose states of mind" we can "hope or even want to recapture": "There is no single best narrative. . . . What is best is always determined in light of different background assumptions, interests, and values; and none of these can make an exclusive claim to being perfectly and objectively valid."[105] When Caravaggio's actual birthdate was discovered and the archival evidence about the Contarelli Chapel found, every earlier account had to be revised. He was not as precocious as had been believed. But in accounts of his psychology, possible political sympathies, religious beliefs, and visual quotations, appeals to the facts are less decisive. For the humanist, the artist's life contains "a principle of unity," and his life is expressed in his art, so that "any unevenness of production is ascribed to changes caused by evolution, maturation, or outside influence. . . . Governing this function is the belief that there must be . . . a point where contradictions are resolved."[106] If Caravaggio's early "homoerotic" works seem inconsistent with his late religious pieces, that change must be explained by some change in his beliefs.

Humanist narrators occasionally reveal themselves by glossing over facts or contradicting themselves in the course of trying to achieve a consistent narrative. According to Sandrart, when D'Arpino refused to duel Caravaggio because the latter was not a knight, Caravaggio went to Malta to become one and returned in haste "to settle his score with Arpino," a haste that produced "a high fever," the cause of his premature

105. Alexander Nehamas, "What an Author Is," *Journal of Philosophy* 83 (1986): 685–91, and *Nietzsche* (Cambridge, 1985), 27, 100.

106. Michel Foucault, *Language, Counter-Memory, Practice*, ed. D. F. Bouchard (Ithaca, 1977), 128. One art historian who has developed this argument is Rosalind Krauss; see her *Passages in Modern Sculpture* (New York, 1977), 256, and *The Originality of the Avant-Garde and Other Modernist Myths* (Cambridge, 1985), 25.

death.[107] Knowing that Caravaggio became a knight in Malta and died of fever, but not the details of his troubles on that island or his later work in Sicily and Naples, Sandrart constructs a seemingly plausible narrative from incomplete data.

Hibbard's much more accurate book suggests that "the report of Caravaggio's Roman crime alone might have been the cause of his downfall, since men convicted of homicide were not allowed to become Knights of St John."[108] But Caravaggio was never convicted of homicide. Bellori says that he escaped alone from Malta, an account contradicted by one modern historian, who says that "the knights helped him to escape from this impregnable fortress in order to avoid the embarrassment of having to punish ... so famous a painter."[109] Here the seicento account is overruled because it seems implausible.

Peter Watson's popular novel employs the humanist's procedures in a more literal way, re-creating the artist's thoughts just before he was beaten in Naples: "Caravaggio ... was sitting at a table drinking. ... It was a warm, sticky evening. ... The white, somewhat sour Neapolitan wine had brought a beaded ring of sweat to his hairline."[110] All these imagined details make the scene seem real. Bellori says only that Caravaggio "found himself surrounded by several armed men who manhandled him and gashed his face."[111] Watson suggests that Caravaggio was on the run from the Roman police, the Maltese Knights, and the friends of Runuccio Tammassoni, whom he had killed in Rome. The Knights might have sought revenge, particularly if they had not helped him escape from Malta. But the Roman police are Watson's invention, as is the suggestion that Tommassoni's friends sought revenge by inflicting a gash akin to "the fatal one [Caravaggio] inflicted on Tammassoni."

Sandrart, Hibbard, and Watson all tie together the details of Caravaggio's life, providing as many connections as possible between the painter's life and his art. For the humanist, the multiplicity of plausible interpretations ought to be positively dismaying: as only one account

107. Quoted in Hibbard, *Caravaggio*, 379.
108. Hibbard, *Caravaggio*, 235.
109. Gash, *Caravaggio*, 27. Since escape was difficult, "everything points to one explanation: connivance ... at the highest level." According to John Azzopardi, *The Church of Saint John in Valletta* (Malta, 1978), 24, Wignacourt himself "provided rope, boat and passport."
110. Peter Watson, *The Caravaggio Conspiracy* (Garden City, N.Y., 1984), 110.
111. Quoted in Friedlaender, *Caravaggio Studies*, 251.

can correctly re-create the artist's mental states, there can be only one true interpretation. But once we reject humanism, we can recognize that a plurality of plausible and original interpretations, all true to the facts, are possible.

If the seicento commentators and modern artwriters describe Caravaggio differently, who is right? There are two possible answers to this question. As the tools of the modern artwriter were unavailable in Caravaggio's time, perhaps our Caravaggio is an altogether different figure from Bellori's. Maybe Winckelmann's theory of classical art, Kantian aesthetics, novelists' discovery of the inner monologue, the birth of the museum, the use of photographic reproductions, and the professionalization of art history are necessary preconditions for interpreting Caravaggio as we do. But perhaps when properly interpreted the older texts are as sophisticated as the modern accounts. Jacques Derrida's essay "Plato's Pharmacy" may help explain what Poussin meant when he claimed that Caravaggio was destroying painting: "The origin of difference and division, the *pharmakos* represents evil both introverted and projected. Beneficial insofar as he cures . . . harmful insofar as he incarnates the powers of evil."[112] The trouble with perfect imitations is that "the imitator would |then| become another being no longer referring to the imitated"; in language closer to Bellori's, a perfect image would not be an artwork.

Here, as in the previous chapter, how we understand the relation between early and modern artwriting depends upon our interpretation of the early accounts. Once we admit that such texts, like novels or philosophical treatises, can be variously interpreted, then this point becomes obvious. The humanist's attempt to present a uniquely correct re-creation of the artist's mental states is futile because artwriting itself is a form of representation. The previous chapter described the interpretation of individual works of an artist whose life we know very little about. The present chapter has discussed the interpretation of an artist whose art can be linked to his life because we have some knowledge of his personality. A third way to interpret is to compare and contrast artworks by different artists within a tradition. The next chapter takes up such a case.

112. Jacques Derrida, *Dissemination*, trans. B. Johnson (Chicago, 1981), 133. See also Louis Marin, *Détruire la peinture* (Paris, 1977), 141. For the traditional view of the relation between Poussin and Caravaggio, see René Julian, "Poussin et la Caravaggisme," in *Nicolas Poussin*, ed. A. Chastel (Paris, 1960), 225–31.

4

Allegory in Flemish Art: Comparative Interpretations of Jan van Eyck and Robert Campin

• • •

This chapter considers the interpretation of two Flemish paintings, one by Jan van Eyck and the other by Robert Campin. As in the previous two chapters, I begin with the older interpretations. For Ruskin, van Eyck's *Arnolfini Marriage* (Fig. 9) is a marvelous example of the "ingenuity of the inventor of oil painting, eminently remarkable for reality of substance, vacuity of space and vigor of quiet colour . . . exhibiting, even in its quaint and minute treatment, conquest over many of the difficulties which the boldest practice of art involves."[1] The inscription, "Johannes de Eyck fuit hic, 1434," can be translated, as Charles Eastlake noted, "This man was here." Maybe "the portraits are of van Eyck and his wife," though they do

1. *The Works of John Ruskin*, ed. E. T. Cook and A. Wedderburn (London, 1909), 12:256.

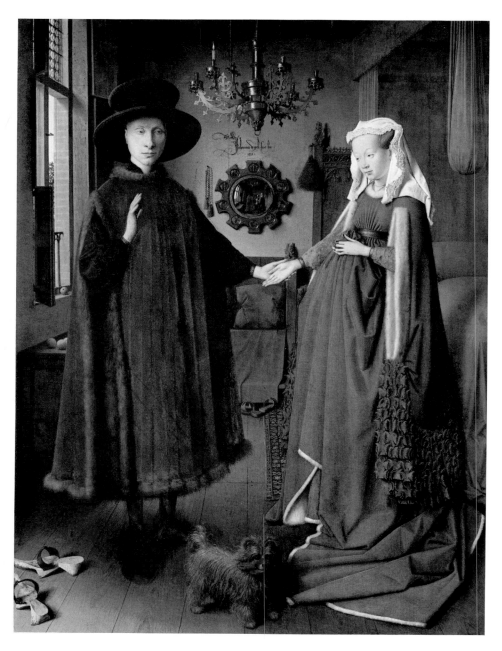

Fig. 9. Jan van Eyck, *The Arnolfini Marriage*, London, National Gallery (photo: National Gallery)

not resemble other images of them.[2] In 1872, Crowe and Cavalcaselle praise the sense of depth and atmosphere: van Eyck "nowhere blended colours more carefully, nowhere produced more transparent shadows."[3] As late as 1921, the work is treated as a masterpiece of naturalism:

> As for Arnolfini . . . the Lord deliver us from being caught as debtors to the like of him.

> 'Jan van Eyck was here.' Only a moment ago, one might think. The sound of his voice still seems to linger in the silence of this room. . . . That serene twilight hour of an age . . . suddenly reveals itself here.[4]

It is possible to find early anticipations of an iconographic analysis of the work. In 1902 Warburg briefly discussed the inscription on the far wall: "Jan van Eyck is placed in this room; as if the painter wants to say: 'draw back so to better be able to consent to give visual testimony to this domestic intimacy.' "[5] And Hegel, who did not usually interpret individual pictures, suggests in a general way that Flemish painting is not naturalistic: "Many artists have proceeded to introduce symbolic features. . . . For example . . . we often see Christ lying . . . under a dilapidated roof . . . and, round about, the ruins of an ancient building, while in the background is the beginning of a cathedral."[6] Friedländer both summarizes the tradi-

2. Charles L. Eastlake, *Methods and Materials of Painting of the Great Schools and Masters* (1847; repr. New York, 1960), 185. Compare two earlier accounts cited in W. H. James Weale, *The Van Eycks and Their Art* (London, 1912), 118: "The man is trying to read in the lines of the lady's outstretched hand the future of the babe"(1853); "The man . . . is solemnly holding up his right hand to attest . . . that the child whose birth the lady is evidently expecting is his"(1855).

3. J. A. Crowe and G. B. Cavalcaselle, *The Early Flemish Painters* (London, 1872), 101.

4. Martin Conway, *The Van Eycks and Their Followers* (London, 1921), 68; J. Huizinga, *The Waning of the Middle Ages*, trans. F. Hopman (London, 1927), 237. My source for many of these references is Martin Davies, *Early Netherlandish School* (London, 1945), 39. Though more detailed, these comments do not differ in kind from the remarks of a quattrocentro commentator, who praised one Flemish picture for lacking "only a voice" and said of another van Eyck: "Nothing is more wonderful . . . than the mirror painted in the picture, in which you see whatever is represented as in a real mirror" (quoted in Michael Baxandall, "Bartholomeus Facius on Painting," *Journal of the Warburg and Courtault Institutes* 27 [1964]: 102.

5. Aby Warburg, *La rinascita del paganesimo antico*, trans. E. Cantimori (Florence, 1980), 152. And Weale noted the six-armed chandelier with one candle burning, the armchair with the depiction of Saint Margaret, and the reflections of two people in the mirror (Weale, *Van Eycks*, 112).

6. *Hegel's Aesthetics*, trans. T. M. Knox (Oxford, 1975), 2:861, 883.

tional view that van Eyck is a great naturalist, offering us "a kind of snapshot, giving an event—the betrothal—in a certain place at a certain hour," and hints at a very different view of the picture: "The most trifling things are depicted with grave and inward-looking scruple, investing them with the value and meaning of ritual objects."[7]

Given this tradition, Panofsky's famous 1934 essay marks a sea-change in interpretive style. Pointing to problems earlier artwriters had only hinted at, he offers the interpretation that later interpreters debate and amend. As the *Arnolfini Marriage* is "a 'pictorial marriage certificate,' the question arises whether this marvellous interior . . . is still rooted to some extent in the medieval tendency of investing visible objects with an allegorical or symbolic meaning."[8] Panofsky refers to the dog, "here indubitably used as a symbol of marital faith"; the burning candle, which stands for "the all seeing wisdom of God"; the "fruit on the window sill," which reminds us of our innocence before the Fall; and the discarded shoes at the lower left, an allusion to God's command to Moses on Mount Sinai, showing that the setting is sacred.[9]

Once given, such an allegorical interpretation is readily supplemented. The mirror can have other meanings. "Van Eyck superimposes here on the sacrament of marriage the idea of redemption. . . . the little convex mirror is a symbol of the terrestrial world."[10] It can also symbolize the Virgin "and at the same time, through the reflection appearing in it, [be] a model of painting as a perfect image of the visible world."[11] It may "introduce into the world of God a painted world which would be an infinitesimal reflection of its proportions."[12] But its function could be more mundane: "The convex diminishing mirror is there in order that the whole of the room may be seen. . . . Convex mirrors are always round, for which reason the roundness in this case is not to be interpreted as a symbol of the world."[13]

One seemingly small detail in Panofsky's account has been much

7. M. J. Friedländer, *Early Netherlandish Painting* (Leiden, 1967), 1:41.

8. Erwin Panofsky, "Jan van Eyck's 'Arnolfini' Portrait," repr. in *Modern Perspectives in Western Art History*, ed. W. E. Kleinbauer (New York, 1971), 198–201.

9. Erwin Panofsky, *Early Netherlandish Painting* (New York, 1971), 203.

10. Charles de Tolnay, *Le maître de Flémalle et les frères van Eyck* (Brussels, 1939), 33.

11. Heinrich Schwartz, "The Mirror in Art," *Art Quarterly* 15 (1952): 100.

12. Henri Focillon, *The Art of the West in the Middle Ages* (London, 1965), 2:169.

13. Ludwig Baldass, *Jan van Eyck* (London, 1952), 75; see also Elisabeth Dhanens, *Van Eyck* (New York, n.d. [after 1977]), 203.

debated. Panofsky writes: "van Eyck took the liberty of joining the right hand of the bride with the left of the bridegroom, contrary to ritual and contrary, also, to all the other representations of a marriage ceremony."[14] Subtle deviations from perfect naturalism indicate that this seemingly naturalistic scene is full of symbols. One candle is lit in the chandelier, in daytime. But why is the bride's right hand held in the groom's left? Panofsky says that this "is an anomaly often found in English art with which Jan van Eyck was demonstrably familiar." Just as Piero's political allegories may be explained by postulating suitable journeys by Byzantine diplomats, so we may imagine that van Eyck saw these works when sent to England on a secret mission.[15]

But perhaps this is "a morganatic, i.e. left-handed marriage," in which "while the bride as usual offers her right hand, the groom now takes it in his left."[16] If correct, this claim would force us to abandon the traditional identification of the sitters. In response, a defender of Panofsky has argued that as morganatic marriages were not performed in the Arnolfinis' homeland, a symbolic reading of the gesture of the groom's right hand, which seems "expressive of the sacred commitment of the matrimonial vow," is more apt.[17] We are caught here between "a literal [that is, realistic] reading" in which van Eyck depicts a morganatic marriage and Panofsky's claim that the gesture is to be "attributed to artistic [that is, symbolic] license."[18]

14. Panofsky, " 'Arnolfini' Portrait," 199.

15. Panofsky, *Early Netherlandish Painting*, 439. The account to which Panofsky refers to support his claim, however, argues that "the right hand of Arnolfini is raised not so much in a gesture of prayer, as Panofsky thinks, but of speaking.... The intimacy of the ceremony is thus enhanced.... It is the anticipation of action, rather than the action, which commands attention" (Helen Rosenau, "Some English Influences on Jan van Eyck," *Apollo* 38 [1942]: 126).

16. Peter H. Schabacker, "*De Matrimonio ad Morganaticam Contracto:* Jan van Eyck's 'Arnolfini' *Portrait Reconsidered*," Art Quarterly 35 (1972): 377.

17. Julius S. Held, *Rubens and His Circle* (Princeton, 1982), 56–57.

18. Craig Harbison, "Realism and Symbolism in Early Flemish Painting," *Art Bulletin* 61 (1984): 602. In arguing that "the mirror establishes the sacramental connection between Passion and marriage while pointing to the latter's anagogical value as it leads the soul upward toward the final purifying marriage in heaven," Roger Baldwin offers a still more elaborate allegorical reading; see his "Marriage as Sacramental Reflection of the Passion: The Mirror in Jan van Eyck's *Arnolfini Wedding*," *Oud Holland* 98 (1984): 67. Friedländer anticipated the distinction between realistic and symbolic readings: "Arnolfini is ... reaching out to her with his hand, against which she shyly and reluctantly lays her own. His other hand is raised in an 'eloquent' gesture.... the master's instinct for uncovering the hidden is wisely tempered" (Friedländer, *Early Netherlandish Painting*, 41). The history of interpretation of the painting is summarized in this text, which views Arnolfini's one hand naturalistically while attributing to the other a symbolic role.

No clear evidence from van Eyck's time directly supports either view. Panofsky's interpretation was highly successful because it is visually convincing, explaining otherwise inexplicable details in the work. Gombrich questions the validity of such explanations. If there is "no medieval or Renaissance text which applied this doctrine [that pictures may have symbolic meaning] to works of pictorial art," is Panofsky's interpretation justifiable?[19] This objection is tricky to evaluate. The original frame, now stolen, of another van Eyck contained the words:

> As the sunbeam through the glass
> Passeth but not staineth
> Thus, the Virgin, as she was,
> Virgin still remaineth.[20]

It would be remarkable if the artist did not apply those words to his images. What Gombrich means, I believe, is that though medieval and Renaissance texts compare light passing through a window to the Virgin's conception of Christ, none says that Flemish painters depicted such scenes. Perhaps Gombrich's test here is too strict. If "religious pictures do embody things as symbol," he argues, then "the symbol functions as a metaphor which only acquires its specific meaning in a given context. The picture has not several meanings but one." This begs the question. What justifies speaking of symbolic *and* literal meanings in the *Arnolfini Marriage* is that the dog symbolizes fidelity and the fruit innocence.[21]

How may such an allegorical reading be justified? It is helpful to consider another example, Meyer Schapiro's skillfully motivated account of Robert Campin's Mérode Altarpiece (Fig. 10). Here mice are caught in Joseph's trap, as the devil, Augustine wrote, is trapped by the cross. The "tiny naked . . . child bearing the cross" emphasizes that here "metaphor and reality are condensed in a single object." The quaint late medieval

19. E. H. Gombrich, *Symbolic Images* (London, 1972), 15–16.

20. Millard Meiss, *The Painter's Choice* (New York, 1976), 10–11.

21. "St Anne stand[s] for the Church that does not want to have the passion prevented" (quoted in Gombrich, *Symbolic Images*, 16). Gombrich's argument is that we have only one meaning here because the painting "had never been conceived as a realistic representation." But how can he then distinguish realistic and allegorical scenes? Gombrich elsewhere takes Giotto's *Mourning of Christ* to be a realistic scene: "We seem to witness the real event as if enacted on a stage" (E. H. Gombrich, *The Story of Art* [London, 1966], 147).

legend that Joseph helped deceive the devil, preventing him from recognizing Christ's divine paternity, fits with this analysis, as does the sexual symbolism of the mousetraps, candles, lilies, windows, and fireplace: "they are drawn together in our minds as symbols of the masculine and feminine." As mice were thought to be lascivious, seeing "the mousetrap of Joseph as an instrument of latent sexual meaning ... is therefore hardly arbitrary." That trap, "a female object," is also "the means of destroying sexual temptation."[22]

Like Panofsky's account of the van Eyck, Schapiro's account of the Campin alterpiece inaugurates a tradition that accepts his basic interpretation while taking issue with details. Where Schapiro sees Joseph making a bait box, a marine equivalent to the mousetrap, Panofsky saw the board on which Joseph is working as "the perforated cover of a footstand intended to hold a warming pan," and another historian sees Joseph making spike blocks for Christ to drag on the ground as he carries the cross.[23] Bait box; warming pan; spike block; each of these objects can be related to the life of the Virgin, Joseph, or Christ. Given the difficulty of producing a certain identification of the object, it is predictable that once Schapiro offered his allegorical reading, other interpreters would follow. Concluding that Joseph's board is just an ordinary carpenter's board would now be as disappointing as deciding that the egg shape in Piero's Brera Altarpiece is merely decorative.

22. Meyer Schapiro, " 'Muscipula Diaboli': The Symbolism of the Mérode Altarpiece," repr. in his *Late Antique, Early Christian and Medieval Art* (New York, 1979), 1–11.

23. Panofsky, *Early Netherlandish Painting*, 164; Margaret Freeman, "The Iconography of the Merode Altarpiece," *Bulletin of the Metropolitan Museum of Art* 16 (1957): 138; Irving Zupnik, "The Mystery of the Mérode Mousetrap," *Burlington Magazine* 108 (1966): 130, an account defended in Gösta Berg, "Medieval Mouse Traps," *Studia Ethnographica Upsoliensia* 26 (1969): 7–8. All these interpretations, in turn, have been questioned. A warming pan cannot be made of wood, a combustible material; it is "far-fetched" to imagine Joseph preparing "instruments of torture for his son"; and Schapiro's account does not adequately link the object to the mousetrap. The holes Joseph drills would, if fitted with pieces of the nearby dowel, make a maze to lure mice. But many pieces of the trap are not depicted; not only must Joseph add another plank, he must also build ends and sides for the trap. Another historian sees a different "devil-deceiving ... device," a version of the fire screen in the central panel; a "holder of the rods" of Mary's suitors, with the dowel being Joseph's rod; and "the centerboard of the strainer of a small winepress" (William S. Heckscher, "The Annunciation of the Merode Altarpiece: An Iconographic Study," in *Miscellanea Jozef Duverger* [Ghent, 1968], 48; see also Mojmir S. Frinta, *The Genius of Robert Campin* [Mouton, 1966], 20; Charles I. Minott, "The Theme of the Mérode Altarpiece," *Art Bulletin* 51 [1969]: 267–68; and Marilyn A. Lavin, "The Mystic Winepress in the Mérode Altarpiece," in *Studies in Late Medieval and Renaissance Painting in Honor of Millard Meiss* [New York, 1977], 298).

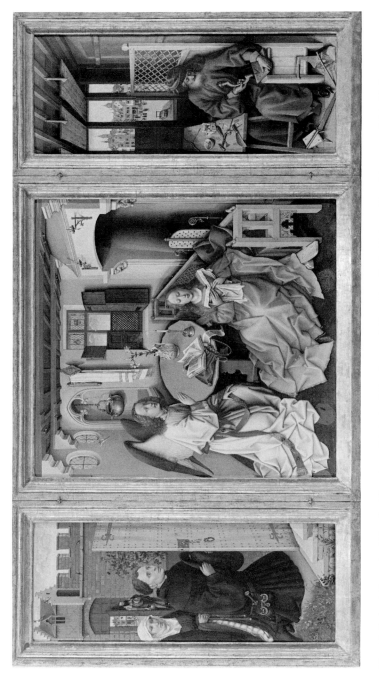

Fig. 10. Robert Campin. Mérode Altarpiece. Triptych of the Annunciation. New York, Metropolitan Museum of Art, Cloisters Collection (photo: Metropolitan Museum)

To note how this iconographic puzzle, like those considered in the previous two chapters, seems to lead to open-ended debate is not to suggest that all purported solutions to it are equally good. Focusing not on the mousetrap but on the ax, saw, and rod beneath Joseph's feet, Charles Minott draws attention to a text in Isaiah sufficiently obscure to require quotation: "Shall the ax boast itself against him that heweth therewith? or shall the saw magnify itself against him that shaketh it? as if the rod should shake itself against them that lift it up, or as the staff should lift up itself as if it were no wood."[24] This leads to an account of the mousetrap via another text: "The proud have hid a snare for me, and cords; they have spread a net by the wayside; they have set gins for me" (Psalm 140:5). Minott's narrative, less skillful than Schapiro's, brings out the problems inherent in any such account. Just as Schapiro begins with the mousetrap, so Minott starts with the ax, saw, and rod; just as Schapiro weaves together Christian and psychoanalytic texts, so Minott links Isaiah and Psalm 140. Minott's account is comparatively weak because it refers to obscure texts whose connection with the painting is not self-evident. But given that Scripture somewhere contains references to most of the objects depicted by Campin, how can we compare these interpretations? As "there is no known reference, either scriptural or exegetical, that links St Joseph specifically to this unusual carpenter's product," the mousetrap, how can we validate Schapiro's interpretation?[25]

That interpretation falls into two parts. Augustine's text was influential, and a contemporary writer described "the fishhook and bait," related to the bait box. Schapiro's links between mousetraps, the devil, Joseph the deceiver, and lascivious mice depend upon Christian traditions the painter might have known. By contrast, his psychoanalytic observations, Schapiro says, need no such support. "We lack . . . all knowledge of the life history of both the artist and the donor . . . but the process of symbolization is a general one." This symbolism "is not consciously hidden by the artist . . . but was implicit for him and contemporary spectator . . . in the objects in question because a certain allegorical meaning was traditionally associated with them."[26]

Just as Clark's Pateresque description of Piero and Hibbard's account

24. Minott, "Theme," 267.
25. Zupnik, "Mystery," 126.
26. Schapiro, " 'Muscipula Diaboli,' " 1–11.

of Caravaggio's castration anxiety are dated, so too now is this account in which pointed and hollow things are "symbols of the masculine and feminine." Where Schapiro finds a happy bourgeois household, the surrealists—some of whom he knew personally—might have differently described the continent Joseph who, separated from his virgin wife, drills holes in a shop filled with instruments that bore, cut, slice, and pierce. "The different layers of meaning sustain each other," as Schapiro says, only when we follow his selective psychoanalytic account of the evidence. Schapiro's strategies differ from Panofsky's in some important ways. Because van Eyck's inscription, which is discussed by earlier interpreters, demands explanation, once we recognize the difficulty of identifying the figures it is easy to believe that only an allegorical interpretation can provide a consistent analysis. By contrast, the Mérode Altarpiece mousetrap is not obviously puzzling, and so the break between Schapiro's account and the descriptions of the earlier interpreters is more dramatic. The earlier interpreters do not anticipate Schapiro's allegorical account: "[The artist] outdoes himself in representing everything with the utmost realism. . . . He revels in depicting still life elements and becomes almost obtrusive in his naturalism. All the details are 'genre,' with an almost imperceptible flavour of the comic about them."[27]

Panofsky's and Schapiro's accounts place these two Flemish works in different art-historical contexts. For Panofsky, in Flemish art "medieval and modern realism are so perfectly reconciled that the former has become inherent in the latter." According to Schapiro, that realism involves a secularizing tendency, making painting "a vehicle of personal life and hence of unconscious demands."[28] Where Panofsky finds a perfect harmony, Schapiro sees a "combat" between religion and "the new secular values." In the *Arnolfini Marriage* religious images are literally placed in "a marginal position . . . a secondary reality forming a border around the reflecting glass." For Panofsky, "reality itself" gives "rise to a flow of preternatural associations"; for Schapiro, "the development of realism . . . the imagining of the world for its own sake, as a beautiful fascinating spectacle" is one step toward secular art. Schapiro can view Campin's mousetraps as forerunners of Bosch's instruments, which more openly manifest the conflict between religion and secularism. In his *Early Nether-*

27. Friedländer, *Early Netherlandish Painting*, 11–37; Huizinga, *Waning*, 279.
28. Panofsky, *Early Netherlandish Painting*, 201; Schapiro, " 'Muscipula Diaboli,' " 9.

landish Painting, Panofsky identifies Bosch as beyond "the scope of this volume . . . [and] also . . . beyond the capacity of its author."[29]

Schapiro, a friend of the abstract expressionists, writes of Cézanne's "conception of a personal art [that] rested upon a more general ideal of individual liberty."[30] Panofsky was unenthusiastic about modernism. For Schapiro, Campin's altarpiece marks one step toward the secular art of Cézanne and de Kooning; for Panofsky, van Eyck achieves a synthesis seemingly unattainable for a modern painter. Although these observations help us understand why the interpretations of Schapiro and Panofsky differ, they do not tell us how to choose between them. Nor do they permit us to characterize one or the other interpretation as subjective, for what historical perspective gives an "objective" view of Flemish art? The very notion of "an objective viewpoint" here is highly complex.[31] Every artwriter who discusses Flemish art must adopt some larger perspective, whether she is a specialist who knows nothing of modernism or someone whose interests are as wide-ranging as Schapiro's.

The same is true of writers on Piero or Caravaggio, but whereas those writers are guided by what is known of the former's interest in perspective and the seicento commentary on the latter, the analysis of Flemish art cannot draw on such materials. Allegorical readings are most naturally introduced by indicating problems with viewing a picture as a purely naturalistic image. Why one burning candle in a sunlit interior? Why seven beams of light passing through a window? Six or eight might occur in a naturalistic image, but seven is a magic number.[32] Why does van Eyck show an unreasonably large Madonna in a church?[33] Just as we explain word slips, the life of exotic peoples, and "crazy" behavior by attributing to agents beliefs that rationalize their behavior, we make sense of such apparent deviations from naturalism in the work of skilled artists by assuming that the images are intended to be allegorical.[34] But

29. Panofsky, *Early Netherlandish Painting*, 357.
30. Meyer Schapiro, *Cézanne* (New York, 1952), 30.
31. See Michael Podro, *The Critical Historians of Art* (New Haven, 1982), 181.
32. Meiss, *Painter's Choice*, 8.
33. Panofsky, *Early Netherlandish Painting*, 145.
34. If someone says "mother" instead of "mistress"; if a tribe tells us that hyenas are Orthodox Christians, and so fast on feast days; if a man asserts that he is the reincarnation of Plato, then we attribute to these people further beliefs that, by our lights, make sense of their statements. See *Rationality and Relativism*, ed. M. Hollis and S. Lukes (Cambridge, 1982), and Donald Davidson, *Inquiries into Truth and Interpretation* (Oxford, 1984).

in the first case, we need not suppose that the people in question would accept, or even recognize, our interpretations. When we analyze Flemish allegories, however, our interpretations are subject to a further apparent constraint: we aim to interpret the artist's image as he intended it to be seen.

Panofsky's procedure involves a possible paradox, which he states in a passage that fails to acknowledge its full implications. A van Eyck "possibly meant to express an allegorical meaning" can, nevertheless, appear perfectly naturalistic.[35] But if the naturalism is perfect, then how can we know that the image is allegorical? In the case of word slips, the life of exotic peoples, or "crazy" behavior, the very fact that such behavior is confused, by our lights, is what causes us to seek a rationalizing explanation. If someone's behavior is rational by our lights, we need not seek to explain it in this way. Writers who draw a parallel between the allegorists' passion for details and the behavior of the obsessional neurotic correctly note that an erudite art historian can find textual evidence somewhere in Scripture or commentary on it to support the claim that any depicted object is a symbol.[36] Perhaps it is wrong to think that this is a problem. If Flemish artists believed that God manifests himself everywhere, then why should they not put sacred symbols everywhere in their pictures? But the problem for the artwriter is interpreting such pictures. If every picture element can have such a meaning, then where will the analysis stop? And how can we know that any given interpretation is not arbitrary?

Julius Held worried that "with every object potentially a carrier of concealed meaning . . . some trigger-happy iconologists may take this as an invitation to shoot from the hip." The motto for *Early Netherlandish Painting*, he suggested, should be "There is . . . no other answer to this problem . . . than the use of historical methods tempered . . . by common sense."[37] But when the standards of interpretation have changed, what is "common sense"? Crowe and Cavalcaselle would be as astonished by Panofsky's interpretation of the *Arnolfini Marriage* as they would by Lavin's account of Piero, or Posner's view of Caravaggio. Because the consensus

35. Panofsky, " 'Arnolfini' Portrait," 201.

36. Craig Owens, "The Allegorical Impulse: Toward a Theory of Postmodernism," *October* 12 (1980): 72; Angus Fletcher, *Allegory: The Theory of a Symbolic Mode* (Ithaca, 1964), 6.

37. Julius S. Held, review of Panofsky, *Early Netherlandish Painting*, Art Bulletin 37 (1955): 213.

changes with the times, we cannot justify or criticize present-day interpretations by appeal to an ahistorical notion of common sense.[38]

Another approach is more promising. Panofsky's and Schapiro's accounts may have seemed eccentric when first published, but they offered more fruitful directions for research than earlier accounts of Flemish art. Though their interpretations also had problems, it seemed possible that they would be solved with further research. Panofsky and Schapiro had no direct evidence from the time of van Eyck and Campin to support their interpretations. Today, however, most artwriters would accept the general claim that Flemish painting is allegorical, for a long tradition of such interpretations has made such accounts seem convincing.

Biblical exegesis offers a parallel.[39] "The Jews then said to him, 'You are not yet fifty years old, and you have seen Abraham?' Jesus said to them, 'Truly, truly, I say to you, before Abraham was, I am' " (John 8:57–58). Christian readers of this passage recall Exodus 3:14, 'And God said unto Moses, I AM THAT I AM.'[40] This passage, not "of the slightest interest or importance to any of the great rabbinical commentators," became important when Christians sought to reduce "the Hebrew Bible to that captive work, The Old Testament." A rabbi found Jesus' words nonsensical, arguing commonsensically that "there can be no father and son in the Divinity. . . . a father precedes a son in time." A theologian replied: "The Jews remain caught in the trammels of their own thought. . . . They cannot understand, because the notion of the Revealer's 'pre-existence' can only be understood in faith."

Christians believe that the New Testament fulfills the Old; and as these are complex texts and finding links between them is not hard, they inevitably do match one text with the other. Jews do not share that belief, and so point to the problems in matching texts. Believe that the New

38. Such genuinely eccentric accounts as Maurice W. Brockwell's *Pseudo-Arnolfini Portrait* (London, 1952), which claims that Panofsky confused the *Arnolfini Portrait* with another picture, or Zdzistaw Kepiński's essay " 'Arnolfini Couple,' or John and Margaret van Eyck as 'David and Bathsheba' " (*Rocznik historii sztuki* 10 [1974]: 149–64) receive the kind of reception that Shakespearians give to books proclaiming the Baconian theory.

39. Here I borrow from Frank Kermode, *The Genesis of Secrecy: On the Interpretation of Narrative* (Cambridge, 1979).

40. Or in Harold Bloom's preferred translation: "I will be present wherever and whenever I will be present" (Harold Bloom, " 'Before Moses Was, I Am': The Original and Belated Testaments," in *Notebooks in Cultural Analysis*, ed. N. Cantor [Durham, 1984], 5–13.

Testament fulfills the Old, and you will find that it does; reject that belief, and the practice of matching texts seems full of contradictions. What for the rabbis is a paradox—how could Jesus have seen Abraham?—is for Christians a sign that Jews do not know how to interpret. Of course, after studying many cases where it was not possible to find the Old Testament convincingly fulfilled in the New, a Christian might abandon that interpretive strategy. She would have lost her faith. An artwriter who found the problems we have noted with Panofsky's and Schapiro's interpretations sufficiently compelling might seek some other way of analyzing the paintings in question.

Craig Harbison offers a highly ingenious response to this dilemma. He illustrates the contrast between realism and allegory by comparing the work of van Eyck and Campin. Van Eyck manipulates "realistic objects to form religious symbols"; Campin distinguishes between opposites that "van Eyck was intent on blending and at the same time transcending." Just as a structural anthropologist explicates the meaning of ritual by noting how it is performed differently by two neighboring tribes, Harbison interprets Campin and van Eyck in light of the different modes of symbolism they employ:

> Campin seems drawn to a form of symbolism that does not compromise the integrity of the visible world; Van Eyck, on the other hand, attempts to grasp in a single image the way the Spirit . . . penetrates and transforms the world through time.
>
> Van Eyck thus overcomes the split between realism and symbolism which in Campin's works make "the transition from earthly object to sacred symbol . . . distinct and disturbing. . . ."[41]

Panofsky and Schapiro transform the diachronic opposition between earlier naturalistic accounts of Flemish art and their own allegorical interpretations into a synchronic opposition between two kinds of reference present simultaneously in one artwork. Similarly, Harbison contrasts earlier, simpler discussions of visual allegory with his more complex opposition between van Eyck and Campin. "The ways images operate seem much

41. Harbison, "Realism and Symbolism," 591–93.

freer and more suggestive than that indicated by the notion of a work intentionally illustrating an abstruse intellectual speculation."[42]

The problem with allegorical interpretations may seem to be that we are too ignorant of van Eyck's and Campin's artworld to know their intentions. To see why appeal to intentions does not solve the problem, consider two examples of possibly allegorical images from periods closer to the present. According to Ruskin, in Turner's *Apollo and Python* the "dragon was a treasure-guardian. . . . Apollo's contest with him is the strife of purity with pollution; of life, with forgetfulness; of love, with the grave." Scarlet stands for dignity and power; it is "the great sanctifying element of visible beauty inseparably connected with purity and life." But a darker message is present also. A serpent crawls from the dying Python. "Alas, for Turner! This smaller serpent-worm, it seemed, he could not conceive to be slain."[43]

Turner knew Ruskin, dined with him, and read part of *Modern Painters*, so it ought to be possible to have some idea about whether this interpretation captures the artist's intentions. Turner scholars, however, disagree about whether Ruskin's interpretation is correct. Was his account "wholly alien to a man who was a poet in paint," or, rather, is "there . . . little doubt that Turner knew a great deal of mythology and . . . understood it essentially the way his interpreter claimed"?[44] The factual evidence seemingly provides no answer to this question.

Rauschenberg's 1960s collages of old-master images also can be interpreted as allegories. Indeed, one is called *Allegory*. How should we analyze them? If "the utilization of every detail" carries "both formal and

42. Harbison's imaginative procedure might be compared to Paul de Man's account of literary allegory, in which, since "it is impossible to decide by grammatical or other linguistic devices which of the two meanings . . . prevails . . . [t]his choice can be made only if one postulates the possibility of distinguishing the literal from the figural." (Paul de Man, *Allegories of Reading* [New Haven, 1979], 10, 201.

43. John Ruskin, *Modern Painters* (Boston, n.d.), 5:405.

44. Joan Evans, quoted in George P. Landow, *The Aesthetic and Critical Theories of John Ruskin* (Princeton, 1971), 433, 436–37; see also Jack Lindsay, *Turner* (London, 1973), 285, and Elizabeth K. Helsinger, *Ruskin and the Art of the Beholder* (Cambridge, 1982), 254: for Ruskin, "what counts . . . is not the illumination of a particular picture . . . but our understanding of the image . . . whose meanings are greater than and independent of any particular picture . . . in which they occur." Such a view of artwriting does not encourage close analysis of individual pictures. Here, as we have seen with Panofsky and Schapiro, an artwriter's larger concerns influence his approach to individual pictures.

thematic significance within the work," then we can read *Female Figure* (*Blueprint*), made by placing the model on photographic paper, as "a witty example of those reclining females so dear to the Romantic tradition," see the rooster in *Odalisk* as "a parody of Ingres's *Grande Odalisque*," and note that in *Rebus* the wings in "the photograph of the flying insect . . . rhyme with those of the wind deities in the neighboring Botticelli."[45] If we believe, however, that such interpretations involve "only the blind application of traditional art-historian methodologies to contemporary art," then we may think it "difficult, if not impossible" to discover in Rauschenberg's works "any common property that might coherently link these things."[46] We could, of course, question Rauschenberg. But as it is also claimed that he misunderstood his own work, nothing he says will convince some artwriters. Whether we see beneath the apparent randomness of his collages a meaningful order or, alternatively, view his work as a statement about the impossibility of achieving order depends upon our larger view of contemporary art.[47]

Attention to such modern allegories may influence how we understand Flemish art. Postmodernists reject the view that visual artifacts differ in kind from texts. Allegory privileges texts over pictures, contrasting the immediate presence and unity of the image with the opposed properties of a system of texts.[48] The traditional ideal of the artwork as an organic unity, a self-sufficient whole with nothing missing or superfluous, is superseded. Now the artwork becomes a rebus, in which we can identify the whole only by replacing "each separate element by a syllable or word that can be represented by that element in some way or other. The words . . . may form a poetical phrase of the greatest beauty and significance."[49]

But does not this postmodernist view of art also change how we think of Panofsky's account of van Eyck's allegories? Panofsky found charm in these paintings in which "the spectator is not irritated by a mass of complicated hieroglyphs," implying that our awareness of the picture elements as symbols is overruled by our perception of the images as

45. Charles F. Stuckey, "Reading Rauschenberg," *Art in America* 65 (1977): 74–84.

46. Douglas Crimp, "On the Museum's Ruins," *October* 13 (1980): 68.

47. Those artwriters interested in "the end of art" conclude that, whatever Rauschenberg himself says, the former interpretation is more plausible. For discussion, see my *Artwriting* (Amherst, 1987), chap. 4.

48. See the discussion in Fletcher, *Allegory*.

49. *The Complete Psychological Works of Sigmund Freud*, ed. J. Strachey (London, 1955), 4:277.

naturalistic compositions.[50] But as a reviewer of *Early Netherlandish Painting* asked, is "the alleged sophisticated planning of complex allegories producing in the picture a strew-pattern of allusive detail . . . really consistent with the stilled life of Jan van Eyck's world?"[51] What gives such a painting its *apparent* unity is its presentation of a seemingly consistent space. Although the aim of an allegorical interpretation is to fit each individual symbol together with the others, the result is to turn the work into a rebus whose significance is apparent only when the visual scene is linked with many texts and images. A formalist would seek to isolate the individual work, explicating its "meaning" without describing its "content"; the iconographer recognizes that only by relating the work to the culture in which it was created can we understand its unity of form and content. Van Eyck's *Arnolfini Marriage* is comprehensible only in relation to documentation of marriage customs and a tradition of portraiture, and Campin's Mérode Altarpiece is understandable only when interpreted in light of both Christian and psychoanalytic views of symbolism. The seemingly self-sufficient picture is meaningful only in relation to a larger interpretive context.

The more an art historian reads and the more visual references she gathers, the more elaborate her interpretations become. Once we abandon humanism and cease to think that the goal of interpretation is to recover the unique original meaning of a work, we will view interpretation differently. Interpretation is an open-ended process; the successors of Panofsky and Schapiro can treat every object as "potentially a carrier of concealed meaning." This is fortunate, however, for it means that future art historians have much to do. They will find other plausible contexts in which to place artworks, their ability to construct interpretations being limited only by their ingenuity. Just as Panofsky's and Schapiro's accounts reflect their different estimates not only of Flemish art but also of modernism, so future interpretations may—if more art historians take an interest in contemporary art—be influenced by the postmodernist revival of allegory in the 1980s.[52]

50. Panofsky, " 'Arnolfini' Portrait," 201.

51. Otto Pächt, "Panofsky's 'Early Netherlandish Painting'—II," *Burlington Magazine* 98 (1956): 276.

52. One such approach, I predict, will question the idea that Flemish art reveals its "deep" meaning behind its surfaces. What makes such accounts seductive is the belief that hidden meanings are "deeper" than those that appear merely on the surface. Recent studies of Titian

The act of constructing a verbal representation is most effectively performed by an artwriter who is self-consciously aware of the ultimate arbitrariness of any particular boundaries to the context in which she places the artwork. To understand Panofsky's interpretation of the *Arnolfini Marriage*, we must know something of his view of Bosch and his defense of humanism; to grasp the full significance of Schapiro's interpretation of the Mérode Altarpiece, we must recall his *Cézanne*, his interest in psychoanalysis, and his relation to the surrealists. The most conservative analysis differs from the most speculative account only in choosing narrower limits to define its context. Harbison's analysis of Flemish allegory makes this point (which was merely implicit in the working procedures of Panofsky and Schapiro) explicit, underlining the fact that interpretation may best proceed by comparing and contrasting the work of two different artists. By thus undercutting the humanists' preoccupation with re-creating the career of the individual artist, artwriters become aware that they creatively describe the artworks they interpret.[53]

I have spoken repeatedly of artwriting as a form of representation. But how, exactly, does an artwriter's text verbally represent a visual artifact? Part Two turns to this question.

and seventeenth-century Dutch art offer one precedent for an argument that is sure to be developed in some future account of Flemish art. (Models are provided by Charles Hope, *Titian* [New York, 1980], and "Artists, Patrons, and Advisors in the Italian Renaissance," in *Patronage in the Renaissance*, ed. G. Lytle and S. Orgel [Princeton, 1981], 293–343; and Svetlana Alpers, *The Art of Describing* [Chicago, 1983].) Once we give up the belief that allegorical readings reveal deep truths, once we question Panofsky's vision of humanism and Schapiro's magnificent but dated view of psychoanalysis, the suggestion that van Eyck and Campin were "just" superb naturalists may seem interesting again. But when that happens, it is also possible to predict, we will not simply return to the pre-Panofskian era of interpretation; for us, the "discovery" that Flemish art is an art of naturalism will involve a rejection of the complex tradition of allegorical interpretation.

53. To these interpretations I am now prepared to add a modest example of my own. Alerted by Panofsky's account of the one lit candle in the *Arnolfini Marriage* and Heckscher's discussion of the smoldering candle in the Mérode Altarpiece, we may ask what other candles we can find in Campin's painting. There are two candleholders above the fireplace, though only the one on the Virgin's right holds a candle. Given the equation of left with evil, the absence of a candle in the holder on the Virgin's left appears meaningful; that side of the fireplace is the one closer to the place where Joseph labors making traps. This interpretation, admittedly, is insufficiently motivated; I lack an apt text. But once attention is called to the empty candleholder, it is both surprising to discover that it has not been discussed earlier and hard to believe that the lack of a candle is merely an accident.

PART TWO

. . .

The History of Art History

5

Ekphrasis and Interpretation:
The Creation of
Modern Art History

. . .

How does Vasari's account of an artwork differ from interpretations of the same painting by modern art historians? "And as he journeyed, he came near Damascus: and suddenly there shined round about him a light from heaven: And he fell to the earth, and heard a voice saying unto him, Saul, Saul why persecutest me?" (Acts 9:3–4). Michelangelo depicts this scene in his *Conversion of Saint Paul* (Fig. 11). Vasari retells the story in his *ekphrasis*: "Paul in fear and amazement [is] fallen from his horse. . . . surrounded by the soldiers engaged in lifting him, while others flee in varied and beautiful attitudes, terrified by the voice and glory of Christ, and a fleeing horse drags along the man who is seeking to retain it."[1]

1. Giorgio Vasari, *The Lives*, trans. A. B. Hinds (London 1963), 4:144.

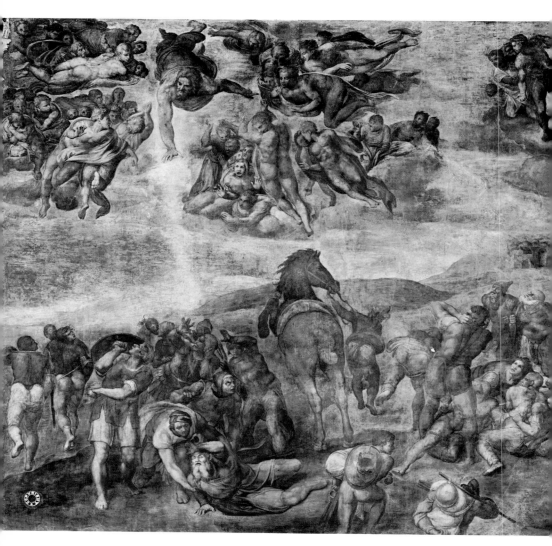

Fig. 11. Michelangelo, *The Conversion of Saint Paul*, Rome, Vatican, Cappella Paolina
(photo: Alinari/Art Resource, New York)

An *ekphrasis* is a verbal re-creation of a story depicted in a painting. Vasari's text differs from Acts, which says nothing about the horse, the soldiers, and Paul's position. His *ekphrasis* is highly selective both in the details it mentions and in the use it makes of those details. Vasari retells the story without saying much about the composition of the painting. He tells us nothing about where Paul is placed in relation to his horse, or where the soldiers stand in relation to Paul. Had the painting been destroyed, Vasari's text alone would hardly permit us to imagine the spatial relations of Michelangelo's figures.

Wölfflin says much more about how the picture is put together: "Michelangelo put his horse immediately beside Paul, but moving in the sharpest possible contrast of direction, and into the picture. The whole of this group is pushed unsymmetrically over to the left side and the one great line which descends steeply from the figure of Christ is flattened out and continued over to the other side."[2] He goes on to compare this image to Raphael's picture of this scene. Freedberg adds a further observation: "Even the angels who attend Christ are untouched by grace and the human actors are explicitly unbeautiful . . . as if their heavy bodies had been flung into their attitudes of fear or flight and they were incapable of any other motion by exercise of will."[3] Such interpretations extend or take issue with earlier accounts.

Once we have read an *ekphrasis* of Michelangelo's painting, we know what scene is depicted in the picture. Although more details could be added, further detail is unnecessary if the aim is merely to identify the story. By contrast, because an interpretation does more than tell the story, one interpretation almost inevitably calls for another. Freedberg refers to interpretations by Wölfflin and other writers, and adds original observations. A student writing her thesis on the painting could identify details not discussed by earlier writers or compare this painting with other pictures. As the painting contains many figures, and deals with an often depicted scene, such interpretation is likely to be an open-ended process.

Another way to differentiate *ekphrases* and interpretations is to contrast Vasari's institutional role with that of modern art historians. An *ekphrasis* conjures up an image of a painting in a text without illustrations. Rich in

2. Heinrich Wölfflin, *Classical Art*, trans. P. and L. Murray (London, 1952), 201.
3. S. J. Freedberg, *Painting in Italy 1500–1600* (Harmondsworth, 1970), 326–27.

anecdotes, Vasari's book contains no footnotes, references to earlier accounts of the paintings, or systematic analysis of style. Present-day interpretations appear in illustrated texts that refer to a long sequence of earlier interpretations. A new interpretation will be reviewed by rival experts, who, if they find it interesting, will refer to it in turn. Vasari was a painter who wrote his marvelous *Lives* while practicing his profession. He had no immediate successors.[4] Some important nineteenth-century artwriters—Crowe and Cavalcaselle, Giovanni Morelli, William Hazlitt— also were amateurs, but by Wölfflin's time the writing of serious art history had become an academic activity. Present-day art historians are engaged in training graduate students, and so their work involves passing on teachable skills to the next generation of interpreters, who will in turn find new ways of reinterpreting familiar works.

An *ekphasis* can, I grant, be considered a kind of interpretation. The difference between an *ekphrasis* and an interpretation could be judged a matter of degree. For present purposes, however, I prefer to emphasize the differences between these two modes of artwriting.[5] I want to focus on the ways in which an interpretation, unlike an *ekphrasis*, is intended to be debatable. Consider, for example, the criticism by Gombrich of Steinberg's interpretation of the Michelangelo described by Vasari.

An interpretation, Steinberg asserts, must be "probable if not provable"; it should make "visible what had not previously been apparent"; and it should be sufficiently convincing "that the picture seems to confess itself and the interpreter disappears." According to his interpretation, *The Conversion of Saint Paul* is intended both "to convey . . . the inward experience—the actual conversion" and to indicate what will happen to Saul after he becomes Paul. Steinberg draws attention to two hitherto unobserved details that, if he is correct, change the way we see the entire

4. See Denis Mahon, *Studies in Seicento Art and Theory* (London, 1947).

5. In thus contrasting *ekphrases* and interpretations, I am deliberately marking a difference in kind where another historian of artwriting might find instead a difference of degree. *Ekphrases* have been much discussed recently. See Svetlana Alpers, "Ekphrasis and Aesthetic Attitudes in Vasari's Lives," *Journal of the Warburg and Courtauld Institutes* 23 (1960): 190–215; Henry Maguire, "Byzantine Descriptions of Works of Art," *Dumbarton Oaks Papers* 28 (1974): 113–40, and *Art and Eloquence in Byzantium* (Princeton, 1981); John R. Spencer, "Ut Rhetorica Pictura: A Study in Quattrocento Theory of Painting," *Journal of the Warburg and Courtauld Institutes* 20 (1957): 26–44; J. J. Pollitt, *The Ancient View of Greek Art: Criticism, History, and Terminology* (New Haven, 1974); E. R. Curtius, *European Literature and the Latin Middle Ages*, trans. W. Trask (New York, 1952), 436–38; and Michael Baxandall, *Giotto and the Orators* (Oxford, 1971).

painting. Saint Paul's right leg, like Christ's left hand, points toward Damascus, while Christ's right hand projects a line through the apostle to the viewer below. We as viewers are thus involved in "a system of five interconnected points" occupied by Christ, Paul, Damascus, the two soldiers at the bottom, and ourselves. The soldiers "complete a commanding pattern that runs from Christ through the Apostle to the spectator's position . . . and hence, in line with their march, to their goal on the horizon," Damascus. Within the painting, Paul and the man opposite him are positioned like the reclining river gods arranged on the Capitoline Hill so that they "constituted a worthy counterpart to the Vatican—the two hills together symbolizing Rome in her secular and ecclesiastical primacy." That visual quotation brings the viewer into the work, providing "a visual parallel by which to make present to the beholder, along with the moment of Paul's vocation, an image of the political heart of Rome."[6]

It is easy to see that these claims are controversial. The lines going from Christ's right hand through Paul to the spectator and from Christ's left hand to Damascus run through many other figures; and there are other lines—for example, the one from Christ's body through the horse to the soldiers—that play no role in Steinberg's interpretation. The topological allusion too is controversial. Even if we accept the claim that Michelangelo quotes the Roman river gods, why should we also conclude that he intends to refer to the city in which they are located? Gombrich criticizes both claims. Neither Paul's calf nor his foot points toward Damascus. In any case, why should Paul's body point toward that city "since he was headed there anyway?" Gombrich also objects to the claim that the painting contains a visual quotation. As "one can hardly lie on the ground with the upper part of the body raised without remotely echoing this pose," why assume that Michelangelo intended his figures to refer specifically to the river gods?[7] As we saw in the discussion of Caravaggio, claims that one work is intended to refer to another are always vulnerable to the counterargument that as there are only so many ways of depicting a figure in a given position, the visual parallel may be merely coincidental. Unless we have some direct record of the artist's intention to refer to an earlier artwork, it may be more plausible to conclude that the visual similarity of two works is simply accidental.

6. Leo Steinberg, *Michelangelo's Last Paintings* (New York, 1975), 6, 22, 28, 29, 37.
7. E. H. Gombrich, "Talking of Michelangelo," *New York Review of Books*, 20 January 1977, 17–20.

Gombrich's analysis illustrates how interpretations often lead to fur-
ther debate, for he makes one error. Finding the idea that Paul quotes
the river god implausible, Gombrich asserts that Steinberg "retracts" this
parallel later in the book when "he rightly calls the comparison . . . 'unpro-
ductive.' " In fact, what Steinberg says is: "The comparisons are unproduc-
tive *if they stop at the similarities.*"[8] Steinberg does not retract the earlier
comparison, but elaborates it: Paul's pose both quotes the river god and
defines his place in the line running from Christ's right hand to the
spectator. If the parallel with the river god is dropped, Gombrich asks,
"what becomes of the Roman Capitol re-enacted or evoked somewhere
onto the road to Damascus?" Steinberg's answer, I believe, is that Michel-
angelo refers both to Damascus, Paul's intermediate destination, and to
the saint's ultimate destination, Rome.

Gombrich's general objection to Steinberg's analysis is that it anachro-
nistically treats Michelangelo like "artists of our own time whose cre-
ations may indeed resemble dreams where personal and public mean-
ings interpenetrate."[9] Steinberg acknowledges that he is "perpetually in
danger of projecting my contemporary artistic experience upon the
past. . . . But there is another way of putting the matter. If there ever were
earlier artists who conceived multi-storied symbolic forms, then ours is
the generation equipped to detect it."[10]

Both historians agree that Steinberg's account is influenced by mod-
ern art. Gombrich concludes that Steinberg therefore overinterprets. If
cinquecento artworks were thus composed, why does Vasari "never refer
to any work of art . . . in which the postures and actions of figures in a
story are so cunningly devised that they also convey a topological allu-
sion?"[11] Gombrich assumes both that Vasari himself was capable of cor-
rectly describing his friend's painting and that Renaissance artwriters
had the skills needed to verbally represent artworks of their time. Both of
these claims may be questioned. Gombrich admits that "Vasari missed

8. Steinberg, *Michelangelo's Last Paintings,* 38 (italics added).
9. See Gombrich, "Talking of Michelangelo," 19, and, for his more general view of psychoana-
lytic criticism, "Freud's Aesthetics," *Encounter* 26 (1966): 30–40. Gombrich seems to refer to
surrealism, but as Steinberg's key point is that Michelangelo's composition contains an implicit
reference to the spectator, a better way of making this point would be to say that Steinberg has
been influenced by minimalist art of the 1960s.
10. Leo Steinberg, *Other Criteria* (New York, 1972), 320.
11. Gombrich, "Talking of Michelangelo," 19.

certain things and was altogether not a very profound man."[12] Steinberg says that Vasari lacked "the conceptual equipment and the will to articulate this special dimension of Michelangelo's power."[13] Maybe no art writer of his time was capable of correctly interpreting Renaissance art.

Perhaps Renaissance pictures were more advanced than Renaissance artwriting. There is no reason to conclude a priori that Vasari's texts provide an adequate account of Michelangelo's painting. After all, Giotto had no Vasari to comment on his work, and Alberti's quattrocento treatise says nothing about his contemporary, Masaccio. It was left to later artwriters to provide an adequate description of those painters' work.[14] Vasari's great achievement was to invent a new literary genre. Michelangelo's painting could build on a long tradition; Vasari's artwriting could not, and so he may have lacked the verbal skills needed to represent his friend's painting adequately. Here I return to a point made in Part One. The texts of earlier artwriters are important sources for modern art historians, but as they may have regarded paintings differently than we do, it can be misleading to treat them as fully sharing our view of artworks.

Gombrich's suggestion that Vasari is our best guide to Renaissance art raises complex problems. Vasari saw the colors of Paul's clothing. Did he, like Steinberg, see them as arousing "an intuition of meaning"?[15] He knew Raphael's version of the same scene. Did he, like Wölfflin, compare that version to Michelangelo's? He said that some of Pontormo's figures were not in proper High Renaissance style. Did he, like Freedberg, think of Michelangelo's figures too as unbeautiful? He sometimes identifies pictorial quotations. Did he see Michelangelo's figures as referring to the statues of the river gods? We know only what Vasari wrote, not what he saw. That he elsewhere compares compositions, calls figures unbeautiful, and identifies quotations does not tell us whether he saw the same qualities in Michelangelo's painting but said nothing about them or did

12. Compare Johannes Wilde's view that "Michelangelo thoroughly disagreed with the contents of [Vasari's] book as far as his own affairs were concerned" (Johannes Wilde, *Michelangelo* [Oxford, 1978], 8).

13. Leo Steinberg, "The Line of Fate in Michelangelo's Painting," in *The Language of Images*, ed. W.J.T. Mitchell (Chicago, 1980), 125–26.

14. "Our own disappointment with the humanists' remarks about art, our sense of their inadequacy as a contemporary account of Giotto and Masaccio, is of course unhistorical; it is not difficult to regain perspective by reminding oneself of the function of humanist discourse" (Baxandall, *Giotto and the Orators*, 111).

15. Steinberg, *Michelangelo's Last Painting*, 39.

not recognize those features of that painting. Ironically, Gombrich's argument is itself subject to the very objection he makes against Steinberg. Complaining that Steinberg's interpretation "centres emphatically on the event on earth," Gombrich notes that the angels above "are only perfunctorily described"; but "it is unlikely that Michelangelo wishes . . . to subordinate his vision of heaven to the drama on earth."[16] This is a good observation, but as it is not based on anything Vasari says, here Gombrich, though in a more modest way than Steinberg, engages in speculation too.

 None of these questions, I emphasize, can be raised by an *ekphrasis*, which, unless it tells the wrong story, is uncontroversial, incapable of inspiring such an ongoing debate. Vasari's account of *The Conversion of Saint Paul* prompts no debate. Steinberg's interpretation does, for he both raises questions that demand further discussion and induces us to read earlier interpretations differently. Johannes Wilde said that the image appears to extend "beyond the limits of the picture space . . . symbols of the force that draws . . . the worshipper towards the spiritual centre of the interior, the altar."[17] Now we may see Wilde as anticipating Steinberg's view of the spectator. As Gombrich notes, once an imaginative interpretation such as Steinberg's is proposed, even readers who reject it are forced to respond. Gombrich's defense of Vasari's account requires, perhaps paradoxically, more sophisticated theorizing than we would readily attribute to that Renaissance writer. But although Steinberg does get us to see the picture in new ways, his interpretation does not necessarily contradict earlier accounts. As we will see in later chapters, it is often difficult to determine exactly when different interpretations are in conflict. Wölfflin's account of the composition of Michelangelo's painting and Freedberg's remarks about the unbeautiful actors are not obviously inconsistent with Steinberg's interpretation, though certainly each artwriter induces us to see the painting differently.

 The contrast between *ekphrasis* and interpretation introduces ideas that will be developed later in this book. An interpretation, by drawing attention to key details that—like the lines and visual quotations Steinberg discusses—may not have been identified earlier, shows that attending to these picture elements may change our sense of the whole. An

16. Gombrich, "Talking of Michelangelo," 19–20.
17. Wilde, *Michelangelo*, 172.

ekphrasis metaphorically re-creates an image in words; an interpretation employs metonymy, the trope that "assign[s] priority to parts for the ascription of meanings to any putative whole."[18] Vasari's text permits us to imagine viewing the picture. Wölfflin, Freedberg, and Steinberg concentrate our attention on different parts of Michelangelo's painting and invite us to view the whole work in terms of the meaning of those parts.

This contrast between two ways of describing a visual artwork permits us to grasp the difference between Vasari's interests and those of modern art historians. By verbally re-creating a visual work, an *ekphrasis* implies an attitude toward the story told. Quintilian says that "the aim of rhetoric is not simply to give the 'facts' but to imply how those facts are to be understood." Oratory "fails of its full effect . . . if the judge merely feels the facts on which he has to give his decision are being narrated to him, and not displayed in their living truth to the eyes of the mind."[19] Like the rhetorician, Vasari aims to re-present the artwork to the viewer, an important goal when paintings could be reproduced only in engravings and artwriters' texts contained no illustrations. Just as the orator's audience "likes words that set an event before their eyes; for they must see the thing occurring now, not hear of it as in the future,"[20] so Vasari's reader is given a metaphorical equivalent to the absent visual artwork. Vasari's text aims to produce the same effect as the artwork, re-presenting the story itself.[21]

What separates the modern art historian from Vasari is not just her concern with interpretation, but her inability to accept his view that the artwriter's goal is to re-create the scene depicted. The cinquecento artwriter who believes that language can metaphorically re-create the depicted scene and the modern interpreter who thinks that drawing attention to parts can explain the significance of the entire picture have different conceptions of artwriting. And once we have read modern interpretations that seek the meaning of Michelangelo's *Conversion of Saint Paul*, Vasari's concern with retelling the story told in the picture seems much less interesting. Vasari's *ekphrasis* does not encourage that close

18. Hayden White, *Tropics of Discourse: Essays in Cultural Criticism* (Baltimore, 1978), 72–73.
19. Quintilian, *Institutio oratoria*, trans. H. E. Butler (Cambridge, Mass., 1966), 3:245.
20. *The Rhetoric of Aristotle*, trans L. Cooper (Englewood Cliffs, N.J., 1976), 207–8.
21. As Quintilian says, the rhetorician aims to tell the story so vividly that he "seems not so much to narrate as to exhibit the actual scene, while our emotions will be no less actively stirred than if we were present at the actual occurrence" (Quintilian, *Institutio oratoria*, 2:433).

looking which is the goal of the interpreter. The real gap here between the interests of modern and those of Renaissance writers is measured by their employment of different topics of discourse.[22]

Where can we locate this historical break between Vasari's *ekphrases* and the modern interpretations? An *ekphrasis* is concerned with the visual appearance of an artwork; an interpretation aims to reveal its deeper meaning. Hegel, as we have see, seeks such deeper meanings: "We begin with what is immediately presented to us and only then ask its meaning. . . . we assume behind it something inward, a meaning whereby the external appearance is endowed with the spirit."[23] His interpretations of visual artworks are rudimentary, and his terminology (with its reference to spirit) is now outmoded, but when his lectures on aesthetics contrast what is visually present with what lies beneath the surface, we can recognize his kinship with the modern art historians. His un-Vasarian distinction between surface and depth meanings marks him as the ancestor of our artwriters.

Can we find any comparable account in seventeenth-century art writing? Unlike Vasari, the members of the French Academy were loquacious. Le Brun's analysis of Poussin's *Israelites Gathering Manna in the Desert* (Fig. 12) is seventeen pages long. And that analysis, like modern interpretations, became the subject of considerable debate. If we look more closely at Le Brun's account, however, we become conscious of a difference between his concerns and those of modern interpreters.

Poussin himself prepared the way for Le Brun's discussion by providing an *ekphrasis* of his own painting: "I . . . show the misery and hunger to which the Jewish people had been reduced, and also the joy and happiness which came over them, the astonishment which had struck them, and the respect and veneration which they feel for their lawgiver."[24] LeBrun discusses Poussin's visual quotations of antique sculptures and his use of the movements and expressions of the various figures to

22. This is the claim of Michel Foucault, *The Order of Things* (New York, 1970); see also Tzvetan Todorov, *Theories of the Symbol*, trans. C. Porter (Ithaca, 1982), and David E. Wellbery, *Lessing's Laocoon: Semiotics and Aesthetics in the Age of Reason* (Cambridge, 1984), 25: "Beneath the level of what people thought about language an event took place which remade language."

23. Hegel's *Aesthetics*, trans. T. M. Knox (Oxford, 1975), 1:19–20.

24. Quoted in Anthony Blunt, *Nicolas Poussin* (London, 1967), 223. For further discussion of the historical background, see André Fontaine, *Les doctrines d'art en France* (Geneva, 1970); Rensselaer W. Lee, *Ut Pictura Poesis: The Humanistic Theory of Painting* (New York, 1967); and Norman Bryson, *Word and Image* (Cambridge, 1981), chap. 2.

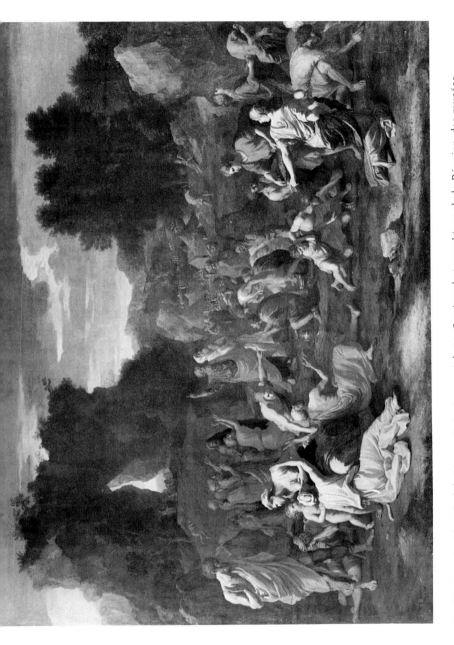

Fig. 12. Poussin, *The Fall of the Manna*, Paris, Louvre (photo: Service photographique de la Réunion des musées nationaux)

express the theme.[25] Poussin was criticized for showing a daytime scene when Exodus says that the manna was already on the ground in the morning and for depicting a young woman suckling her aged mother when Scripture implies that the dinner of the previous night satisfied the people's worst hunger. In his response, Le Brun argues that Poussin nevertheless tells the story successfully. Félibien gives a similar account: "As that painting is admirable for the diversity of his gestures and the force of expression, it is constructed so that all the actions of its figures have particular causes which relate to its principal subject, the fall of the manna."[26]

These texts, which say much about the work without discussing its meaning, are closer to traditional *ekphrases* than to interpretations. At one point, however, Félibien makes a point that approaches the modern art historian's concern with pictorial composition: "The two parts of the painting on the left and right form two groups of figures which leave the middle open and free to view, the better to display Moses and Aaron, who are more distant. The robe of the former is blue, and his mantle red; the latter is dressed in white." Once Félibien asks how the two parts of the picture are linked, he transcends the concerns of *ekphrasis*. This point, however, is not developed.

What is in general striking to the modern reader is what the seventeenth-century writers do *not* say about the meaning of the picture. Manna is a complex substance. The word literally means "what is it?" and "no substance is known that satisfies all the requirements of the old testament references."[27] For Christians, manna is an anticipation of the

25. I use the text reprinted in *Conférences de l'Académie Royale*, ed. Henri Jouin (Paris, 1883), 48–65.

26. I use the text reprinted in Claire Pace, *Felibien's Life of Poussin* (London, 1981), 139, 142. Compare Joshua Reynolds's well-known account of Titian's *Bacchus and Ariadne*: "The figure of Ariadne is separated from the great group, and is dressed in blue, which added to the colour of the sea, makes that quantity of cold colour which Titian thought necessary for the support and brilliancy of the great group. . . . it was necessary to carry some of the mellow colours of the great group into the cold part of the picture, and a part of the cold into the great group; accordingly Titian gave Ariadne a red scarf, and to one of the Bacchante a little blue drapery" (Joshua Reynolds, *Discourses on Art* [New York, 1966], 149–50). Once artwriters begin to study systematically the composition of a picture, clearly the tradition of *ekphrasis* has been left behind; see Thomas Puttfarken, *Roger de Piles' Theory of Art* (New Haven, 1985).

27. *The New Westminster Dictionary of the Bible*, ed. Henry S. Gehman (Philadelphia, 1970), 585. Manna is "a symbol in the pure state, and therefore capable of being charged with any sort of symbolic content whatever" (Claude Lévi-Strauss, quoted in Jacques Derrida, *Writing and Difference*, trans. A. Bass [Chicago, 1978], 290).

Eucharist; according to one Jewish account, the leftover manna "melted and flowed in streams. Animals drank of it, and these were hunted by the other peoples who, eating the flesh, experienced the taste of the manna, and thereby appreciated Israel's distinction."[28]

Modern artwriters naturally ask the meaning of this symbol. One art historian asserts that Poussin's painting is intended to remind us of the Eucharist; another observes that "neither in Poussin's own remarks nor in the commentaries of the French Academy is there any mention that the miracle of manna should be considered a symbol of the Eucharist."[29] Both interpretations are controversial. Only when artwriters turn from composing *ekphrases* to discussing the meaning of pictures does the failure of the seventeenth-century writers to discuss this obvious question seem a striking omission. Although it is possible to retell the story of Poussin's painting in an *ekphrasis* without raising the question of the symbolism of manna, once artwriters interpret his picture, and ask about its meaning, this question seems so inescapable that we are astonished it was not raised earlier.

Unless it simply misidentifies the story told in a picture, an *ekphrasis* cannot be wrong. It is possible to compose another *ekphrasis*, telling the story differently, but as the primary aim of an *ekphrasis* is to identify the story, there is no reason to compose another except as a literary exercise. Vasari wrote before the creation of institutionalized art history. His *Lives* was widely read, without receiving the critical response elicited by modern interpretations. A more elaborate *ekphrasis* may provide more details or describe the same details more eloquently; it does not identify a different story. By contrast, an interesting interpretation aims to be controversial. Steinberg is an important interpreter because his claims are debatable, inspiring further discussion. His account creates a demand for other, equally imaginative accounts. Unless the next generation of artwriters can find new ways of analyzing these pictures, how can the process of interpretation continue? If Steinberg has provided the definitive account, then nothing more can be written about them.

There is, however, at least one possible exception to the generalization

28. *The Soncino Chumash: The Five Books of Moses with Haphtaroth*, ed. A. Cohen (London, 1947), 426.

29. John Rupert Martin, *Baroque* (New York, 1977), 125; Walter Friedlaender, *Nicolas Poussin: A New Approach* (London, 1966), 146. See also Walter Friedlaender, *Nicolas Poussin: Die Entwicklung seiner Kunst* (Munich, 1914), 64.

that an *ekphrasis* cannot be wrong unless it is simply mistaken—namely, a deliberately misleading *ekphrasis*. Even if the example I offer is unique, it tells much about the general relation between *ekphrases* and interpretations. In general, distinguishing deliberate misrepresentations from erroneous accounts requires an explanation of why the writer chose to give a false account. Vasari, a busy man and hasty writer, made many factual errors. If we wish to claim that he deliberately misdescribed a work, we must describe it correctly, demonstrate his errors, and then show that he had reason to lie.

Steinberg argues that Vasari deliberately misidentified one figure in Michelangelo's *Last Judgment* (Fig. 13) and wrote a deliberately misleading *ekphrasis*. Consider first Vasari's less important error: "M. Biagio . . . said it was a disgrace to have put so many nudes into such a place. . . . This angered Michelangelo, and in revenge, as soon as they had gone, he drew M. Biagio from memory, as Minos in Hell."[30] But Biago's visit did not take place, as Vasari says, when Michelangelo was painting Minos.[31] In any case, it is hard to believe that a prominent dignitary would be shown in a chapel in the Vatican with a serpent fondling his penis. Vasari tells a somewhat similar story about the Judas in Leonardo's *Last Supper*; perhaps here he merely repeats such a story, this time doing so to mislead his readers.[32] A contemporary verse specifically indicates that Biagio is shown elsewhere in the picture, at just the place where Michelangelo was working when Biago visited.

Vasari, Steinberg argues, had reason to compose a false *ekphrasis*. He believed that the painting's "very survival would be imperilled if truth were told. . . . It was . . . to protect Michelangelo's fresco . . . that there arose a tradition of interpretation which sought to adjust the work to the orthodoxies of the Council of Trent."[33] The Council of Trent reaffirmed the doctrine that the pains of hell are eternal, and Michelangelo, some of whose closest friends were devout believers who had questioned that view, visually asserts in his *Last Judgment* what had become a heterodox theology. "The intention of Michelangelo's Christ is unknowable"; he is not necessarily damning the sinners. In Michelangelo's picture, the "Vir-

30. Vasari, *Lives*, 4:141–42.

31. Leo Steinberg, "A Corner of the Last Judgement," *Daedalus* 109 (1980): 215, 231, 234.

32. Leo Steinberg, "Michelangelo's Last Judgement as Merciful Heresy," *Art in America* 63 (1975): 50, 61.

33. Steinberg, "Michelangelo's Last Judgement," 50, 52, 53, 56.

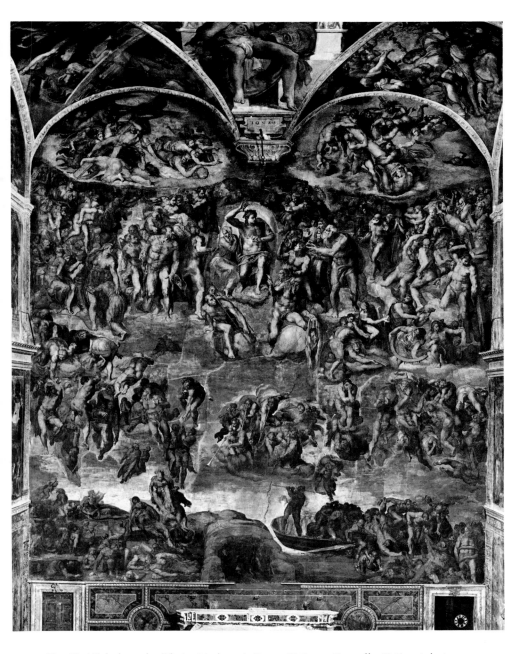

Fig. 13. Michelangelo, *The Last Judgment*, Rome, Vatican, Cappella Sistina (photo: Alinari/Art Resource, New York)

gin is not represented as scared" at the terror of the Last Judgment. The picture shows that "Michelangelo disbelieves in material Hell" and in an everlasting punishment.[34] Steinberg defends these claims in a very detailed analysis. I consider only one part of his argument, his account of the composition.

How can we describe the structure of a visual work with so many figures? This is an important question because how we describe the composition determines our view of its meaning: "Begin by seeing an irascible God, and the Madonna and Saints will be quaking in fear, the Martyrs abetting their Lord by calling for vengeance, the downward trend of the design will predominate, and the whole turn into a *dies irae*."[35] Two plans are suggested by earlier interpreters. Some see a circular composition. Christ's condemnation of the damned sets in motion "a gigantic slow rotation of the wall"; this "grandiose vision of a heliocentric universe" anticipates Copernicus and revives the "astral myths of antiquity," the "slow movement from left to right" expressing "the common destiny of Mankind."[36] Taken literally, Steinberg says, this would imply "that the Saints must soon go to Hell and the wicked rise to the top," which cannot be correct.[37] Wölfflin offers an alternative view: "The main articulations of the picture are the two diagonals which meet in the figure of Christ. The gesture of His hand runs down through the whole picture. . . . This line repeats itself on the other side of the picture."[38] Steinberg develops this view in a much more elaborate account:

> Reading upward from Minos, an oblique axis passes through the flayed skin with Michelangelo's self-portrait to the wound in Christ's side up to the vault of heaven. . . . The great diagonal emerges as a moral-theological vector, discharged from the artist's self-image two ways—its descent charting his consciousness of demerit; its ascent, his Christian hope.

34. Steinberg, "Michelangelo's Last Judgement," 50.
35. Steinberg, "Michelangelo's Last Judgement," 50.
36. Freedberg, *Painting*, 324; Charles de Tolnay, *Michelangelo*, trans. G. Woodhouse (Princeton, 1975), 59–60; Wilde, *Michelangelo*, 164.
37. Steinberg, "Michelangelo's Last Judgement," 49.
38. Wölfflin, *Classical Art*, 199. See David Summers, "Contrapposto: Style and Meaning in Renaissance Art," *Art Bulletin* 59 (1977): 348.

Moving downward from Christ's left hand, a counterdiagonal runs through a figure who lifts two souls by a rosary to end in a death figure, the female counterpart to Minos. "Much ranging and structured attention is needed" to follow this complex analysis in which "neither Christ nor his consort . . . indeed, few of the major figures scattered across this vast surface are to be understood in isolation."[39]

Evaluating this analysis is a task for specialists. What interests me is the response to such an account. Once someone has found a deeply meaningful structure that earlier artwriters did not see, even critics who dismiss the analysis find that they see the picture differently. Studying Steinberg's text, I find myself marking those places where he seems to offer a choice between only two alternatives, his reading and the conclusion that the pattern he has found is meaningless. If we are to identify the pattern Michelangelo created, "there is no alternative" to following these diagonals. "One line wilfully torn from a welter of multidirectional forces" is perhaps meaningful if the alternative is a meaningless composition. When the Virgin places her foot on a grill like that used in the martyrdom of Saint Lawrence and we see a ladder marking the upward path open to sinners, "are we hallucinating?" "Is this a fluke, or is it a thought that relays the pledge of the Madonna della Scala down to the nether regions?"[40] Once Steinberg has called attention to these problems, only an equally imaginative interpretation that accounts for his data can successfully challenge his account.

Interpretation of Scripture involves similar problems. "And a young man followed him, with nothing but a linen cloth about his body; and they seized him, but he left the linen cloth and ran away naked" (Mark 14:51–52). In a modern novel, we might dismiss this seemingly trivial episode as a naturalistic detail. But in a text whose every sentence may have a hidden meaning, once we ask the identity of this man, it is not easy to think that he is unimportant. "Where enigmas are credibly thought to exist in a text, it is virtually impossible to maintain that some parts of it are certainly not enigmatic."[41] The young man is not just a naturalistic figure. Why is he wearing only a flimsy, expensive garment on

39. Steinberg, "A Corner," 238, 240–41.
40. Steinberg, "A Corner," 238, 240, 261.
41. Frank Kermode, *The Genesis of Secrecy: On the Interpretation of Narrative* (Cambridge, 1979), 57.

a cold night? Might he be Mark himself, or the figure who elsewhere appears in such a garment prepared to be baptized?[42] More ingenious interpreters find a reference to Amos 2:16: "And he that is courageous among the mighty shall flee away naked in the day, saith the Lord." The man in the Gospel of Mark does not seem courageous, and it is night. But an ingenious interpreter who believes that the Old and New Testaments are linked might explain away these apparent discrepancies.[43]

Arguing against Steinberg's account of Michelangelo's *Conversion of Saint Paul*, Gombrich cites Vasari's story about Minos as an example of an indisputable documented fact.[44] A critic arguing against Steinberg's interpretation of Michelangelo's *Last Judgment* could cite Vasari's *ekphrasis* as an equally solid piece of evidence. But if Steinberg is correct, then both of these arguments are wrong. Like the letter in Poe's "Purloined Letter," Michelangelo's statement against the principles of the Council of Trent is hidden in the least secret place imaginable. And because Vasari knew as much, Steinberg argues, he chose to misinterpret the work of his friend.[45] Whatever the ultimate verdict on this particular interpretation, Steinberg has demonstrated that in art history there are no unquestionable data, no givens that every interpreter must accept. Even if his account is mistaken, the debate surrounding that account itself shows that we cannot trust Vasari to compose an *ekphrasis* that is not intentionally misleading.

The road from *ekphrasis* to interpretation is a one-way street. Once artwriters turn from creating *ekphrases* to interpreting, it is hard to imagine

42. These alternatives are considered in C. E. B. Cranfield, *The Gospel According to Saint Mark* (Cambridge, 1972), 439, and Vincent Taylor, *The Gospel According to Saint Mark* (London, 1966), 562.

43. In two places Steinberg makes an important observation that is relevant to this New Testament parallel. When we see a puzzling detail, he says, "it becomes our duty . . . to announce . . . what we were the first to see"; thus "logic . . . led Panofsky and Tolnay to see" in Michelangelo's *Last Judgment* "what no one had seen before" (Steinberg, *Other Criteria*, 320), and "Michelangelo's Last Judgement," 49). I originally thought that Steinberg had made a slip here; what he meant, I took it, was that he or Panofsky or Tornay should describe what they were the first observers since the artist to see. I made the same error that earlier in this chapter I accused Gombrich of making in his critique of Steinberg; I assumed that there was some way that the painting really is, and so should be seen, independently of how it is represented in artwriters' texts.

44. Gombrich, "Talking of Michelangelo," 18.

45. This argument, which respects Vasari's intelligence by positing that he misinterpreted the picture because he did understand it, is sympathetically discussed by Francis Haskell, "The Age of Watteau," *New York Review of Books*, December 20, 1984. 25

how that turn could be reversed. Gombrich makes a similar point about visual representations: "One thing would be denied even to the greatest of contemporary artists: he could not make the hobby horse mean to us what it meant to its first creator."[46] The transition he describes from an art of making to an art of making and matching is akin to the transition from composing *ekphrases* to writing interpretations. Just as it is unthinkable that Michelangelo could have come before Giotto, so it is hard to imagine an artworld in which Vasari is Steinberg's successor. In artwriting, as in art, there is what we may call progress.

46. E. H. Gombrich, *Meditations on a Hobby Horse*, (London, 1963), 11.

6

Winckelmann and Pater:
Two Styles of Art-Historical Writing

. . .

Johann Joachim Winckelmann's *Geschichte der Kunst des Altertums* (1764) is a great, relatively little known book. It prompts a seemingly simple question. As Winckelmann "only knew what had already been available for some time—a body of Roman and Greco-Roman antiquities," and as the Roman texts that provided the model for his narrative were familiar, why only at this late date did an artwriter create "a history for Greek and Roman sculpture that had not existed before"?[1] Walter Pa-

1. Alex Potts, "Winckelmann's Construction of History," *Art History* 5 (1982):377. On the differences between Winckelmann and his contemporaries, see Potts, "Winckelmann's Interpretation of the History of Ancient Art in Its Eighteenth Century Context" (Ph.D. dissertation, London, 1978).

ter's well-known "Winckelmann" (1867) prompts an analogous question. As Pater discusses much of the same antique sculpture and Renaissance painting as Winckelmann, and as his account also does not depend upon any new evidence, why at this late date is Winckelmann's work radically reinterpreted?[2]

Earlier I contrasted Vasari's *ekphrases* with the interpretations of modern art historians. Now I wish to locate the origin of interpretation more precisely, developing my claim that artwriting is a verbal representation of visual artifacts. Winckelmann has been called the father of modern art history. Unlike Vasari, he offers a systematic analysis of individual works and a detailed history of the rise, development, and decline of ancient art.[3] Not a dispassionate scholar, he is an intuitive, highly subjective writer, whose often purple prose is unlike a modern scholar's.[4] And while some parts of his book read like modern art history, large chunks of it are devoted to topics such as "geography and climate . . . detailed information about materials and techniques" that are not normally discussed by art historians.[5]

Pater's highly wrought "Winckelmann" has two parts: the story of Winckelmann's life, in which we are told that he is a great writer on antiquity because "he is in touch with it; it penetrates him, and becomes part of his temperament"; and a discussion of the art he admired. That art exhibits "the supreme and colorless abstraction of divine forms." Winckelmann's "conception of art excluded that bolder type . . . which deals confidently and serenely with life, conflict, evil." Ultimately, Winckelmann is most interesting because he inspired a greater man, Goethe, who created in his art both "the blitheness and universality of the antique ideal" and "the fullness of the experience of the modern world." If "a sort of preparation" for this "romantic temper is noticeable

2. The Elgin marbles and other early Greek sculpture had been rediscovered, but they are not of central importance in Pater's account.

3. Hans Robert Jauss, "Geschichte der Kunst und Historie," in *Geschichte, Ereignis und Erzählung,* ed. R. Koselleck and W.-D. Stempol (Munich, 1973), 177.

4. Ingrid Kreuzer, *Studien zu Winckelmanns Ästhetik* (Berlin, 1959), 12, 94; see also Alex Potts, "Political Attitudes and the Rise of Historicism in Art History," *Art History* 1 (1978):193.

5. Potts, "Winckelmann's Construction," 401. Apart from Potts's work, I have also learned from Michael Fried, "Antiquity Now: Reading Winckelmann in Imitation," *October* 37 (1986), and Barbara M. Stafford, "Beauty of the Invisible: Winckelmann and the Aesthetics of Imperceptibility," *Zeitschrift für Kunstgeschichte* 43 (1980):65–78.

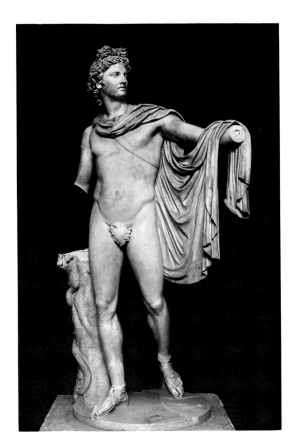

Fig. 14. *Apollo Belvedere*, Rome, Vatican Museum (photo: Alinari/Art Resource, New York)

even within the limits of the Greek ideal itself," this "Winckelmann failed to see."[6]

Pater makes some curious errors. In Greek sculpture, "the hair, so rich a source of expression in painting . . . is withdrawn from attention . . . its texture . . . lost."[7] But Winckelmann says that in the *Apollo Belvedere* (Fig. 14) "the soft hair plays about the divine head as if agitated by a gentle

6. Walter Pater, *The Renaissance: Studies in Art and Poetry*, ed. D. L. Hill (Berkeley and Los Angeles, 1980), 178, 179, 184.

7. Pater, *Renaissance*, 178.

breeze. . . . it seems to be anointed with the oil of the gods, and tied by the Graces with pleasing display on the crown of his head."[8] In Greek sculpture, Pater writes, "the eyes are wide and directionless, not fixing anything with their gaze, nor riveting the brain to any special external object."[9] Apollo, Winckelmann asserts, has pursued and slain the python: "His lofty look, filled with a consciousness of power, seems to rise far above his victory, and to gaze into infinity."[10]

For Pater, who makes a dramatic contrast between Greek sculpture and modern painting, the *Laocoon* (Fig. 15) is a transitional work in which "patient science . . . has triumphed over an almost unmanageable subject . . . in which sculpture has begun to aim at effects legitimate, because delightful, only in painting." For Winckelmann, this is no transitional work but the first of four masterpieces he analyzes in detail. In sculpture, Pater says, "no member of the human form is more significant than the rest": sculpture "unveils man in the repose of his unchanging characteristics . . . reveals . . . the tranquil godship in him, as opposed to the restless accidents of life."[11] Winckelmann, however, provides a detailed inventory of the parts of the *Apollo Belvedere*, and in *Niobe and Daughter* he finds "the daughters . . . represented in that state of indescribable anguish, their senses horror-struck and benumbed, in which all the mental powers are completely overwhelmed and paralyzed by the near approach of inevitable death."[12]

Winckelmann's descriptions employ an opposition between restraint and emotion. The *Laocoon* shows a "man in extreme suffering" who "is striving to collect the conscious strength of his soul to bear it." If his "muscles are swelling and the nerves are straining," yet "determined spirit is visible in the rigid forehead"; and restraint is both present and absent in his chest, which "is distended by the obstructed breath and the suppressed outburst of feeling." His "expression . . . is complaining but not screaming"; the mouth and upper lip show sorrow, "but in the upper lip . . .

8. Johann Winckelmann, *The History of Ancient Art*, trans. G. H. Lodge (Boston, 1880), 2:313. The hair on this statue, Potts has noted, is quite exceptional, which presumably is "why Winckelmann and his contemporaries liked it so much."

.9. Pater, *Renaissance*, 174.

10. Winckelmann, *History*, 2:313. The eyes of this work, Potts has observed, are unusual in being so precisely directed; more characteristically, Winckelmann sees most male nude sculptures as "so self-contained that they do not need to interact with the world outside them."

11. Pater, *Renaissance*, 170, 173.

12. Winckelmann, *History*, 1:361.

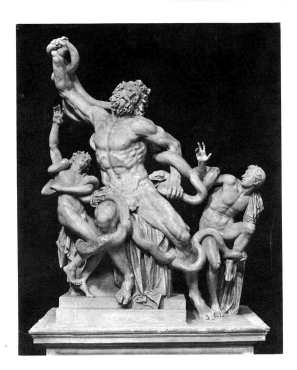

Fig. 15. *Laocoon*, Rome, Vatican Museum (photo: Alinari/Art Resource, New York)

this expression is mingled with pain which . . . rises to the nose, swells it, and manifests itself in the dilated and upward-drawn nostrils." This opposition appears "concentrated in one point below the forehead. . . . whilst the pain elevates the eyebrows, resistance to it presses the fleshy parts above the eyes downward and towards the upper eyelid."[13]

Where Pater finds "tranquil godship," Winckelmann sees a figure in which "no part is in repose," who "wishes to raise his legs, that he may flee from his distress." Only when we follow Winckelmann's account closely do we see how it depends upon a carefully organized narrative in which it seems natural to move from mouth to underlip to upper lip and on to nose and forehead because we expect the sculpture to show the suppression of feeling concentrated in one point.

13. Winckelmann, *History*, 2:230–31.

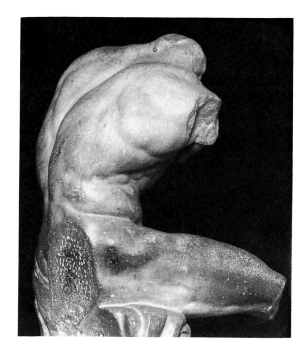

Fig. 16. *Torso Belvedere*,
Rome, Vatican Museum
(photo: Alinari/Art
Resource, New York)

The *Torso Belvedere* (Fig. 16) is a tranquil figure, but here too Winckelmann's narrative develops a system of oppositions. He moves from the arm he imagines to the head that he must also imagine: "His face probably had a pleased expression as he meditated with satisfaction on the great deeds which he had achieved." Then we continue to the bent back, which suggests the "powerfully developed chest . . . against which the giant Geryon was squeezed," and finally to the thighs of the man "who overtook the brazen-footed stag, and travelled through countless lands even to the very confines of the world."[14] Winckelmann here reads downward, that is, because the expressive effect of the whole is exactly the opposite of that of the *Laocoon*. We go from resolution, visible in the face, to the activities performed by the missing organs.

Metonymy, it has been argued, is *the* eighteenth-century trope, which

14. Winckelmann, *History*, 2:264.

was replaced by synecdoche when it became apparent that "the closer
the examination, the greater the number of 'parts' that might be used to
represent the ... whole.... debate is bound to break out over *which* part
is the truly distinguishing aspect of the whole and by reference to which
the nature of the whole ought to be signified."[15] If we reverse the order of
Winckelmann's description of the *Laocoon* and move downward from fore-
head to nose and mouth, then instead of seeing withheld feeling re-
solved above, we see in the forehead emotions openly expressed lower
in the face. If we move upward in the *Torso Belvedere* from torso to back to
head, the figure's repose appears to be undermined by the emphasis
placed upon his imagined deeds. How Winckelmann orders his narrative
determines how he reads expressive details that, viewed in a different
order, would collectively have a different meaning.

These set pieces differ from Vasari's *ekphrases*. Vasari describes Do-
natello's *Judith and Holofernes* tersely, giving only enough details to remind
us of the story. He notes "the external simplicity of Judith in her dress
and aspect ... while the appearance of Holofernes exhibits the effects of
wine and sleep, with death in his cold and drooping limbs."[16] By contrast,
a typical modern account says much more about the sculpture's parts,
mentioning "the pressure of the right foot of Judith on the groin of
Holofernes, the pressure of her left foot on the right wrist of Holofernes,
contorted behind him, the pressure of the two heavy bodies on the
cushion over the triangular base."[17] For Vasari, to indicate a work's sub-
ject usually is already to identify that work's expressive qualities. By
contrast, the subjects of the works Winckelmann analyzes are often diffi-
cult to identify.

Herder's critical commentary on Winckelmann's account of the *Apollo
Belvedere* illustrates how Winckelmann's reading of the expressive quality
of the whole depends upon the order in which the parts are described.
He asks a good question: "Does Apollo return from victory over a python,
as Winckelmann assumes? Does a god, Apollo, thus come back from
victory? ... And from what victory returns Apollo here? From victory over
the little snake.... In short, who doesn't see ... that Apollo doesn't here
return ... but rather goes, striding forward to something he wants to

15. Hayden White, *Tropics of Discourse: Essays in Cultural Criticism* (Baltimore, 1978), 253.
16. Giorgio Vasari, *The Lives*, trans. A. B. Hinds (London, 1963), 1:305.
17. Charles Seymour, Jr., *Sculpture in Italy 1400 to 1500* (Baltimore, 1966), 145.

do?"[18] Lessing discusses this problem: "How do we obtain a clear idea of a thing in space? First we observe its separate parts, then the union of these parts, and finally the whole. Our senses perform these various operations with such amazing rapidity as to make them seem but one."[19] This confidence, which Lessing and Winckelmann share, that we can obtain "an idea of the whole, which is nothing more than the result of the conception of the parts and of their connection with each other," justifies their faith in metonymy.[20] Winckelmann's use of that trope determines how he describes the relation of body parts to the whole, which must be understood as having the properties of its parts: "The ideal is not found in every part of the human figure taken separately, but can be ascribed to it only as a whole; for beauties as great as any of those which art has ever produced can be found singly in nature, but in the entire figure, nature must yield the palm to art."[21]

We may contrast Winckelmann's metonymic focus on parts with Pater's use of synecdoche. In Pater's essay not only individual sculptures but an entire period of art history, and Winckelmann too, become parts in a larger narrative whole that in this Hegelian account includes the art of antiquity, in which "the mind begins and ends with the finite image," medieval painting, which uses color to express "the mystic depth and intricacy of the middle age," and modern romantic art, which commands that "width, variety, delicacy of resources which will enable it to deal with the questions of modern life." Winckelmann's life itself is like an artwork, with "that beauty of living form which regulated Winckelmann's friendships," just as his works "are a life, a living thing," Like a modern romantic work, he possesses "an inexhaustible gift of suggestion."[22]

18. Johann G. Herder, "Denkmal Johann Winckelmann," in *Werke in zwei Bänden* (Munich, 1953), 2:647; my translation has been corrected by Wilfried Sieg.

19. Gotthold E. Lessing, *Laocoon: An Essay upon the Limits of Painting and Poetry*, trans. E. Frothingham (New York, 1957), 102.

20. David E. Wellbery, *Lessing's Laocoon: Semiotics and Aesthetics in the Age of Reason* (Cambridge, 1984), 210.

21. Winckelmann, *History*, 1:315, 318. Then, more eccentrically, Winckelmann adds that in representing eunuchs and hermaphrodites, art may surpass nature, expressing "in the mixed nature of the two sexes an image of higher beauty." As Lady Townshend observed of a hermaphrodite, it was "the only happy couple she ever saw" (quoted in Francis Haskell and Nicholas Penny, *Taste and the Antique: The Lure of Classical Sculpture 1500–1900* [New Haven, 1982], 235. So natural is it for Winckelmann to focus on the parts of the whole that he describes the beauty of the "private parts": "the left testicle is always the larger," in art "as it is in nature" (Winckelmann, *History*, 1:406).

22. Pater, *Renaissance*, 141, 153, 155, 164, 184.

If the problem inherent in metonymy is that focus on parts makes the unity of the whole difficult to grasp, the difficulty with synecdoche is that parts lose their independence in the whole. Synecdoche does not encourage close focus on the individual work, as Pater's most famous set piece, his account of the *Mona Lisa*, demonstrates. Pater does, I grant, mention the head and the eyelids, which "are a little weary"; the rocks on which the woman sits; her hands; and of course "the unfathomable smile."[23] But the general effect of his description of the image first as a condensed image synthesizing all of Leonardo's interests and then as a symbol of modern romantic art is to draw our attention away from the individual artifact.

Panofsky's close look at the *Arnolfini Marriage* and Schapiro's attention to fine details in the Mérode Altarpiece lead those writers too to discuss a diverse body of other images and texts. But they start by focusing on the unity of the artwork to be interpreted. Pater does not, and this difference points to a real problem inherent in metonymic narrative. Even if we share the Hegelian belief that "the truth is the whole," how are we to demarcate that whole? When Pater treats the *Laocoon* as a transitional work, he does so not on the basis of a detailed analysis of that artifact, but because in the whole of interest to him—European art as described by Hegel—the representation of violent emotion properly belongs only to painting.

Winckelmann's problem is explaining how the parts he describes fit together to comprise the whole artwork whose expressive quality he identifies. Pater's problem is showing how individual artworks are placed within a historical framework. These two modes of representation have complementary strengths and weaknesses. As metonymy focuses first on the parts, the meaning of the whole is seemingly contingent, dependent upon the particular, perhaps arbitrary order in which the parts are described. As synecdoche depends upon placing the individual work within a larger whole, the meaning of the individual artifact is seemingly arbitrary, dependent upon the particular whole in which it is placed.

If we look at the sculptures Winckelmann describes in a different order, their expressive significance may be altogether different. If we place the sculptures Pater discusses in a system including Indian and Chinese sculpture, their meaning will be different. Just as there is within the individual artwork no unambiguous indication of the order in which the

23. Pater, *Renaissance*, 16, 97, 98.

parts should be scanned, so there is no way of determining within what whole an individual work should be placed. There is no neutral mode of verbal representation, no technique of emplotment that does not imply some interpretation of the artworks described. How an artwriter emplots her account will heavily influence her analysis of individual objects.[24]

Two further examples support the claim that synecdoche is the dominant trope of late nineteenth-century artwriters. Pater's "School of Giorgione" (1877) begins with an extended discussion of romantic art. Pater then discusses the history of Venetian painting, asserting that attributions are unimportant, "for, in what is connected with a great name, much that is not real is often very stimulating."[25] We must "supplement the narrower range of the strictly ascertained facts" with an awareness of the more elusive ways in which Giorgione's paintings relate to "the making or hearing of music, song or its accompaniment" and "rustic buildings, the choice grass, the grouped trees."[26]

Morelli's general approach is very different, but his rhetoric is similar. While "all amateurs," he remarks, "are simply guided by the general impression," connoisseurs look at such details as fingernails and ears. "The spirit of the master . . . finds expression" not just in "the pose and movement of the human figure . . . expression, type of countenance, colouring . . . [and the] treatment of the drapery," but also in "the hand, the ear, the landscape background . . . and . . . colour." As "all these several parts of the painting are characteristic and distinctive," permitting us "to penetrate to . . . the very soul of the master," a connoisseur should concentrate on them. These minor details, not reproduced by copyists, are the key to reliable attributions: "The types of Saints and the mode of treating the drapery are usually common to a school . . . while . . . every

24. When, for example, Clark defends Winckelmann's account of the *Laocoon*, arguing that Winckelmann "was contrasting it . . . with the works of the decadent baroque tradition, the current style of his youth," and contrasts such different models of "art for art's sake" as Guido Reni's *Samson* and a Brancusi with the *Laocoon*, where, "although the situation is improbable, the conduct of the fable is remarkably real and afflicting," he places the *Laocoon* within a new context (Kenneth Clark, *The Nude: A Study in Ideal Form* ([Garden City, N.Y., 1956], 305).

25. Pater, *Renaissance*, 118–21.

26. Such statements may seem innocuous, but if, as has been recently argued, Giorgione's *Tempest* is in fact a political allegory, Pater's account is both false and misleading. See Deborah Howard, "Giorgione's *Tempesta* and Titian's *Assunta* in the Context of the Cambrai Wars," *Art History* 8 (1985): 271–85, and Paul H. D. Kaplan, "The Storm of War: The Paduan Key to Giorgione's *Tempesta*," *Art History* 9 (1986):405–19.

individual master has his own special conception and treatment of . . . the form of the hand and ear."[27]

But although Morelli too is concerned with details, he emplots his narrative differently than Winckelmann. For Pater, the expressive significance of the whole depends upon an understanding of the parts. He shows the suppression of feeling in the *Laocoon* by studying the priest's lip, nose, eyebrows, and forehead. By contrast, for Morelli the expressive quality of the whole is manifest in every part: "The modelling of the eyes . . . so too the drawing of the hands and the defective modelling of the first phalanx of the fore-finger . . . the 'spongy' flesh tine, and the Florentine background . . . all these characteristics convince me that . . . this . . . portrait is [by] . . . Pontormo."[28] Such diverse elements could hardly add up to a significant whole. In fact, each of these elements expresses the same thing, the artist's personality. Morelli's detailed account of Giorgione's *Castelfranco Madonna*, is not un-Pateresque: "The effect of the early morning light upon the sea . . . is of indescribable charm. The serenity and peace pervading the whole painting has a hallowing effect and awakens devotional feeling. We are struck by the simple and natural demeanour of the two saints who stand on either side of the throne."[29]

In part, the difference between Winckelmann and Morelli reflects an ambiguity in the concept of expression.[30] For Winckelmann, a sculpture expresses some feeling appropriate to the depicted figure; for Morelli, a painting expresses the painter's personality. There are two reasons for this difference. Winckelmann is not primarily concerned with attributions, and the subjects of the works that interest him are often hard to identify. Morelli, on the other hand, usually discusses painting with known subjects, and attributions are his central topic. The notion of an

27. Giovanni Morelli, *Italian Painters: Critical Studies of Their Works*, trans. C. J. Ffoulkes (London, 1892), 1:74, 76.

28. Morelli, *Painters*, 1:120–30.

29. Morelli, *Painters*, 2:215.

30. This point is misunderstood in some commentaries on Morelli. Max Friedländer writes that the painter "renders the human figure . . . under the stress of emotional tension. . . . he lapses into convention and routine when he draws parts . . . such as the ear or hand which seem to be of secondary importance" (Max Friedländer, *On Art and Connoisseurship* [Oxford, 1946], 168). Similarly, Hauser says that Morelli was interested in the features "which had least to do with the artist's . . . ways of expression" (Arnold Hauser, *The Philosophy of Art History* (Cleveland, 1963), 109). Unlike them, Berenson states the point correctly: "A real artist . . . is of the same quality throughout" (Bernard Berenson, *The Study and Criticism of Italian Art* [London, 1912], 77).

art history centered on personal expression is alien to Winckelmann, as it is to Vasari.[31]

Despite their different ways of thinking about art, for both Pater and Morelli synecdoche is the most important trope. For Pater, every Giorgionesque work manifests the nature of romantic art. For Morelli, every part of an artwork expresses the artist's personality. There is, however, one admirer of Morelli whose emplotting involves metonymy, and study of his rhetoric raises the question whether in the early twentieth century metonymy remains a viable rhetorical mode for artwriting.

Freud, admitting that he is "no connoisseur," describes Michelangelo's *Moses* (Fig. 17) in an analysis that, although he says it draws on Morelli's writings, is actually more closely akin to Winckelmann's account. He directs us to look from "the much-admired beard of Moses" to the right index finger, which "affects mainly the strands of hair from the left side. . . . what man who . . . has drawn his beard over to the other side, would take it into his head to hold down the one half across the other by the pressure of a finger?" The statue, Freud concludes, exhibits three distinct emotional strata: "The lines of the face reflect the feelings which have won the ascendancy; the middle of the figure shows the traces of suppressed movement; and the foot still retains the attitude of the projected action. *It is as though the controlling influence had proceeded downwards from above.*"[32]

This account has the same problems as Winckelmann's discussion of the *Laocoon*. If the expressive quality of the whole can be determined only by viewing these three parts in this order, what feature of the sculpture tells us that it should be seen in this way? Moving from the foot to the middle to the face would give an entirely different view, implying that Moses is losing control of his suppressed emotions.[33] If

31. As Foucault's refusal to explain this change is notorious, Ginzburg's Foucaultian account in his discussion of Morelli is worth noting: "In . . . advanced capitalism . . . any claim to systematic knowledge appears as a flight of foolish fancy. To acknowledge this is not to abandon the idea of totality. . . . Reality is opaque; but there are certain points . . . which allow us to decipher it" (Carlo Ginzburg, "Clues: Morelli, Freud, and Sherlock Holmes," in *The Sign of Three: Dupin, Holmes, Peirce*, ed. U. Eco and T. A. Sebeck [Bloomington, Ind., 1983], 109).

32. *The Complete Psychological Works of Sigmund Freud*, ed. J. Strachey (London, 1955), 13:211, 223, 224, 230 (italics added). A bibliography of the literature on Freud's view of Morelli appears in Giovanni Previtali, "À propos de Morelli," *Revue de l'art* 42 (1984):27–31.

33. A modern viewer might conclude that the work is fascinating because it is inherently ambiguous, but that is not Freud's point, even if it is naturally suggested by his more general account of representation in dreams.

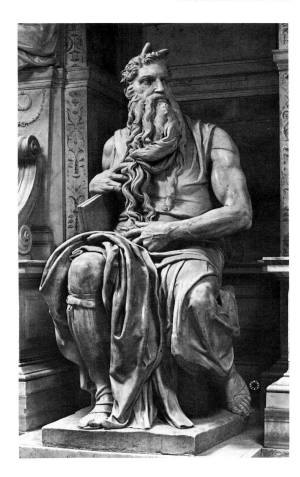

Fig. 17. Michelangelo, *Moses*, Rome, S. Pietro in Vincoli (photo: Alinari/Art Resource, New York)

Freud's artwriting thus employs what in his time was an archaic mode of emplotment, he nevertheless shares the nineteenth-century view of expression. For him the statue's position expresses the thoughts of Michelangelo. He thus links the two concepts of expression I mentioned earlier: the artist's self-expression and what is expressed by the sculpted figure.

In describing a visual artwork with many parts, where should the artwriter begin? Steinberg describes Michelangelo's *Conversion of Saint*

Paul differently than Wölfflin and Freedberg; interpreters of Caravaggio, Piero, and Flemish allegories disagree about what features of these artworks are the most significant. In all such cases, an artwriter's narrative strategy influences her interpretation. Winckelmann's use of metonymy and Pater's of synecdoche exemplify alternative narrative strategies, but though we can compare their modes of emplotting, there is no neutral way of describing the artworks they discuss. Subtracting the rhetoric from an artwriter's text is as impossible as subtracting the style from a novel.

How, then, do Winckelmann and Pater differ from modern art historians? If we answer this question by comparing their texts with those published in the *Art Bulletin*, then the difference will be a matter of degree. Their historical concerns make sense to us, even if we are amazed by their sometimes purple prose.[34] If, however, we define the historical place of an artwriter by his rhetoric, as I do, then the difference between Winckelmann and Pater and their successors will be a difference in kind, not a matter of degree.

Freedberg is heavily influenced by the older traditions of artwriting, and his account of Giorgione's *Castelfranco Madonna* represents a compromise between a metonymic focus on the whole understood as the sum of its parts and Pater's synecdochic placement of the work in a historical framework: "The imitative truth of parts of the Giorgione altar may resemble Bellini's, but the facts are related by a different principle.... Giorgione has connected parts he may have described precisely into an arbitrarily smoothed pattern to make a purified and artificial whole."[35] We understand that whole by comparing the achievement of Bellini: "In the Giorgione ... there are elements that assert existence ... more than in the Bellini; and even more, there are elements that assert a principle of order. Both the existence and the order are, however, differently conceived." In place of Winckelmann's focus on the successive parts of the *Laocoon* and Pater's sweeping contrast between classical and romantic art, Freedberg gives an exquisitely refined transcription of an essential tool of professionalized art history, the slide comparison. Freedberg both finds a role for the reality of the individual Giorgione, as Pater does not,

34. Paul Barolsky takes a different view, arguing that modern art history shares more with Pater's writing than I allow. See his *Walter Pater's Renaissance* (University Park, 1987).

35. S. J. Freedberg, *Painting in Italy 1500–1600* (Harmondsworth, 1970), 79.

and, unlike Winckelmann, implies that the painting's expressive qualities can be explained only by comparison with other artworks.[36]

How are we to understand the change in sensibility between Winckelmann's time and Pater's? Within eighteenth-century aesthetics, there is one uncanny anticipation of Pater's work. Lessing's *Laocoon* contrasts the poet, who describes both visible and invisible acting beings, with the painter. "This distinction cannot be made on canvas, where every thing is visible, and visible in precisely the same way."[37] Why then cannot Winckelmann, a very self-conscious literary stylist, write like a poet? Consider two late eighteenth-century examples. In 1795, Schiller wrote: "The plastic arts . . . must become music. . . . This, precisely, is the mark of perfect style in each and every art: that it is able to remove the specific limitations of the art in question without thereby destroying its specific qualities."[38] In 1798, Goethe said about the *Laocoon*: "A true work of art will always have something of infinity in it. . . . it cannot be thoroughly understood, nor its essence nor its merit be clearly defined by words."[39] How are we to understand this sea-change in the rhetoric of artwriters? Unlike Winckelmann, Pater is self-conscious about his medium of representation, words. Unlike Winckelmann, writers of Pater's time give a special semiotic role to color.

If Lessing's theorizing anticipates Pater's ideal of art as approximating the condition of music, Lessing nevertheless makes a clear distinction between poetry and the prose of artwriting: "I do not deny that language has the power of describing a corporeal whole according to its parts. It certainly has. . . . But I deny that this power exists in language as the instrument of poetry." Representing the successive parts of sculptures "which in nature the eye necessarily takes in at a glance is an encroachment of the poet on the domain of the painter." Winckelmann's set

36. In Freedberg's analysis both Florentine and Venetian cinquecento classicism represent "a solution, in terms of art that do not touch political reality, and are not essentially touched by it, to the Quattrocento's cultural dilemma" (Freedberg, *Painting*, 3); nevertheless, his account of the period is accompanied by a much more detailed analysis than Pater provides.

37. Lessing, *Laocoon*, 77, 100. Because words, the signs employed in poetry, are less material than the signs employed in sculpture, "poetry is located at a more advanced level in the progress of semiosis by which mind liberates itself from actuality," the ultimate goal in that movement toward the "imageless and wordless language of God" (Wellbery, *Lessing's Laocoon*, 55).

38. Friedrich Schiller, *On the Aesthetic Education of Man*, trans. E. Wilkinson and L. A. Willoughby (Oxford, 1967), 155.

39. *Goethe on Art*, ed. and trans. John Gage (Berkeley and Los Angeles, 1980), 78.

pieces, legitimate employments of prose, cannot be poetry. The poet, taking Homer as his model, "paints nothing but progressive actions."[40] In Winckelmann's and Lessing's accounts there is no equivalent to color as it is described by Pater, for whom it signifies expressiveness and indeterminacy. In classical sculpture, Pater writes, "colour . . . has always been more or less conventional." Only in painting can it "refine most delicately upon a single moment of passion, unravelling its subtlest threads."[41] "Color" here stands not for color as such, but for the distinctive qualities of romantic art.

The dramatic historical break between Winckelmann and Pater is illustrated in the contrasting views of color expressed by historically intermediate figures, Kant and Hegel. Kant has difficulty determining whether color is "merely an agreeable sensation or . . . a beautiful play of sensations" that, "in being estimated aesthetically, convey . . . a delight in . . . form."[42] For Hegel, by contrast, color is essential in painting: "For the expression of the inner soul painting . . . presents spatial intervals and shapes by means of color. . . . the material, in itself dark, has its own inner and ideal element, namely light."[43]

These philosophers offer complicated arguments for their views, but my concern is the general change of sensibility that occurs in this period. When an artwriter says that "yellow and green are gay colours; blue is sad; red projects objects into the forefront; yellow attracts and retains shafts of light; azure blue is somber and best suited to create an aura of mystery," we know that his account, which might have been written by Baudelaire, marks a decisive change in sensibility.[44] Neither Winckelmann nor Kant employs such rhetoric. No pre-Hegelian artwriter gives such a Pateresque account of color in Renaissance art, and Hegel, who never visited Italy, and Pater, who did travel there, knew less about Italian painting than Alberti, Vasari, or Winckelmann. Why, then, is this art described so differently in the nineteenth century?

40. Lessing, Laocoön, 92, 105–6, 109.

41. Pater, Renaissance, 169. Baudelaire makes exactly the same point, in a way that makes it clear that "color" means not color as such, but a quality of vagueness that engages the viewer's imagination. Daumier's black-and-white "lithographs and . . . woodcuts arouse the idea of colour" by exactly this quality (Charles Baudelaire, Selected Writings on Art and Artists, trans. P. E. Charvet [Harmondsworth, 1972], 224).

42. Immanuel Kant, The Critique of Judgement, trans. J. Meredith (Oxford, 1952), 66, 189.

43. Hegel's Aesthetics, trans. T. M. Knox (Oxford, 1975), 2:810.

44. The account occurs in Stendhal's L'Histoire de la peinture en Italie (1817), 40.

Winckelmann knows only one kind of visual sign, that part of the sculpture which is one element in the whole. Pater knows two kinds of signs: definite line and indefinite color. Their rhetoric relies upon these binary opposites. An artwriter needs some such classificatory system, for she can identify an artwork, or a kind of art, only by contrasting it with something else, with what it is not. Winckelmann contrasts actual, imperfect bodies with the idealized forms of the classical sculpture he so loved; Pater contrasts beautifully colorless antique sculpture with more deeply expressive colored modern works. Binary oppositions here imply value contrasts: idealized sculpted forms are more perfect than real bodies; color introduces into art a kind of expression unattainable in antiquity. Winckelmann's opposition between the perfection of sculpted bodies and the imperfection of actual bodies can also be read as a contrast between the unhappy German world of his youth and the Italy to which he escaped. For Pater, the important contrast is one between two kinds of artworks.[45]

45. Without indulging in extensive or vulgar biographical analysis, it is easy to observe this difference in the very lives of these artwriters; Winckelmann lived out a life which, so it seems, for Pater remained merely fantasy. An instructive example of a vulgar account is found in Mario Praz, On Neoclassicism, trans. A. Davidson (Evanston, 1969), 49: "The fixed, static character of Winckelmann's aesthetic ideal lies, essentially, in the transposition into terms of art of an erotic substratum such as his." As Winckelmann was very widely admired, mostly by men and women who did not share his erotic interests, surely the real question is why an artwriter whose responses were so highly personal attracted such wide interest. The documentation in Potts's Winckelmann's Interpretation demonstrates how unique a figure he was, and how little understood by his contemporaries. Gombrich and Fried make important contributions, but both misunderstand Winckelmann. Gombrich argues that we can deconstruct Winckelmann's text—its "pages somehow also contain the seed of their own destruction"—by showing that Winckelmann's belief in the corruption of contemporary art is inconsistent with his belief that Greek art was "so great because it sprang from the peculiar and unique conditions of Greek culture" (E. H. Gombrich, The Ideas of Progress and Their Impact on Art [New York, 1971], 18, 48). But why is it inconsistent to suggest that modern artists can escape the corruptions of their age by imitating Greek art, an option which was not open to the Greeks? Fried argues that Winckelmann inconsistently maintains that whereas the moderns depict imperfect bodies, the ancients "were led by their experience of a vastly superior nature" to idealize and thus their experience of art "had its origin in an experience of lack " (Fried, "Antiquity Now," 88–89). Given that this notion of idealization is alien to us, however, the claim that it originated in the awareness of the "contour . . . the young wrestler leaves in the sand" (Winckelmann, quoted in Fried, "Antiquity Now," 89) is unconvincing. Seeing beautiful bodies, Greek artists conceived of an ideal not attained by any actual body; such idealization, however strange, does not require the presupposition that actual bodies manifest a lack. Fried offers a misleading reconstruction of Winckelmann's doctrine of idealization, failing to take seriously its historical context. I see no reason to think that Winckelmann is inconsistent in this way in his comparison of the moderns and the ancients.

For Pater, the fundamental opposition is a contrast between two kinds of art, not an opposition between sculpted bodies and living figures. Unlike Winckelmann, he can self-consciously admit that his artwriting is an art form. According to its own definition of art, *The Renaissance* is a romantic artwork. White argues that the modern trope par excellence is irony, which "represents a stage of consciousness in which the problematic nature of language itself has become recognized. It points to the potential foolishness of all linguistic characterizations of reality."[46] Indeed, irony is just what we find in Morelli's book, in which one character denounces connoisseurs: " 'My dear sir,' I exclaimed, 'spare me these details of hands and ears. . . . In the presence of art . . . it is utterly impossible to think of these things. Raphael's spirit has cast its magic spell over me, and I cannot descend to that prosaic level requisite for studying forms and details in a work of art."[47] Morelli can speak ironically about his metonymic troping because he shares with Pater a belief in the indescribable spirit of the whole, that organic unity which reveals the artist's spirit in every part.

Like the historians who fear that White's concern with emplotting deprives them of the possibility of achieving objective truth, present-day art historians are unlikely to welcome this conclusion: "If it can be shown that Irony is only one of a number of possible perspectives on history, each of which has its own good reasons for existence . . . the Ironic attitude will have begun to be deprived of its status as the necessary perspective from which to view the historical process."[48] The role of rhetoric in art history has as yet been little discussed by professional art historians. Yet rhetoric was extremely important to Pater and Winckelmann, the ancestors of those art historians. How they represent artworks determines how they interpret them. But what role does rhetoric play in the practice of present-day art history? The remainder of this book is devoted to answering that question.

But this disagreement about a point of detail should not obscure my intellectual debt to Fried's exciting text.

46. Hayden White, *Metahistory: The Historical Imagination in Nineteenth-Century Europe* (Baltimore, 1973), 37.

47. Morelli, *Painters*, 1:55.

48. White, *Metahistory*, 375.

David's *Oath of the Horatii*:
The Search for Sources of an
Eighteenth-Century Masterpiece

· · ·

To be taken seriously, a new account of Piero, Caravaggio, or van Eyck must deal with a large body of artwriting. There is an established methodology for interpreting the art of these painters, and even an artwriter who adopts a radically new approach must take this literature into account. By contrast, the eighteenth century has been less intensively studied.[1] Compared with Piero or Caravaggio, Watteau, Chardin, and Greuze are marginal figures, and so the tradition of older writing provides relatively

1. The present-day art historian dealing with the eighteenth century, like such earlier art critics as Diderot, Fry, and Greenberg, inherits aesthetic theories whose relation to the art she wants to write about is problematic. For a discussion of this point, which I owe to Norman Bryson, see my essay "The Art of Artwriting," *New Observations* 47 (1987):20–23.

few models for describing their art. Jacques-Louis David seems a more traditional painter, and he has almost always been greatly admired. But there is no tradition of David scholarship comparable to the older accounts of Piero or Caravaggio. With few exceptions, the earlier literature on David is unimpressive.[2]

In retrospect, what is most striking about the older descriptions of David's *Oath of the Horatii* (Fig. 18) are the barren variations on a single unconvincing claim: "In contrast to . . . [the] altogether manly, strongly expressed and plastically executed group, the two women . . . are pushed to one side. . . . The Horatii . . . create an extremely masculine image and raise a moral light . . . against anything feminine, weak, and personal."[3] The composition implies that male is to female as strength to weakness: "Firm masculinity, by which a man forgets himself in order to perform a moral duty, is contrasted with femininity, which cannot face up to death and lets itself be overwhelmed by horror."[4] But where is the "moral duty" in this petty quarrel in which the Horatii murder and are murdered? David's women can face death. In his *Lictors Returning to Brutus the Bodies of His Sons* it is the women, not Brutus, who look at the dead sons: "Masculine courage and resolve is contrasted with feminine tenderness and acquiescence; the taut muscles of the brothers . . . are balanced . . . by the softly pliant draperies and meltingly compassionate gestures of the women."[5]

A formalist could note the symmetry of the composition. But how can muscles be "balanced" against draperies and compassionate gestures? "The striking contrast between the world of men, strong and fierce, and that of the women bent in exquisite arabesques, . . . makes this one of the great themes David invented."[6] In noting David's radical opposition of male strength to feminine weakness, these accounts raise a real question. How can such a dramatically divided composition achieve pictorial unity? Contrast it to a *Rape of the Sabine Women* by Poussin, Pietro da

2. The best-known older account is Edgar Wind, "The Sources of David's Horaces," *Journal of the Warburg and Courtauld Institutes* 4 (1940–41):124–38; see also Robert Rosenblum, *Transformations in Late Eighteenth Century Art* (Princeton, 1968), 70–71.

3. Walter Friedlaender, *David to Delacroix*, trans. R. Goldwater (Cambridge, 1952), 16–17.

4. Jean Starobinski, *1789: The Emblems of Reason*, trans. B. Bray (Charlottesville, Va., 1982), 110.

5. Hugh Honour, *Neo-Classicism* (Harmondsworth, 1968), 35–36.

6. Antoine Schnapper, *David*, trans. H. Harrison (New York, 1982), 78–80. As Bryson notes, this theme is not David's invention: "*Oath* is an exact image of visuality for the subject living under patriarchy" (Norman Bryson, *Tradition and Desire: From David to Delacroix* [Cambridge, 1984], 20).

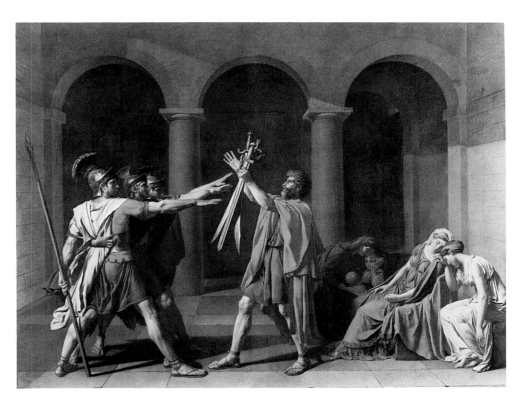

Fig. 18. David, *The Oath of the Horatii*, Paris, Louvre (photo: Service photographique de la Réunion des musées nationaux)

Cortona, or Rubens. Those seventeenth-century masters show struggle throughout the picture. David presents a world in which men and women are brutally separated. The discussions of pictorial unity in David's painting deal with this problem unconvincingly: "The women on the right appear a secondary appendage, but they are linked to the Horatii figures in terms of the overall composition, for the left foot of the elder Horatius visually leads directly to the seated female figure."[7] But how can this

7. F. Hamilton Hazlehurst, "The Artistic Evolution of David's Oath," *Art Bulletin* 42 (1960):61.

overlap, which means that the men stand in front of, and so apart from, the women and children, *link* the figure groups?

As these texts find the male/female contrast unproblematic, so the traditional Marxist accounts consider the work's political significance transparent: "The precision and objectivity, the restriction of the work to the barest essentials . . . were more in harmony with the stoicism of the revolutionary bourgeoisie than any other artistic trend."[8] The link between a neoclassical style and revolutionary consciousness is here supported only by the assumption that because the painting was made on the eve of the revolution, it reflects the "precision and objectivity" of the revolutionaries. Because the gender conflicts that David shows have at most a tangential relation to the revolution, Marxists downplay their importance: "Civic virtue is extolled by means of highlighting the group of women . . . one of whom, Camilla, is weeping both for the anticipated loss of her beloved and her three brothers who are leaving for the combat."[9] But as she weeps in anticipation of her lover's death, and is killed by her surviving brother for mourning that lover, can David's picture really be said to extol civic virtue?

One innovation of revisionist artwriters has been to examine the composition. Another has been to question the claim that the picture is an emblem of the revolution. In 1785 "the Revolution was still four years away" and David "a completely apolitical creature."[10] Unless we believe that great artists are in touch with "the spirit of the times," how can we link this picture with the events of 1789? Moreover, it is not easy to relate the male/female opposition in the picture to revolutionary politics. If *The Oath of the Horatii* must be given a political reading, a feminist could argue that it shows that the revolution was a male struggle in which women, as usual, were often the victims.

Thomas Puttfarken places the novel composition in an art-historical context: "We have only to compare the academic discussion of Poussin's *Gathering of the Manna* in 1667 with its sophisticated arguments . . . with the simplistic criticism of David's *Oath of the Horatii* to see that the whole concept of *l'unité de sujet* has undergone some drastic changes." A "political interpretation" of the composition was "inappropriate and incorrect

8. Nicos Hadkinicolaou, *Art History and Class Struggle*, trans. L. Asmal (London, 1978), 157, 161.

9. Arnold Hauser, *The Social History of Art*, trans. A. Hauser and S. Godman (New York, 1960), 3:146.

10. Anita Brookner, *Jacques-Louis David* (New York, 1980), 74.

at the time when the picture was produced."[11] But as in the case of the similarly composed *Brutus* (in which Brutus on the left is balanced by a group of crying women on the right), the question of which figure group we are to identify with is one "which we have to decide . . . on grounds of our own moral commitments as human beings and as citizens."[12]

This claim is worth challenging. Norman Bryson indicates one problem: "David separates Brutus from his women by a poignant void that emphasizes . . . the unbridgeable gulf between masculine stoicism and feminine abandonment to the passions."[13] If in his *Brutus* David separates his figures by gender, then *for whom* is there a choice of which figure group to identify with? Can I as a male really identify with the women? If female, could I imagine myself one of the men?[14] Bryson argues that *The Oath of the Horatii*, by contrast, shows its figures from a viewpoint that is neither male nor female. If, as he believes, all viewpoints imply a gender for the person occupying them, then this picture "seems to require a vantage point . . . outside that which is portrayed. . . . but how can the *image* exit from visuality?"[15] Of course, any picture must depict its figures from some actual vantage point, but Bryson implies that this picture is uncanny because the viewpoint we must adopt requires us to imagine ourselves as neither male nor female.

Fried too recognizes this when he writes of "a perfect matching or fusion . . . of the moral or spiritual and the physical or bodily, as though the inner meaning . . . of swearing an oath were *entirely* manifest in its outward public expression."[16] That perfect fusion occurs because there is

11. Thomas Puttfarken, "David's *Brutus* and Theories of Pictorial Unity in France," *Art History* 4 (1981):298; M.E.J. Delécluze, *Louis David: Son école et son temps* (Paris, 1885), 119–20.

12. Robert L. Herbert, *David, Voltaire, 'Brutus' and the French Revolution: An Essay in Art and Politics* (New York, 1972), 2, makes a similar point: "David uses the effort we must make to join the two sides in order to draw us into a dynamic process of comprehension."

13. Bryson, *Tradition*, 77.

14. Consider another painting that asks the spectator to imagine her role in relation to depicted figures. Manet's *Bar at the Folies-Bergère* asks the viewer to identify with the man propositioning the barmaid. As the viewer must suppose herself to be a middle-aged nineteenth-century Frenchman, nobody today can, without an act of imagination, identify with that figure. But such an imaginative identification is probably easier for a man than for a woman. (See my *Artwriting* [Amherst, 1987], 6–9.)

15. Norman Bryson, *Word and Image: French Painting of the Ancien Régime* (Cambridge, 1981), 230.

16. Michael Fried, "Thomas Couture and the Theatricalization of Action in Nineteenth Century French Painting," *Artforum* 8 (1970): 46 n. 32, and *Absorption and Theatricality: Painting and Beholder in the Age of Diderot* (Berkeley and Los Angeles, 1980), 153.

no possible external viewpoint on the scene. At this time, "the presence of the beholder before the painting ... tended increasingly to be ... an alien influence ... if not indeed a theatricalizing force."[17] But why assume that there must be such a spectator if she can only occupy this impossible position? The difference between Bryson and Fried is not that they see the picture itself differently but that what for Bryson is impossible—finding an external vantage point—is for Fried just what the tradition of antitheatrical painting aspires to achieve.

Thomas Crow offers a different revisionist approach, bringing together in his narrative what the earlier historians separated: the gender contrasts and David's politics. "Two opposed notions of how to compose simply abut one another, masculine versus feminine, without transition or modulation.... The picture refuses to find form for the relationships between men and women which are central to its narrative content."[18] Crow asks: "If painting had it in its power to present to the viewer ... the natural order of things, then ... how does the bourgeois see *himself* in the world?"[19] Class divisions among artwriters of the 1780s show a distinction between a positive view of David among revolutionaries-to-be and the critical remarks of conservatives, who display "a consistent pattern of inarticulate hostility towards David.... His popular success appears to them as something mysterious and vaguely dangerous."[20] Crow must distinguish progressives and conservatives in some noncircular way. Carmontelle, a man who earned six thousand livres a year in 1780 and "spent the last half of his life as the protected intimate of the court of the Duc d'Orléans," belongs among "these angry and radical outsiders," Crow argues, because he "harbored suppressed frustrations and rage," having endured "years of what he clearly felt to be a trivialization of his talent."[21] These artwriters saw that "David's artistic language ... stands in lonely opposition to the servile *métier* of the academic artist, its *political* signifi-

17. Strangely enough, Bryson refuses to recognize this point, calling the *Oath* "an image terrifyingly centered on and for the spectator" (Norman Bryson, review of Fried, *Absorption and Theatricality, Journal of Modern History* 53 [1981]: 704).

18. Thomas Crow, "The *Oath of the Horatii* in 1785," *Art History* 1 (1978): 443, 457–58.

19. Crow, "*Oath*," 450 (italics added).

20. Crow, "*Oath*," 429. An earlier discussion appears in Louis Hautecoeur, *Louis David* (Paris, 1954), 84–85.

21. Crow, "*Oath*," 425, 431, 434, 437. And leftists who drifted "in an underworld of illegal scandal sheets, political agitation, even pornography peddling" genuinely were "men on the margins of Parisian literary life" (Crow, "*Oath*," 454).

cance declared in its emphatic plainness of expression, its renunciation of sensual appeal and emotional nuance."[22]

Here again, as with Caravaggio, we encounter the problems of interpreting contemporary responses to an artist. Did Carmontelle and other "radicals" respond positively to David because of their political commitments? Or did political "radicals" respond more readily than their conservative contemporaries to avant-garde composition?[23] How are we to choose between these hypotheses? One strategy is to describe the composition, and in doing so Crow disagrees in important ways with the traditional accounts. David depicts "a moment which temporarily banishes emotional complexity altogether," challenging the belief that art involves "a shared vocabulary of forms"; his picture "partakes less of the mediated properties of vision than of the overly vivid yet generalized and dissociated character of hallucination."[24]

Compare this account with Robert Rosenblum's earlier analysis, which begins with a traditional description of the composition: "In the group of the Horatii . . . the tense muscles . . . seem permeated with the metallic rigidity of the javelin and swords. . . . In the group of women . . . a style of malleable, fluent contours . . . create abstractly the image of limp and hopeless mourning."[25] Rosenblum then adds an original observation of special relevance to Crow's account. Gavin Hamilton's *Oath of Brutus* (Fig. 19) and Jacques-Antoine Beaufort's *Brutus* offer precedents for David's composition. David develops his images within an artistic tradition. Indeed, as Anita Brookner observes, the "brilliant singleness" of David's image "hides or resolves an unbelievable confusion of sources," including Poussin's *Rape of the Sabine Women*, *Death of Germanicus*, and *Testament of Eduamidas*, as well as the works cited by Rosenblum.[26]

Still, David's painting does not look like any of these works. "He not only copies; he misleads critics as to his sources." Although David certainly learned from earlier art, the contemporary response to his work

22. Crow, "*Oath*," 442, 447–48. Without any sociological analysis, Wölfflin made a similar point: "Diderot contests in Boucher not only the artist but the man. This purely human feeling seeks the simple. And now appear[s] the demand. . . . the figures in the picture shall remain isolated" (Heinrich Wölfflin, *Principles of Art History*, trans. M. D. Hottinger [New York, n.d.], 234).

23. See Régius Michel, "Le serment des Horaces," in *David e Roma* (Rome, 1981), 137, for a discussion of Crow's account.

24. Crow, "*Oath*," 431, 457, 461.

25. Rosenblum, *Transformations*, 70, 71.

26. Brookner, *David*, 79.

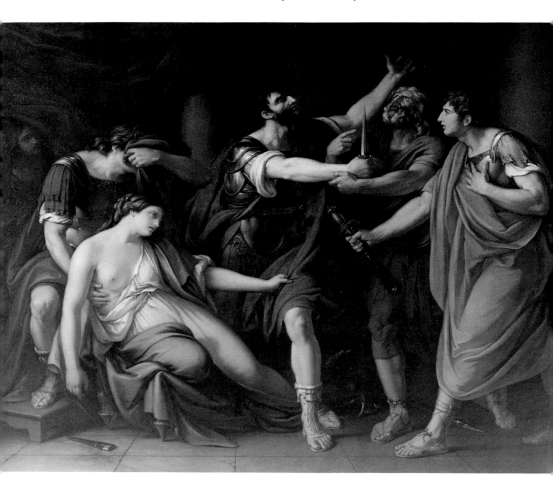

Fig. 19. Gavin Hamilton, *The Oath of Brutus*, New Haven, Yale Center for British Art, Paul Mellon Collection (photo: Yale Center for British Art)

shows that his work appeared to have no connection with the tradition. His painting was an artistic equivalent to the political revolution his admirers sought. And if today we can place it within art history, that is because the issues of 1789 seem historically distant. Brookner and Crow

agree about the effect of the work while disagreeing about how to explain its cause. Brookner appeals to the artist's psychology; David portrays "murderous impulse checked by tight control."[27] This, Crow notes, makes the David of 1785 an apolitical artist.[28]

But Crow, in turn, can read the work as a political statement only by putting a political construction on the accounts that seem to describe the composition. Ingeniously, he finds political significance in the seemingly least political aspects of *The Oath of the Horatii*. Crow attributes to the Frenchman of 1785 a capacity to suppress both recognition of what the picture says about gender and questions about the meaning of the oath. Like a formalist, Crow must doubly bracket the content of the painting: it is not about what it seemingly depicts, Roman history; and it is not about what it apparently shows, male-female conflicts.[29]

Bryson offers a different interpretation: "The females, denied political authority . . . are consigned to silence . . . while . . . the males are inserted into the equally destructive registers of language and of power. . . . The women do not support or participate in this system . . . they are its victims."[30] His argument with Crow can seem merely verbal. How does refusing to find form for gender relations differ from asserting that their form is indeterminant? But there is real disagreement here. If *The Oath of the Horatii* is "investigating the same area" as psychoanalysis, as Bryson claims, how can it be about "economic, social and political conflict," as Crow asserts?[31] But perhaps these interpretations do not conflict. As the French Revolution was not a feminist revolution, the selfsame image may *both* show the role of women under patriarchy *and*, by refusing to

27. Brookner, *David*, 80.

28. See Crow's review of Brookner, *David*: " 'Gross David, with the Swoln Cheek,' " *Art History* 5 (1982): 109–17.

29. Ironically, Crow's general argument is anticipated by the traditional Marxist account of Hauser, who, without doing any of Crow's archival research, concludes that "this clarity, this uncompromising rigour, this sharpness of expression, has its origin in the republican civic virtues; form is here really only the vehicle, the means to an end." (Hauser, *Social History*, 146). The content of the picture is almost irrelevant, for it is the form that shows the virtues of the revolutionary: clarity, sharpness of expression, and an inability to compromise. We might ask why these are qualities of the revolutionary rather than the reactionary, but even if we accept that claim, what still seems puzzling is the implication that these political ideals find unmediated expression in a painting. See also Michel Thévoz, *Le théâtre du crime: Essai sur la peinture de David* (Paris, 1989).

30. Bryson, *Tradition*, 70–73.

31. Bryson, *Tradition*, 70; Crow, "Oath," 443.

accept traditional standards of composition, implicitly criticize the exist-
ing social order. A social historian who wanted to extend Crow's account
might ask why commentators have discussed only the implications of
the composition for class struggle, not its relationship to patriarchy.
According to Crow, the picture answers a question posed by the revolu-
tionaries: "How does the bourgeois see *himself* in the world?"[32] The pro-
noun in this sentence may be revealing. If the women are "the only group
of figures composed in a traditional way," that suggests that they re-
mained marginal in revolutionary rethinking of social relations.

I have argued that the narrative structure of an artwriter's text shapes
the form and content of her conclusions. That argument is supported by
the accounts of Brookner, Crow, and Bryson. Brookner's text mimics
David's painting as she describes it, exercising over earlier interpreta-
tions that control which she finds in David's paintings. Hers is a magnifi-
cently ironical narrative. The image seems simple; earlier artwriters' inter-
pretations are complex, ingenious, and mistaken. The picture has usually
been read as a political image, but is really about "control of murderous
impulse."[33] And that control is as ephemeral as David's achievement of
this style. Soon the men will go forward to murder, and the only survivor
among them will return to slay his sister.

Crow's narrative places the picture in a larger art-historical perspec-
tive, in which David and Courbet were "responsible for defining advanced
art in terms of opposition to established convention, making painting a
scene of dispute over the meaning of high culture." David's defiance of
academic rules shows that "the antagonistic character of these pictures
can thus be read as duplicating real antagonisms within the audience
assembled in the salon."[34]

In this larger context, *The Oath of the Horatii* anticipates David's *Brutus*,
which reveals a later stage of revolutionary thought: "David . . . made
dissonance and discontinuity into elementary constituents of picture-
making. And this is entirely appropriate to a subject that concerns politi-
cal and emotional conflicts which admit of no immediate resolution."
But as 1785 seems early for a revolutionary icon, so 1789 seems too early

32. Crow, "*Oath*," 450 (italics added).

33. Brookner, *David*, 74.

34. Thomas Crow, "Modernism and Mass Culture in the Visual Arts," in *Modernism and Moder-
nity*, ed. B. H. D. Buchloh, S. Guibaut, and D. Solkin (Halifax, Nova Scotia, 1983), 224.

a date for a picture whose composition illustrates what happens in the 1790s, when "a deliberate excess of order has become a new order with its particular coherence and appropriateness."[35] This objection assumes that a Marxist framework, in which an artist's work reveals conflicts in the body politic that will only later be fought over, is an illegitimate mode of emplotment. For the Marxist, however, the problem with Brookner's characterization of David is that she treats his art as a product of his merely personal concerns, as if it were only tangentially related to the politics of his time: "To the small, inarticulate, violent, and vulnerable David came this fantasy of strength, calm, power and indifference to public opinion on which he tried to model himself in the years that ensued."[36]

Bryson's narrative has yet another structure. An image showing "humanity broken in two . . . each fragment living in permanent incompleteness" depicts an unstable situation, a tension for which we expect, and find, a resolution. A conservative might assert that this is "how things have always been"; Bryson implies that this situation cannot continue. In his narrative, in *The Intervention of the Sabine Women* gender divisions are "confined *to the figures*. . . . |they do| not extend to the place of the viewer . . . |who| simply looks at the scene. . . . He is not implicated in visual disturbance, as he must be when he scans and construes the spaces of the *Oath*."[37] Creation and resolution of tension is so basic a narrative device that what we expect, and find here in Bryson's text, is a resolution in David's later art of the gender conflicts posed by his earlier work.

Brookner, Crow, and Bryson offer very different viewpoints on David's picture, which now seems a complex artwork. Let us take this debate further by raising a question not much discussed by these commentators. Hamilton's *Oath of Brutus* was one of David's sources, but to simply say, as Rosenblum does, that David's work is "a translation into the language of genius of an idea first stated tentatively by Hamilton" leaves unanswered what we want to explain: why is David's picture so much better?[38]

35. Thomas Crow, *Painters and Public Life in Eighteenth-Century Paris* (New Haven, 1986), 253.

36. Brookner, *David*, 74. A reader of her novels would not be surprised at her characterization of the painter.

37. Bryson, *Tradition*, 75, 93–94.

38. Robert Rosenblum, "A Source for David's 'Horatii'," *Burlington Magazine* 119 (1970):273; see also his "Gavin Hamilton's 'Brutus' and Its Aftermath," *Burlington Magazine* 103 (1961):14.

One way to answer the question is to describe the narratives of the two paintings. *The Oath of Brutus* is puzzling. Seeing the wounded Lucretia supported by a man she grabs, we need some time to link the dagger held by that man, the scabbard Lucretia has dropped, and the fatal wound in her side; and we are confused by the inclusion of another weapon held by the man on the extreme right. Viewing David's master-piece, we immediately see the three swords held by the men on the left, who stand apart from the group of women on the right. David poses his oath-takers in a line; Hamilton places his so that their gazes meet in no single point, as if they were one figure seen in three successive positions as he is rotated around a center.[39] David separates the men and women into distinct groups; Hamilton places one man next to Lucretia. David's composition is clear, and so his narrative seems straightforward; Hamil-ton's picture is hard to read, and it takes time, and perhaps a glance at the title, to decipher the action. I say "seems," for what the recent inter-pretations of David's picture claim is that the action is really not clear.

We might seek to understand both pictures by appealing to Leo Bersani and Ulysse Dutoit's account of narratives depicting violence. The spectator's pleasure in such scenes, they argue, requires a complex act of identification. In those narratives that traditionally have been most highly valued, the story moves ahead "only if a principal drama emerges and works towards a climax against a background of secondary . . . events." But other narrative images refuse to center the representation on the violence; then "narrative goals are subverted before they are reached, and our visual pleasure lies not in being carried along in one direction toward a central point of interest, but rather in being submitted to the repeated interruptions of incomplete movements." "Continuous changes of direction," for example, thwart "the impulse to complete movement, to freeze representations into the finality of a motionless tableau." We then become less interested in the depicted violence "than in the very tension of the displacing movement itself."[40]

Bersani and Dutoit offer a novel discussion of a traditional problem, one we have touched on in the discussion of *ekphrasis* in Chapter 5. *Ut pictura poesis*: the painter must present that moment of an unfolding story

39. Bryson, *Word*, 226–27.
40. Leo Bersani and Ulysse Dutoit, *The Forms of Violence: Narrative in Assyrian Art and Modern Culture* (New York, 1985), v, 34, 46, 52, 98.

which best reveals what has happened and what is to come. Judged by that standard, Hamilton's picture is perhaps superior to David's. Hamilton shows how Lucretia has been murdered, depicting both the weapon and its scabbard, as well as the consequences of that action, the men's oath. David's is an elliptical narrative, showing the oath and the grieving women without giving us any way of connecting them. The earlier interpreters said much about this radical separation of the sexes. What we might now add is that this separation both gives the composition its classical clarity and makes the action hard to understand. Svetlana Alpers's influential distinction between Renaissance narrative painting and that art of description marked by the "deliberate suspension of action achieved through a fixity of pose and an avoidance of outward expression" nicely captures this contrast between Hamilton's and David's pictures.[41] Hamilton's very frankness in showing the violence means that his image, unlike David's, is not centered on the weapons. His less clear picture more clearly links past, present, and future events.

We can explain why Hamilton's picture is confusing by appeal to a psychoanalytic model. Freud writes: "If [young] children . . . witness sexual intercourse between adults . . . they inevitably regard the sexual act as a sort of ill-treatment or act of subjugation: they view it, that is, in a sadistic sense."[42] What a crude Freudian sees in *The Oath of Brutus* is a version of this fantasy, Lucretia dying with her fatal wound exposed as Brutus holds upward the dagger. The swords in the open center of *The Oath of the Horatii* do not serve merely to divide the blindly active men from the passive women. As Bersani and Dutoit write, "Fetishism is an intriguing narrative jumble; it is fundamentally an antinarrative phenomenon in that its principal strategy is to confuse a certain story line, to deny both beginnings and climaxes."[43]

Why should such a Freudian apologize for the crudity of her interpretation? David's insistence on the radical separation of the sexes *is* crude. This crude analysis supplements the earlier accounts of the composition. David's use of fetishes permits him to create a clearly composed image that tells a confusing story, and Hamilton's picture appears confused

41. Svetlana Alpers, "Describe or Narrate? A Problem in Realistic Representation," *New Literary History* 7 (1976):15.

42. *The Complete Psychological Works of Sigmund Freud*, ed. J. Strachey (London, 1955), 8:196.

43. Bersani and Dutoit, *Forms*, 68.

because it illustrates a familiar sexist fantasy: "Ultimately, the meaning of woman is sexual difference. . . . The male unconscious has two avenues of escape . . . preoccupation with the re-enactment of the original trauma . . . counterbalanced by the . . . punishment . . . of the guilty object . . . or else disavowal of castration by the substitution of a fetish."[44] Hamilton pursues both of these strategies, showing a "vaginal" wound in Lucretia's side and exhibiting the fetish, the dagger.

My aim in appealing to these Freudian conceptions is less to urge that these paintings be viewed as representations of fantasies than to find some strategy for comparing and understanding their narratives. I want to explain why David's picture is both uncannily lucid and hard to understand. "He excites the imagination to an extraordinary point. With all the force of his temperament, he strains his hallucinatory expression toward the sublime idea that he expresses."[45] The women mourn, as if what is to come had happened already. The men's "fury is literally blind," as if what has happened predetermined their future.[46] The sort of interpretation I have sketched will become convincing, I believe, only when it is supported by a developed account of the place of David's work in the history of art. Developing such an account is a large task. Here I consider one smaller, hitherto unaddressed question about the revisionist accounts of David's masterpiece. Although *The Oath of the Horatii* has recently been reinterpreted in very diverse ways, everyone agrees that it is a great artwork. As Brookner, Bryson, and Crow describe it so differently, it ought to seem surprising that they agree about the quality of David's work.

In part the status of David's painting depends upon its historical importance. Unlike David's pictures, Hamilton's could not "inflame anyone for liberty."[47] David's work was influential, and Hamilton's was not. But neither of these facts by itself shows that *The Oath of the Horatii* is a great painting. As the history of Piero's and Caravaggio's reputations shows, tastes do change.[48] Suppose we reject F. R. Leavis's claim that Jane

44. Laura Mulvey, "Visual Pleasure and Narrative Cinema," *Screen* 16 (1975):13.

45. Jean Locquin, *La peinture d'histoire en France de 1747 a 1785* (Paris, 1911), 222.

46. Bryson, *Tradition*, 72.

47. Ellis K. Waterhouse, "The British Contribution to the Neo-Classical Style in Painting," *Proceedings of the British Academy* 40 (1954):72; see also John Barrell, *The Political Theory of Painting from Reynolds to Hazlitt* (New Haven, 1987).

48. See also many examples in Francis Haskell, *Rediscoveries in Art: Some Aspects of Taste* (London, 1976).

Austen's novels reveal "an intense moral interest of her own in life," or accept Fredric Jameson's claim that "the Jamesonian point of view ends up furnishing a powerful ideological instrument in the perpetuation of an increasingly subjectivized and psychologized world." Then we may question the current consensus about the importance of these novelists.[49] Many critical analyses of such living painters as Balthus and David Salle focus on the content of their art, which is perhaps pornographic. Moralizing influences our judgment of these artists' importance. Imagine then, a revisionist judgment of the quality of *The Oath of the Horatii*—this monument to patriarchy by a painter who (if we accept Brookner's account) was a hysteric, incapable of self-awareness; this work that (despite Crow's articulate pleading) is not really about 1789, even if the revolutionaries adopted it as an emblem; this work that (as Bryson observes) perpetuates rigid stereotypes of gender. Perhaps it is not a great painting. After all, if Caravaggio's recent rise to fame is due, in part, to gay politics, and if Piero's status derives from his appeal to modernist taste, then why should not these critical judgments of *The Oath of the Horatii*, which are so natural a product of the recent revisionist interpretations, lead us to question the claim that it is a masterpiece?

This question can be answered only by future artwriters. It is too soon to know whether the recent revisionist interpretations of David's work will lead to a reevaluation of the importance of his art. Like the art of Piero, Caravaggio, and Manet, David's paintings can be interpreted in diverse ways; Bryson's quasi-Lacanian framework leads to a quite different analysis than Crow's sophisticated Marxist approach or Brookner's concern with David's personality. What we still lack is a theory of narrative in David's art. Whether this situation reflects the limitations of the psychoanalytic and Marxist theories Bryson and Crow employ or the lack of a larger historical perspective, in any event *The Oath of the Horatii* remains somewhat isolated, its place in the history of art not clearly established.

Interpretation of David's painting thus conforms only in part to the model we found in the interpretation of Piero and Flemish allegory, and to some extent also in the interpretation of Caravaggio: a sharp historical

49. "Without her intense moral preoccupation she wouldn't have been a great novelist" (F. R. Leavis on Jane Austen, in *The Great Tradition* [New York, 1973], 7; Frederic Jameson, *The Political Unconscious: Narrative as a Socially Symbolic Act* (Ithaca, 1981), 221.

break between the seemingly simple early accounts and the complex interpretations of modern art historians. We might have expected that the role played in the discussion of Flemish painting by Panofsky's allegorical analysis of the *Arnolfini Marriage* would here be taken by Edgar Wind's essay on David. Wind claimed to provide a knockdown solution to the problems of *The Oath of the Horatii* by locating a text for the painting. He observed that as it contains no scene that matches David's image, Corneille's *Horace* cannot be the source. In the play, three swords appear, but they "are carried onto the stage by a subordinate character." Wind then argued that the painting was inspired by a ballet-pantomime. But on further investigation this claim was found to be unconvincing: there is no evidence that David saw the ballet; and in any case it did not look much like his painting. As further study has uncovered no other textual source, Brookner urges that we abandon the search for one "to concentrate on the emotional impact of the work. . . . this is very much closer to the facts of David's personality . . . than the attempt to recast him as a gentleman scholar, something of an archivist, collating one classical text with another and weighing up their relative merits as pictorial material."[50]

Bryson and Crow too acknowledge the fruitlessness of the search for a textual source. Bryson remarks that "David's presentation of the story is rather different from that of Corneille"; and Crow observes:

> [David's initial] conception was quickly abandoned for one that appears in none of the texts. . . . The public world of battlefield or civic square is no longer visible; the fatal pledge takes place in a private interior and within the bonds of the family. The final picture is fashioned out of nothing more than these minimal elements; the essential action of the story is present only by implication.[51]

Lacking a textual source, each artwriter must create a narrative placing the work. And although Crow, Brookner, and Bryson disagree, perhaps their different accounts are all convincing. Just as Caravaggio's works can be plausibly interpreted both as superb exercises in naturalism and as complex allegories, both as the work of an aggressive nonbeliever and as the work of a pious man, so here we have three plausible alternative

50. Brookner, *David*, 72.
51. Bryson, *Tradition*, 73; Crow, *Painters*, 213.

interpretations. Brookner treats the picture as an exercise in self-expression; Bryson, as an illustration of the politics of gender; Crow, as a revolutionary statement about pictorial composition—and all three of these apparently incompatible exercises in emplotment could be right.

The real disagreement among these three artwriters turns not on matters of fact but on methodology: should an artwriter's narrative discuss David's personal life, describe the politics of gender in his work, or place his work in the politics of his time? All three approaches can provide convincing accounts of the picture. As in the debate among Piero's interpreters, the one belief otherwise opposed artwriters seem to share is that only one account can be correct. They would do better to give up this belief.

Although this may be an apt response to a work whose textual and art-historical sources are so elusive, it does pose an interesting problem. Were David's painting and all reproductions of it destroyed, it would not be obvious that Brookner, Bryson, and Crow are interpreting the same image. In a curious way, David's inability to achieve a traditional unified composition is mimicked by his commentators, who say so much about the picture without really touching on one another's claims. The arguments about Piero's iconography or Caravaggio's sexuality may be impossible to resolve, but it is clear the commentators are arguing with one another. The debate about Flemish allegory may be open-ended, but Panofsky's account of the *Arnolfini Marriage* and Schapiro's analysis of the Mérode Altarpiece employ basic strategies most interpreters accept, even as they argue about points of detail. Because Wind's account has not played an analogous role in discussion of *The Oath of the Horatii*, the revisionist commentators lack a common starting point for their interpretations. This helps to explain why they have so much difficulty arguing with one another.

One consequence of revisionist art history is the abandonment of the claim that there is some single correct interpretive strategy, some master key to interpretation. With the abandonment of that claim, creative artwriters turn to differing techniques of emplotting. The absence of a strong tradition of commentary on David makes him an especially apt figure for such revisionist treatment.The above discussion of David raises two questions: First, what techniques of emplotment are available to the revisionist artwriter? And second, how are those techniques relevant to old-master art? The next two chapters offer answers to these questions.

PART THREE

·　·　·

Toward a Revisionist Art History

8

Where Is the Painting?
The Place of the
Spectator in Art History Writing

. . .

What narrative options are open to the present-day artwriter? The art historian requires a conception of the spatial position of the spectator, and her conception of the spectator's position influences her strategies of emplotment. I will introduce the discussion of the spectator's place by means of an analogy between the place of a spectator of a painting and the position of a viewer standing before a mirror.[1] All the problems

1. As the birth of illusionistic painting is tied to the use of mirrors, this is a natural analogy. On the history of perspective and mirrors, see Martin Kemp, "Science, Non-Science and Non-sense: The Interpretation of Brunelleschi's Perspective," Art History 1 (1978): 134–61. One standard older account of perspective is Richard Krautheimer, with Trude Krautheimer-Hess, Lorenzo Ghiberti (Princeton, 1982), chap. 16; the link with mirrors is also discussed in Hubert Damisch, "L'origine de la perspective," Macula 5/6 (1979): 112–37.

involved in analyzing a viewer's relation to her mirror image reappear, in more complex form, when we describe her place in relation to an artwork.

Mirror images seem simple, but they have surprisingly complex properties. Consider two different accounts of a spectator before a mirror. Because my point of view determines my location, it follows that when I see my reflection I am in front of the mirror.[2] The mirror allows me to see myself as others do, from the outside, enabling me to discover "that I have an outside in a way logically inseparable from my discovery that others have an outside."[3] The description of me looking at myself in the mirror contains a possible infinite regress: I see myself (seeing myself (seeing myself . . .)))).

Perhaps, however, there is no such infinite regress before that mirror image. The image reflects what is before the mirror. That image exists only in an imaginary space, a place behind the mirror surface accessible to sight alone. I can see my image, and so can you, but we cannot reach into that space to touch the image, though we can of course touch the mirror surface.[4] If an infant achieves self-awareness in part by observing its reflection, then it may be important that early on I saw *myself,* there in the space behind the mirror, *at some distance from my eyes.* If I am *in* the imaginary space, then no infinite regress can arise. Because I see myself in an imaginary space, it appears that I am not where my eyes are, but where I see them, in that space containing my mirror image.

Consider now two accounts of a spectator before a painting. Looking into the picture, I stand before an imaginary space whose contents, including mirrors or figures looking outward, are positioned in relation to my place outside that space. There are pictures like a mirror. Parmigianino's *Self-Portrait in a Convex Mirror* (Fig. 20) shows Parmigianino seeing himself (seeing himself (seeing himself . . .)))). At the moment when I "accept the illusion . . . of seeing an actual reflected image in an

2. Daniel Dennett, *Brainstorms* (Montgomery, Conn., 1975), 314.

3. Arthur Danto, *Jean-Paul Sartre* (New York, 1975), 10.

4. Jacques Lacan, "The Mirror Stage as Formative of the Function of the I as Revealed in Psychoanalytic Experience," in his *Écrits,* trans. A. Sheridan (New York, 1977), 1–7; "Some Reflections on the Ego," *International Journal of Psycho-Analysis* 34 (1953): 11–17; *Le séminaire, Livre II: Le moi dans la théorie de Freud et dans la technique de la psychanalyse,* ed. J. A. Miller (Paris, 1978), chap. 4. For commentary, see James W. Fernandez, "Reflections on Looking into Mirrors," *Semiotica* 30 (1980): 27–39, and Jacqueline Rose, "The Imaginary," in *The Talking Cure,* ed. C. MacCabe (New York, 1981), chap. 7; for the analytic literature, see Colin Radford, "Report on Analysis 'Problem' No. 19," *Analysis* 43 (1983): 113–15.

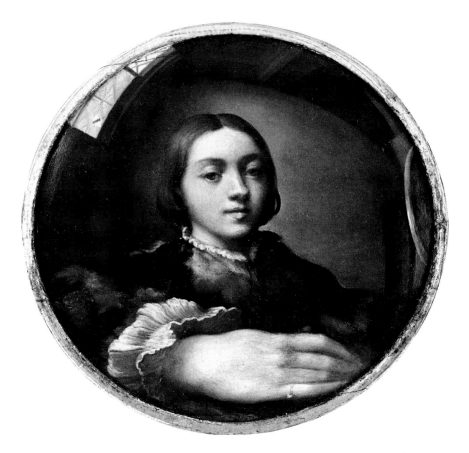

Fig. 20. Parmigianino, *Self-Portrait in a Convex Mirror*, Vienna, Kunsthistorisches Museum (photo: Kunsthistorisches Museum)

actual mirror," there is in that imaginary space no room for me.[5] The illusion is different in kind from that offered by a naturalistic image before which I am placed without any special account being taken of my identity as spectator, apart from my occupying a particular place before the depicted scene.

5. S. J. Freedberg, *Parmigianino: His Works in Painting* (Cambridge, 1950), 104.

Another way of understanding Parmigianino's painting, however, links the interpretation of it to the account of the spectator before the mirror. If I am located not where my eyes are but in the imaginary space behind the mirror, then there is no contradiction in assuming that I can view an image of Parmigianino. Standing before a mirror, I see myself located behind the mirror. Standing before his painting, I see him as if he were located behind the picture surface. As there is no infinite regress when I view myself in a mirror, on this analysis, so there is no infinite regress in Parmigianino's *Self-Portrait in a Convex Mirror*.

A painting need not contain a depicted mirror to raise these problems. Works in which a depicted figure gazes outward raise the same conceptual problems.[6] Aestheticians have had much to say about how the viewer sees a pigmented surface as a representation; they have had less to say about cases in which viewing an illusionistic image within a picture requires us to make implicit assumptions about an illusionistic space extending in front of the picture.

The place of the spectator before the picture as it is represented in artwriters' narratives can be expressed in terms of four transformations of one sentence:

> (1) I see the picture.
> (2) I see the picture and the figures in the picture see me.
> (3) The picture is seen.
> (4) It is not the case that the picture is seen.

The first view is held by Gombrich, the second by Steinberg, the third by Fried, and the last, so seemingly paradoxical view by Foucault. This listing, I believe, exhausts the alternatives discussed by present-day artwriters.[7]

It is easier to see the significance of (2), (3), and (4) if we first consider

6. When, for example, Saint Luke is depicted looking at us while painting the Madonna, how can we properly see that work without imagining ourselves to be her? (Leo Steinberg, "Velázquez' Las Meninas," *October* 19 [1981]: 46–47.)

7. My analysis is derived from Svetlana Alpers's discussion. She writes: "The Albertian picture [Gombrich's model] has been so dominant . . . that exceptions to it are rarely granted and attempts to analyze these exceptions . . . even rarer" (Svetlana Alpers, *The Art of Describing* [Chicago, 1983], 245). But where Alpers sees a binary opposition between the Albertian position of Gombrich on the one hand and the views of Steinberg, Fried, and herself on the other, I find a fourfold structure.

the most familiar position, Gombrich's view. Because his well-known account presents a seemingly commonsensical view, it is important to see exactly what assumptions it makes.[8] Looking out my window, I see a man in the distance. The questions "Who is he?" and "Where is he?" usually have determinate answers. Whoever he is, he is at some definite distance from me. When I view a naturalistic picture, it normally contains objects with a determinate identity and an unambiguous position.[9]

Steinberg, Fried, and Foucault analyze the spectator's role differently. They are systematic thinkers. Once we know how they deal with this issue in one text, we can predict what they will say elsewhere. Knowing Steinberg's essay on Caravaggio, we can predict his view of Jasper Johns, Michelangelo, Picasso, or Pontormo; having read Fried on Courbet, we can guess what he will say about Couture, Greuze, or modernism; Foucault's analysis of Velázquez's *Las Meninas* allows us to anticipate his interpretation of Magritte.

Steinberg introduces us to the dimly lit, apparently architecturally uninteresting Cerasi Chapel in the church of Santa Maria del Popolo by noting that normally visitors come only to see the Caravaggios. But we really "must begin before entering the chapel," which is a miniature cruciform church. The portraits invite us into the space as if onto "a stage while the play is in progress"; the vault panels relate iconographically to the Caravaggios below; the light source is "the painted heaven in the oval 'dome' of the crossing." Viewed frontally, Caravaggio's *Conversion of Saint Paul* and *Martyrdom of Saint Peter* are puzzling compositions. Only when we view them at a glancing angle, as they are represented in Steinberg's account, "which cannot be fully substantiated" by any photograph, do we see how Caravaggio took into account this site.[10]

Although there is no direct evidence, except for their very placement in the chapel, that the paintings were intended to be viewed at an angle, there is much indirect evidence. The first half of Steinberg's "Observations in the Cerasi Chapel" physically places us in the setting; the second

8. I discussed Gombrich's view in detail in *Artwriting* (Amherst, 1987), chap. 2.

9. When Steinberg denies that Leonardo's *Last Supper* "depicts one intercepted moment, a single instant," he find visual ambiguities where Gombrich believes there ought to be none. Steinberg suggests that Christ is so placed in relation to the pavement bands that "one cannot unthink the Passion on seeing Christ's feet joined on an upright stave" (Leo Steinberg, "Leonardo's Last Supper," *Art Quarterly* 36 [1973]: 298, 302).

10. Leo Steinberg, "Observations in the Cerasi Chapel," *Art Bulletin* 49 (1957): 186 n. 15.

half justifies that procedure by presenting the indirect evidence. Here
Steinberg must be speculative. To draw an analogy with church façades
viewed obliquely is to attribute to Caravaggio a rich imagination; to
point to his use elsewhere of intrusive spectators is to draw a complex
analogy between those other Caravaggios, in which the spectator's role
is implied by figures depicted within the painting, and the present pan-
els, which achieve the same effect using the setting in the Cerasi Chapel.
Steinberg places the paintings in historical perspective. The slightly ear-
lier Roncalli painting invokes a relation between a female saint gazing
skyward and a dove above, achieving by "architectural sculpture" effects
Caravaggio creates by "purely painterly means." Viewing these Cara-
vaggios as anticipations of the sculptures in the Cornaro Chapel implies
that there Bernini is engaged in a "transposition in sculpture of Cara-
vaggio's intuition."

The first half of Steinberg's essay offers a view of the actual site; the
second half concerns the larger context. To see these Caravaggios prop-
erly, it is not enough to see how they are placed in Santa Maria del
Popolo. Why does Steinberg think that further evidence is necessary? Is
he not willing to let us trust the immediate evidence of our senses? In
that case, the second half of his essay would be superfluous. But just as
he cannot believe that the diagonals in Michelangelo's *Last Judgment* are
accidental, so I cannot imagine that the second half of his text is super-
fluous. "As in any living encounter, any vital exchange, the work of
art becomes the alternative pole in a situation of reciprocal self-
recognition."[11] Taking seriously this idea of a reciprocal recognition be-
tween artwork and spectator, Steinberg reconstructs not just a relation
between the viewer and two panel paintings, but a context in which his
reader can be placed in response to these two Caravaggios, their setting,
and related sculptures, paintings, and buildings.

Steinberg constructs in his text a representation of this two-way
relation of artwork to spectator and spectator to artwork. By contrast,
Fried argues that Courbet's work characteristically effaces the presence
of its spectator. Where Steinberg finds a built-in spectator, Fried sees a
built-in nonspectator; and these different conceptions of the viewer
imply different narrative strategies. Steinberg describes the larger set-
ting of the Cerasi Chapel Caravaggios; Fried describes only the central

11. Steinberg, "Las Meninas," 54.

portion of Courbet's *Studio* (Fig. 21). That central portion depicts a painter, a model, a landscape picture, and a small boy. The painter is seated in a pose reminiscent of Courbet's self-portraits. "Pitched very near to the surface of the picture," the image of the sitter in *Man with Leather Belt* shows the painter translating "himself bodily into the painting on which he was working." In *Studio* the painter, in an only superficially different pose, turns toward his landscape as the earlier figures turn toward the spectator; the "obscure merging" of the painter's body with his landscape is "not unrelated to the implied dissolution of the boundary between the 'worlds' of painting and beholder" that we see in the earlier work. Comprehension of these parallels requires a digression from Courbet to Fried's larger claim: the aim of progressive painting of the time was "to establish the supreme fiction of the beholder's non-existence—the meta-illusion that no one was really there, standing before the picture."[12]

Fried's essay has three parts. The first and second parts introduce the self-portraits and Fried's general thesis about French painting, focusing on the figure in the central portion of *Studio* who manifests "within the painting an intense conviction of [Courbet's] own embodiedness." But a figure who faces his own canvas would seem to be very differently positioned than an artist facing us, and so Fried must supply an explanation of this change in orientation. *Bathers* depicts a woman from behind, as if "representing a relationship between [the painting] itself, imagined to be facing away from us, and a beholder who views it . . . from the other side"; *Wheat Sifters* shows someone "like the figure of the painter at his easel, absorbed in a task requiring sustained physical effort." The sifted wheat on the ground cloth bears a "surprising resemblance" to the trees at the top of the painting within *Studio*. The female figures in these two pictures stand both for the model in the central portion of *Studio* and for the landscape painting the artist there faces.

Were we inside the painting looking toward our actual position, we would face the woman in *Bathers*. But as we are not inside the painting, her presence facing away from us projects an ideal of "the painting as an object of desire with which union of a sort is not only conceivable but 'natural'." In *Studio* the "implied movement of the painter's lower body

12. Michael Fried, "Representing Representation: On the Central Group in Courbet's 'Studio'," *Art in America* 69 (1981): 131, 133, 168, 170.

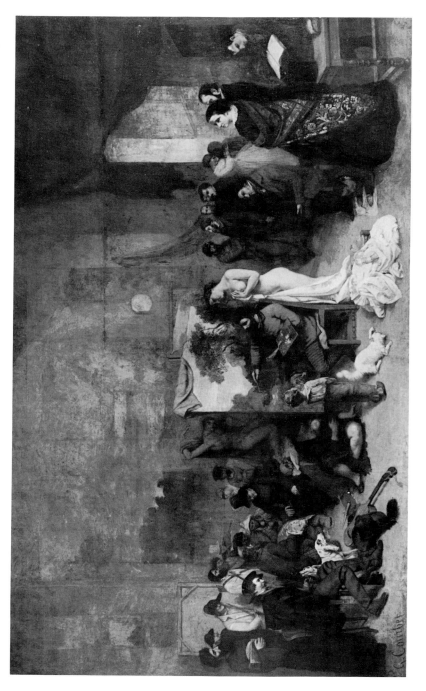

Fig. 21. Courbet, *The Studio*, Paris, Musée d'Orsay (photo: Service photographique de la Réunion des musées nationaux)

into the painting is reciprocated, or anticipated, by a counter-movement of the painting out toward the painter." The woman in Bathers stands "for the painting she inhabits," thus becoming for the spectator an "object of desire." Certainly it is hard to achieve an aesthetic distance from her. In Studio the female figure is behind the painter, but if we think of the landscape painting within the painting as a substitute for her, then we see the painter "already immersed in the painting on which he is working." The presence of the model reminds us that the artist "is physically subsumed . . . within the painting he is making." Bathers represents a viewpoint within the painting, facing the model; Studio, a place facing the landscape. In both works our intended viewpoint is inside the picture space.

Erotic images such as Courbet's are complex.[13] Steinberg imagines the artist as making visually accessible what cannot be seen from any one vantage point; Fried thinks of him as creating a space into which the spectator can be placed. For Steinberg, "if the fill of depicted space presses toward us, it also craves penetration, approaches to be approached, open-laned as it were, open to impalement or entry."[14]

Finally, we come to another figure in the center of Studio, the small boy. A late addition, this figure, a spectator outside the landscape, indicates the ultimate impossibility of absorbing the spectator into the work. Even as Courbet's picture seeks to absorb the viewer, it remains a panel we face. Even if it seeks to elide our presence, it is nevertheless visible to us only when we stand before its surface. Steinberg seeks to place us before the Cerasi Chapel Caravaggios, as if giving us enough information about the setting and historical context of those works would permit us literally to *see* the validity of his interpretation. Fried demonstrates that our proper place, strictly speaking, is within the painting. His observer must be "something other than an 'eye', a disembodied but spatially situated visual apparatus, in short the occupier of a point of view."[15] Yet as Fried's hesita-

13. Contrast Steinberg's analysis of Picasso's Figura Serpentinata, which makes available to the spectator viewpoints on the front, back, and sides of the model, with Fried's account of the spectator's position within Courbet's pictures (Leo Steinberg, Other Criteria [New York, 1972], 183).

14. Leo Steinberg, "The Polemical Part," Art in America 67 (1971): 121. Describing Picasso's landscapes, Steinberg quotes Nietzsche, whose words are relevant to both his and Fried's accounts: "The degree and kind of a man's sexuality reach up into the ultimate pinnacle of his spirit."

15. Michael Fried, "The Structure of Beholding in Courbet's Burial at Ornans," Critical Inquiry 9 (1981): 664.

tions indicate—Courbet desired that the beholder disappear into the painting, but "we cannot quite imagine what perfect success" in that undertaking "would mean"—the goal that he attributes to the painter is difficult even to describe.[16] The paintings can define this internal viewpoint only through some implied reference to our actual viewpoint, as when we view the figures in *Bathers* and *Sifters* from behind and imagine being before them, or see the artist in *Studio* as merging with his landscape.

This is not to make the obvious point that we cannot really go inside a picture space.[17] Only because we see the bather with her back to us, the painter merging into his canvas, the obelisk in David's *Bélisaire* marking our position within the picture space, only because there is in each painting some way for us to identify our would-be place within the picture, is Fried's conception of our relation to these pictures intelligible. The pictures contain a representation both of our place within them and of the image we would see from that point.[18] However difficult it is to imagine this place, it can be identified in a text. The guiding thread in Fried's essay is his argument that the orientation of depicted figures defines the spectator's place. If Courbet's depicted figure faces outward, the spectator stands in the picture; if the bather faces away from me, I must imagine myself facing her frontally.

These positions within the pictures show that Courbet's paintings are expanded "body-images" of Courbet "in the act and situation of painting." Courbet depicts himself; Courbet paints the landscape; Courbet represents the bather and the sifter: the recurrent figure in Fried's texts whose story is thus narrated, this figure depicted as absorbed in the painting, has a complex identity because she exists only if we accept Fried's argument. "The power of writing lies in its constant engagement to make a consistent whole, a character, out of what in

16. Michael Fried, "The Beholder in Courbet: His Early Self-Portraits and Their Place in His Art," *Glyph* 4 (1978): 116.

17. Apollinaire makes a joke of this: "M. Jourdain then turned on a landscape. He charged, running like a madman, but that painting of Cézanne's was not a canvas, it *was* a landscape. [He] dived into it and disappeared on the horizon, because of the fact that the earth is round!" (*Apollinaire on Art: Essays and Reviews 1902–1918*, trans. S. Suleiman [New York: 1972], 20).

18. This is why the artwork as such—the represented scene within *Studio* that we are to imagine seeing from inside the picture, for example—is not a physical object (Michael Fried, "Art and Objecthood," repr. in *Minimal Art: A Critical Anthology*, ed. G. Battcock [New York, 1968], 136 n. 10).

reality can only be an unordered series of experiences in an unrelated series of locations."[19]

Compare Fried's text to a novel. *Pride and Prejudice* is a story about Elizabeth Bennett because it is centered on her. It is more difficult to think of the figures identified by Fried as constituting a "character" of this sort, for the paintings in which he places them exist independently of his interpretation of them. Steinberg centers his narrative on the spectator, whom he aims to place ever more firmly within the Cerasi Chapel. Fried elides the spectator's presence, identifying a complex, almost unvisualizable positioning of her inside the artwork. What is essentially true of an artwork, many philosophers think, is that it excludes its spectators from the space it occupies. This Fried denies, and as for him the works he discusses have no place for the spectator except this space opened up within his texts, it is hard for him to understand how anyone might interpret them differently. A conciliatory reader might observe that viewing *Bathers* from the far side and *Bélisaire* from the obelisk would support Fried's interpretation, while doubting whether these are the only possible viewpoints on these paintings. But for Fried, even to speak of such *other* possible viewpoints is mistaken. The artworks as such—as distinguished, that is, from the paintings that we can all see—have built-in spectators, and so cannot be viewed from other positions.

Foucault's narrative is even more complex.[20] His account of *Las Meninas* (Fig. 22) falls into two parts: a discussion of the position of the painter and a parody of an attempt "to supply the plot—a little playlet ... of which this picture is a scene."[21]

"The painter is standing a little back from his canvas. He is glancing at his model ..." The "subtle feints" that Foucault then attributes to Velázquez occur here also in his own text, which imagines the painter as moving "in a moment," so that he will stand before the painting. Meanwhile, however, the painter is looking at us, at "our bodies, our faces, our eyes." Here momentarily it seems that Foucault is adopting Steinberg's

19. Alexander Nehamas, "Memory, Pleasure and Poetry: The Grammar of the Self in the Writing of Cavafy," *Journal of Modern Greek Studies* 1 (1983): 317.

20. Michel Foucault, *The Order of Things* (New York, 1973), 3–16.

21. Svetlana Alpers, "Interpretation without Representation, or the Viewing of *Las Meninas*," *Representations* 1 (1983): 33; see also John F. Moffitt, "Velázquez in the Alcazar Palace in 1656: The Meaning of the Mise-en-scène of *Las Meninas*," *Art History* 6 (1983): 295.

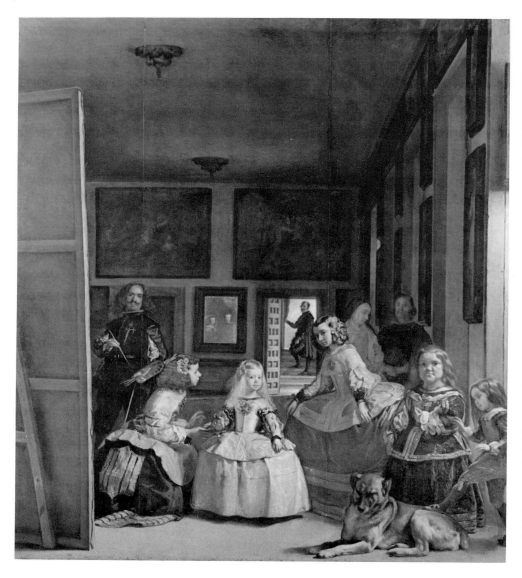

Fig. 22. Velázquez, *Las Meninas*, Madrid, Museo del Prado (photo: Museo del Prado)

vision of a reciprocal relation between painting and spectator: "As soon as they place the spectator in the field of their gaze, the painter's eyes seize hold of him, force him to enter the picture." Yet just when that relation seems about to be established, Foucault turns to the distant mirror in which "we can in fact"—in a moment he will deny this—"apprehend nothing . . . but its lustreless back." That mirror is described by a sequence of negations: it is not a picture like the other rectangles on the wall; the only visible representation no one looks at, it reflects nothing; it says "nothing that has not already been said"; unlike mirrors in Dutch paintings, it "shows us nothing of what is represented in the picture itself"; "it is not distorting any perspective."

Eventually, "rather than pursue to infinity a language inevitably inadequate to the visible fact," Foucault does name the figures reflected in the mirror. They are the king and queen. But he then immediately takes back that claim. If "what we see never resides in what we say," then better to bracket this information "and interrogate that reflection in its own terms." It has three functions: it echoes the reverse of the hidden canvas; it is windowlike; it "forms an opening," like the adjacent door. Canvas, mirror, door: these are "the three possible roles assignable to a picture plane."[22] The mirror is one center of the picture, the infanta another; and as "the fluttering attention of the spectator decides to settle in this place or in that," Foucault's text moves between these two places, coming to a halt only when it identifies a viewpoint "exterior to the picture." The real center, then, must be in the viewer, for when she sees the reflection, she "restores, as if by magic, what is lacking in every gaze."

The painting is like a perception lacking a perceiver until we attend to the royal couple, whose place "belongs equally well to the artist and to the spectator." But as we might expect of a writer who elsewhere questions the notion of an author, that location too is unstable. The physical absence of the reflected king "both conceals and indicates another vacancy," that of the artist who makes and the spectator who views the picture.[23] Even as "representation undertakes to represent itself . . . in all its elements," something is missing: the subject who views the scene. There is no place for a viewer either before or within the picture.

Reading an *Art Bulletin* article, I would expect to be able to paraphrase

22. Steinberg, *Other Criteria*, 74.
23. Foucault, *Order*, 16.

the argument in my own words. Describing a novel, I know that a para-
phrase leaves out the author's style. What makes analyzing Foucault's
"*Las Meninas*" hard is the difficulty of determining whether it is an art-
historical interpretation or a literary text. I will address this problem by
offering a two-stage narrative, first analyzing the argument, pretending
that Foucault is an art historian; then discussing his style.

The argument. Velázquez's mirror shows the royal couple; they see the
painter, and the spectator sees them viewing him. A closed system of
viewers and viewed is achieved only if the spectator is identical with the
royal couple, for then the tripartite relation is replaced by a dual one, the
royal couple—identified with the viewer—viewing the painter. Were we
able thus to place ourselves in the royal couple's position, the painting
would be a representation of the act of representation, an image includ-
ing its spectator. But how could any representation include within itself a
representation of the subject *for whom* it is a representation? One element
essential to classical representation cannot here be represented: "The
representation of visual space contains no suggestion of a subject."[24]

If this is Foucault's argument, then it is unexciting. *Las Meninas* reveals
nothing more than any mirror; Foucault makes a simple error in measure-
ment.[25] The mirror is to the left of picture center, and so must show
figures standing before the picture to the left; the spectator cannot be in
the position of the royal couple. Just as the viewer of any illusionistic
picture must imagine that she is facing the scene represented, so we
must imagine that we are standing next to the royal couple. We see them
beside us, and they do not see us.[26]

The style. When they concentrate on the mirror, Steinberg says, Fou-
cault's critics leave "a disproportionate acreage of the canvas . . . unac-
counted for."[27] Similarly, an account of Foucault that leaves such a dispro-

24. Ludwig Wittgenstein, *Notebooks*, 1914–1916, trans. E. M. Anscombe (New York, 1961), 74.

25. As independently noticed by Joel Snyder and Ted Cohen, "Reflections on *Las Meninas*:
Paradox Lost," *Critical Inquiry* 7 (1980); 429–47, myself, and no doubt other readers of John R.
Searle's essay "*Las Meninas* and the Paradoxes of Pictorial Representation," *Critical Inquiry* 6
(1980): 477–88. A fuller account is provided in Joel Snyder, "*Las Meninas* and the Mirror of the
Prince," *Critical Inquiry* 11 (1985): 539–73. All these accounts are criticized in Geoffrey Waite's
pungent essay "Lenin in Las Meninas: An Essay in Historical-Materialist Vision," *History and
Theory* 25 (1986): 248–85.

26. On such identifications, see the account of imagination in Richard Wollheim, *On Art and
the Mind* (London, 1973), chaps. 2 and 3.

27. Steinberg, "Las Meninas," 36.

portionate amount of his text unexamined cannot be satisfying. The unexamined assumption of my reconstruction of Foucault's argument is that he really thinks that the picture can be interpreted. The book in which Foucault's account is embedded, however, argues that the notion of representation is problematic. What better way to demonstrate the problematic character of representation than to show the difficulties with actually narrating an account of Velázquez's painting? Foucault can write his narrative only by appealing to a figure who appears nowhere in the picture, the spectator whose gaze, he says, completes the composition, a figure who is, in fact, "an essential void."

Foucault pretends that he can give a narrative; he asserts that we see nothing in the mirror; he confuses the mirror with a picture; and the function of all these statements, which he later retracts, is to exemplify the very failure of representation manifested in the picture. His essay is a splendid story about the nonexistence of the spectator, a story that can be told only after the playlet that Foucault deconstructs has been narrated. Foucault thus demonstrates that the spectator can stand neither before Las Meninas, in that reciprocal relation that Steinberg seeks, nor within it, as Fried might imagine. That double negation points to his essential strategy. Foucault both asserts and denies the reality of his representation even as he presents it. "Las Meninas" is a story about a painting, a story that denies its own presuppositions, negates its own starting point, and effaces its own attempt to represent the painting; the nonexistence of the spectator is demonstrated by the reader's ultimate ability to find even a fictively consistent role for herself within that narrative.

In chapter 6 I suggested that the different ways Winckelmann and Pater develop their oppositions reflect their authorial personalities; the same is true of Gombrich, Steinberg, Fried, and Foucault. Just as it is possible to link Winckelmann's fascination with the male nude and Italy to his unhappy youth and Pater's fascination with fatal woman to his aesthetic, so it is possible to link the work of these four artwriters with their lives. Gombrich and Steinberg were both emigrants. Gombrich, who chose to live in England, developed a theory of interpretation that emphasizes that successful images are unambiguous; he is not at home even with cubist art. Steinberg, a New Yorker by choice, is concerned to place the spectator in relation to the work, a concern that has ironically led him to the position of being called father of the postmodernist theories that assert that the relation of images to reality and to their spectators is

highly problematic. Fried pretends to efface himself, writing brilliant, highly personal accounts that he disguises under a formidable scholarly apparatus as art-historical interpretations. Foucault was a very knowledgeable epistemological nihilist, a cultural historian who perversely used his learning to write a narrative rejecting the very idea of comprehending history.

My aim is not to present a "psychobiography" of these men, but to indicate how their views of the spectator might be linked to their lives. What I seek is not to explain, or explain away, their work by appeal to their lives, but to note how artwriting always involves personal concerns. I do not criticize them for being subjective narrators. On the contrary, their "subjectivity" is one reason their texts are worth analysis. But if all strategies of emplotment have an inescapable personal dimension, how can there be objectivity in art-historical interpretation? Here I return to a question raised in Part One.

Steinberg's, Fried's, and Foucault's texts can be analyzed as if they were fictional narratives. What is the difference between an art-historical interpretation and a poetic or novelistic narrative? Freedberg's *Parmigianino: His Works in Painting* discusses Parmigianino's *Self-Portrait in a Convex Mirror*, as does John Ashbery's long poem of that title. Parmigianino, Freedberg says, was often concerned with "a strong connection with the spectator . . . effected through the gaze of a figure outward from the panel." He contrasts "the complex, delicate and hardly stable" equilibrium of Parmigianino's subjective composition with that of paintings of the High Renaissance, discusses the "response of astonishment in the spectator" to the "technical brilliance" of the *Self-Portrait*, notes that the mirror image and tondo form were novel, mentions Vasari's account, and describes in finely worked prose the effect of the sitter's face: "He emanates a gentleness and an unaffected grace which makes Vasari's judgment of *più tosto d'angelo che d'uomo* seem not exaggerated."[28]

Ashbery quotes Vasari, describes the figure's gaze and the geometry, quotes Freedberg, discusses Parmigianino's life during the sack of Rome, notes how artists may fail to achieve their intentions, and mentions mirror images:[29]

28. Freedberg, *Parmigianino*, 18, 106.
29. John Ashbery, *Self-Portrait in a Convex Mirror* (Harmondsworth, 1975), 68–83. A fuller commentary might appeal to Hegel's view: "[The wise man's] role is that of a perfectly flat and

> This otherness, this
> "Not-being-us" is all
> There is to look at
> In the mirror, though no one can say
> How it came to be this way.

Imagine, then, two texts, identical word for word—one published in the *Art Bulletin*, the other in *American Poetry Review*.[30] As Yeats turned Pater's account of the *Mona Lisa* into a poem by printing it in verse, so parts of Ashbery's text could be turned into art history by printing it as prose. Freedberg has a style, and Ashbery discusses art history. What justifies classifying one text as art history and the other as poetry? Perhaps we can say something more about why Ashbery's text is poetry.

> The soul establishes itself.
> But how far can it swim out through the eyes
> And still return safely to its nest?

Here we are taken far from specifically art-historical concerns.

> I think of the friends
> Who came to see me, of what yesterday
> Was like. . . .

The references are oblique. "One can make out individual words or phrases, but has no clear idea what the speakers are talking about."[31] Ashbery discusses Parmigianino:

> The shadow of the city injects its own
> Urgency: Rome where Francesco
> Was at work during the Sack . . .

indefinitely extended mirror" (Alexandre Kojève, *Introduction to the Reading of Hegel*, trans. J. H. Nichols, Jr. [New York, 1969], 176); and to Louis Marin's introduction to the French translation of Fried's *Three American Painters*, repr. in *Peindre: Revue d'Esthétique* 1 (1976): 245.

30. The importance of such examples in philosophy has been emphasized by Arthur Danto; see my discussion of his work in the overture to *Artwriting*.

31. Marjorie Perloff, *The Poetics of Indeterminacy: Rimbaud to Cage* (Princeton, 1981), 270.

and then goes on to make a more personal statement:

> Vienna where the painting is today, where
> I saw it with Pierre in the summer of 1959; New York
> Where I am now

Freedberg's personal statement is confined to the preface of his book.

Freedberg's text, however self-consciously stylish, ultimately returns us to the painting. Ashbery's poem, however concerned with art history, uses the painting as the pretext for an independent literary creation. What distinguishes them, then, is less that one is fiction and the other history than that Ashbery's text is too wide-ranging to count as an interpretation of *Self-Portrait*. Other interpreters can argue with Freedberg. Is he correct in claiming that "an intense psychological contact with the spectator through the direct gaze out of the picture opens the compositional maze"?[32] It would be more difficult to present an assertion about *Self-Portrait* that is contradicted by Ashbery's poem.

Gombrich's model of the viewer implies that artwriting can be transparent. The text describing a painting aims to place us before the work, without making reference to its own rhetorical role. Despite their differences, Steinberg, Fried, and Foucault agree that the strictly visual meaning of a painting can be properly understood only when the painting's place within their text has been understood. If the spectator can stand apart from the work she sees, then Gombrich is correct; an interpretation can efface the traces of the viewer's presence, mirroring the artwork as it really is. But even mirrors, as we have seen, are complex. Does the mirror show me myself standing before the glass, or does it show me in the imaginary space behind the glass? These two interpretations of mirror images, with their dramatically opposed implications, suggest two ways of thinking about paintings. An art historian's interpretation cannot be extracted without remainder from its literary context because that narrative may refer to the presence of the reader, who can stand before the painting.

32. Freedberg, *Parmigianino*, 18. Louis Marin, who is fascinated with Caravaggio's mirrors, offers a different account: "It would be possible to play with that effect of the surface . . . as seventeenth-century artists play with linear perspectives in anamorphic images" (Louis Marin, *Détruire la peinture* [Paris, 1977], 155).

One point discussed in this chapter remains unresolved—namely, the relation between Foucault's analysis and his style. Given that Foucault's analysis of the geometry of *Las Meninas* is defective, can his interpretation still be of interest? Before we can answer this question, we need a better understanding of the practice of art historians.

9

When Is the Painting?
The Temporal Place of the
Spectator in Art History Writing

· · ·

Panofsky's account of Poussin's two versions of *The Arcadian Shepherds* (Figs. 23 and 24) is a classic iconographic analysis, an exceedingly elegant presentation and solution of a pictorial puzzle.[1] Like his account of the *Arnolfini Marriage*, it has been embellished, but not seriously challenged. William Hazlett's account from a century earlier does not recognize the problem that concerns Panofsky: "The eager curiosity of some, the expression of others who start back with fear and surprise, the clear breeze playing with the branches of the shadowing trees, 'the valleys low, where the mild zephyrs use,' the distant, uninterrupted sunny prospect

1. Erwin Panofsky, "Et in Arcadia Ego: Poussin and the Elegiac Tradition," repr. in his *Meaning in the Visual Arts* (Garden City, N.Y., 1966), 312–13.

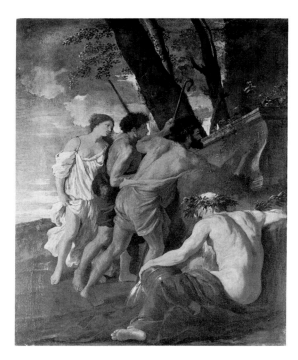

Fig. 23. Poussin, *The Arcadian Shepherds*, Devonshire Collection, Chatsworth (photo: Courtauld Institute)

speak (and for ever will speak on) of ages past to ages yet to come."[2] We have two paintings of this theme by Poussin and two readings of the phrase "Et in Arcadia Ego." Panofsky's "solution" to the puzzle posed by the two paintings and the two readings lies in his demonstration that each reading of the phrase provides an interpretation of one version of the picture.

Before Panofsky, nobody seems to have noticed the problem. "Et in Arcadia Ego" has two readings: "I, the person entombed here, also lived in Arcadia"; and "Even in Arcadia there is death." In the first, the words are spoken by a now dead Arcadian. In the second, an observation about

2. William Hazlitt, *Table Talk, or Original Essays* (London, 1908), 172–73. A footnote implies that here Hazlitt describes both versions of *The Arcadian Shepherds.*

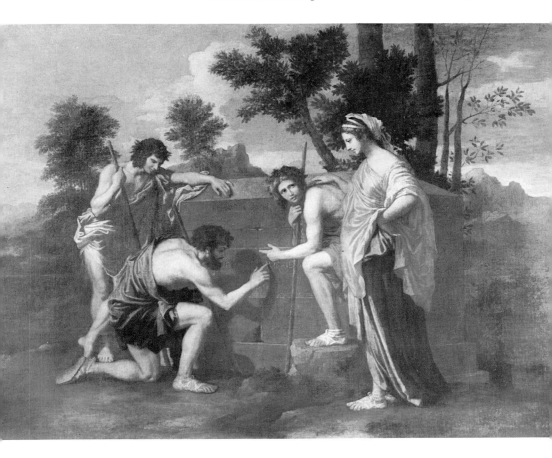

Fig. 24. Poussin, *The Arcadian Shepherds*, Paris, Louvre (photo: Service photographique de la Réunion des musées nationaux)

the inevitability of death in human life is made without reference to the presence of a speaker. This distinction between what linguists call the deictic and aorist tenses—between "utterance in carnal form," which "points back to the body of the speaker," and the description of an action "without involvement or engagement on the part of the speaker recount-

ing that action"—corresponds to the difference between Poussin's two images.[3] The picture illustrating the first reading of the phrase conveys a moralistic message. In the second "we can observe a radical break" with that tradition. There is "a basic change in interpretation. The Arcadians are not so much warned of an implacable future as they are immersed in mellow meditation of a beautiful past." Poussin changed his view of Arcadia in the course of his artistic development.

Panofsky's classic "solution" to this puzzle assumes that a picture should be given a unique interpretation, linked to one and only one text; each reading of the phrase "Et in Arcadia Ego" is illustrated by one picture.[4] His solution thus reflects the humanist assumption that the artist intended to present an unambiguous depiction. But once we question humanism, we notice how few unambiguous visual details Panofsky identifies. He writes that "the element of drama and surprise has disappeared" in the second version. Certainly the death's head has been eliminated, but is it obvious that the figures in the first version are "checked in their progress by an unexpected and terrifying phenomenon" and that only those in the second version are "absorbed in calm discussion and pensive contemplation"? Consider his eloquent description of the second version: "One of the shepherds kneels . . . as though rereading the inscription for himself. A second seems to discuss it with a lovely girl who thinks about it in a quiet, thoughtful attitude. The third seems trajected into a sympathetic, brooding melancholy." Is it clear that these words can apply to only one of the two paintings? Panofsky's analysis depends upon a controversial attribution of thoughts and sentiments to Poussin's actors. His interpretation is not necessarily supported by an analysis of the pictures' place within Poussin's development. The first arranges four figures in a recessive composition; the second, two reading figures and another looking at the fourth in a planar composition. This change from a baroque to a classical composi-

3. Norman Bryson, *Vision and Painting* (New Haven, 1983), 88. For a technical discussion, with historical background, see Ann Banfield, *Unspeakable Sentences: Narration and Representation in the Language of Fiction* (Boston, 1982).

4. See the useful account of Oskar Bätschmann, *Dialektik der Malerei von Nicolas Poussin* (Zurich, 1982), 64. The other recent revisionist account—Louis Marin's "Toward a Theory of Reading in the Visual Arts: Poussin's *The Arcadian Shepherds*," in *The Reader in the Text*, ed. S. R. Suleiman and I. Crowman (Princeton, 1980), the full version of which appears in Marin's book *Détruire la peinture*—does not make this point.

tion fits into a plan of development in which "the general change of content . . . is consistent with the more relaxed and less fearful spirit of a period that had triumphantly emerged from the spasms of the Counter-Reformation" only if Poussin's own stylistic development is retrogressive. He abandons the baroque influences of his youth in favor of classicism. For Panofsky, Poussin's personal development between the first and the second picture fits neatly within this larger framework.[5] Panofsky's historical narrative inserts these two pictures, painted within a few years of each other, into a panorama that takes us from Greek views of Arcadia to Renaissance ideas about death to later images of the same scene.

Panofsky's text is important because it both drew attention to puzzles unnoticed or not taken seriously by earlier writers and offered a solution to them.[6] Recent scholars accept Panofsky's interpretation without ex-

5. Morchard Bishop's 1952 extension of this account—"the idea of Communism did . . . in its inception spring from this root of Arcadia"—indicates the arbitrariness inherent in the emplotting of such a narrative (see Morchard Bishop, "The Natural History of Arcadia," *The Cornhill* 992 |Summer 1952|: 89). Anthony Blunt's account, however, does link the compositional change more completely to the change in the meaning of the phrase: "As befits this new conception of the subject, Poussin has eliminated all movement, and has changed the diagonal arrangement of the figures. . . . All sense of urgency has gone . . . the shepherds stand motionless in contemplation" (Anthony Blunt, *Art and Architecture in France 1500–1750* |Harmondsworth, 1970|, 286).

6. Consider three interpretations of the painting that fail to address Panofsky's concerns. For Jerome Klein, it was "no accident" that only in the second version is the woman "the only fully erect figure, her attitude denoting independence. . . . she is able to face with composure the prospect of final dissolution, since that nearer death of the sexual life, so much closer for women than men, holds no terror for her" (Jerome Klein, "An Analysis of Poussin's 'Et in Arcadia Ego,' " *Art Bulletin* 19 |1937|: 314). Panofsky's account of Arcadia discusses death, not reproduction; and he says nothing about gender roles in the picture. Although a speculative psychoanalytic account might link Klein's analysis with Panofsky's, Klein's observation has no obvious relation to Panofsky's account of Poussin's development of the motif.

Lawrence Steefel's recent interpretation does extend Panofsky's account; focusing on a hitherto neglected element, the shadow, he contrasts the earlier "basically centripetal, parenthetical symmetry of the compositional enclosure" with the later image, "figurally interplayed from our left to our right, culminating in the richly meditative and marvelling figure of the 'goddess' who gives visual stability and 'ponderance' to a complex yet integral heuristic pondering" (Lawrence D. Steefel, Jr., "A Neglected Shadow in Poussin's *Et in Arcadia Ego*," *Art Bulletin* 57 |1975|: 113). In the second version of the painting, the reading shepherd "is unaware of the ironic presence of his own shadow which . . . translates the older *memento mori* element of the iconography . . . into a transient phenomenon and a symbol of death." This is puzzling, for in both versions the man who casts the shadow looks toward it; in the second version one shepherd does point to the shadow while looking away, but why should we conclude that he is the reading shepherd?

tending it.[7] Comparison with an analysis of another painting by Poussin may help explain this situation.

Just as Poussin painted two versions of *The Arcadian Shepherds*, so he created two versions of the seven sacraments, one of which—the second version of *The Ordination of the Apostles* (Fig. 25)—has also received a complex iconographic reading. In the first version, Anthony Blunt writes, "the landscape closes the picture like a backcloth," whereas in the second the landscape is "planned in three dimensions," a slightly earlier moment in the ordination is illustrated, and a column with a carved E is added. It is this last feature that prompted Blunt's iconographic reading.[8] Although Blunt's interpretation has not attained the canonical status of Panofsky's reading of *The Arcadian Shepherds*, its argument is in some ways similar.

Why does Poussin's column show a carved E? The simplest theory, that the letter is an abbreviation for "Ecclesia," may be too simple. As Poussin was a highly intellectual artist, he may have intended a more complex symbolism.[9] Blunt says that the simpler theory "does not seem completely satisfactory," but he provides little argument to support that claim.[10] One

7. But whereas all later discussions respond to his account of the *Arnolfini Marriage*, it is possible to discuss Poussin's picture without dealing with Panofsky's interpretation. Why then has no art historian challenged that classic analysis? Friedlaender does claim that "Poussin's visualization" in the first painting "seems to substantiate the feeling and mood of either interpretation" (Walter Friedlaender, *Nicolas Poussin* [London, 1966], 116). He is not suggesting that the painting is polysemous, but observing that we lack sufficient evidence to provide a unique interpretation. Marin ("Toward a Theory," 322) does propose to "leave the inscription to its indiscernible meaning, an indeterminacy which may be the sense of Poussin's painting." But the argument he gives is unlikely to be acceptable to art historians.

8. Blunt, *Art*, 289.

9. The theory that the E is an abbreviation for "Ecclesia" is presented in Hans Wolfgang van Löhneysen, "Die ikonographischen und geistesgeschichtlichen Voraussetzungen der 'Sieben Sakramente' des Nicolas Poussin," *Zeitschrift für Religions- und Geistesgeschichte* 4 (1952): 146. None of the iconographic interpretations of this painting appeal to any earlier account derived from Poussin or his contemporary commentators.

10. The parallel Blunt adduces to support his interpretation—Panofsky's account of the letter Y in a painting entitled *The Choice of Hercules*—shows that "the idea of using a letter of this type as a kind of philosophical signpost would not be unique." But in that image the presence of the Y calls for some explanation, and the claim that it refers to Hercules' choice is confirmed by the very title of the work (Anthony Blunt, *Nicholas Poussin* [New York, 1967], 203). Panofsky's account provides no direct evidence about the *Ordination*. The recent catalogue by Nicholas Gendle, *Poussin: Sacraments and Bacchanals* (Edinburgh, 1981), 66, repeats Blunt's claim, but provides no new argumentation.

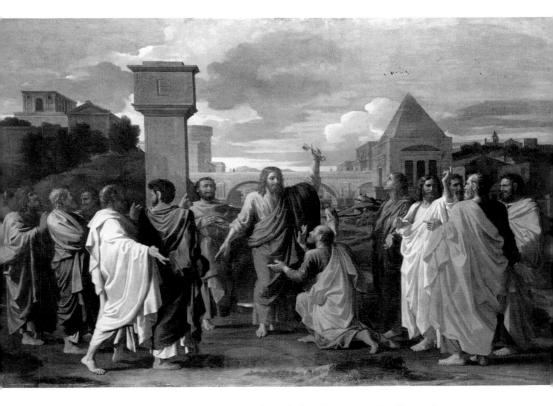

Fig. 25. Poussin, *The Ordination of the Apostles*, Edinburgh, National Gallery of Scotland, Duke of Sutherland Collection, on loan to the National Gallery of Scotland (photo: National Gallery of Scotland)

text known to Poussin, Plutarch's writing "The E at Delphi," offers an embarrassment of riches. The E at Delphi may stand for Delphi itself, where it appeared on a column; it may stand for the second vowel of the Greek alphabet; it may mean "if"; it may mean "thou art," indicating that god "has eternal being"; and it leads Plutarch into a sophisticated discussion of personal identity: "Dead is the man of yesterday, for he is passed into the man of to-day; and the man of to-day is dying as he passes into

the men of to-morrow. Nobody remains one person, nor is one person; but we become many persons."[11]

Each of these readings suggests an interpretation of the painting. Perhaps the placement of the apostles' ordination in Delphi implies a deep analogy between Christianity and paganism.[12] As E is the second Greek vowel, perhaps it signifies Christ, the Second Person of the Trinity. Perhaps Christ is saying to Peter, "If you take these keys, you will be head of the Church." And just as a man retains his identity over time, so the church remains the same church as members enter it or die.[13] Only the first of these interpretations has been seriously proposed. Some historians accept Blunt's claim that the apostles are in Delphi.[14] Other Poussin scholars, however, refuse to take it seriously.[15]

If no direct evidence supports Blunt's analysis, how might it be defended? The abbreviated word in the second version of the *Ordination*, as it is interpreted by Blunt, functions differently from the inscribed words in *The Arcadian Shepherds*. Compare the *Ordination* to the Poussin discussed in my account of *ekphrasis*. *Israelites Gathering Manna in the Desert* shows Old Testament Jews in poses that quote classical sculpture. No one has suggested that Poussin implies some deep relation between these Jews

11. *Plutarch's Moralia*, trans. F. C. Babbit (Cambridge, 1963), 5:245.

12. This interpretation was presented by Anthony Blunt in the catalogue of the 1960 Poussin exhibition; see *Exposition Nicolas Poussin*, catalogue by Anthony Blunt (Paris, 1960), 107.

13. The standard text on identity is David Wiggins, *Sameness and Substance* (Oxford, 1980).

14. These last three readings of the letter E given by Plutarch have not, to my knowledge, been developed by Poussin scholars, though they are all viable interpretations of the E in the painting. In his 1969 book Kurt Badt criticizes Blunt's 1960 analysis, arguing that we should look to Plutarch's text not just for a geographical reference, but for a statement about some deeper relation between Christianity and paganism. The E, he concludes, stands for "the answer of God to Moses: *Ego sum qui sum*" (Kurt Badt, *Die Kunst des Nicolas Poussin* [Cologne, 1969], 591–92). In his Mellon lectures published in 1967 Blunt adopts a similar approach. "A shorthand allusion to the theme of the painting," the letter E may signify either "the words spoken to Peter by Christ in the scene depicted, 'Thou art Peter. . . .' " or—if the artist "intended more than one kind of allusion"—a reference to "the parallel between the Sacraments and the Mysteries of the Greek religion" (Blunt, *Poussin*, 201). I may make too much of the distinction between this analysis and his 1960 account, but he does, I believe, modify or at least extend his earlier account, though without specifically indicating that he does so.

15. In both his early (1914) and his late (1966) books on Poussin, Walter Friedlaender ignores this E altogether, as does Christopher Wright in the most recent *catalogue raisonné*; and Doris Wild's 1980 book is skeptical about Blunt's argument (Walter Friedlaender, *Nicolas Poussin: Die Entwicklung seiner Kunst* [Munich, 1914] and *Poussin* [London, 1966]; Christopher Wright, *Poussin Paintings: A Catalogue Raisonné* [London, 1985]; Doris Wild, *Nicolas Poussin: Leben, Werk, Exkurse* [Zurich, 1980], 119).

and the pagan Greeks. As these classical sculptures were regarded as models of beautiful expressive images, it was natural for Poussin to quote them.

But the *Ordination* raises more complex problems. Poussin may merely imply that Christianity and paganism share some values, an idea supported by Blunt's account. But to place the apostles' ordination in Delphi is to do more than draw attention to parallels between Christianity and paganism. Understood literally, the image is anachronistic, presenting the apostles not in Palestine in the first century, but in Greece several centuries earlier. We are not puzzled when a quattrocento painting shows the crucifixion of Christ in a Tuscan landscape with figures in contemporary Italian dress. The artist makes the scene seem as real as possible by placing it in a contemporary setting. But Poussin was concerned with historically accurate images of sacred scenes.[16] What is the meaning of the apparent anachronism of his *Ordination*?

Christ and his apostles can only be in one place at one time, and to show them in Delphi is to depict them where Poussin knew they never were. If Blunt is correct, the *Ordination* is a temporally polysemous work, a single image sited in two different places referring to two distinct temporal moments. Although no Poussin scholar has posed the problem in this way, interpreters of another masterpiece from the same decade do raise such questions. The accounts of Rembrandt's *Night Watch* (Fig. 26) suggest how we might understand *Ordination*.

According to Alois Riegl, we can grasp the unity of *Night Watch* only by seeing the assembled men as responding to the spoken words of their captain:

> The command of the captain to the lieutenant is the theme; the group is a casual arrangement. . . . The inner unity of *Night Watch* refers therefore to their subordination to the captain.
>
> Thus seeing the depicted man as responding to those spoken words permits us to place ourselves in relation to these figures: the connection of the viewer to the picture is established not through mere attention, but through a direction of individual attention. The . . . extended hand of the captain permits no doubt

16. In his second version of the *Eucharist*, for example, he shows the apostles "lying on couches round the table—a point of archeological accuracy to which Poussin attached great importance" (Blunt, *Art*, 286).

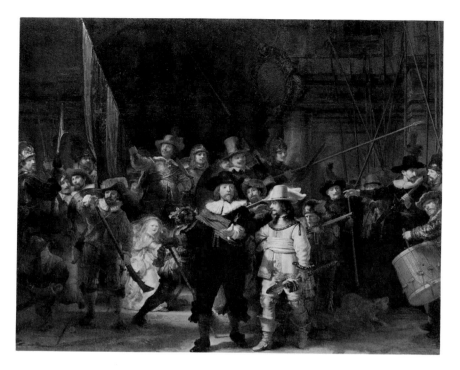

Fig. 26. Rembrandt, *The Night Watch*, Amsterdam, Rijksmuseum
(photo: Rijksmuseum)

that in the next moment the entire group, following this com-
mand, will move toward the viewer.[17]

Like Steinberg, Riegl emphasizes the mutual relationship of picture and
spectator; without the spectator's presence, the composition remains
incomplete.[18] What today seems dated about Riegl's account is the sug-

17. Alois Riegl, *Das Hollandische Gruppenporträt* (Vienna, 1934), 193, 194, 199.
18. This account, though it has not been generally accepted, is supported by the writings of at
least one other art historian and one creative writer. Christian Tümpel argues that Rembrandt,
unlike earlier Dutch painters, unites in a single image a group portrait and a scene of marching
men; Paul Claudel says that the effect of this forward movement is to transform the spectator into

gestion that Rembrandt's paintings can be interpreted as if they were photographs.[19] E. Haverkamp-Begemann, who is not unsympathetic to Riegl's account, argues that Night Watch is not just a genre scene but a group portrait that also contains three figures who "are purely symbolic—the musket-shooting boy and the girls in yellow. . . . [Rembrandt] emphasized their symbolic nature by giving their action a direction contrary to that of the citizens."[20] Just as the Ordination is ambiguously sited, so here Rembrandt too creates a temporally polysemous work, placing his depicted figures at two distinct sites in two different times. The archway in Night Watch, similar to that in Rembrandt's etching The Triumph of Mordecai, signifies a parallel "between Mordecai, who delivered the Jews from the destruction plotted against them by Haman, and the Amsterdam militia, who had protected the city . . . most recently against the Spaniards."[21] Poussin depicts Christ and the apostles in Delphi; Rembrandt shows Captain Cocq and his men as the saviors of Amsterdam, seventeenth-century Dutch equivalents to Mordecai.

In linking Night Watch to The Triumph of Mordecai, Haverkamp-Begemann asserts that Rembrandt did not present Captain Cocq's company "as participating in a historical event . . . [rather] he painted in accordance to his imagination." The two works show similar scenes; in both "the two principal figures are placed to the right of center . . . walking towards the viewer . . . com[ing] forth from an archway, in [which] . . . they are in the process of changing directions." Contemporary Dutch writers draw parallels between Old Testament events and occurrences of their own time. Mordecai's triumph was once adduced "as a historical parallel to contemporary militia companies." As Rembrandt makes similar allusions "later and more directly" in The Conspiracy of Claudius Civilis, "it therefore seems possible" that the parallels between Night Watch and The Triumph of Morde-

an actor in Rembrandt's scene (Christian Tümpel, "Beobachtungen zur 'Nachtwache,' " Neue Beiträge zur Rembrandt-Forschung, ed. O. von Simson and J. Kelch [Berlin, 1973], 173; Paul Claudel, Introduction à la peinture Hollandaise [Paris, 1938], 99).

19. Criticizing a similar account of The Syndics, an art historian complains: "It is being tacitly assumed that everything to be seen in it reflected a single real-life situation, preferably at a glance, an idea that prepared the way for naturalism" (H. van de Waal, Steps towards Rembrandt, trans. P. Wardle and A. Griffiths, ed. R. H. Fuchs [Amsterdam, 1974], 251).

20. E. Haverkamp-Begemann, Rembrandt: 'The Nightwatch' (Princeton, 1982), 109–110.

21. E. Haverkamp-Begemann, "Rembrandt's Night Watch and The Triumph of Mordecai," Album Amicorum J. G. van Gelder, ed. J. Bruyn et al. (The Hague, 1973), 6–7.

cai are "not purely formal." Rembrandt "may have thought that the role of the militia company was not incompatible with that of Mordecai."[22]

As with the Poussin interpretations of Panofsky and Blunt, each stage in this argument can be questioned. That Rembrandt used his imagination does not necessarily show that he created a scene with symbolic figures; that contemporary writers drew parallels between Old Testament events and Dutch politics does not show that painters also did; that a similar allusion appears in a later Rembrandt does not show that *Night Watch* anticipates the later theme. Any interesting interpretation, however, must go beyond the facts. The claim that Rembrandt placed symbolic figures in *Night Watch* to create a temporally polysemous image offers one re-creation of his activity. The claim that the picture is just a very skillful group portrait offers a different re-creation of that activity. The more parsimonious account, as well as the most speculative interpretation, must go beyond the undisputed visual evidence.

Only specialists can participate in this ongoing debate between those who favor a straightforward account of *Night Watch* as a group portrait and those who either, with Riegl, see it as involving the creation of a novel pictorial unity that refers to the presence of a spectator or, with Haverkamp-Begemann, see it as containing symbolic figures. But this debate can help us understand Poussin's *Arcadian Shepherds* and *Ordination*.

Words may be used either to place a depicted scene at one temporal moment or to make the temporal position of a scene ambiguous in a temporally polysemous picture. Because the aorist tense narrates an action impersonally, a picture using words in that tense has no particular temporal relation to the spectator. According to Panofsky, the inscribed words in the second version of *The Arcadian Shepherds* do not place that scene at any particular moment in time. The words "Even in Arcadia there is death" are not uttered by any depicted speaker. For Riegl, by contrast, in *Night Watch* the deictic tense is employed. Captain Cocq issues his command, and we see his troop marching toward us "right now," in the immediate implied present of Rembrandt's images.

Images, unlike sentences, usually lack temporal reference. We illus-

22. Gary Schwartz's claim that some of Rembrandt's very early works also are temporally polysemous—the correct title of Rembrandt's earliest known painting, he argues, is *The Stoning of St. Stephen: A Biblical Analog to the Execution of Johan van Oldenbarnevelt*—could also support this analysis (see Gary Schwartz, *Rembrandt: His Life, His Paintings* [Harmondsworth, 1985], 38; for his account of *Night Watch*, see 209–13). His account of *Night Watch*, is however, is un-Rieglian.

trate the statements "I was in Rome," "I am in Rome," and "I will be in Rome" by adding to a picture of me in Rome words indicating the time of that picture. As we saw in chapter 8, the question "*Where* is the depicted scene?" is familiar to artwriters. The question "*When* is the depicted scene?" is less frequently asked. Normally, viewing a history painting tells us when the scene takes place. An image of Christ is set in his time, as a picture of Moses is set in his. But as we have seen, Poussin's *Ordination* and Rembrandt's *Night Watch* may have complicated temporal settings. The former does not show just a scene from the first century A.D.; the latter does not show merely a group portrait from the 1640s.

Many baroque artworks place the depicted scene in the viewer's present. These I call deictic images. Caravaggio's eye-catching self-portrait in *The Martyrdom of Saint Matthew* reminded Catholics of the Counter-Reformation that "dying for the faith was a contemporary reality."[23] Walking under the main dome of the church of Santa Maria della Vittoria, we see Bernini's *Ecstasy of Saint Theresa*, vividly present to the spectator, who, "coming from his world as the Cornaro effigies have come from theirs, also sees the truth and bears witness to Teresa's glorification in the love of God and of the sacrament."[24] Such deictic images invoke the spectator's presence. Aoristic images, by contrast, appear complete in themselves, making no reference to the viewer. In the first version of *The Arcadian Shepherds*, as interpreted by Panofsky, and in *Night Watch*, as interpreted by Riegl, words are spoken by depicted figures. In the second version of *The Arcadian Shepherds* and in the *Ordination* the written words are spoken by no one. Just as in a novel the use of the deictic tense places the reader in the fictional present of the speaking character, so in deictic paintings spoken words place the viewer in the pictorial present of the figures who are shown speaking.

That deictic images show both events from the distant past and scenes of the viewer's time need not be paradoxical. Readers easily shift back and forth between the "temporal present" of the narrative, the fictional present created in the novel, and the real present time at which they are reading.[25] If the equivalent transition seems more complex in viewing

23. Howard Hibbard, *Caravaggio* (New York, 1983), 104.

24. Irving Lavin, *Bernini and the Unity of the Visual Arts* (New York, 1980), 97–98.

25. A clear discussion of this appears in Gérard Genette, *Narrative Discourse: An Essay on Method*, trans. J. E. Lewin (Ithaca, 1980).

pictures, that is perhaps because the photograph, an indexical image that usually is "of" the moment when it was made, influences how we see old-master paintings. But as paintings, unlike undoctored photographs, are not the product of a causal relation between the image surface and what is represented on that surface, they need not be "of" the moment when they were produced. A painting can unparadoxically represent events of two different times.[26]

Quattrocento Florentines were advised to pray by envisaging the scenes of the Passion as if they were taking place in their native city. This practice provides a way of understanding the seemingly paradoxical quality of temporally polysemous paintings that depict sacred events from the distant past in surroundings from the artist's own time. Like those paintings, the mental images described in the quattrocento prayer handbook conjoin historically distant sacred events with scenes from contemporary life. As the mental image recommended to the pious worshiper sites the stations of the cross in quattrocento Florence, so the *Ordination* refers to two spatial locations and two distinct temporal moments, and *Night Watch* to two distinct temporal moments, the time it was painted, 1640, and that moment in the viewer's present when she imagines hearing Captain Cocq's command.

What evidence do we have that painters of the 1640s intended to create such artworks? The weakness of Blunt's, Haverkamp-Begemann's, and Riegl's interpretations is that they present no direct evidence that the pictures they discuss are temporally polysemous. As we have seen, however, only rarely can interpreters of Piero, Caravaggio, or Flemish allegory appeal to such direct evidence. Three kinds of indirect evidence support the claim that paintings from the 1640s are temporally polysemous: the concept of *figura* in scriptural exegesis; the art of memory; and the Elizabethan masque.

Originally *figura* meant "plastic form" or "outward appearance," but in a

26. Quattrocento sacred images provide an earlier model of deictic paintings. The artist was a "visualizer of the holy stories," but "the public mind was not a blank tablet on which the painters' representations . . . could impress themselves"; spectators came to paintings with definite expectations about how those sacred scenes ought to appear. Paintings of sacred scenes were public versions of the "private" mental images devout believers invoked in everyday prayer. The best way to pray, a quattrocento handbook urges, is to fix the "sacred places and people in your mind . . . taking a city that is well known to you. In this city find the principal places in which all the episodes of the Passion would have taken place . . ." (Michael Baxandall, *Painting and Experience in Fifteenth Century Italy* [Oxford, 1972], 45–46).

curious reversal, it came to refer to "the hidden allusion . . . something which for political or tactical reasons, or simply for the sake of effect, had best remain secret or at least unspoken." For Christians, "persons and events of the Old Testament were prefigurations of the New Testament." Adam "provided a figure of Christ." To treat an earlier event as a *figura* of a later one, Tertullian asserted, is not to deny the literal reality of the earlier event. Moses is a "*figura* of Christ . . . but also a historical reality. Real historical figures are to be interpreted spiritually . . . but the interpretation points to a carnal, hence historical fulfillment." To interpret the Old Testament allegorically is to treat it as prefiguring what will come; to read it as merely a history is to deny that it prefigures the future. To treat it as *figura* is to identify two poles "separate in time, but both, being real events . . . within time."[27]

Just as Moses is both a *figura* of Christ and a real historical personage, so Poussin's apostles are Christians set in classical Delphi, and Rembrandt's watchmen are both the men Rembrandt portrayed and Old Testament figures. Such visual *figuras* show two distinct historical moments within one image. Both events are equally real; the earlier scene is not merely a symbol of the later. Medieval and Renaissance texts that discuss disguised symbolism give indirect support to Panofsky's discovery of disguised symbolism in Flemish art. Similarly, the tradition of figural readings of Scripture provides indirect evidence for interpreting the *Ordination* and *Night Watch* as visual *figuras*.[28]

The art of memory originated in the need to "deliver long speeches from memory with unfailing accuracy . . . in the ancient world, devoid of printing, without paper for note-taking." The orator memorized his speech by recalling places in real or imagined buildings, each associated with an image "which he visualizes within, as though it were the art of some consummate painter."[29] Public speaking depended upon a system of visual representation, upon the mental images that an orator commit-

27. Erich Auerbach, "Figura," in his *Scenes from the Drama of Western Literature*, trans. R. Manheim (New York, 1959), 11, 20, 27, 30, 34, 53. For a discussion of the practice of the interpretation of Scripture in Rembrandt's Holland, see Christian Tümpel's "Iconographic Essay" in *The Pre-Rembrandtists*, ed. Astrid Tümpel (Sacramento, 1974), 128–30.

28. In one way, however, allegories and visual *figura* differ. In the allegorical interpretations of the *Arnolfini Marriage* and the Mérode Altarpiece there is a strong suggestion that the things depicted are mere stand-ins for what they symbolize. The candle van Eyck depicts is a symbol of God's presence. By contrast, visual *figuras* both represent real things and are symbols.

29. Frances Yates, *The Art of Memory* (Chicago, 1966), 2, 4, 19.

ted to memory.[30] These mental images are like paintings. Artists were perhaps influenced by this widely known technique.[31]

Unlike modern plays, which typically distinguish between the imaginary world of the actors performing on stage and the spectators in the audience who observe their performance, the Elizabethan masque involved both actors and real figures, such as the king, who must in the performance retain their real-world identities: "The monarch was at the center, and [the masque] . . . provided roles for members of the court within an idealized fiction . . . [that] opened outward to include the whole court. . . . What the noble spectator watched he ultimately became."[32] A modern theatrical performance often provides an escape from everyday

30. According to Plato, the essential defect of writing is that it corrupts men's natural memory. But as public speaking in the ancient world depended upon a system of inner representations, the contrast here is not between what men say naturally and what they are enabled to say by a system of representation, writing, but between two rival systems of representation: the orator's mental images and the writer's texts. All public speech is thus "corrupted" by reliance upon a system of representation. I borrow this argument from Jacques Derrida's discussion of the *Phaedrus* in *Dissemination*, trans. B. Johnson (Chicago, 1981).

31. Giotto's images of the virtues and vices look like memory images; a fourteenth-century representation of hell is akin to a memory image; and a depiction of Saint Thomas Aquinas "may not only symbolise the extent of Thomas's learning but . . . also allude to his method of memorising it by the art of memory." Nevertheless, Yates finds no direct evidence that paintings were compared with the images used in the art of memory (Yates, *Art*, 92, 94, 121). The further discussion in her *Giordano Bruno and the Hermetic Tradition* (Chicago, 1964) and *Theatre of the World* (Chicago, 1969) does not provide additional evidence. Just as the seicento commentaries on Caravaggio's naturalism can be variously interpreted, so there are two plausible ways of explaining this absence of direct evidence of a connection between painting and the art of memory. Perhaps the art of memory was so well known that there was no need to mention its relevance to painting. Alternatively, maybe the belief that mental images can be turned into paintings by being copied onto an external surface—which assumes that the only difference between mental images and paintings is that the former are inner and "private" and the latter outer and public— is plausible only within the framework of the Cartesian philosophy of mind that arose at the end of the era of the art of memory. The historical account in K. V. Wilkes, *Physicalism* (London, 1978), supports this claim, as does Yates's discussion of Descartes' hostility to the art of memory. One passage in Descartes explicitly assimilates mental images to pictures: "Engravings . . . represent to us forests, towns, men and even battles and tempests. And yet, out of an unlimited number of different qualities that they lead us to conceive the objects, there is not one in respect of which they actually resemble them, except shape. . . . We must hold a quite similar view of the images produced on our brain . . . the problem is to know how they can enable the soul to have sensations of all the various qualities in the objects to which the images refer" (*Descartes: Philosophical Writings*, trans. and ed. E. Anscombe and P. T. Geach [Indianapolis, 1971], 244).

32. Stephen Orgel, *The Illusion of Power: Political Theater in the English Renaissance* (Berkeley and Los Angeles, 1975), 39. Hence Queen Elizabeth's remark: "We princes . . . are set on stages, in the sight and view of all the world duly observed" (Orgel, *Illusion*, 42).

life. The masque was an explicit statement about political reality. "Every masque is a ritual in which the society affirms its wisdom and asserts its control of its world and its destiny."[33] Reality and illusion merge in the masque, which culminated in "the removal of masks so that 'all were known' and the revelation that the chief masquer is also the king. . . . With the king's unmasking, . . . the admiration of spectator for dancer turned necessarily to the homage of subject for sovereign."[34]

A letter by Poussin or archival evidence about Rembrandt's patrons is direct evidence for interpreting the artist's work. By contrast, indirect evidence involves conceptions of visual imagery that could have been known to Poussin or Rembrandt in the seventeenth century. Going back to examples from earlier chapters, let us consider some problems with indirect evidence. Are Caravaggio's early works homoerotic? A verse of 1632 says:

> [To the Italians it is] a peasant pastime,
> making songs and singing Sonets
> of the beauty and pleasure of their Bardassi,
> or buggerd boyes.[35]

As this verse was published in England, however, it provides little evidence about sexual practices in Caravaggio's Rome.

Does Joseph make a mousetrap in the Mérode Altarpiece? Consider another English verse:

33. Stephen Orgel and Roy Strong, *Inigo Jones: The Theatre of the Stuart Court* (London, 1973), 113.

34. Stephen Orgel, *The Jonsonian Masque* (New York, 1981), 32. This was a very real practical problem with the masque: "It created its own reality, and having done so, could control it without difficulty. . . . the sometimes dangerous confusion of royal power within the performance and in the real world was always present" (Orgel and Strong, *Inigo Jones*, 63). Orgel offers one wonderful example of the relation between illusion and reality. In Ben Jonson's *Mask of Proteus and the Adamantine Rock*, the villain "hides a sword on stage in preparation for committing a murder during the interval between acts—a time that, as far as the other characters are concerned, does not exist" (Orgel, *Jonsonian Masque*, 15). The studies I cite deal only with Elizabethan masques. In England there was no tradition of history painting; Orgel and Strong note that English observers had some difficulty understanding the visual conventions of the masque: it took people a long time to learn the visual rules of the new art. "For the first twenty years . . . Jones provided an annual spectacle of Renaissance art appreciated only by the Venetian ambassador" (Orgel and Strong, *Inigo Jones*, 37).

35. The epigraph to Donald Posner, "Caravaggio's Homoerotic Early Works," *Art Quarterly* 34 (1971): 302.

The humble Joseph, so *genteely* made,
Poor Gentleman! as if above his trade,
And only fit to compliment his wife;
So *delicate*, as if he scarcely knew
Oak from deal-board, a gimlet from a screw,
And never made *a mouse-trap* in his life.[36]

Because this is a late eighteenth-century verse, it provides little evidence about symbolism in Campin's painting.

By contrast, what makes the concept of *figura*, the art of memory, and the Elizabethan masque good indirect evidence is that they were present within the culture of Rembrandt's and Poussin's time. We need not ask whether a painter working in New York in the late 1940s knew about psychoanalysis or *Ulysses* to interpret his work in terms of ideas that formed part of the common culture of that time, absorbed by even the least bookish of artists. Similarly, as Dutch theologians of the seventeenth century discussed *figura*, and Bernini was an accomplished set designer, we may seriously consider interpretations of Rembrandt's and Poussin's paintings based on such indirect evidence. Humanists are confused about this point. What is at stake, they think, is a matter of fact. Either Poussin was influenced by Campanella or he was not. All we need ask, I claim, is whether Campanella's ideas, which were available in Poussin's world, provide a convincing way of interpreting that artist's paintings.[37]

We need not appeal to either recent analytic philosophy or poststructuralism to show the limitations of the humanist's analysis. Consider a well-known example from historiography. Why was the golden age of the Dutch Republic accompanied by great painting, but not by great literature?[38] To answer that question we need not consider only the recorded

36. Quoted by Hamish Miles, "The Mérode Mousetrap," *Burlington Magazine* 108 (1966): 323.

37. When Blunt argues that Poussin's late work was influenced by the utopias of Tommaso Campanella, he regrets his inability to offer direct evidence of this claim. The fact that Campanella and Poussin had mutual friends is, he thinks, helpful in demonstrating such an influence (Blunt, *Poussin*, 327–31). What is at stake, for Blunt, is a matter of fact. Either Poussin was influenced by Campanella or he was not. All we need ask, I claim, is whether Campanella's ideas, which were available in Poussin's time, provide a convincing way of interpreting that artist's paintings.

38. See J. L. Price, *Culture and Society in the Dutch Republic During the Seventeenth Century* (New York, 1974), and the classic account of J. Huizinga, *Dutch Civilization in the Seventeenth Century* (London, 1968).

views of seventeenth-century Dutchmen. Our historical perspective and the tools of modern historiography may permit us to understand the age better than any Dutchman of the time could. As the golden age of Holland was a collective creation, no single individual then living may have understood it as well as we can today.[39] Our goal would be to produce the best possible account of that age, and though we would be interested in what figures of that time had to say about themselves, we would not limit ourselves to re-creating their worldview.

The same point applies to interpretations of Poussin's *Ordination* and Rembrandt's *Night Watch*. Once we abandon humanism, we recognize that the goal is to produce the best possible account of these paintings, using direct and indirect evidence. The test of these interpretations, as of interpretations of Piero's iconography, Caravaggio's symbolism, Flemish allegory, and David's depictions of gender relations, is not, as the humanist thinks, whether they match some hypothetical reconstruction of the artists' intentions. That test is both useless in practice, as we can have only indirect knowledge of those intentions, and methodologically flawed. The right test is simply whether these interpretations help us understand the paintings.

Interpretation as practiced by Panofsky, Blunt, Haverkamp-Begemann, and Riegl involves empirical holism. A historian of the golden age of the Dutch Republic must decide whether discussing seventeenth-century England and Spain, new technology, imperialism, religious struggles, class conflicts, psychobiographies of key figures, and the Muslim world helps her to explain that age. An interpreter of the *Ordination* and *Night Watch* must consider whether appeal to *figura*, the art of memory, and the masque is useful. Nothing is gained here by a humanistic appeal to the artists' intentions.

What perhaps discredited traditional holistic historical explanations was the Hegelian belief that a given culture at a given time must possess a unity. If we accept this belief, then we need to explain how *Night Watch*

39. The best-known discussion of historical explanation is Arthur C. Danto, *Narration and Knowledge* (New York, 1985). Richard Wollheim seemingly argues that the denial of humanism leads to purely arbitrary art-historical interpretations: "Where the view is taken that criticism is at liberty to project on to a work of art . . . whatever it finds original or suggestive or provocative . . . critics . . . cut off the branch on which they sit . . . relegat[ing] art to the status of nature" (Richard Wollheim, *The Sheep and the Ceremony* [Cambridge, 1979], 13). This I deny; giving up humanism does not mean abandoning standards by which to judge interpretations of artworks.

can be temporally polysemous. At about the time it was painted, Spinoza wrote: "We should depart as little as possible from the literal sense . . . first ask[ing] whether this text . . . admits of any but the literal meaning. . . . If no such second meaning can be found the text must be taken literally."[40] Rembrandt's temporally polysemous painting is "contradicted" by Spinoza's text.[41] If Poussin's *Ordination* is better understood in relation to *Night Watch*, the art of memory, and *figura* than in the context of Bernini's sculpture, the painting of Pietro da Cortona, and Catholic theology of the 1640s, that only shows that we cannot predict how best to interpret a work.

My argument that Panofsky's interpretation of *The Arcadian Shepherds* depends upon an elegant matching of the two readings of "Et in Arcadia Ego" with the two pictures may have appeared critical of his analysis. That, however, is not quite what I intended. Panofsky's essay is a brilliant exercise in rhetoric that deserves its canonical status because it is original and suggestive. Panofsky's key assumption is that because the correct interpretation identifies the artist's intention, there is only one correct way of matching image to words. But Panofsky's essay can be admired by the antihumanist. Placing Poussin's artwork in context by constructing a convincing text need not involve re-creating the inner mental state of the artist.

The humanist believes that when this inner state is described, it may then be matched with the visual image: a proper interpretation identifies

40. Baruch Spinoza, A *Theological-Political Treatise*, trans. R.H.M. Elwes (New York, 1951), 102.

41. It is salutary to observe the problems in a sublimely naive account of Rembrandt and Spinoza: "The two geniuses . . . must have met more than once in the street. But each was so absorbed with his own thoughts that he did not recognize the other, not knowing what each would mean to our world" (W. R. Valenter, *Rembrandt and Spinoza* [London, 1957], 89). My discussion of empirical holism is inspired in part by Fredric Jameson's account: "The type of interpretation here proposed is . . . the rewriting of the literary text in such a way that the latter may itself be seen as the rewriting . . . of a prior historical or ideological *subtext*, it always being understood that that 'subtext' . . . must itself always be (re)constructed after the fact" (Fredric Jameson, *The Political Unconscious: Narrative as a Socially Symbolic Act* [Ithaca, 1981], 81). But as, unlike Jameson, I do not hold that the culture of any given society must ultimately possess a unity, I do not need to explain the fact that various cultural manifestations may be in conflict with one another. Just as Foucault attacks the assumption that an artist's work possesses a unity, so I question the same assumption about cultures. Only historians who believe a priori that cultures do have a unity need be bothered by what is for them the mere *appearance* of disunity. Hegelian holists must explain how it was possible for two such different men as Rembrandt and Spinoza to live in Amsterdam at the same time. For the empirical holist that question does not arise.

the artist's intention, providing a uniquely correct description of the visual artwork. If Blunt is correct, Poussin intended his E to refer to Plutarch's text; if Haverkamp-Begemann is right, Rembrandt intended to insert symbolic figures and make a topological reference in *Night Watch*; and if Riegl is not mistaken, Rembrandt intended the figures to be seen as responding to Captain Cocq. The antihumanist understands interpretation differently. Rhetoric in artwriting does not mark our inability to know artists' intentions with certainty, but rather indicates that interpretations are narratives that, starting from the facts, aim to be original, suggestive, and plausible. What for the humanist is merely a limitation owing to our lack of knowledge is inherent in the practice of interpretation, which must construct from the facts an account that satisfies these criteria. We would do better to give up the belief that we can or should re-create the artist's mental state.

What is then gained? There are conflicting interpretations, and I, like the humanist, compare them in terms of their originality, suggestiveness, and plausibility. But unlike the humanist, I do not believe that any further question of truth or falsity is at stake; we must allow for a plurality of good interpretations. Blunt offers one reading of the *Ordination*, and his critics another. Haverkamp-Begemann and Riegl think *Night Watch* complex in ways that their critics do not. Barring further discoveries, there is no a priori way of choosing between these interpretations. To interpret a painting is to make sense of it by constructing a narrative that explains as many features as possible in ways that are original, suggestive, and plausible. Different interpretations of a painting are possible because more than one such narrative can be constructed. Interpretation is an exercise in rhetoric. Good interpretations of Piero, Caravaggio, Flemish allegory, antique sculpture, Manet's paintings, and *The Oath of the Horatii* are narratives, consistent with the facts, that are original, suggestive, and plausible.

I have criticized humanism, but have not yet presented a developed antihumanist interpretation. That is the task of the next two chapters.

10

Manet:
Modernist Art, Postmodernist Artwriting

. . .

To interpret an artwork, I argued in Part One, is to put it in a context, relating it to the artist's life, other images, and texts. The role of the artwriter, I claimed in Part Two, is to construct a narrative that places the work in context. Almost all of my examples of interpretation in Parts One and Two were drawn from studies of old-master art. What happens when we turn to modernist art is that both the artist and the artwriter are dealing with the same concern: how is representation possible? Manet plays a key role because he creates inherently ambiguous images just at the time when art history becomes an academic discipline. This unique historical position of his art is related to a present-day uncertainty about how to interpret his works. Is he an interesting artist whose achievement

is flawed by the unevenness of his work? Or does that unevenness reveal his sensitivity to his place in the history of art?

As Manet is a highly elusive personality, his humanist interpreters attempt to construct a consistent view of his intentions. Perhaps the divisions within his art reflect a divided personality. A strange revolutionary, "he demanded an audience at any cost"; because he was "protractedly supported by conservative parents," he was "obsessively ambitious for conventional recognition."[1] But it is also possible to describe his ambitions in a more positive way.[2] Perhaps he "paraphrased the methods of academic painters, their heavy allegory and elaborately constructed compositions, to make a wry comment about their precepts."[3]

Some art historians urge that we avoid such speculation and let "the paintings . . . speak for themselves."[4] But this is impossible, as even the simplest descriptions of Manet's works involve speculation. Is the cat in the drawing Cat under a Bench Mallarmé's cat, or another?[5] To answer that seemingly trivial question, we may need to ask some potentially far-reaching questions about Manet's relation to the poet, who wrote about his work. If the cat in Olympia refers to one in a famous Chardin, then can we also accept the traditional claim that the painting illustrates Baudelaire's "Le Chat"?[6]

> Je vois ma femme en esprit. Son regard,
> Comme le tien, aimable bête,
> Profond et froid, coupe et fend comme un dard,
> Et, des pieds jusques à la tête,
> Un air subtil, un dangereux parfum
> Nagent autour de son corps brun.

1. Seymour Howard, "Early Manet and Artful Error: Foundations of Anti-Illusionism in Modern Painting," Art Journal 37 (1977): 20.

2. "Manet . . . will never be able to fill completely the gaps in his temperament"; "he has a weak character": two letters quoted in George H. Hamilton, Manet and His Critics (New York, 1969), 36. See also Robert J. Niess, Zola, Cézanne, and Manet: A Study of L'Oeuvre (Ann Arbor, 1968).

3. Wayne Andersen, "Manet and the Judgment of Paris," Artnews 72 (1973): 67. See Theodore Reff's critical reply, "Manet and Paris: Another Judgment," Artnews 72 (1973): 50–56, and the discussion in Wayne Andersen, My Self (Geneva, 1990), chap. 15.

4. Jed Perl, "Art and Urbanity: The Manet Retrospective," New Criterion 2 (1983): 45.

5. F. Cachin et al., Manet: 1832–1883 (New York, 1983), 379.

6. Michael Fried, "Manet's Sources," Artforum 7 (1969), 71.

Chardin's cat, unlike Baudelaire's, lacks erotic significance, but Manet might be invoking both sources in one picture. Manet portrayed Monet several times; learning whether his sitter wears the same hat in works painted "when Monet and Manet were both working in Argenteuil" may influence our view of their style.[7] Manet depicted his stepson Léon in *The Luncheon* and perhaps also in *Study of a Boy*. Our reading of those pictures may be influenced by the information that the boy might be his natural child.[8]

Perhaps his naturalistic images have symbolic meanings. *The Balloon* has been read as an allegory of the crucifixion, symbolically juxtaposing balloon and crippled boy.[9] Although the Japanese print in *Portrait of Émile Zola* may have been merely a bit of studio decor, it perhaps also alludes to Zola's criticism.[10] That portrait contains three pictures within it: the Japanese print depicting a wrestler, a modified version of *Olympia*, and a Goya after Velázquez. Do these images show strength versus sensuality and allude to the coarse life Zola loved to describe, or are they included merely because they make an attractive composition? They could have all these meanings.[11]

Interpretation requires a re-creation of Manet's personality. If he was a "mischievous but gallant man-about-town," he could have included the sword in *Boy with a Sword* as "a disguised comment" on his "personal and professional interests." Would he have joked about Nana's virtue by depicting a crane—*la grue*, a high-class prostitute—behind her in *Nana* (Fig. 27)?[12] A leftist could not have painted *The Old Musician* without deep awareness of that figure's tragic plight. But as "the only direct evidence" we have for Manet's feelings about Haussmann's rebuilding of Paris is his "delight in the novel visual effects provided by a tree left standing in a destroyed garden and . . . the whiteness of a workman's clothing against a white plaster wall," perhaps he, a wealthy dandy, merely thought the violinist a picturesque vagrant.[13]

7. Cachin et al., *Manet*, 364.

8. Cachin et al., *Manet*, 292, 295.

9. Cachin et al., *Manet*, 135, 292; Bradford R. Collins, "Manet's 'Rue Mosnier Decked with Flags' and the Flaneus Concept," *Burlington Magazine* 117 (1975): 713.

10. Theodore Reff, "Manet's Portrait of Zola," *Burlington Magazine* 117 (1975): 35–44.

11. Theodore Reff, *Manet: Olympia* (New York, 1975), 26.

12. Cachin et al., *Manet*, 76, 344.

13. Theodore Reff, *Manet and Modern Paris* (Washington, D.C., 1983), 19, 180.

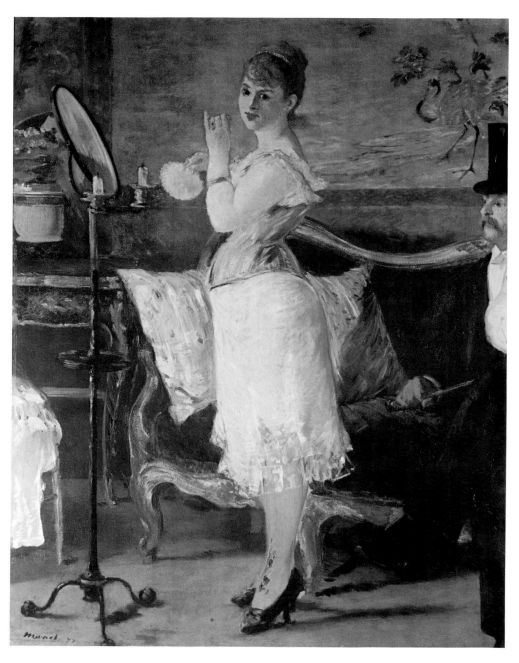

Fig. 27. Manet, *Nana*, Hamburg, Kunsthalle (photo: Foto Marburg)

As with Caravaggio, it is unclear when Manet's recorded comments are ironical. While painting *The Monet Family in the Garden*, he said of Renoir: "He has no talent, that boy! . . . tell him to give up painting."[14] We expect one good artist to recognize another.[15] An ironical man says the opposite of what he means, but maybe Manet spoke literally. Even if he was not a believer, the claim that *The Dead Christ and the Angels* was "painted for an exhibition, not a church" is not necessarily correct, and George Mauner's interpretation of that painting as a sacred work is not refuted.[16] A non-Catholic might develop a complex religious iconography.

Many historians find meaning in Manet's choice of subjects. His presentation of *Olympia* and *Christ Scourged* in the same salon emulates Titian's presentation of a pair of works, one erotic and the other religious, to Charles V.[17] An earlier work, *Battle of the Kearsarge and the Alabama*, depicting a naval battle of the American Civil War, "touched personal experience"; when young, Manet served as a seaman. Might he, "savaged by the critics" in 1864, have "identified with the fallen bullfighter" in *The Dead Toreador*; with Christ in *Christ Scourged*, the "French" angel showing that he was tormented by the French public; and with the emperor Maximilian in *Execution of the Emperor Maximilian*, "another victim of the imperial Regime"?[18] Our answer to these questions depends upon speculation about his politics.

There is a remarkable contrast between the recent interpretations that assert that even apparent infelicities—"faulty" composition, hasty brushwork—are meaningful and the older accounts, which treat Manet as a simple man:

> There are those who seek a philosophical meaning in [*Olympia*]; others . . . have only been angered to discover an obscene inten-

14. Cachin et al., *Manet*, 362.

15. Cezanne's highly critical view of Gauguin or Zola's of Cezanne might lead us to question that assumption.

16. Edgar Wind, *Art and Anarchy* (New York, 1969), 13; George Mauner, *Manet: Peintre-Philosophe* (University Park, Pa., 1975), 140.

17. Cachin et al., *Manet*, 221. See also Anne Coffin Hanson, *Manet and the Modern Tradition* (New Haven, 1979), 121–24.

18. Cachin et al., *Manet*, 198; Fried, "Manet's Sources," 57; Richardson, *Manet*, 7. Reff argues: "Manet, a practicing Catholic . . . would hardly have conceived such a blasphemy" (Theodore Reff, " 'Manet's Sources': A Critical Evaluation," *Artforum* 8 [1969]: 44). But perhaps only a believer would find such blasphemy meaningful.

tion. Well!, say to them dear master that you have nothing to do with thought, that for you a painting is only a simple pretext for analysis. You need a nude woman, and you choose Olympia, the first who comes along. (Zola)

In Manet there is scant evidence of a reflective mind, an inquiring intellect, or a participating will. (Hamilton)

There is no psychology and nothing to allow us to glimpse the secrets of mind or heart. Manet, if one likes, is a painter of the epidermis. (Courthion)[19]

Even John Richardson, who admires Manet, agrees that his compositions are defective. He asks why Manet did not at least disguise his weaknesses by copying well-composed pictures. But if Manet quotes so often, perhaps that is because he wants us to notice his references. Admiration for the artists he copies, not an inability to compose, may explain such borrowings from the past.[20] More recently, this defect has been said to demonstrate his historical awareness: "the very quality of Manet's painted surfaces" reveals the difference between his position and Velázquez's.[21]

The visual quotation in Le Déjeuner sur l'herbe (Fig. 28) is as disputed as Caravaggio's quotation from Michelangelo in his Saint John. According to a well-known reminiscence by a friend, Manet redid a famous Giorgione in contemporary dress. Many critics note that Manet borrows part of a Raimondi engraving after Raphael. Fried relates the painting to Watteau's La Villageoise; Mauner says that it shows both pagan and Christian subjects and describes "the opposition of spirit to flesh"; and Linda Nochlin claims that it was a practical joke.[22] For Pierre Schneider "the breaking point . . . between tradition and originality . . . becomes visible" in this work; Gombrich sees only "a simple transposition of a detail from a composition by Raphael."[23] Where Gombrich finds success

19. Émile Zola, Mon salon, Manet, Écrits sur l'art (Paris, 1970), 110; Hamilton, Manet, 276; Pierre Courthion, Manet (New York, n.d.), 9.

20. Peter Gay, Art and Act (New York, 1976), 69.

21. Svetlana Alpers, "Interpretation without Representation, or the Viewing of Las Meninas," Representations 1 (1983): 42; Perl, "Art," 45.

22. Fried, "Manet's Sources," 40; Mauner, Manet, 44; Linda Nochlin, Realism (Harmondsworth, 1971), 252.

23. Pierre Schneider, The World of Manet 1832–1883 (New York, 1968), 25; E. H. Gombrich, The Ideas of Progress and Their Impact on Art (New York, 1971), 76.

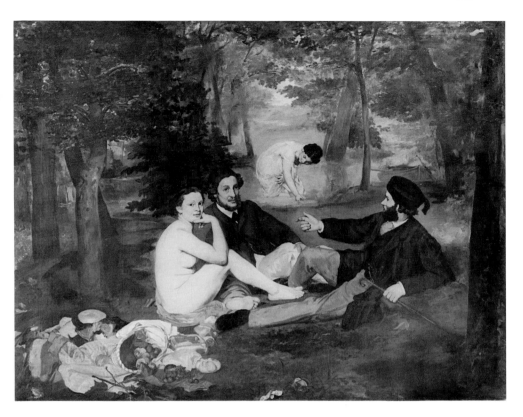

Fig. 28. Manet, *Le Déjeuner sur l'herbe*, Paris, Musée d'Orsay
(photo: Service photographique de la Réunion des musées nationaux)

ful naturalism—"as we stand before one of [Manet's] pictures, it seems more immediately real than any old master"—postmodernists see a deliberately unreal image.[24]

How critics see individual pictures depends upon their general view of the artist's goals. Does *The Balcony* show its "figures . . . lifeless . . . painted with no sympathy and not a trace of irony either," or does Manet "play on the contrast between the slightly stifling exuberance of the setting and

24. E. H. Gombrich, *The Story of Art* (London, 1966), 388.

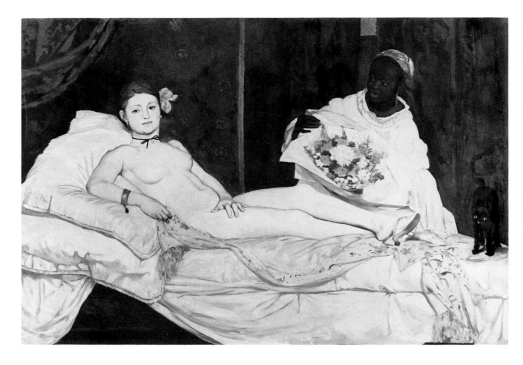

Fig. 29. Manet, *Olympia*, Paris, Musée d'Orsay (photo: Service photographique de la Réunion des musées nationaux)

the reserved delicacy of the young woman's head," a device that reflects the psychological tension of the scene?[25] This disagreement between a critic who lacks sympathy with Manet's art and one who finds its every detail meaningful also involves a disagreement about Manet's relation to modernism and postmodernism.

Just as Caravaggio has been called a mere naturalist and a creator of allegories, an atheist and a devout believer, according to the artwriter's view of his personality, so too with Manet. Some historians call *Olympia* (Fig. 29) a protofeminist work, more truthful than conventional salon

25. Perl, "Art," 50; Cachin et al., *Manet*, 306.

nudes.[26] By contrast, *Ball at the Opera*, it has been said, shows pleasure in "a scene of erotic commerce" in which the men are sizing up the woman.[27] Perhaps Manet was only a sometime feminist; maybe— *Olympia* is the earlier painting—he gave up his feminist views; possibly he failed in the later work to understand the achievement of *Olympia*—or perhaps feminists have been too sympathetic to *Olympia*.[28]

What all these otherwise opposed interpreters share is the belief that there is some deeper pattern of consistency lying beneath the apparent contradictions of Manet's work: "Manet's artistic enterprise was a formidably intelligent one, with a quite remarkable unity and coherence. Any disjointedness, any apparently ragged edges, are due largely to our lack of understanding of the ways in which he developed his paintings."[29] This view of Manet's work is not a discovery, but stems from the humanists' belief that an artist's oeuvre *must* possess such a unity. Just as Steinberg is criticized for importing a modern sensibility into his accounts of old-master art, so methodologically conservative art historians complain that innovative interpretations project "upon Manet an intellectual move that belongs rather to the age . . . of conceptual art than to the painter of 1860."[30] Reff objects that Fried claims for Manet's art "the ambitions and attitudes that [Fried] would claim for modernist art one hundred years later."[31]

But how can we know that Manet did not think like a modernist? As with Caravaggio, we may appeal to contemporary commentary. But which contemporary account should we trust? Baudelaire called Manet a "man of brilliant and facile ability" with "a weak character," but that was only a casual remark by a person in failing health who had, in any

26. Her disarming stare marks a refusal to be treated as a sexual object. See Eunice Lipton, "Manet: A Radicalized Female Imagery," *Artforum* 13 (1975): 48–53, and Mark Roskill and David Carrier, *Truth and Falsehood in Visual Images* (Amherst, 1983), 31–39.

27. Linda Nochlin, "A Thoroughly Modern Masked Ball," *Art in America* 71 (1983): 196.

28. Nochlin, *Realism*, 84.

29. Juliet Wilson Bareau, "The Hidden Face of Manet: An Investigation of the Artist's Working Processes," *Burlington Magazine* 128 (1986): 21; Cachin et al., *Manet*, 84.

30. Krauss argues that *The Nymph Surprised* is really a version of *Susannah and the Elders* in which the spectators of the picture are to play the role of the male voyeurs who spy on Susannah (Rosalind Krauss, "Manet's Nymph Surprised," *Burlington Magazine* 109 [1965]: 622–25). Her interpretation is criticized by Beatrice Farwell, who argues that Manet changed the subject (Beatrice Farwell, "Manet's 'Nymphe Surprise'," *Burlington Magazine* 117 [1975]: 225–29). For another view, see Fried, "Manet's Sources," 72.

31. Reff, " 'Manet's Sources,' " 48.

event, seen only Manet's early work.[32] Zola's *La Bête humaine* reveals an aesthetic seemingly opposed to Manet's; is that reason to distrust his account? Compare his commentary on *Olympia*, quoted earlier, with Mallarmé's: "The bouquet still wrapped in its paper, the mysterious cat apparently suggested by the poems in prose by the author of the *Fleurs du Mal*—all the accessories are truthful, but not immoral.... but they were undoubtedly intellectually perverse in their tendency."[33] "Les Impressionistes et Édouard Manet" is as Mallarmesque as Zola's account of Manet is Zolaesque. Which friend of the artist provides the more reliable interpretation?

Some commentators think that a close reading can explain these apparent conflicts. Zola's denial of the importance of the content of *Olympia* might reflect "a tactical goal." He desired to underplay the importance of "social phenomena of which he was aware keenly as journalist and writer."[34] But if Zola never mentioned Manet's subtle quotation of *Olympia* in his portrait even though he owned the work, then either he was sly or he was not an acute observer. If Mallarmé's choice of graphic images shows that "his taste was quite different from Manet's," why trust his interpretation?[35] For Mallarmé "the successful poem should impart both a sense of completeness and a mood of spontaneity." Are these the qualities "Mallarmé understood and admired in Manet's mature paintings"? Jean Clay ingeniously argues that Baudelaire's famous judgment "You are only the first in the decrepitude of your art" expresses deep sympathy for Manet: "It is Manet's fluctuations, a certain return to the museum picture ... and the apparent abandonment of the path penned by *Music in the Tuileries* that is being denounced."[36] But if the meaning of Baudelaire's statement can be so opposed to its obvious sense, then no modern historian can appeal to any unambiguous contemporary commentary on Manet.

This is why the contrast between attempting to see Manet as he was seen in his own time and projecting attitudes from the present onto

32. Hamilton, *Manet*, 36.

33. Stéphane Mallarmé, "Les Impressionistes et Édouard Manet," trans. P. Verdier, *Gazette des beaux-arts* 86 (1975): 150. This text was first published in English in 1876; the original French text is lost.

34. Reff, *Olympia*, 22–24.

35. Jean C. Harris, "A Little-Known Essay on Manet by Stéphane Mallarmé," *Art Bulletin* 46 (1964): 562–63.

36. Jean Clay, "Ointments, Makeup, Pollen," *October* 27 (1983): 34.

his work is misleading. As his contemporaries offer no equivalent to the modern accounts, the real choice is between applying traditional art-historical methodologies developed by late nineteenth-century art-writers to his art and seeking novel interpretive strategies. Nearly without exception, Manet's interpreters claim that their accounts are almost certainly correct.[37] As my view is that all interesting interpretations are controversial, it is useful to consider here an admittedly dubious interpretation.

In an incomplete, undated letter by Manet whose intended recipient is unidentified we read: "Impossible to do anything worthwhile on the fan you sent me."[38] As nothing more seems to be known about that fan, this sentence is like one with which Nietzsche's editors had to deal: "I have lost my umbrella." That phrase seems not to belong to the corpus of Nietzsche's philosophical writings.[39] But maybe it is possible to find meaning in Manet's letter. In *The Balcony* (Fig. 30) (1868) Berthe Morisot holds a folded fan, and her sister a parasol. According to the catalogue of the 1983 Manet exhibition, this painting is not, as Fried says, an allegory about Manet's development or, as Mauner argues, a *memento mori*, but "a striking image because it shares the realistic intentions of the time."[40]

But if the unaddressed letter was for Morisot, then we can see why the fan, which appears also in *Repose: Portrait of Berthe Morisot* and *Berthe Morisot with Fan*, becomes "an attribute he was to choose for her repeatedly."[41] Another woman, Mme. Guillemet, is shown in *In the Conservatory* with a parasol, not a fan. There is a fan in *Lola de Valance* (1862), but not in that work's source, Goya's *Duchess of Alba*. The fan functions to personalize Manet's use of that visual quotation, identifying it as a quotation in his style.[42] In 1862 he uses the fan motif as merely an extraneous element; by 1868 repeated use of that motif had made it an integral element of his art.

Focusing on a fragment of Manet's oeuvre and this one fragment of a

37. An exception is Michael Fried, "Painting Memories: On the Containment of the Past in Baudelaire and Manet," *Critical Inquiry* 10 (1984): 523; Fried accepts some details of Reff's critique of "Manet's Sources."

38. Cachin et al., *Manet*, 529.

39. The phrase is quoted and discussed in Jacques Derrida, *Spurs: Nietzsche's Styles*, trans. B. Harlow (Chicago, 1978), 123.

40. Cachin et al., *Manet*, 306.

41. Cachin et al., *Manet*, 315.

42. Cachin et al., *Manet*, 146.

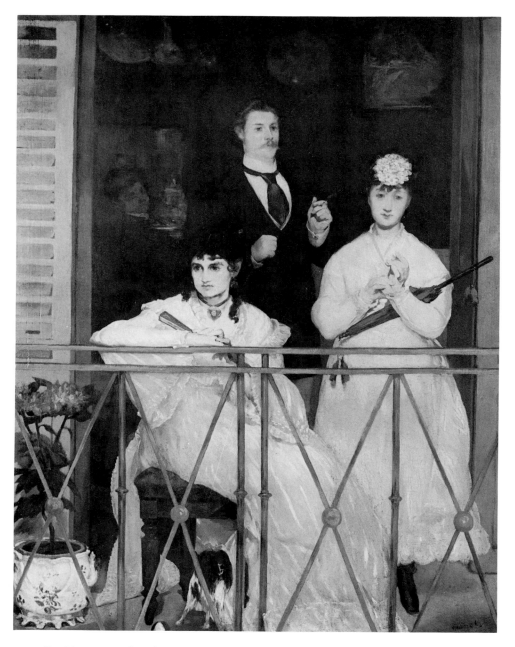

Fig. 30. Manet, *The Balcony*, Paris, Musée d'Orsay (photo: Service photographique de la Réunion des musées nationaux)

letter is an appropriate procedure when dealing with an artist whose work is so involved with fragmentation. He himself cut up some works, and other paintings were tampered with after his death; Mauner argues that only a photographic collage he displays showing *Olympia*, a detail from *Le Déjeuner*, and two isolated figures from the Parthenon pediment provides a complete image of Manet's intentions.[43] Interpretation puts the paintings in context, linking their details to the painter's life, his correspondence, the views of his contemporaries, the culture of his time, the artworks he quotes, and whatever else can be made relevant to his art.

Sometimes, it is true, the fragments fail to fit together, as in Pierre Courthion's unintentional parody of a deconstructionist account: "*The Balcony* was inspired by Baudelaire whose famous poem of the same title was written about that time: 'And evenings on the balcony, veiled in pink mists . . .' . . . there are no pink mists in Manet's painting, but . . ."[44] The interpretation of Manet's fan motif is more plausible, for as my Nietzsche quotation reminds us, fragments were important in late nineteenth-century culture.[45] For what is the relevant whole here? If it is relevant to study paintings Manet saw in Spain or his correspondence with Baude-laire and Zola, if we may speculate about his relations with his family or his view of class struggle, then what rule tells us that we may not also consider texts by Zola that he never read, or the writings of such near contemporaries as Nietzsche?

The catalogue of the 1983 exhibition provides an illustration of this point, as one of its authors complains that nowadays "the paintings seem peripheral to the explanations of them," while another writer in the same catalogue uses X-rays of some paintings and illuminatingly com-pares photographs of Clemenceau with Manet's portraits of him.[46] How can we learn that "what is mere gesture in the photographs" has in the paintings "been translated into the posture and personality of a powerful political figure" without going outside the paintings themselves? When we are told that in one portrait "Manet's presence [is] not by any means

43. Charles F. Stuckey, "Manet Revised: Whodunit?" *Art in America* 71 (1983): 158–77; Mauner, *Manet*, 98, shows the collage.

44. Courthion, *Manet*, 102.

45. This point is missed by John House, who dismisses interpretations that "fragment Manet" (John House, "Seeing Manet Whole," *Art in America* 71 [1983]: 184).

46. Cachin et al., *Manet*, 20, 27.

obliterating that of Clemenceau," those words—whatever their author's intentions—may remind us of Georges Bataille's famous description of another Manet: "The picture obliterates the text."[47] The catalogue itself raises this very problem, for the unity of that collective product is as problematic as that of Manet's oeuvre.

As an astute reader may have guessed by now, the interpretation of Manet's fan motif is my invention, suggested by Derrida's account of Nietzsche's sentence about his umbrella. The defects of this interpretation are obvious. I do not link the fan mentioned by Manet in his letter to those he depicted, nor do I show that fans had any special significance for him.[48] Nevertheless, the problems my undeveloped interpretation raises are shared by some more serious accounts. Fried's analysis describes at length Manet's link with Michelet, though he admits that there is no evidence that Manet read that historian.[49] Mauner's *Manet: Peintre-Philosophe* offers a highly erudite account whose central thesis—that Manet had a highly complex iconography—runs counter to what Manet's contemporaries say about his artistic goals.

The point is that the relation between an artwriter's text and the art it aims to represent is as complex as that between an artwork and the scene it is said to represent. Identification of the content of artworks by Piero, Campin, or Manet on even the most basic level involves a controversial act of interpretation. Determining whether the Brera Altarpiece shows an egg, the Mérode Altarpiece a mousetrap, or *Olympia* a cat quoted from Chardin requires a complex judgment about the intentions of those artists. What distinguishes Manet from the earlier figures, however, is that interpretation of his work has long been linked with the definition of modernism.

"Manet's paintings became the first Modernist ones by virtue of the frankness with which they declared the surfaces on which they were painted."[50] Developing Greenberg's classic analysis, Fried wrote in 1965

47. Georges Bataille, *Manet*, trans. A. Wainhouse and J. Emmons (New York, 1983), 31. See the review of Cachin et al., *Manet*, by Richard Thomson, "Promoting Fantin, Moderating Manet," *Art History* 7 (1984): 260–62.

48. Compare Schapiro's claim that Cézanne found apples psychologically significant (Meyer Schapiro, "The Apples of Cézanne," repr. in his *Modern Art* [New York, 1978], 1–38).

49. Fried, "Manet's Sources."

50. Clement Greenberg, "Modernist Painting," repr. in *The New Art*, ed. G. Battcock (New York, 1966), 103.

that painting since Manet is "characterized in terms of the gradual withdrawal of painting from the task of representing reality."[51] Today few
critics are formalists, and Fried's account has not stood the test of time.
Now an altogether different view of Manet's art has begun to emerge. In
1967 a then little-known Frenchman published a brief article in which he
characterized Manet's work as "perhaps the first 'museum' paintings:"
"Flaubert is to the library what Manet is to the museum. They both
produced works in a self-conscious relation to earlier paintings or
texts. . . . They erect their art within the archive."[52]

Today Foucault's account has become more influential than Fried's
1965 modernist analysis, as these recent texts show:

> The exact provenance of these forms is not of interest in itself. We
> learn nothing much by tracking them to their sources.
>
> The art object is 'layered' by representational codes—to be deci
> phered by an observer schooled by previous art in the artificiality
> of perception itself.
>
> He makes paintings, but they are dead, inert representations of
> the impossibility of passion in a culture that has institutionalized
> self-expression.[53]

These could be descriptions of Manet's images, so filled do those images
now seem to be with difficult-to-trace quotations whose expressive significance is indeterminate. In fact, they describe postmodernist paintings.[54] Here a historical perspective may be helpful. Reff draws attention

51. Michael Fried, *Three American Painters* (Cambridge, 1965), 5.

52. Michel Foucault, *Language, Counter-Memory, Practice*, ed. D. F. Bouchard (Ithaca, 1977), 92.

53. Carter Ratcliff, "David Salle and the New York School," in *David Salle* (Rotterdam, 1983), 38;
Janet Kardon, *Image Scavengers: Painting* (Philadelphia, 1983), 8; Thomas Lawson, "Last Exit:
Painting," *Artforum* 20 (1981), 42. Fried's view, which takes issue with such postmodernist accounts, is that the failure of recent critics to understand Manet "as a painter of major ambition"
is what is at stake in calling him "a *modernist* painter, a term that revisionist art history tends to
shun" (Fried, "Painting Memories," 523). For a discussion of Fried, see my *Artwriting* (Amherst,
1987), chap. 3.

54. According to what seems to be the earliest use of the word "postmodern," a postmodernist houseowner is "free from all sentimentality or fantasy" (John Hodnut, *Architecture and the
Spirit of Man* [Cambridge, 1949], 119)—an apt description, many artwriters would say, of Manet's
world. Manet lived in a time of lack of confidence (Arnold Toynbee, *An Historian's Approach to
Religion* [London, 1956], 150), and in such times there is a felt "nostalgia of the whole and the

to the link between the publication in 1864 of "the first comprehensive, illustrated history of European painting" and the simultaneous appearance "of Manet's ambitiously 'historical' paintings . . . not so much a fortunate coincidence as the product of specific cultural conditions, in which the foundations of modern art history and those of modern art were laid down together."[55]

The difficulties posed by Manet's art are threefold: relating its expressive content to his highly elusive personality; identifying the meaning of his quotations; grasping the unity of his oeuvre. All three problems arise also in interpreting Caravaggio's art, but whereas that debate mostly concerns art historians, the interpretation of Manet is relevant to debates about modernism and postmodernism.[56] Just as visual representation has its history, so also do the verbal representations of artwriting. A history of artwriting must present both histories in one narrative, which must link the development of representation in art to the history of representation by artwriters.[57]

The observation that Manet appropriates images from earlier art does not distinguish him from many earlier artists: "When Reynolds portrays his sitters in attitudes borrowed from famous pictures . . . , when Ingres deliberately refers in his religious compositions to those of Raphael . . . do they not reveal the same historical consciousness that informs Manet's early work?"[58] We could ask the same question about Caravaggio: when he quotes Michelangelo, does he not also reveal that selfsame historical consciousness?

But did Reynolds and the artwriters of Caravaggio's time possess the

one" (François Lyotard, *The Postmodern Condition* [Minneapolis, 1984], 81; see also Lawrence Alloway, *Network: Art and the Complex Present* [Ann Arbor, 1984], 233).

55. Theodore Reff, "Manet and Blanc's 'Histoire des Peintres'," *Burlington Magazine* 112 (1970): 458.

56. Frank Stella's *Working Space* (Cambridge, 1986) aims to persuade contemporary painters that Caravaggio's use of space is relevant to abstract painting today. His interpretations of old-master and modernist painting employ a now dated formalist methodology; see my essay "The Era of Post-Historical Art," *Leonardo* 20 (1987): 269–72.

57. In the discussion of Pater in Chapter 6, I suggested that Hegel's lectures on aesthetics can mark the origin of art history. Unsurprisingly, then, these problems are anticipated by his contrast between the history of Spirit as it appears "in itself" and Spirit as it is "for itself." His *Phenomenology* explains in one narrative both how what he calls Spirit comes to know itself as it really is and how that self-discovery appears to Spirit as it evolves. The historian of art history too must explain how her discipline achieves self-consciousness.

58. Reff, " 'Manet's Sources,' " 40.

self-consciousness about the use of their medium that our artwriters display? As Greenberg's modernism induces us to see old-master art differently, so postmodernism changes our view of artwriting about the old masters. The history of artwriting mimics the history of art; the problems of making visual representations that truthfully represent the external world find their equivalent in the problem of achieving truthful interpretations of those visual representations. As an art historian explains how a representation can be truthful to what it depicts, so the historian of artwriting asks how an interpretation can be true to the painting it describes. Manet plays a special role in my account because his painting, as it now appears related to postmodernism, achieves that self-consciousness about its status as representation that has now been achieved by artwriting as well.

For Greenberg, modernist art comes to self-consciousness in Manet's recognition that representations must acknowledge their status as representations, that the artist must give up the ancient dream of making transparent images that are illusionistic equivalents for what they depict. Now artwriting too has come to self-consciousness with the recognition that interpretations of artworks never transparently present those artifacts as they really are. Artwriting has become self-conscious about its own status. In a Hegelian history, once such self-consciousness is achieved the story is concluded. History must come to an end. But in our world, unlike the one Hegel so imaginatively describes, the development of art history continues. Just as the modernist self-consciousness about the nature of representations did not lead to the end of art, so the postmodernist awareness that artwriting is a form of representation need not lead to the end of interpretation. On the contrary, once artwriters recognize that they are engaged in a process of constructing verbal representations, they can proceed, perhaps in a more self-conscious way, with the task of interpretation.

11

Matisse:
The End of Classical Art History and the Fictions of Early Modernism

• • •

Most recent accounts of Matisse are methodologically conservative. They fail to show what is genuinely new in his art. According to Pierre Schneider, *The Conversation* (Fig. 31) (1911) is a modern Annunciation: "One is reminded of the Fra Angelico annunciation. . . . In Matisse's picture, the man is cast in the active role of the angelic messenger, the woman in the passive one of the Virgin listening to the annunciation: the artist bringing into the household the force that is 'alien to ordinary life'."[1] Even on a formal level this is unconvincing, for the paintings look

1. Pierre Schneider, *Matisse* (New York, 1984), 23. A similar criticism applies to two accounts of Matisse's *Bonheur de vivre.* James W. Cuno, "Matisse and Agostino Carracci: A Source for the 'Bonheur de Vivre,' " *Burlington Magazine* 122 (1980): 503–5, and Thomas Puttfarken, "Mutual Love

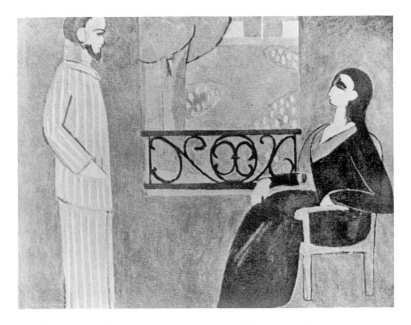

Fig. 31. Matisse, *The Conversation*, Leningrad, Hermitage Museum (photo: copyright 1989 H. Matisse/ARS, New York)

different. Fra Angelico's angel kneels; Matisse shows himself standing. Fra Angelico's Virgin kneels; Matisse presents his wife sitting. What could it mean to compare this family portrait to an Annunciation? If Matisse is to be identified with the angel, what message is he bringing the mother of his three children?

Rejecting Schneider's interpretation, Jack Flam offers another: "The composition . . . is clearly based on the ancient stele of Hammurabi . . .

and Golden Age: Matisse and 'gli Amori de Carracci,' " *Burlington Magazine* 124 (1982): 202–6, treat Matisse as traditional art history treats Caravaggio, seeking sources for Matisse's image in old-master art. As there exists no *catalogue raisonné* of Matisse's paintings, I will refer to his works by the titles given in my sources. While this practice leads to inconsistencies—some titles appear in French, others in English—at least it allows readers to locate reproductions of the works I discuss.

The pose of the seated god, the position of the arms, and the strict profile are all echoed in the figure of Amélie Matisse; the figure of her husband echoes the rigid verticality of the king. . . . The seated woman 'lays down the law'."[2] This too is unconvincing. Although both images show two facing figures, Matisse has his arms lowered, whereas the king raises his left arm to his chin; the god extends his left hand to touch the king, but Matisse and his wife are separated by a window.

Our discussion of Piero and Caravaggio pointed to the problems raised by the search for image quotations in old-master art. As there are only a finite number of ways of depicting a figure in any given position, if we are to identify quotations, we need evidence that the artist intended to refer to past works, as well as some idea of the meaning of those quotations. Applying traditional art-historical methodologies to The Conversation, Schneider and Flam interpret the painting as if its composition could be analyzed quite apart from the revolutionary ways in which Matisse presents its content.[3] Our discussion of Manet showed how traditional methodologies become inadequate in the discussion of early modernism. As we shall see, the same holds true for Matisse.[4]

Drawing on my discussion of the place of the spectator, I will analyze one motif common to old-master art and Matisse's work, self-portraits of the artist. Self-portraits function in two different ways in old-master art. Some place the scene in the present. Caravaggio's self-portrait The Martyrdom of Saint Matthew sets that scene in the presence of the viewer. Others set the scene in the past, with the artist present there.[5] Matisse's self-

2. Jack Flam, Matisse: The Man and His Art, 1869–1918 (Ithaca, 1986), 250.

3. Schneider and Flam adopt "a peculiarly transparent view of the work of art, according to which a painting becomes like a pane of glass which we look through to detect a compositional source or a hidden theme" (Richard Wollheim, "Poussin's Renunciations," The Listener 80 [1986]: 247).

4. Lawrence Gowing's interesting, extremely elliptical account of The Conversation offers another approach: "Matisse is seen to be the painter of the emotional contretemps and maladies of a marriage. . . . he was to be the painter of anxiety. . . . It was in this situation that exotic harmony came to his rescue. . . . Colour washed the conflict away" (Lawrence Gowing, Matisse [New York, 1979], 93). Seeking the sources for Matisse's images, Gowing implies, is not the best way to understand why he is a modernist. But as the painting does not appear to be an expressionist work, how can we identify it as a scene of anxiety?

5. There are at least eight such self-portraits in Bernardo Cavallino's work. He stands to the side in The Martyrdom of Saint Bartholomew; holds a lance amid the crowd in The Procession to Calvary; and turns his body toward the action and his face toward the viewer in Mucius Scaevola before King Persenna. He appears as a dandy, a bystander seemingly aloof from the momentous nearby dramas. See Ann. T. Lurie and Ann Percy, Bernardo Cavallino of Naples: 1616–1656 (Cleveland, 1984).

portraits show him at work. He often uses a mirror image, with his model and the picture he is making also seen in the mirror.

This motif has been much discussed. "Since Matisse through most of his life worked directly from a model," it has been suggested, "he continually found himself in the picture if a mirror was near the model."[6] This is true, but it is odd to think that an artist who so carefully controlled his studio environment merely happened to have mirrors around, and so included them in his pictures. Picasso often uses mirrors, but—so Steinberg notes—he disdains "their capacity to throw back the dependable image of an alternate aspect—though it delighted" many other artists, Matisse among them.[7]

Matisse's presence in the mirror images, it has been argued, "does not disturb our contemplation of the model. Artist, model and work of art—each plays his respective roles as part of a harmonious whole."[8] But although Matisse's mirror images place him in the distance, they change how we view his model. We see her being seen *by* him, which is different from regarding her without being aware of his presence nearby. These self-portraits, it has been written, by emphasizing the artist's presence "reveal a profound sense of alienation, anxiety and loneliness."[9] But we see an artist at work, too preoccupied with the task at hand to be obviously anxious or lonely.

A catalogue of Matisse's uses of this motif is revealing. *Carmelina* (1903) shows him looking away toward his canvas. *The Painter and His Model* (1919) defines his archetypical triangular relation, artist-model-painting. The motif is developed in many paintings done in Nice. *La leçon de peinture* (1919) shows him at work before a model and a mirror reflecting a landscape; *La séance de peinture* (1919) shows the artist and a mirror reflecting flowers on the table; *Intérieur au phonographe* (1924) shows a small image of Matisse facing the mirror behind a drawn-back curtain; and *Nu dans l'atelier* (1928) depicts the model and Matisse reflected in the mirror, as if we were viewing them from the position of the painting.[10]

6. Riva Castleman in John Elderfield et al., *Matisse in the Collection of the Museum of Modern Art* (New York, 1978), 34.

7. Leo Steinberg, *Other Criteria* (New York, 1972), 180.

8. Jack D. Flam, "Some Observations on Matisse's Self-Portraits," *Arts* 49 (1975): 51.

9. John Jacobus, "Matisse's *Red Studio*," *Artnews* 71 (1972): 34.

10. The Nice paintings are reproduced in *Henri Matisse* (Zurich, 1983), plate 63 (see the catalogue entry: "The picture unifies various themes: the studio, the . . . theme of the artist with

The most radical development of his motif occurs in drawings from the 1930s. *Artist and Model Reflected in a Mirror* (Fig. 32), typical of many drawings, shows the model, her reflection, and the reflected image of Matisse at work; this is a straightforward transcription of the motif as employed in the paintings. But *Reclining Nude in the Studio* shows the model from Matisse's vantage point, his right hand depicted in the act of drawing in the image in the lower left-hand corner.[11] As the image he draws includes an image of him drawing that image, we have here a potential *mise en abîme*. Finally, the most complex development of this motif is a drawing in which we see the mirror image showing the model and Matisse in the act of drawing; the model sitting before him; and—in the left foreground—a drawing of that model.[12] As the model takes up distinctly different poses when viewed directly and in the mirror—in the foreground, but not in the mirror, she clasps her right leg—this picture depicts the very process of creating that drawing.

As we saw in chapter 8, depicted mirrors in paintings extend the illusionistic picture space to place the objects they reflect in front of the image itself, in the viewer's space. Here we may link that discussion with the account of temporally polysemous images given in Chapter 9. According to one influential recent argument, a photograph essentially is *of* the past.[13] Seeing a photograph of Baudelaire taken by Nadar in 1863, I now view a scene from 1863. A photograph shows us events of the past, from that time when the film was exposed. Some paintings have a more complicated temporal relation to their viewers. Caravaggio's self-portrait in *The Martyrdom of Saint Matthew*, shows an event of the first century of the

his model as well as the mirror reflecting a landscape"; in fact, I will argue, there is but one theme), and Jack Cowart and Dominique Fourcade, *Henri Matisse: The Early Years in Nice 1916–1930* (Washington, D.C., 1986), plates 77, 144, and 183. This motif appears in at least one late painting, *The Painter and His Model* (1942). On this motif, see also Jean Laude, "Les ateliers de Matisse," in *La sociologie de l'art et sa vocation interdisciplinaire* (Paris, 1976), 225, and Stewart Buettner, "The 'Mirrored Interiors' of Henri Matisse," *Apollo*, February 1983, 129.

11. These are plates 85 and 79 in John Elderfield, *Drawings*. They are discussed in Yve-Alain Bois, "Matisse Redrawn," *Art in America* 73 (1985): 131; Bois interprets the *mise en abîme* differently than I do.

12. The only reproduction I know of this drawing appears in Christian Zervos, "Automatisme et espace illusoire," *Cahiers d'art* 2 (1936): 97.

13. The relation of this point about photographs to Matisse's art is hinted at in Flam, *Matisse*, 94, who writes that Matisse's "increasing awareness of self in relation to the images he was creating [led] to the realization that the question *Where am I?* implies *Who am I?*"

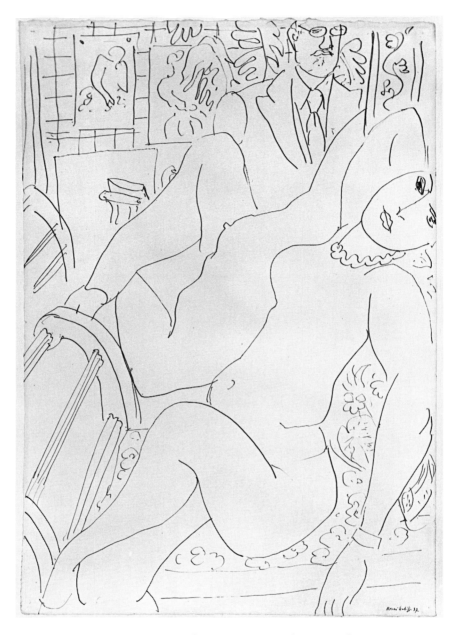

Fig. 32. Matisse, *Artist and Model Reflected in a Mirror*, Baltimore, Baltimore Museum of Art, Cone Collection, formed by Dr. Claribel Cone and Miss Etta Cone of Baltimore, Maryland (photo: Baltimore Museum of Art)

Christian era set in that artist's time. With time, the indexical reference to the artist's present of such temporally polysemous images shifts. When it was painted in 1600, Caravaggio's picture was set in the present and in Saint Matthew's time. Today, it is still set in 1600 and in the first century, but now both times belong to the distant past.

When are Matisse's self-portraits? The converse of photographs, they are always in the immediate present of their viewer. Images showing their own making, they always refer to that present moment in which they are viewed, that time at which the viewer seemingly sees Matisse in the act of making the picture that she is at that moment viewing. This seems paradoxical. How can a drawing made in Nice in 1935 refer now to the present moment long after the death of the artist who created that image? Discussion of a parallel case from literature helps explain this sense of paradox.

In À la recherche du temps perdu "the narrator relates in enormous, painstaking detail all the silly, insignificant, pointless, accidental, sometimes horrible things he did in his rambling efforts to become an author.... This book ... will ... show how these unconnected chance events somehow finally enabled him to become an author ... to begin his first book ... a book he has not yet begun to write but which his readers have just finished reading."[14] Narratologists discuss the relation between the "present" of such a fictional narrative and the present in which the story is read; compare the time needed to read the narrative and the time that elapses in the narrative; and contrast the temporal intervals of the story that are described in great detail with the "uninteresting" times that are passed over quickly.[15]

Normally the narrated events are in the reader's past. In the text "now" refers not to the temporal present of the reader, but to the present moment in the narrative. The temporal distinctness of these two "nows" is no more paradoxical than the spatial distinctness of the physical pigment depicting Caravaggio and his apparent position in the illusionistic space of his picture. What perhaps is paradoxical, however, is the combination of two statements, both seemingly true of Proust's novel:

14. Alexander Nehamas, Nietzsche: Life as Literature (Cambridge, Mass., 1985), 167–68. The importance of Proust for Matisse is suggested in a different way by Elderfield, Drawings, 55.
15. See Gérard Genette, Narrative Discourse: An Essay on Method, trans. J. E. Lewin (Ithaca, 1980).

(1) This is the story of a man who will write a novel.
(2) The novel he will write is the book we are reading.

Matisse's motif can be described by an analogous pair of statements:

(1) This is an image of Matisse making a picture.
(2) The picture we see is the image Matisse is making.

Just as Proust's novel is about a man who is writing that very book, so Matisse's picture is an image about the creation of the very picture we see. Such texts and pictures are seemingly locatable only within the present experience of the spectator. Drawing an analogy with indexical words such as "now," "here," and "I," whose reference depends upon the presence of a speaker, I call these pictures "indexical images." Reading Proust's text and viewing Matisse's indexical images, we naturally identify with their creators, for as these representations appear to exist to be read or seen only at the moment when we perceive them, we seemingly create them by reading or viewing them. When, for example, Matisse shows himself in the mirror image working, he places himself in our space before the image.[16] Matisse's picture, however, is only seemingly paradoxical, for there is no genuine *mise en abîme*. We see the model, Matisse's image of her, and a rough sketch of an image of her. There is ultimately nothing paradoxical in his attempt to abolish any position for the spectator outside the space created by his image. Nor is Proust's novel actually paradoxical. We are not really reading the book Marcel Proust will write. These representations are not genuinely paradoxical; we cannot view a finished image while it is being made. And so the real question is why such artworks seem paradoxical.

Such artworks extend the conventions that govern our experience of all fictional narratives and illusionistic images. Normally we read a story or view a picture that stands apart, in space and time, from us. Matisse's motif, like Proust's novel, invokes the fantasy that we spectators are not

16. *Reclining Nude in the Studio*, which places us so that Matisse's right hand is where our right hand is as we hold the drawing, is but the most extreme development of the apparent paradox implicit in Matisse's motif. In his picture space, there is no place for the spectator outside the studio in which he is depicting his model. Perhaps this is what Gowing suggests when he writes, "The studio and the ways of thought that went with it absorbed the whole of Matisse's life" (Gowing, *Matisse*, 150).

experiencing an already existing artwork, but are in some way creating that work. Gombrich's account of illusionistic images appeals to a fiction, the "Pygmalion fantasy"—grounded in a psychoanalytic framework—to explain how representations function.[17] In analyzing Matisse's motif, I appeal to what may be another fiction, a view of the self also developed within psychoanalysis.

In a wonderfully titled essay—"The Mirror Stage as Formative of the Function of the I as Revealed in Psychoanalytic Experience"—first presented in 1936, Jacques Lacan develops ideas about the self relevant to indexical images.[18] The child first forms an idea of her identity by perceiving herself in the mirror, a process that "symbolizes the mental permanence of the I at the same time as it prefigures its alienating destination." The infant discovers her body in that imaginary space behind the mirror which is both visible and inaccessible; the self, paradoxically, is located "out there" in this imaginary space.[19]

What is complex about this experience is that the very notion of discovering the self in the mirror stage is itself highly paradoxical. "The mirror stage is a turning point. After it the subject's relation to himself is always mediated through a totalizing image which has come from the outside." But how can this stage be a turning point if it is also the origin of the awareness of self, "the moment of the constitution of that self. What . . . precedes it?"[20] Before that moment there was no subject, and so we cannot contrast the self as it was before the mirror stage, unaware of its own nature, and the self as it becomes after that moment. The self, it seems, is created in the mirror stage. Lacan's mirror stage marks a difference in kind between an inability to know a unified self and an identification of that self with the mirror image of the body. But when the

17. See my *Artwriting* (Amherst, 1987), 18–20, 44.

18. Jacques Lacan, *Écrits*, trans. A. Sheridan (New York, 1977), 1–7. The commentaries I have found most valuable are Catherine Clément, *The Lives and Legends of Jacques Lacan*, trans. A. Goldhammer (New York, 1983), 84–96, and Jane Gallop, "Lacan's 'Mirror Stage': Where to Begin," *SubStance* 37–38 (1983): 118–28. In connecting Lacan's theory and Matisse's art of the same time, I am not suggesting that Matisse knew that theory.

19. Though presented in a psychoanalytic context, Lacan's account has its basis in a Hegelian tradition that places great emphasis upon the link between alienation and self-discovery. "Culture first comes to the infant by way of an image: its own image, born of a separation. And the child laughs" (J. Laplanche and J.-B. Pontalis, *The Language of Psycho-Analysis*, trans. D. Nicholson-Smith [New York, 1973], 251, s.v. "mirror stage").

20. Gallop, " 'Mirror Stage,' " 121–22.

subject achieves that self-awareness, she cannot think of herself as the same person who existed before the mirror stage.

Matisse's motif raises similar issues. As Lacan's infant discovers her identity by viewing her body image in the mirror, so Matisse comes to understand his identity as artist by using mirrors to create a self-sufficient image showing him at work before the model making the very picture we see him working on. But this is an impossible task. No picture can both be complete and exhibit the ongoing process of its own making.[21]

Lacan describes the split between the eye and what he calls the gaze: "I see only from one point, but . . . I am looked at from all sides. . . . consciousness, in its illusion of *seeing itself seeing itself*, finds its basis in the inside-out structure of the gaze."[22] I see the external world; I am aware that this world contains other perceivers like myself. A Cartesian philosophy of mind begins with self-consciousness and only then deduces the existence of other embodied consciousnesses who can perceive my body and infer that I too have a mind. For Lacan, an anti-Cartesian, my relationship to the gaze of those other beings must be brought into the analysis of perception right at the start. When I perceive, I "turn myself into a picture under the gaze. . . . I am looked at, that is to say, I am a picture."[23]

As we saw in chapter 8, analysis of mirror images reveals that when I view my image in the mirror, I am at a position I can locate only in the imaginary space behind the mirror. That is a place—like that marked by pigment in an illusionistic picture—that I can see but not physically reach. The split between the eye and the gaze has further consequences for how we think of the self. Whenever I see the world, I also see myself as being seen by others. My awareness that I exist in a world in which others perceive me is built into my very experience of perception. Lacan represents his theory of the self by means of an image employing two intersecting triangles, the gaze placed at the base of the triangle at whose apex the subject is positioned. The line formed by joining the points where these triangles intersect, a line perpendicular to a line

21. Schneider recognizes this point: "The presence of the painter . . . posed a major problem. It threatened the integrity of the closed circuit. . . . Matisse's response to this problem was to reduce the artist's unavoidable presence to a strict minimum" (Schneider, *Matisse*, 438).

22. Jacques Lacan, *The Four Fundamental Concepts of Psycho-Analysis*, trans. A. Sheridan (New York, 1978), 72, 82.

23. Lacan, *Four Fundamental Concepts*, 106.

joining the gaze to the subject, forms what he calls the screen: "If I am anywhere in the picture, it is always in the form of the screen."[24]

One reason that Lacan's analysis is hard to understand is that it is difficult to visualize. Common sense tells us that we are where our eyes are, and that others are where their eyes are. As Lacan seeks to undermine this intuition, it is hard to visualize perception as he understands it.[25] Studying Matisse's art helps us to visualize Lacan's model. Lacan's diagram includes the self, the gaze, and the screen; Matisse's motif contains the artist, the model, and the image the artist is making. To understand the self, Lacan says, one must consider both the subject and the other, that *objet a*—in his jargon—"from which the subject, in order to constitute itself, has separated itself off as organ."[26] For Matisse to achieve his ideal of completeness in his art—"the wholeness of the body was precious in itself" to him—he must depict that triangular arrangement of figures: artist-model-image.[27]

This analogy between Matisse's motif and the Lacanian account of perception explains why Matisse's indexical images are situated *as if* in the immediate present of the spectator. A painter of sacred scenes shows events of the distant past; Matisse depicts his activity as a painter. And this difference between the implied time of sacred painting and that of Matisse's pictures is reflected both in the different ways space is presented and in the different content filling that space.[28] Matisse's pictures give us the illusion of seeing the making of the very pictures we are

24. Lacan, *Four Fundamental Concepts*, 106.

25. Philosophers of mind have not yet studied Lacan's analysis, perhaps because his presentation is not easy to follow. Certainly it is easy to criticize that analysis; even if we agree that a Cartesian account of other minds is unsuccessful, it by no means follows that the only or best alternative is Lacan's account.

26. Lacan, *Four Fundamental Concepts*, 103.

27. Gowing, *Matisse*, 69. We see in this motif an image of the desiring subject made whole: Matisse represents both his object of desire, the beautiful model, and his relation to her as depicted in the image he is making. In one extraordinary painting, *La séance de trois heures*, the artist's role is played by a young woman, as if for Matisse this triangular arrangement provided so basic a model of interpersonal relations that the place normally taken by the male viewer, the artist, could be occupied by either a man or a woman. For a reproduction, see Coward and Fourcade, *Matisse*, plate 147.

28. See Carla Gottlieb, "The Role of the Window in the Art of Matisse," *Journal of Aesthetics and Art Criticism* 22 (1964): 418: Matisse "avoided the break between inside and outside worlds, as found in Jan van Eyck's Rolin *Madonna*. Van Eyck raised the observer in status above the observed; Matisse maintained a democratic spatial continuity."

perceiving. That is why his indexical images look different from photographs. Viewing *The Negress* in progress and an early state of *Blue Nude* IV visible in the mirror in a photograph he perhaps composed, I see a scene from 1952 when that photograph was made.[29] Looking at his images of him depicting his model, I view pictures that seem to come into existence at the very moment I perceive them.

Matisse seemingly explores every variation on this triangular motif, presenting the artist-image-model first from one side, then from another, as if he were finding all of the possible ways of rotating his three "actors." Ultimately, however, he does move on, it would appear, to other concerns. Perhaps he had exhausted all the possible variations on this motif, or maybe the motif poses an ultimately insoluble problem. Just as Proust's novel cannot really tell a story of its writing, so Matisse's motif cannot represent the very act of perception; and Matisse's realization of this fact, we might conjecture, caused his apparent abandonment of the motif. Most accounts of his career stress the break between the paintings made in Nice and the late, revolutionary cutouts. Certainly those cutouts appear very different from the paintings and drawings utilizing the artist-image-model motif. In one cutout, however, he uses words to develop a further variation on this motif, an unexpected "solution" to the problems posed by those images.[30]

The Thousand and One Nights (Fig. 33) has at the upper right a quotation from *The Arabian Nights*: "She saw the light of day, she fell discreetly silent." The story narrated in Matisse's images is of a king who slept with a new woman each night and had her killed in the morning. Scheherazade held the king's attention with her story until, on the 1001st night, she showed him the three children she had had by him, and he granted her her life. In

29. This photograph is reproduced in John Elderfield, *The Cut-Outs of Henri Matisse* (New York, 1978), 121.

30. Matisse was mistrustful of words: "The sign is determined at the moment I use it. . . . For that reason I cannot determine in advance signs which never change, and which *would be like writing*: that would paralyse the freedom of my invention." This seems puzzling. Surely the meaning of words is not fixed, but depends upon context. Why should a poet have any less freedom of invention than a painter? Matisse's point becomes clearer, however, if we consider what he says about the unity of an artwork, which, he adds, is "a collection of signs invented during the picture's execution to suit the needs of their position. Taken out of the composition for which they were created, these signs have no further use" (*Matisse on Art*, ed. Jack D. Flam [London, 1973], 137; italics added). A discussion of Matisse's writing appears in Roger Benjamin, Matisse's *"Notes of a Painter"*: *Criticism, Theory, and Context*, 1891–1908 (Ann Arbor, 1987).

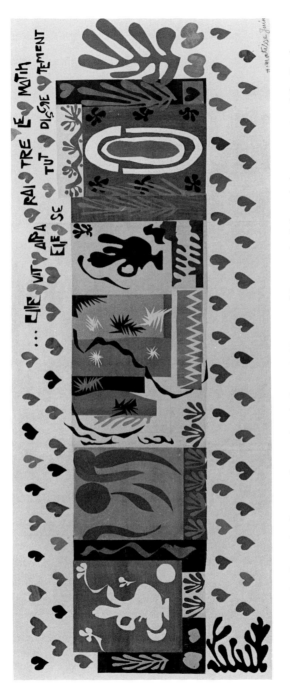

Fig. 33. Matisse, *The Thousand and One Nights*, Pittsburgh, Carnegie Museum of Art, acquired through the generosity of the Sarah Mellon Scaife family, 1971 (photo: Carnegie Museum of Art)

an essay published just two years after Matisse completed his work, Jorge Luis Borges drew attention to the 602d night. "On that night, the king hears from the queen his own story. He hears the beginning of the story, which comprises all the others and also—monstrously—itself." In this *mise en abîme*, akin to that created by Matisse's motif, what is disturbing, Borges adds, is the suggestion that "if the characters of a fictional work can be readers or spectators, we, its readers or spectators can be fictitious."[31]

In light of Borges's essay, Matisse's cutout may be read as a variation on the seemingly paradoxical texts and images we considered earlier. Remove the words (and ignore the title) and we have merely a marvelous image; only those words indicate that the cutout is a *mise en abîme*, an artwork related to Matisse's earlier scenes of himself painting the model, creating the picture we see. Those earlier indexical images create that infinite regress by giving the spectator the illusion that she sees the image as it is being created. In this cutout Matisse illustrates a story *about* such an infinite regress. Matisse once again creates a picture that places the spectator within the scene she is viewing. Now, however, he achieves that result in a new way, using picture and text. How ironical, then, that Matisse was so frequently criticized for the triviality of the "content" of his art, or praised for being a decorative artist, when in fact he is a philosopher-painter.[32]

This analysis provides a quite different view of Matisse than the conventional accounts I began by criticizing. How convincing is it? Here I return to another image that uses mirrors to bring the spectator into the picture— Velázquez's *Las Meninas*. Foucault says that since the mirror "hangs right in the middle of the far wall . . . it ought, therefore, to be governed by the same lines of perspective as the picture itself."[33] Given that his interpretation depends upon a straightforward misreading of the perspective, can

31. Jorge Luis Borges, "Partial Magic in the Quixote," in his *Labyrinths: Selected Stories and Other Writings*, ed. Donald A. Yates and James E. Irby (New York, 1964), 195, 196.

32. On the "triviality" of Matisse's subject matter, see Alexander Romm, *Henri Matisse*, trans. C. I-Wan (Ogiz-Izogiz, 1937), 9: "In his phantastic decorative world he calms the soul of the bourgeois, gives him forgetfullness of the social dangers of modern life, whispers to him of eternal well-being." See also Norman Bryson, review of Flam, *Matisse*, *Times Literary Supplement*, 27 March 1987, 326.

33. Michel Foucault, *The Order of Things* (New York, 1973), 7. This claim is made earlier in straightforward accounts. "We must imagine the royal pair outside the picture," Gombrich writes, "where we are and seeing what we see: their own reflection in the distant mirror" (E. H. Gombrich, *The Story of Art*, 11th ed. [New York, 1966], frontispiece caption).

we still take seriously Foucault's claims?[34] Perhaps we should consider a different way of interpreting Foucault. Foucault is an ironical narrator, and irony often involves saying the opposite of what one means.[35] What better way to exemplify the claim that today the classical system of representation is incomprehensible than to write a deliberately false description of *Las Meninas*, an account whose very falsity shows the unavoidable problems with that system of representation?

Any claim that an interpreter has produced a deliberately false account of an artwork is difficult to justify.[36] How can we distinguish a deliberately false account from one that is simply erroneous? In suggesting that Foucault's account is deliberately false, I appeal to the context of his interpretation. Knowing Gombrich's writings, I conclude that if he says that the mirror places the spectator in the royal couple's position, he means his account to be taken literally, and so he has made an error in measurement.[37] Knowing Foucault's texts, I must consider the possibility that his interpretation is ironical. Elsewhere in *The Order of Things* we read that "it is in vain that we say what we see; what we see never resides in what we say"; and in the midst of the discussion of Velázquez's picture our attention is drawn to "an essential void. . . . This very subject . . . has been elided."[38]

This reading of Foucault provides a precedent for my interpretation of *The Thousand and One Nights*, which also, I will argue, must be read ironically. If we do not trust Borges, but read for ourselves the 602d night of *The Arabian Nights*, we find nothing like the exciting *mise en abîme* he describes.[39] Borges is as unreliable a guide to Arabic literature as Fou-

34. Joel Snyder, "Las Meninas and the Mirror of the Prince," *Critical Inquiry* 11 (1985): 539–72.

35. See Hayden White, "Foucault Decoded," repr. in his *Tropics of Discourse: Essays in Cultural Criticism* (Baltimore, 1978), 230–60, and "Foucault's Discourse: The Historiography of Anti-Humanism," repr. in *The Content of the Form: Narrative Discourse and Historical Representation* (Baltimore, 1987), 104–41.

36. One possible precedent, discussed in chapter 5, is Vasari's *ekphrasis* of Michelangelo's *Last Judgment*.

37. Gombrich's one ironical text known to me is "Rhétorique de l'attribution," *Revue de l'art* 42 (1978).

38. Foucault, *Order*, 9, 16. An analytic philosopher has written, "Charity is forced on us; whether we like it or not, if we want to understand others, we must count them right in most matters" (Donald Davidson, *Inquiries into Truth and Interpretation* [Oxford, 1984], 197); this principle might serve to justify my reading of Foucault: we may prefer to read him as an ironical interpreter of Velázquez's painting in order to better comprehend his larger argument.

39. See *The Book of the Thousand Nights and a Night*, trans. R. Burton (New York, 1934), 3641. Borges invented the episode perhaps because "he wanted to have at his disposal yet another

cault, read literally, is to Velázquez's painting. And yet just as Foucault's narrative, if read ironically, may reveal something of *Las Meninas*, so Borges's deliberate misinterpretation of *The Arabian Nights* may help us understand Matisse's cutout.

Contrast Matisse and Borges with the author whose texts Foucault takes to be characteristic of the classic era. In *Don Quixote* "language . . . enters into that lonely sovereignty from which it will reappear . . . only as literature." Cervantes' hero owes "his reality to language alone. . . . Don Quixote's truth is not in the relation of words to the world but in that slender and constant relation woven between themselves by verbal signs." *Don Quixote* is thus structured like Velázquez's painting, in which, according to Foucault, when "representation undertakes to represent itself" there is left at the center "an essential void," that place where "there ought to appear" the king and queen, the artist, and also the spectator. The claim, familiar to historians of philosophy, that if the world is nothing but a system of representations then there is no place in that world for the subject who perceives those representations is exemplified for Foucault in the artworks of Cervantes and Velázquez. He ironically describes them as if such a worldview, whose very intelligibility he questions, were comprehensible. The "representation . . . of Classical representation" leaves out the subject for whom those representations exist; if the classical world is made up only of representations, then it cannot also contain a place for the spectator who stands before the artwork.[40]

A story that narrates itself, as if not created by an author independent of the reader; a picture that draws itself, as if it existed apart from the artist who constructs it: the art of Proust and Matisse involves these postclassical ideals of representation. We can contrast Velázquez's conception of representation with Matisse's even if we give up a literal reading of Foucault's account of *Las Meninas*. That painting is oriented as

authority from the past . . . thereby literally creating a precursor for himself" (Gene H. Bell-Villada, *Borges and His Fiction* [Chapel Hill, 1981], 49). This procedure has been made famous by Harold Bloom, one of whose readers asserts: "It is really the privilege of new art to extend artistic vitality backward, retroactively influencing, as it were" (Joseph Masheck, "Observations of Harking Back (and Forth)," *New Observations* 28 [1985]: 10; Masheck goes on to write: "David Carrier had been telling me to read Bloom, but I probably had to come a certain distance by myself").

40. Foucault, *Order*, 16, 48.

if toward a spectator, whom the painter, whose painting is hidden from our direct view, stands facing. The king and queen stand before the picture space, in a position alongside the spectator of the work. In Matisse's indexical images, the triad artist-model-depicted model is self-sufficient, creating a space in which there is no room for a viewer. Velázquez and Matisse therefore give different answers to the question "When is the painting?" Las Meninas shows seventeenth-century figures; the royal couple, the courtiers, and Velázquez himself now seem to exist in the distant past. Like a photograph, Velázquez's painting has always been "of" that time, so that what for his contemporaries was a genre picture showing contemporaries has now become a group portrait of seventeenth-century figures. By contrast, Matisse's indexical images are today and always in the present tense.

This discussion provides an explication of Foucault's gnomic remark "In Western culture the being of man and the being of language have never, at any time, been able to co-exist."[41] Velázquez's painting implies a possible place for its spectator. Matisse's goal is to create an artwork in which there is no position, within or outside the implied space of the image, available to the spectator. Matisse's indexical motif creates images that seem to be representations of the process of perception, that here-and-now awareness of the external world extending before the perceiver. Of course, just as Velázquez cannot really place us in the court, but can only create an illusionistic representation of that scene, so Matisse cannot really create an image in which there is no place for the spectator. Both artists create illusionistic representations. But because these representations involve such different views of art and its spectators, we are justified in taking seriously Foucault's claim that today we think of the world differently than men of the classical age. And what follows is that the methods of traditional, humanistic art history are no longer adequate to the representation of Matisse's modernist pictures.

Here, as in our earlier discussion of Manet, we find a deep parallel between the development of visual art and the development of art writing. It is no accident that the development of Manet's painting—so involved in self-critically examining the traditional concept of artistic representation—coincides with the birth of modern art history, and its recent reinterpretation with the rise of postmodernism. Nor is it surpris-

41. Foucault, Order, 339. For a commentary, see Gilles Deleuze, Foucault (Paris, 1986), 134.

ing that the art of Matisse, which asks more radical questions about the very nature of representation, should give rise to the novel interpretation presented in this chapter. The illusion that pigment on canvas depicts a scene we might see and the illusion that the image we view is created by our present act of perceiving it are different kinds of artistic illusions. Lacan suggests how we might understand the particular fascination of Matisse's motif. To treat Matisse as if he gave spectators the same role that old-master painters gave them, as if what is original about his work were only the novel "content" he places in the picture space, is to misunderstand modernist art altogether. The methodologies of artwriting developed to interpret Renaissance and Baroque art are inadequate to Matisse's work. This conclusion was anticipated by our finding that present-day historians of the art of Piero and Caravaggio have failed to understand the consequences of their ways of interpreting that art.

The self-consciousness implied in the very structure of Matisse's indexical images is mimicked by the present book, which aims to self-critically emphasize the role of what I have variously called rhetoric, emplotment, and the tropics of discourse in artwriting. Matisse creates a new relation between the spectator and his images. An adequate interpretation of his pictures must be a text whose awareness of its status as verbal representation mirrors his self-consciousness about the nature of representation. The aim of this chapter has been to sketch such an interpretation. Foucault's account of *Las Meninas*, read literally, is an incorrect interpretation of that work, but to ironical readers that text offers a very suggestive way of understanding an artist not explicitly discussed in *The Order of Things*.

How, then, should we write about Matisse? Perhaps we should imitate Foucault's account of *Las Meninas*: "The painter is standing a little back from his canvas. He is glancing at his model; perhaps he is considering whether to add some finishing touch, though it is also possible that the first stroke has not yet been made . . ."

Conclusion

· · ·

Naturalistic artworks represent the world. Artwriting verbally represents artworks. Just as Gombrich's *Art and Illusion* relates the history of the development of truthful artistic representations, so this history of art history describes the development of truthful representations of art-works. I have defended a relativist account of truth in art history. Today the work of Piero, Caravaggio, and Manet is described differently than at earlier times. If we reject the humanists' claim that interpretations are to be judged by their fidelity to the artist's intentions, the truth of present-day interpretations is measured by the consensus among professional art historians. This consensus determines the implicit rules governing art-historical discourse.

Fifty years ago, art historians did not discuss Piero's iconography,

Caravaggio's sexuality, or Manet's feminism; today these concerns are much discussed. A century hence, the consensus may change again, and then our concerns will seem as old-fashioned as Pater's account of Giorgione does today. To make explicit the rules that define the consensus is the goal of a philosophy of art history. When those rules have been made explicit, we can see how truth in interpretation is possible.

A spelling-out of those rules can affect the practice of art history. The analysis of Matisse's artist-image-model motif in the preceding chapter exemplifies one possible change in that practice. Matisse's images exhibit a self-awareness of the fictional nature of representation, an awareness akin to that of the art historian who acknowledges that her interpretations are like stories by an imaginative writer. The tools of traditional art history—the study of iconography, the search for pictorial sources, the analysis of artists' intentions—are inadequate for the analysis of Matisse's motif. Here the concerns of artists and those of art historians converge. Matisse's motif marks the boundaries of traditional European painting, and the preceding analysis of that motif marks the boundaries of academic art history.

This parallel between the history of art and the history of art history is significant. Ultimately both histories come to the self-conscious recognition that they are systems of representation. Gombrich describes the end of the illusionistic tradition as follows: "Naturalistic art was driven to search for alternatives which could be developed. . . . One by one it eliminated the memories and anticipations of movement and separated out those clues which fuse into a convincing semblance of the visible world. . . . Ultimately we owe it to this invention that we can discover for ourselves that the world can be contemplated as pure appearance and as a thing of beauty."[1] Once attention is focused on how representations function rather than on what they represent, we learn to see the world as pure appearance, as if it were a transparent image. The final paragraph of the final chapter of *Art and Illusion* describes this goal of the naturalistic tradition: "Under the hands of a great master the image becomes translucent."[2] But of course this goal can never be achieved. An image can never really become transparent.

1. E. H. Gombrich, *Art and Illusion* (Princeton, 1961), 329.
2. Gombrich, *Art and Illusion*, 389. I quoted this passage in an earlier debate with Gombrich. In a reply, he asserted: "My statement that 'under the hands of a master the image becomes translucent' refers to the communication of emotions, to our feeling (as I put it) 'of looking into the

A similar point can be made about the art historian's texts. Once she recognizes that her narratives can never transparently represent the artworks they describe apart from the rhetorical conventions that all writing must employ, the traditional view of the function of artwriting becomes questionable. Once she understands that the truth of her narrative is defined by the implicit rules governing such texts and not by fidelity to the artwork *as it really is*, she recognizes that her representations too can never truly be transparent. This is one reason why the critique of humanism has played such a crucial role in this book. As long as artwriters believed that the aim of interpretation was to re-create the mental states of the artist, it seemed that the "content" of such narratives could be subtracted from their "form." Rhetoric, it appeared, was ultimately dispensable. Only when humanism is abandoned does the true significance of rhetoric in artwriting become clear.

Now that the strategies of the founding fathers of art history are mastered by every graduate student, innovative artwriters turn either to new questions about familiar artworks or to artifacts that have not yet been placed within the system of art-historical discourse. But can the process of generating more and deeper interpretations continue indefinitely? Here the parallels between the history of painting and the history of artwriting are suggestive.

Modernist painting had to learn how painting could continue after the end of the tradition of naturalistic art. What would it mean, analogously, for traditional art history to come to an end? I have offered one answer to that question. The artwriter now recognizes that she cannot tell her story without using rhetoric. A history of art history has become timely for the same reason that Gombrich's account of the naturalistic tradition is timely.

Art and Illusion achieves narrative closure because the period in the history of art that it seeks to explain has come to an end. The present book can achieve narrative closure because its interpretations of the modernist art of Manet and Matisse make explicit the limitations of traditional art

invisible realms of mind' " (E. H. Gombrich, "Reply to David Carrier," *Leonardo* 18 [1985]: 213). Because I, unlike Gombrich, can easily imagine a naturalistic image becoming transparent, but find his (Cartesian?) metaphor of "looking into the invisible realms of mind" deeply puzzling, I produced what he describes as an "astounding misrepresentation" of his argument. What this shows, on his theory of interpretation, is that *Art and Illusion* is ambiguous, susceptible to misreading even by a reader familiar with his work. The artwriter is not the privileged interpreter of his own text.

Relativity of artwriting

history. Modernism in painting is marked by self-consciousness about the means of representation. A similar self-consciousness is achieved in art history by spelling out the implicit rules governing representation in artwriting.

In *Artwriting* I argued that as we approached the end of a period inaugurated by Greenberg's criticism, a history of the art criticism of that era was timely. The present book claims that now, as we approach the end of the era of humanistic art history, a history of art history is timely. As both texts are concerned with the rhetoric of artwriting, it is natural that both analyses conclude at that historical point at which traditional narrative strategies no longer seem effective.

But here one last problem remains to be solved. I have analyzed the rhetoric of artwriting, the tropics of discourse employed by the narratives of art history. If this study of representation in art history is to be consistent, however, it must itself satisfy the same tests that it applies to other texts. There is here no metalanguage. No interpretation of texts can itself escape judgment by the very criteria that it applies to those other representations. How, then, may we evaluate my analysis?

I have argued that good representations of artworks, while being true to the facts, construct a plausible story with an apt beginning, a convincing discussion of alternative approaches, and a conclusion that achieves narrative closure. This parallel between representation in artworks and representation in artwriting emphasizes the possibility of alternative accounts of artworks. But just as multiple interpretations of an artwork are possible, so different accounts of the history of art history can be given. A relativist must acknowledge that there are other ways of narrating the history of art history. How then might I have told my story differently?

The case study that originally interested me in this problem was a historical survey of interpretations of the curtain in Raphael's *Sistine Madonna*.[3] Until the nineteenth century, that curtain was not discussed. Art historians then interpreted it as a realistic depiction of a window curtain, as referring to the windowlike character of the painting, or as a symbol for Mary's virginity.[4] The various accounts of this detail show that

3. Johann Konrad Eberlein, "The Curtain in Raphael's *Sistine Madonna*," *Art Bulletin* 65 (1983): 61–77.

4. This published survey of seventy-eight interpretations led another art historian to respond with a variation on an earlier interpretation, arguing that "the late 19th-century account of the curtain as part of a window … fits with the intentions of artist and patron as well as the symbolic interpretation" (Richard Cocke, "Raphael's Curtain," *Art Bulletin* 66 [1984]: 329).

once interpretation begins, it continues indefinitely. When some years ago I sought to understand this argumentation, it was apparent to me that no account dealing merely with the arguments could explain such disputes. The apparent open-endedness of this debate troubled me. How could art historians argue when it seemed clear that they would never agree? Each interpretation involves a debatable starting point. The seventy-eight accounts of the curtain in Raphael's *Sistine Madonna* show that each account creates the demand for yet another. In a time when art history has become a professional discipline, how could this argumentation cease?

At that point I recognized that the obvious disagreements among art historians depended upon a very real consensus. Once we turn from the arguments of historians to their strategies of argument, it becomes clear that at any given time there is an implicit agreement about what sorts of disputes are worth pursuing. As I rejected humanism, this appeal to implicit rules of discourse provided an alternative way of explaining the open-endedness that puzzled me. Steinberg says that the only alternative to accepting his account of the "line of fate" in Michelangelo's *Last Judgment* is to conclude that the work lacks a structure. Analogously, the only plausible alternative I can find to my account of truth in art-historical interpretation is either a knockdown demonstration of the superiority of one kind of interpretation or nihilism. And just as Steinberg does not find it difficult to choose between his alternatives, so I do not find it hard to choose from among mine. I both admit that there is no way of resolving the conflict of interpretations and argue that the consensus among interpreters provides a sufficient foundation for objectivity in interpretation.

Just as an art historian who ponders some puzzling detail of a picture is more likely to find some meaning for it than to give up the belief that it is meaningful, so a historian of art history is more likely to find some way of rationally understanding debates about interpretation than to become a nihilist. Once a problem has been posed, the goal of the skilled storyteller is to achieve narrative closure by finding a way of concluding his story. All histories are in this respect but stories. The ending of every successful fictional narrative, from *The Three Little Pigs* to *Madame Bovary*, appears necessary, the inevitable conclusion to the story that has gone before. The big bad wolf will die in the pot of boiling water; Emma will ruin herself and commit suicide—and then the reader achieves "that golden and monstrous peace" that descends when all the clues the

author has offered us "with the express . . . purpose of having the ripe fruit fall at the right moment" fall into place.[5] But fictional necessity is one thing, and truth in history another. Emma's life must be as it is narrated in the novel, for she is only a fictional character. Even the most convincing historical interpretation, however, provides only one interpretation of events that in another narrative may take on a quite different meaning.

This book achieves narrative closure by linking the birth of modernism in painting to the end of the tradition of humanistic art history. Comparing representations in artworks with the representations of artwriters, it establishes systematic parallels between the history of art and the history of art history. One obvious model for this narrative is *Art and Illusion*. As Gombrich says that the end of naturalistic art comes when artists become self-consciously aware that their images are just representations, so I have argued that traditional art history ends when art historians recognize the inescapably rhetorical character of their narratives. Manet's modernism is marked by his refusal to identify unambiguously the sources and reference of his images, Matisse's by his nontraditional presentation of the spectator's role. As a result, traditional art-historical methodologies are no longer adequate for the interpretation of this art.

An interpretation's truth, I have argued, is measured by the current consensus. The argument presented in this book must itself be judged by the standards of the relativist. When Crowe and Cavalcaselle wrote, Piero's pictures contained no elaborate iconography, Caravaggio's early works were not homoerotic, and van Eyck was a marvelous naturalist. Today these pictures are interpreted differently and therefore look different. To say that our interpretations are truer than those of our grandparents is not in most cases to point to new facts we have uncovered. Rather, it is to signal a change in consensus that came about when a few gifted art historians persuaded their colleagues and successors that their interpretations were better than the earlier accounts.

Is it possible to state this relativist position consistently? Consistency is an obvious problem for any relativist account of truth. The statement that an interpretation is true if it is judged true by the current consensus cannot itself be timelessly true. To be consistent, that statement must be true according to the standard of truth it proposes. Vasari would find my

5. Vladimir Nabokov, *Lolita* (New York, 1966), 248.

account baffling; Crowe and Cavalcaselle and Pater might find it barely intelligible; Panofsky would understand it and, I think, reject it. But there is good reason to accept this relativist account of truth. A relativist can consistently assert that humanism yielded true interpretations when it was accepted by most working art historians but now fails to do so because the consensus has changed. This is one reason the difficulties traditional art history has with Manet and Matisse are important. Once it is recognized that traditional methodologies have difficulty interpreting modernist works, it becomes easier to suggest that humanistic art historians cannot tell the full story about old-master art either. The present awareness of the limitations of humanistic art history makes an attempt to change the standards of argumentation timely. Unless the successors of Panofsky, Riegl, Schapiro, and Wölfflin are equally imaginative at creating new styles of interpretations, art history is unlikely to remain an interesting discipline.

My aim has been to demonstrate that understanding the history of art history can be of value for the practice of artwriting. As I claim to provide a truthful history of art history, this book must be judged by the same standard of truth that it proposes for artwriting. My account self-consciously invokes literary models in its admittedly dubious interpretation of Matisse's fan motif, its "vulgar Freudian" account of David's and Hamilton's narratives, its use of Borges's text, and its ironical reading of Foucault. Recognizing that art history is a literary genre, I borrow from creative writers. Art historians have, I believe, always done that. What is Panofsky's humanism if not a variation on that invention so important to the creation of the modern novel, the interior monologue? Now art historians may borrow openly from literature, knowing that the stories they tell will be successful if they are consistent with the facts and convincing, plausible, and original. My relativist account of truth in art history is successful if it provides a convincing, plausible, and original way of understanding the texts that it discusses.[6]

6. I approach this problem in a somewhat different way in "Erwin Panofsky, Leo Steinberg, David Carrier: The Problem of Objectivity in Art History," *Journal of Aesthetics and Art Criticism* 47 (1989): 333–47.

Index